Sex, Art, and Audience

New Studies in Aesthetics

Robert Ginsberg
General Editor

Vol. 30

PETER LANG
New York • Washington, D.C./Baltimore • Boston • Bern
Frankfurt am Main • Berlin • Brussels • Vienna • Canterbury

Bruce E. Fleming

Sex, Art, and Audience

Dance Essays

PETER LANG
New York • Washington, D.C./Baltimore • Boston • Bern
Frankfurt am Main • Berlin • Brussels • Vienna • Canterbury

Library of Congress Cataloging-in-Publication Data

Fleming, Bruce E.
Sex, art, and audience: dance essays / Bruce E. Fleming.
p. cm. — (New studies in aesthetics; vol. 30)
Includes bibliographical references and index.
1. Dance—Philosophy. 2. Movement, Aesthetics of. 3. Modern dance.
4. Sex in dance. I. Title. II. Title: Dance essays. III. Series.
GV1588.3.F54 792.8—DC21 99-13425
ISBN 0-8204-4476-6
ISSN 0893-6005

Die Deutsche Bibliothek-CIP-Einheitsaufnahme

Fleming, Bruce E.:
Sex, art, and audience: dance essays / Bruce E. Fleming.
–New York; Washington, D.C./Baltimore; Boston; Bern;
Frankfurt am Main; Berlin; Brussels; Vienna; Canterbury: Lang.
(New studies in aesthetics; Vol. 30)
ISBN 0-8204-4476-6

The paper in this book meets the guidelines for permanence and durability
of the Committee on Production Guidelines for Book Longevity
of the Council of Library Resources.

∞

© 2000 Bruce E. Fleming

Printed in the United States of America

Dedicated with love and gratitude to my mother,
Jessie K. Laib Fleming, Ed.D.,
who first introduced me to dance.

Contents

III

Billboards and More

IV

Looking Out

V

Spirit and Letter

Introduction

PEOPLE I MEET AT PARTIES SOMETIMES ask how I became a dance critic. The answer is, I watched to the point where I felt I had something to say. My watching started with my mother, Jessie L. Fleming. She took my brother and me to countless close-to-home performances of the short-lived Washington National Ballet, and, in the summers, to the Saratoga Performing Arts Center where, beginning in its first season in 1966, I discovered the works of George Balanchine—then as now my measuring stick for great choreography.

Sometimes the same people ask, Do I dance? I say: I run, I swim, and I lift weights, but I have never danced. Then how can I write about dance? they want to know. There does exist dance criticism written from the point of view of the dancers, usually by literate dancers or ex-dancers. This book is not such criticism. Instead, it is written from the point of view of the audience. Our role is to sit in our seats and wait to be served. What are we served? How do we digest it? These are the questions I attempt to answer.

Sex, Art, and Audience is composed of, though it is not merely a collection of, essays written over the last two decades for a variety of publications—mostly dance quarterlies, where space is not so restricted as in daily journalism, and where issues of greater theoretical interest can be discussed than merely the merits or shortcomings of Miss X's performance. The majority of these essays appeared in *DanceView* and its precursor publication, *Washington DanceView*; others were written for *Ballet Review*, *The New Dance Review*, *Ballet International*, *Dance Magazine*, *The Dance Critics Association News* and, in the case of the only apprentice piece I have included here, the *Vanderbilt University Register*. The editor of *DanceView*, Alexandra Tomalonis, encouraged me to develop in my own way an all too rarely practiced genre of writing about dance: the dance-related personal and theoretical essay, something that is neither criticism nor publicity piece, but instead a consideration of the larger issues raised by particular performances.

The essays that resulted are clustered here into five related groups that consider a small handful of aesthetic and dance-related topics, through reactions to performances. The opening section focuses on gender issues in

dance; the second section is devoted to considerations of some of the great choreographers of the current scene, and the third to a cluster of more anomalous dance works. The penultimate section considers Western interest in non-Western dance and the arts and the closing section, the most abstract, treats the problem of textlessness in dance, and the resultant difficulties of dance transmission.

Because these essays were written during the late 1980s and the decade of the 1990s, largely about dance presented in America and mostly on the East Coast, they are, among other things, a record of their time: the end of what we in North America call the "dance boom," that somehow Golden Age of the late 1960s, 1970s and early 1980s. The time period covered by this book may not even represent for dance a Silver Age; perhaps it is Bronze, or a very debased one indeed. But it is, if nothing else, ours: this is what we have to react to. Just as movies based on books can be good even if the books are not, so decent writing about dance can be sparked by less than satisfactory experiences in the theater. For a reader, it should be irrelevant whether or not I enjoyed what I saw, and irrelevant whether the choreography was good or bad. Though it is likely that anyone reading this book will be interested by dance, I do not presuppose knowledge of the particular companies or issues discussed.

Collectively, these essays sketch a coherent critical and aesthetic position. Dance is part of a continuum containing all the arts. Watching dance is the same sort of activity as reading, or looking at paintings, or playing the violin. These, in turn, are part of the larger enterprise of life. Yet though dance is part of life (in specific, my life), it is not the same as life. If it were, there would be no point in braving the traffic, hurrying dinner, and paying the baby sitter to get to the theater. Art is a specific activity different from all the rest. We use art, which is both like the rest of life and unlike it, to reflect on our other experiences. (I have developed these perceptions in my esthetic treatise *An Essay in Post-Romantic Literary Theory*.)

Critics must love dance in order to be able to write about it. This does not mean they must love Miss X's particular dance, or Mr. Y's performance. We must, in other words, give ourselves wholeheartedly to the performance. This means we may be betrayed by it. Without the possibility of pain, there can be no pleasure in a performance. In the hushed moments before the curtain rises we wonder, Will this be it? Will it be the real thing? If we do not quiver with anticipation in these few instants of sheer possibility, we do not deserve the name of critics—or our place in the audience.

Sadly, we live in an age when critics frequently seek not the electric charge of direct interaction with the artwork but only fodder for their own pre-conceived theories. Such critics are like the tone-deaf who suggest we do away with music: they have no idea what they are about to destroy. Since they cannot be convinced, they must merely be opposed, and this as strongly as possible. At the same time, our age is rife (as perhaps every age is) with pseudo-artists who substitute posturing for art: if they put something on the stage, they clearly reason, it must be the audience's responsibility to make sense of it.

These essays have emerged from the space, sometimes the gulf, between the effect that art is capable of having on us and reality of particular evenings in the theater. Sometimes the space shrinks to zero: this is happiness.

✪

I am grateful to readers of this book as it developed who, through their comments and reactions, have saved me from error and misdirection. These include the woman who published most of them initially, Alexandra Tomalonis; New Studies in Aesthetics editor Robert Ginsberg, whose enthusiasm for the project kept me going; George Jackson, whose encyclopedic knowledge of dance and European history filled in many gaps in my interpretations; and editor *par excellence* Barbara Palfy, who showed me how better to achieve stylistic consistency. I am grateful too to the editors of the other publications in which pieces originally appeared. One in particular I would like to remember, the late Anita Finkel, whose *New Dance Review* set a high standard for intelligent dance viewing.

I

Do Real Men Watch Dance?

A Parade on Worden Field

WHAT, I WONDERED ONCE again in October—sitting in the bleachers at the U.S. Naval Academy for the final dress parade of the year—is the relation between art and life? For between dodging the already cold shadows in search of a patch of sun and watching the sculls on the Severn River beyond, what I found myself thinking of before this massed sight of the Brigade of Midshipmen was George Balanchine. Or, more precisely, his piece on military movement, *Union Jack*, still fresh in my memory from several summers ago.

We are no longer surprised at the suggestion that the motions of everyday life can be seen as choreography, since the choreographers themselves have appropriated so much of it in recent years—stylized, it may be, or at least put on a stage for us to admire, but recognizable nonetheless as quotidian. Paul Taylor's *Esplanade* taught us this, so too did postmodern dancers Yvonne Rainer and Trisha Brown, so too scores of other pieces and performers, mostly of the "downtown" sort. But what I was watching there on that coolish fall day was not, in any normal sense of the word, everyday. It was as stylized, dressed-up, and patterned as anything we might see on the stage of the John F. Kennedy Center in Washington, D.C., or the New York State Theater in New York.

Certainly it seemed indistinguishable from the entrances to movements one and three of Balanchine's *Union Jack*, not only in the obvious use of military motifs, but also in movement pattern. What did the people do here, or in Balanchine, but walk in and show off their uniforms? Did it really matter that the costumes in one case are stage costumes and in the other "real" ones? And was the appeal of this parade not exactly that of *Union Jack*: masses of healthy bodies, all identically dressed, all moving in unison

with what I can only call minimalist steps? We even had music, provided by the U.S. Naval Academy Band, a stage (Worden Field, brilliantly green in the sun), and an audience with dignitaries (that day, a cluster of admirals in the equivalent of the President's Box, former Superintendents of the Academy who were honored with a seventeen-gun salute of blanks). The dancers inserted words into their motions in best postmodernist style, commands relayed across the field in faraway shouts that produced, all at once, a massive and yet infinitesimal alteration coming over the thirty-six companies before us: white-gloved hands of more than four thousand performers flickered from waist to side, the flutter of black as the performers separated one leg from another, standing at parade rest. There were even critics, officers with clipboards grading each company to see who would carry the flag next year.

What could have been the eye-crushing uniformity of color (Balanchine's designer Madame Karinska would never have put them all in black, I thought) was broken enough to keep the visuals interesting. In most of the companies were one or two spots of blue or gray that did the same movements as the others but stood out like a single off-color swan in a gaggle of normal ones. These were exchange cadets from West Point or the Air Force Academy. Some of the midshipmen were women (it is explained that the appellation is a rank and as such not open to modification), although clearly this was a predominantly male show, a display of flagrantly masculine postures (squared shoulders, thrown-out chests). The postures were in considerably better taste here than in many contemporary dance works that similarly rely on machismo to make their point, such as some of the recent pieces of Martha Graham, or Glen Tetley's *Rite of Spring*. Occasionally, women were among the three leaders of each company who marched in a triangle before the square formations of midshipmen behind them; their steps, being shorter than those of the almost perfectly unison men, provided a kind of rustling visual counterpoint to the otherwise seamless flow.

Aside from the massive entrance and equally massive exit (between them fully half the time I spent here on Worden Field), the prime step was standing: stillness as action, underlined by the sheer mass of performers before me. It was the most convincing stillness I have ever seen in dance, because I sensed the vast potential for chaos in all these bodies which was being so carefully controlled. The stasis was touching because of what was held so completely in check, an act of pure concentration like the brow-furrowing attempt to put a little piece in a machine just *there*, all the

control exercised in damping down, an act of distillation rather than expansion or dilution.

Probably I am not well advised to use the word "machine" in this context, since it has negative connotations, and may be the first word to come to people's minds when they think of military parades in a critical vein. It is, I think, Susan Sontag who suggests that the spell such military movement exercises over us is that it lets us see human beings behaving like machines—a reprehensible frisson, she suggests. If this is true, it leaves little room for fans of the mid-nineteenth-century ballet *Coppélia,* about a doll everyone takes for human, where half the fun is in seeing how successful the humans playing humans playing dolls of Act II are at their mechanical impersonations. However, I suggest the opposite: that the power of this military parade, as motion, lay in my sense of the deeply human aspect of the performers before me, a humanity emphasized and set in relief by precisely the massed and minimal motions and the almost relentless unison of all their actions.

Furthermore, many choreographers setting movement on the corps use the same trick of producing an effect by simple replication that is more than the sum of the individuals doing it. Think of the *Kingdom of the Shades*, that repetitive but serenely beautiful dream sequence from Marius Petipa's *La Bayadère*. Even Balanchine uses this device, sometimes making fun of it: a row of girls will shift a leg, or make incantatory scissoring gestures with their arms. And is the beautiful visual gag when the lights come on in the last section of *Vienna Waltzes* and the stage is full of swirling white skirts not a deeply serious and deeply playful use of this same technique? (Even the Wilis in the Romantic ballet *Giselle* punctuate Albrecht's death-dance by a simple change of arm and leg position—and who can deny that this, at least, is serious and somehow spooky for its very impassivity?) Concurrent repetition alone gives structure to many of the scenes of otherwise almost aleatory gestures in Jerome Robbins's *Goldberg Variations*, where one boy mirrors another's idle steps or traceries on the stage—so that suddenly we have structure, and with it, art. Which brings us back to Worden Field, and to Balanchine.

For art, in Hitchcock's famous phrase (famous, that is, along with "actors are cattle" and "scissors is best way"), is only life with the boring parts cut out. Yet who can deny that this was manifestly life here on the banks of the Severn? (Was it also art?) Or that the walking about in *Union Jack* seems rather boring? Is Balanchine (or at least this bit of Balanchine) therefore not art? Was the difference between what I saw and *Union*

Jack—or for that matter, Graham's *Primitive Mysteries*, where people also walk on and out for long periods of time—merely the fact that in these dances the walking about is only the beginning and end, framing a more interesting or substantial middle? That day in the October sun, I wasn't sure. This performance started at an announced time and had programs and even ushers ("Either side of the bleachers, sir"), a stage and seats for the audience, and an announcer fully as disembodied as the voice that tells us that Miss X is indisposed and that the taking of photographs is strictly forbidden (photographs were even encouraged here).

Compared to most of what usually passes for life, this parade was clearly art—containing as it did no boring parts and being far more structured than the chaos of our lives. Yet for that matter even non-parade hours at the Naval Academy are a good deal more structured, a good deal more like art, than they do at other academic institutions. The students wear identical uniforms which vary only seasonally on appointed days, change classes all together so that the Yard is either overrun with similar shapes or completely empty, scatter to the athletic fields and buildings at the same time every afternoon (a heavenly audience could see patterns of circles and lines, laps in the pool and loops around the track, the splitting apart of a football line at the hike), go at the same time to meals, and vacate the walks for study hours in the evening. Certainly, this is planned, and is structure. Is it life, or is it art?

Let us go one step farther, that step (crucial and usually forbidden for the midshipmen) through the wall into the city of Annapolis. Are the patterns of our motions defined by our work hours and the layouts of our streets art, at least for a heavenly audience, or one in a helicopter? Can we "live" art, or do we have to be distanced from it in quiet perception?

What is the difference between the organized motion I saw on Worden Field and the organized motion of the tidy town of Annapolis? What is the difference between the parade on the field and the parade parts of *Union Jack*? Perhaps that progressively more of the boring parts are cut out? Yet are we not supposed to be the tiniest bit bored at the Balanchine, mesmerized rather than clenching the edge of our seats? And isn't the point of a good deal of postmodern choreography precisely that boring is part of life too? Is it the intention of the choreographer to produce art that makes the product art? Surely those who organized this parade on Worden Field knew they were putting on a show, even if they would not have been willing to call it "art." Did Molière or Bach, artists producing their works for specific presentation

and use, think they were making "art" or merely doing their jobs? Does it matter?

The notion that art and life form a continuum seemed close at hand that day on Worden Field—rather than being antithetical opposites, as they sometimes seem. So too the feeling that what does ultimately differentiate between them is point of view, or accommodation to the perspective of the individual perceiver. Surely I would have found this massive minimalist motion merely boring if I had been in the middle of these four thousand midshipmen, seeing only the person before me. What I saw from my distanced point of view, instead, was the mass; I merely intuited the individuals of which it was comprised.

It would be only a heavenly—or at last airborne—audience that could see the patterns of motion across this bucolic campus (or on the other side of the wall) as art. Such an audience would have to be sufficiently far away to encompass in its viewpoint Bancroft Hall, the track, the change of classes, and Noon Meal formation. Even then some of the boring parts, the fifty empty minutes of deserted lawns every class period, for starters, would have to be edited out. Similarly, it would never occur to most of us to see much overall pattern in the city of New York from street level, but we have only to go up in the World Trade Center at night to see Manhattan as possessing the coherence that turns it to art: the glowing spider webs of the bridges to the left and right, the searing scars of the vertical avenues, the lighted tops of the buildings hovering over midtown.

But is the art in such a case the thing seen—or the seeing? In order to make art, would we not have somehow to capture this view of New York by night, or this spectacle of patterned movement of the Naval Academy going about its business, and offer it to others? Is art the thing captured, or the gesture of offering?

Art is defined, I thought that day, by the givens not of its, but of our, situation, by our limitations of perspective and attention span as human beings. Think what happened to the gigantic canvasses of the New York School and its heirs whose intention was to challenge the standards for size and content imposed on painting by the fact of human size and vision field, to drown the viewer in paint: they merely produced museums with rooms large enough that the viewer could look at them from farther away. And if Andy Warhol's much-mentioned film *Empire*, with its eight hours of static filming of the Empire State Building, has any value at all, it is simply in showing us that art has boundaries defined by the limitations of human perception and attention rather than by limitations of the medium. It shows,

in other words, that such a film is technically possible, and at the same time shows us why no one had ever made it.

Some people believe that art is defined by its secondary characteristics, like stage, celluloid, tickets, jetés, or paint. But these are only a means of ensuring that this somehow more structured perception of the world can also be perceived by others, like capturing the pattern of life at the Naval Academy in words or on film, or photographing New York from the Word Trade Center.

Nor can it be artistic intention that makes art. The parable of the monkeys with the typewriters who, given infinite time to pick away randomly, will end up producing all of the world's literary classics, poses no problems for artistic theory. For what makes Tolstoy's *War and Peace* different from the monkey's is not the intention of a long-dead (or even of a living) author, but rather precisely the near-infinity of reject versions surrounding the monkey's ultimate success: the fact that the chances are so stacked against a creature other than a human being able to present life in this manner to another human being.

We might almost say that the Warhol film, when talked about rather than seen, becomes art because it suddenly shrinks from the hours and hours in which we would be lost to a comprehensible size. This is why it is more interesting to talk about than to see. The modern art scene has been full for years of works like this, which means nothing more than that they are bad art, or no art at all. The parade on Worden Field is art if perceived from the proper distance; otherwise it is near-art pushed over the brink only by its presentation in a written description such as this essay. And this is precisely how life becomes art. Conversely, even Balanchine can sometimes seem merely steps and costumes rather than art, givens of the medium and nothing more. And of how many lesser figures is this even more true?

Art and life can in fact be differentiated, like day and night that form part of a continuous spectrum. This differentiation is based on the fact that it is we, individual finite human beings, who are perceiving both. The organized, concentrated experience of life that is the experience of the artwork is distinguishable from other experiences (only) by the fact that we are limited in size, physical sense, and retentiveness. There is life, and art, and the things in between, all of which are related parts of the same whole, yet quite distinct from one another.

So what did I see that afternoon on Worden Field, by now cold in the lengthy shadows cast by the row of trees behind me: art or life? I saw the

final dress parade of the year at the U.S. Naval Academy in Annapolis, nothing less but also nothing more.

Washington DanceView 1988

Do Real Men Watch Dance?

ONE OF THE SPEAKERS AT THE 1993 conference of the Dance Critics Association (DCA) in New York was Rhoda Grauer, Executive Producer of the WNET TV series entitled *Dancing*. Ms. Grauer was there to present the series's trailer and comment on its content, which included footage of Kabuki, the Kirov/Maryinsky Ballet, dancers from the Javanese court of Yogyakarta, and Asante dancers of Ghana. Yet it was a minor aside rather than anything related to series content that buzzed in my head for days afterward. She observed that it had been a conscious choice on her part to ask a man to narrate the series rather than a woman. Immediately, as a woman talking to an audience composed largely of women, she made a wry face of acknowledgment at what she had said—"I'm a realist, you know"—and then went on to other matters including the scary admission that, with an eye to the ratings, she had initially tried to avoid having a title for the series that included the word "dance."

Everyone in the room understood the economic pressure to have a man narrate a television series, regardless of its subject matter. It isn't the time to go around trying to subvert the norms of the patriarchal culture when the bottom line is money. Arts programs can use all the masculine mainstreaming they can get: we know, if only intuitively, that most men in this country are uninterested in the arts—a country whose business, as Calvin Coolidge assured us, is business. Yet most everyone in the room knew that Ms. Grauer meant more than that. She had chosen a man to narrate her series because it concerned one particular art, namely dance. To appeal to a mainstream (i.e. male and patriarchal) audience, we critics knew, you have to give the message that dance is worth the time of men as well as women. For dance, dance watching, and dance criticism in our society are firmly in the hands of women and gay men, with a few foreigners thrown in. In this world, the marginalized rule.

Why has dance in America the aura of the unmanly, the not-for-us? Can this negative aura be dissipated by having a man introduce a television series,

or is there something in the material that works against its ever having a mass male audience in this country? Edward Villella, former New York City Ballet principal and now director of the Miami City Ballet, says he has found it immensely useful to make sure men know that he is a graduate of New York Maritime College. They immediately breathe a sigh of relief: a real guy. But does the mainstream American man avoid dance because it doesn't have many men in it, or is it the other way around?

I think about this issue at least once a year, at each conference of the DCA, where I find myself in as much of a minority in gender terms as I was in racial ones when I taught as one of a handful of white professors at the National University of Rwanda, central Africa. Back home in Annapolis, it's on my mind as I try to smuggle some dance history into my courses at that bastion of macho values, the U.S. Naval Academy. How to teach dance to male midshipmen, future officers in the U.S. Navy, and have them like it?

Several years ago, when I was teaching an interdisciplinary course in modernism at the Academy, the problem was posed with more than usual force. At that point the Reagan-era defense dollars were still flowing, so I was able to take my class of eight male and one female midshipmen—our senior English honors students—to several concerts and performances in Washington and Baltimore, all at taxpayers' expense. Among them was a program by the Paul Taylor company, which I had chosen because of its treatment of that seminal modernist work, Stravinsky's *Rite of Spring*. Taylor's version is sub-titled *The Rehearsal*, and plays on silent-movie clichés.

The piece the males in the group liked best, however, was the program's opener, *Arden Court*. The reasons, I thought after the fact, were obvious. Stripped to the waist, half a dozen muscular young men flung themselves repeatedly into the air, did things that obviously required brute strength, and generally exhibited high good spirits, smiling broadly at the audience in the middle of each leap. The midshipmen came out at intermission talking excitedly: this was great, was this modern dance?

And after all, what was there for them not to like? These were dancers who, like the midshipmen, looked as if they worked out, who moved in great bounds, eating up the air, and who grinned with boyish pleasure while doing so. This clearly seemed to them dancing by real men, full of fresh air, physicality, and frankness—nothing tenebrous and murky here. Their reactions after intermission were more subdued, and it was *Arden Court* that dominated the conversation as we sat around over drinks later in the Watergate.

Yet how much contemporary dance looks like *Arden Court*? I drove home a little discouraged that I could not offer the midshipmen anything else in this vein, and the concert by the Martha Graham Company to which we went some weeks later failed to satisfy. A few semesters later, trying to teach some of the rudiments of the Romantic ballet from tapes of *Giselle* and *Swan Lake*, I longed to be able to splice in some more grinning muscular acrobats. If takes an *Arden Court* to sell dance at the Naval Academy, and by extension to other males in this country, the mainstream repertory will be severely limited.

A few years ago the critic Laura Shapiro took on this subject in *Newsweek*, in the context of the larger project of touting Twyla Tharp's insubstantial *Everlast*—starring Kevin O'Day in a tank top and a pair of boxer shorts—as a twentieth-century masterpiece. She thought it was the tights that sank classical ballet for men. When Albrecht (*Giselle*) or Siegfried (*Swan Lake*) enters from the wings, all horrified male eyes are on his buttocks and thighs, molded to shimmering white curves of muscle. Although I didn't approve of Shapiro's efforts to trash *Giselle* in order to substitute in its place Tharpian froth, I had to admit that she had at least scratched the surface of talking of ballet in gender terms. It's not just the tights. It's the movement and indeed aspects of the form *per se* that turn men off.

First, however, the tights. In classical ballet, the lower body is exposed, although in a sheath (for most men, I think showing off means skin), and the upper body is hidden. Straight males tend either to want to stand up for a guy whose behind is vulnerable like this, or to resent him because he's flaunting illicit parts of his body. At the same time he's unmanned by being so clothed above the waist. Straight men with a good build do present their bodies to other men (that's what bodybuilding contests are all about, and to a lesser degree the gym and the locker room), but the other guys primarily admire the muscles for the conscious effort they betoken, as well as wish fulfillment: this is what we want to look like. In fact, the purest form of admiration of male physique comes from other straight men: only someone who has a body like this himself and who doesn't want something from us physically can appreciate ours in a disinterested fashion.

Such exhibitions for other men uncover everything but precisely the parts the tights of the classical ballet reveal, namely the behind and the crotch. The male crotch holds no interest for straight men, and the butt is a real embarrassment, a man's most vulnerable part. It's behind him, he can't pump it up at the gym, and it's vulnerable to a gaze that he doesn't control. (It frustrates straight men to learn that women don't worship their biceps and

pecs the way they themselves do. And how crazy-making to learn that women frequently think the best feature of a man is something like his eyes, his hands, or, worst of all, precisely his behind.)

Yet men only exhibit their bodies if they feel like it. Even men with bodies worth flaunting like the protection offered them by our society's allocation of the role of looked-at to women. Trolls can go after showgirls, but the gender-reverse is merely disgusting. For, as the feminist film theoretician Laura Mulvey reminded us nearly two decades ago, in our society it's the man who looks and the woman who's the object of that gaze. Her conclusion was that film, in which the camera eye substitutes for the viewer's, is somehow intrinsically phallocentric. It becomes questionable for a man to show off his body when the exposure is public rather than to other men, or to a woman he's trying to impress. Men who present themselves to public exposure (anybody can watch) come off as somehow female, especially if it's the crotch area that's exposed. The Chippendales retain some vestige of macho because there are no male onlookers; the audience for a female stripper, by contrast, is usually mixed. This is Mulvey's point too. In our society the woman is forced to take on the position of the male viewer with respect to the female body.

In fact, however, the costume is only the beginning of the reason why ballet (to consider this for a moment) just doesn't make it with men. Much more fundamental is the movement style. "Male" movement for a standard-issue American man is forceful and rather abrupt, motion exploding from stillness and returning to it, showing the power of muscles as well as the male virtue of self-containment. (Women, in caricature, are the ones who can't stop talking or moving. Men are taught to "husband" their resources, and to do isolated feats of strength when it counts.) In ballet, by contrast, the flow is all, a continuous thread of motion rather than little discrete muscular packages, and the muscular movement is hidden. The young Baryshnikov made such an effect in his jumps because they seemed to require no preparation.

Then there's the way the body is held in dance. In conventional "male" movement, the torso is upright, frontal, and fairly limited in the degree to which it can diverge from vertical. Men in our society are taught to stand up straight with the chest out. Unlike women, we're not supposed to droop, we don't curl into our seats, and we cross our legs in rigid angles rather than twining them about each other. Of course, this too has to do with power: we look people in the eye to establish dominance, face them so that our arms can deal with any threat, and stay vertical so that we can move or lash out at a

moment's notice. No woman, for example, ever tries to turn the contact of a handshake into a gripping contest the way many men do.

We need only look at military movement to see the all too logical caricature of "male" movement: it's all about rigidity, right angles, and hardness. (The incoming freshmen at the Naval Academy [plebes] have to eat by sitting with a straight backbone on the last three inches of their chairs, and they move the food to their mouth in right-angle gestures. This is called "eating a square meal.") That's also why military "dance" is finally rather boring: the bodies are too upright and the range of movements is too limited. This includes the dress parades at the Naval Academy, and even the jaw-droppingly precise silent drill team of the Marine Corps which twirls and throws rifles in silence.

In ballet, men lift their leg well above the normal Rubicon of forty-five degrees (and, worse, bring it behind them), balance on one foot, raise the arms above shoulder level, and engage in many other such violations of street-movement norms. The reason the rarified social dancing of a Fred Astaire was able to make it to the mass market and find an audience among men was that Astaire always began and ended the dance in what looked like a street-clothes situation, and never diverged too much from an upright, frontal stance.

Average men don't like to deal with the gray areas of gender-blurring. For this reason it would seem that the classical ballet would be appealing to them, offering as it does rigidly gender-determined roles. In the tradition running from Petipa to Balanchine, it's the man who supports the more mobile woman; men's acrobatics involve jumping and lunging. Indeed, in the dance world, the gender roles of the classical ballet have been perceived as so rigid that many contemporary choreographers in America, from Senta Driver to Tim Miller and Mark Morris, have set about subverting them. Yet these distinctions between sexes seem obvious only to people who take for granted the common movement style that unites them. To someone coming from outside the dance world, these gender distinctions in classical ballet look not too absolute, but instead too feeble to be acceptable. If Petipa seems hetero-phallocentric to a contemporary gay choreographer, a straight man strange to the ways of the ballet sees undifferentiated members of a race of dancers defined by their common participation in a liquid movement style.

Even the partnering of the classical ballet will seem unmasculine to most male viewers, despite the fact that the man's strength is needed to lift the woman. The problem is that while this strength is required, it isn't exhibited. The partner is there to make the woman's movements look effortless, not to

showcase his own. For mainstream male taste, the man in ballet is too much the cavalier, a relationship with women more at home in decadent imperial Europe than in frontier America. (We see this even in Balanchinian partnering. Ballet is, after all, woman.)

As an example of a "real man's" partnering, I offer the routines that male cheerleaders do with the females. The boys muscle the girls up onto their palms and support them in the air, so that the act of getting and keeping the girls up is itself an evident proof of strength. And when the girls are ready to come down, they simply let themselves fall, and are saved from splatting onto the ground by the cradle of the boys' arms. Not only do the boys show themselves off as stronger, that is, but the girls abandon themselves to the boys. This is a gender relation in dance the mainstream understands.

But what, we might wonder, makes males demand of movement on the stage the same things they demand of it on the street? After all, there are many situations in the world where straight men do diverge from their vertical, frontal stance. Look at a game of football in the park on weekends. The difference is, these are participation situations. Even their passive counterparts—sports in the flesh or on television—are situations of vicarious participation for most male viewers. Men see the men on the field as being like themselves, and engaged in purposeful activity, even if that purpose is something as bizarre as moving about a blob of pigskin wrapped around air. Their movement patterns are produced incidentally, in the course of (say) running with a ball, rather than for their own sake. In the same way, male audience members in a theater tend to identify with, rather than abstract from, the participants in theater dance, "cutting through" the choreography and proscenium to see other creatures like themselves. (Women, by contrast, are I believe more comfortable with allowing women to become merely cogs in larger structures.) And their dissatisfaction with dance lies precisely in the fact that the men on the stage are doing things they cannot imagine themselves doing.

Much of this is true only with respect to the classical ballet, but some applies to all stage dance, the art form which is surely at the lowest end of the spectrum of theater arts in terms of male acceptability. Plays are much more acceptable to most men than dance is, while opera comes between the two. Most acceptable of all are movies. In opera, the men at least preserve the physical uprightness and normalcy of contact that opera shares with theater, even if they walk around with their mouths open most of the time and do unmanly things like singing songs. In theater, they speak, which being

more "normal" is more acceptable still. In movies they look just like real life, which is best of all. For speech—as many literary critics today dealing with works about the Third World will be quick to corroborate—is power. (As the Nigerian writer Chinua Achebe pointed out, it's an act of disempowerment when, in *Heart of Darkness*, Conrad denies the Africans coherent speech.) One of the peculiarities of dance is that, in this sense, it disempowers everybody. (Think of the way everybody calls dancers "boys" and "girls"). All the dancers move at the will of the choreographer. Men are used to seeing women disempowered, so this doesn't bother them. But it does bother them to see this with men, who are supposed to be in charge. The only person in charge here is the choreographer, who is absent.

Yet if we can construct a scale of acceptability-to-males for various art forms, the fact is that none of them really manages to be completely appealing. All the arts come to seem, in some sense, unmale in our bluff action-oriented Anglo-Saxon society—at least, the individualized, self-expressive arts of our post-Romantic era. Art foregrounds the action toward the goal: the look of the thing, not its ultimate effect, the change it wreaks on the world. (Perhaps the Romantics could still tell themselves that they were acting in and on the world; their successors have had to acknowledge that they are essentially decorationists.) Men, in our society, are taught to be do-ers, not to lollygag around appreciating how the action looks, sounds, or feels. Male artists of all kinds have felt that they were somehow selling out, or being less than masculine, in following their muse (what a phrase!) in our society, as the critic Frank Lentricchia's writings on the poet Wallace Stevens (who also ran an insurance company) reminded me recently.

Is this a fact of all men, everywhere? Has it ever been any different? Is it any different elsewhere now? In the nineteenth century, the male members of the Parisian Jockey Club went regularly to the ballet in order to ogle their mistresses. After all, back then ballet girls were loose women, and there were few other places offstage where so much flesh was publicly exposed. Now, the women in ballet are no looser than any others, and ballet seems chaste by contrast with much of Western culture.

The female strain of influence in American dance, as opposed to, say, American business or politics, has been clear from its beginnings in Isadora and Ruth St. Denis down through Graham, Doris Humphrey, and Twyla Tharp. Perhaps things are different in societies where the emphasis on act rather than appearance is not so emphasized, where being rather than doing is not so clearly the domain of the woman. It is no accident that the greatest

American choreographer and the twentieth century's ballet genius, George Balanchine, was a Russian of Georgian descent.

None of which is meant to be discouraging for those interested in mainstreaming dance in this country and making it more popular among men. Aside from the fact that the arts still have an association with culture and money and so provide a way to show off one's "class," the fact is that some of us grew up involved with the arts (usually because of our mothers) and have learned to say, yes, real men *do* eat quiche—*and* go to the ballet. Many of us have put in at least some time on the Continent or in Latin countries, where gender economics are different; many of us come to realize with age that the dialectic of looker and looked-at that makes sexuality and gender so interesting is by no means as simple as a hard duality. Which is why, despite the odds, it still happens that there is the occasional man who loves dance in general, and the classical ballet in particular. It would be useful, if for no other reason than economic, if there were more.

DanceView 1993

Two to Tango

TWO TO TANGO: ACCORDING TO THE SAYING, that's what it takes. Probably an echo of this insistence on doubling and pairing inspired the name of TANGO X 2 (in somewhat odd all-capital letters, presumably tango-times-two) that appeared this year on tour in Washington, D.C. But two what? People, of course. More precisely, one of each. Each sex, that is.

Or do I mean, as we say nowadays, each gender? No. One of each sex. With tango, you have to tell it like it is. It was sex, not gender, that roiled off the stage along with the clouds of dry ice that night. Primarily, I mean hetero sex, with the gender roles as sharply differentiated as in a John Wayne film, and a clear domination of the woman by the man in the coupling, despite the woman's giving as good as she got. It felt like a guilty pleasure for this unregenerately old-fashioned viewer to see so strong a set of male/female role models being flaunted onstage. In this world, it was clear, men were men, and women loved it. I looked around stealthily to see if anyone was going to notify the thought police, and was relieved that everyone seemed to be having too good a time. I began to relax. Maybe the performers were going to get away with this after all.

Yet, I realized as the evening went on, the almost caricature nature of the gender polarity allowed all sorts of other possibilities to slip in too: drag for the women in several numbers, men dancing happily with each other (program note: "originally the tango was performed between men in competition for a woman's favors"), and a potent whiff of the poisoned flower of narcissism for all, the occasionally solo men clasping their own obliques as if the side of a partner, and swaying back and forth as if replicating themselves with a ghostly Other. The more strongly you underline differences, it seems, the more you can begin to form new combinations of them. At least you're working with a conflict that goes somewhere.

Unisex it wasn't. It was heady stuff, decadent and delicious, glamorous and gutsy, sophisticated and steamy. Needless to say, it was politically incorrect to beat the band—although the band, led by sizable and talented Daniel Binelli on lead bandoneon, looked as if it could take care of itself if things came to beatings.

Or was it? For the point of talking of "gender" rather than "sex" is to emphasize the way we human beings act out the roles, foreordained or assumed, of men and women. Sex is a biological fact, gender is constructed. And the gender roles in tango, although in some ways valorizing for the traditionalists, are at the same time nothing if not blatantly constructed.

It's considered okay nowadays, even laudable, for the critic to make his/her own point of departure clear, to rupture the so-evidently false pretense of the objective viewer. A white male critic is expected to handicap himself if he's writing about (say) a black female choreographer, at least if what he is about to say is negative, and in some circles it's considered unsound (the word is Conrad's apropos Kurtz, the villain of *Heart of Darkness*) for a straight critic to wade into choreography evidently aimed at the gay portion of the audience. It's *our* dance, many such minorities feel; stay out of it.

In the same way, I felt that this was *my* dance. I loved everything about it. First off, I loved the clothes (by the choreographers Mr. Zotto and Ms. Plebs), and what they said about the sexual roles of the dancers. In our society, the woman expresses her femaleness by exposing herself to the male gaze, and the man expresses his masculinity by covering up in uniform clothing. The man becomes the do-er, the woman becomes the be-er. I loved seeing these so well-dressed men in their nicely cut tuxedos manipulating these half-naked women who hugged the men's chests. I loved the skirts slit up to the women's waists. I loved the way the sharpest stiletto heels this side of Frederick's of Hollywood made the women's calf muscles stand out. I

loved the sheen the stockings gave their beautiful long dancers' legs. I loved the patent-leather hair for the men (1930s equivalent of the military-style buzz cut that sharpens the contours of the male face), and the way their dark formal clothing contrasted with the colored togs of the women, which in turn looked as if a good rip would pull them off. This show had glamor to burn. And I love glamor, in all its mannered beauty.

I also found myself thinking about the social-dancing basis of tango, the body usually staying within the limits set by "normal" street movement. Here, it meant that the upper body for both men and women remains upright, save for a few instances where the woman is bent slightly backwards. Arms, with few exceptions, do not go over the head, and legs hardly ever break a forty-five degree angle over the floor, except for the woman's, which occasionally curl around the man's waist. (That one made my blood hum too.) Nobody looks "weird," as they do in ballet or modern dance, art forms that raise legs up, turn the hips out, or horizontalize the body on the floor or in the air. The art form here is that of filigree: complexity within fixed boundaries.

This is why the theater was full (oh all right, the Argentinean Embassy may have bought out half the house, judging by the crowd). Because social dancing stays by and large within the normal parameters of everyday body motion, it is valorizing to a mainstream audience, including hetero men as well as women who sometimes honorifically adopt the position of the male gaze. (If you need to be convinced of this, think about how most Hollywood films work: everybody is asked to take the point of view of the male hero.) That's also why Fred Astaire (on the macho scale of tango, a sexless wimp) was "acceptable" as a dancer to mass audiences in his own day. He, too, covered up; I've written about the glistening sheath of the male ballet dancer's tights or the modern dancer's leotard and how this alienates the mainstream male viewer, who is simultaneously appalled and jealous. And it's probably why few people would call tango more than a minor art form, at least in our still-modernist age of "make it new."

I even loved the floor patterns of the tango, which appeal to what I think of as a male sense of linearity. At any rate, I could feel it pushing my own buttons. The movement here is up and back, the man leading the woman backward and then giving way himself. It seems relentless, driven, requiring concentration and facial impassivity from the partners. In tango, the man leads. But he leads by being perfectly attentive to his partner, a metaphor for the male role in sex.

This kind of movement, in which the man seems to be taking the couple somewhere, offers a perfect contrast to tango's gender complement, the waltz. In the waltz, the movement is that of two more nearly equal people who look over each others' shoulders making curliques like on an Etch-a-Sketch when you twirl both knobs simultaneously. Its quintessential movement is the great sweep of the woman's long gown, which makes loops across the stage (think of the moment when the lights come on in the last movement of Balanchine's *Vienna Waltzes*). The man is necessary to spin the woman, just as he must lift her in ballet. But the focus is on the female.

The tango is a man's dance. Men with women, men with each other, women dressed as men. There are deep truths imbedded in the tango, I thought, about how men and women interact as couples precisely by emphasizing their divergences.

Yet, at the same time, I had the uncomfortable feeling that I was watching a stage full of impersonators. Which, of course, I was. And not just the women in drag. Even the men were miming macho as well as exhibiting it. But this too seemed logical, this merging of the mannered and the deeply real. There is, after all, an uncomfortably thin line between being and posturing macho, feminine and femme. On one side of this nearly invisible boundary is the parade dress uniform of the Marine Corps, and back to back with it is pseudomilitary or leather get-up in a Gay Pride parade. On one side of the line is a glamorous woman from *Vogue*, cheek to cheek with her is a vogueing drag queen. Which side of the line did this show fall on? Perhaps it straddled the two, or merged them, like a person and that person's image in a mirror joined at the mouth.

More uncomfortably yet, reading the program produced the unsettling realization that virtually all of these dances were made in "homage" to a personality from the 1930s or 1940s, or based on a film sequence or dancer. Abruptly, the evening I had been enjoying so immensely as a valorization of long-held beliefs seemed resurrected from a world as shadowy as Norma Desmond's in *Sunset Boulevard*. Tango expressed a sensibility that was mannered when it was new, now recycled and spiffed up as entertainment for the jaded 1990s. For a few moments, I was convinced that the whole show was in fact an exercise in nostalgia, rather than a living art form, no matter how skillful.

But did it ultimately matter? Clearly, anything went in this world, people danced in vaporous cafés to pass the time before the end of the world, and everyone dressed to the nines to do it. It all seemed so elegant. So intelligent.

I kept waiting for Sally Bowles to enter stage right. Pick your partner, of whatever sex. Or is it gender?

Maybe TANGO X 2 had nothing to do with John Wayne at all.

Something for Everyone to Dislike

THE MOVEMENT IN RECENT YEARS to alternative or against-the-grain casting in theatrical productions has produced some startling, if variable results: sometimes the flip turns out to teach us something, sometimes not. The actress Pat Carroll playing Falstaff made an indelible impression in Washington several seasons back, though the only change to the play was the character's somewhat higher than usual voice; a gender-reversed version of *Lear* played recently in New York, where the effect took longer to get used to; and a color-reversed version of *Othello* in 1997 at Michael Kahn's Shakespeare Theater in Washington (only the title character was white) made us reflect on our racial presuppositions. Matthew Bourne's no-toe-shoes version of *Swan Lake* is the most recent in this long line of "what if" alternative takes on classics: the swans are male. The gender switch is not across the board, however: the Prince remains a prince rather than becoming a princess, and longs for his object of lust and fantasy in just the same way as before. As a result, the switch ends up mattering a lot.

The piece has been wildly successful in stage runs in London and Los Angeles, and opened in October in New York. Its widest audience, however, was undoubtedly in the video version as cut (slightly less than ten minutes lost) for television, which I saw shortly before hearing the choreographer himself at the 1998 Dance Critics Association conference in New York (weekend of July 11). Noting the video release in a column for *DanceView*, the critic Robert Greskovic refused to react to the work until he had seen it on the stage. Rushing in where angels fear to tread, I am prepared to say some things about it based on the television version, though acknowledging that it will have been altered in the process. (I think of one of Twyla Tharp's pronouncements: "Television is about two things: the dollar sign and the square.") At least I can say some things about the gender switch, which after all is at the center not only of the work's buzz, but its very essence.

I find this work deeply puzzling. To me it seems simultaneously homoerotic and homophobic. On the one hand, it contains some of the most frankly steamy duets for two male dancers ever seen on mainstream stages. The Act II duets with the muscular Adam Cooper as "The Swan" (muscular by dancer standards, not Naval Academy weight-room standards) are gently affectionate if insistent, like extended foreplay. In Act III the macho-out-the-wazoo Cooper, now dressed to kill in leather pants and oozing tango-level forcefulness, drops the velvet glove to reveal the iron hand, vamping first the women in the room and then the Prince (Scott Ambler) before turning to the Queen (Fiona Chadwick). (Here I thought of Pier Paolo Pasolini's film *Teorema*, where a blonde Terence Stamp seduces all the members of a proper Milanese family: daughter, mother, son, father.) Yet when the Prince wants to follow up with the Odile character, who after all has given him plenty of good reasons to expect something, he is brutally repulsed, almost cut down. And in Act IV, infantilized, shut away, awash in what seems fantasies, he dies. In best *Celluloid Closet* style, in short, the gay man is once again the misfit and victim, and must disappear in order for the natural order of things to be re-established.

By changing one of the sexual poles of the work but not the other, Bourne has made it impossible for us to think that he's primarily expressing "universal" themes such as longing and the impossibility of finding love. This works when we're not concentrating on the gender of the love-object—that is to say, when that gender is the expected one. When that issue is foregrounded, however, as it is here, we see the particularity of the male-male relationship. And I regard Bourne's pronouncements, at the DCA and elsewhere, that he thought of male swans because real swans are so aggressive, as so much wannabe-mainstream window-dressing blather.

At some level, this homoerotic/homophobic mixture makes perfect sense. Bourne's *Swan Lake* is the nightmare journey of a gay man who has finally gotten up the nerve to *do* something about his secret longings, and is punished. Not only does the object of his life-long desire turn out to be a (predominantly [?]) straight man, he isn't even a very nice one, apparently willing to lead on his admirer out of sheer malice before chopping him off at the knees. This may well correspond with reality for many gay men; what I have against this work is that Bourne seems to be telling us that this is the way things have to be. He feels, and shows, the Prince's pain, but as a remedy offers only fantasy and death. And then we're supposed to find it beautiful, attain a sense of dramatic closure. I couldn't.

Bourne is apparently voting for nature over nurture in the determination of sexual orientation. As a young boy in the work's first scene, the Prince has dreams of a rather diabolical-looking (bottom-lit, with a forelock) half-naked man ("The Swan") who bears not the slightest resemblance to the stuffed animal swan the boy cuddles in his sleep. The Prince is terrified by this dream, which is unsurprising, as children *are* afraid of the power of sex (they do *what* with each other???). But at the same time the dream obviously serves as a template for his adult desire: the real man he finally tries to approach is the same one he's dreamed of as a pre-pubescent.

One critic friend of mine has tried to correct my perception that the prince dreams of a hunky man: "Bruce," he assured me, "it's a swan." And Bourne's own mainstreaming comments in an interview included as part of the notes to the video version try to deflect the perception that this is a "gay Swan Lake" by insisting that the steamy Act II duet is, after all, a duet for a man and a swan.

I'm sorry to have to tell Bourne this, but it's a duet for two men, both dancers. As far as that goes, the costumes the dancers wear do *not* telegraph "swan," they telegraph "satyr." The dancers wear white furry-looking (not feather-smooth) haunches from waist to knees, and nothing else. In the context of the hyper-rigid and meticulously clothed all-black world the Prince inhabits (costuming is one of this production's more witty aspects: kudos to designer Lez Brotherston, who probably produced exactly the costume Bourne wanted), their bare chests seem positively provocative. Too bad that the dancers on the video don't look all that great without their shirts. (Send them all to see a Paul Taylor concert, I say, to show them what some serious lifting can do for a guy.) The important exception is Cooper, who does look good, but largely because he looks. He's sexy because of his direct gaze, his air of knowing exactly what he wants. Men, sit down and learn something.

Some critics, such as Greskovic, hold that there are no swans in the traditional Petipa/Ivanov *Swan Lake* except the toy one that glides, usually jerkily, across the stage at the opening of Act II. The women we see, that is, aren't even "supposed" to be swans. Of course they flap their wings, but we assume that that is because their transformation back to women, which happens at night, is somehow imperfect, or that their magical stage exercises its power over them even then. Other critics cite a moment, now lost in most productions, where the swans change to women on the stage before us. After all, Siegfried's friends are about to shoot until he stops them, hardly likely if what they see are already women. At any rate, we see this *Swan Lake*

silhouetted against the version we know, not against swans in the park. In P/I we see female dancers, here we see male ones.

To be sure, the Prince has an early and not very passionate romance with a voluptuous and more than slightly vulgar girl (Emily Piercy, who looks like Goldie Hawn in a female impersonator wig), but apparently he finds the experience inadequate. Indeed, it's clear he's not getting affection from anybody, not from his mother the Ice Queen, and not from this girlfriend—who, it turns out, has been paid off by the palace's Press Secretary (Barry Atkinson), a combination of Major Domo and procurer for both Queen and Prince. In the notes to the video that identify him as the Press Secretary, he's called Von Rothbart—clever, no?—but he looks like Lenin. The Web site for the production calls him the Private Secretary and gives him no name.

There's a lengthy scene where the Prince (still called Siegfried, at least in the video notes) takes the girlfriend with him to the Royal Box at the ballet. She's obviously from the wrong side of the tracks, applauding at the wrong time, dropping her program, and in short fully earning Mom's disapproval, which we suspect she would have gotten anyhow. I found the parody dance-within-a-dance, which is a ha-ha "funny" *Swan Lake* danced by insects with elements of *Giselle* and *Nutcracker* thrown in, simply dumb. Other critics liked it. At least it serves as a smaller version of the *Swan Lake* we're seeing, with its elements of *Nutcracker* and *Giselle* in Acts II and IV.

A good deal of the plot is unclear on video, and it seems unlikely that they will be any clearer on stage. What is Lenin doing pushing on Siggie, apparently behind the Queen's back, a girl so obviously not to the manner born? Backstage gossip I've heard has suggested that this character is a riff on Fergie: fine, but what explains the palace intrigue? If he was going to get the prince a trophy girlfriend, why didn't he at least get him one who knew the rules? Is old Vladimir trying to Make a Man of the Prince? Why doesn't he just get him a prostitute? Later, it seems he knows that Sig is gay, having apparently egged on his polymorphously perverse son to seduce him. (There has apparently been some vacillation on Bourne's part regarding this relationship, as the company's Web site makes no mention of paternity, and identifies the new arrival only as "The Stranger."). Is he therefore out to destroy the Prince? Nor is the reason for Mom's disapproval any clearer. Because the girl is so obviously dishy, Mom's disdain reads as a disapproval of Siggie's manhood per se. If she knew what he really dreams of, we think, she wouldn't be so disapproving of what he's actually brought home.

The scene between Sig and Mom that follows the bad ballet is no clearer. All I got was that he wanted something from her that she was refusing. She was horrified. Or was it furious? From the way he clings to her skirts and throws himself at her, I couldn't tell whether he had the hots for her, or whether he wanted to be a baby again. The characterization of Mom is equally puzzling. It hardly seems likely that the Queen could be such a public nympho in a world portrayed as being so repressive of Sig's sexuality (his childhood and young adulthood are a series of supervised public performances that make him seem boxed in); she's obsessed with protocol, so it seems unlikely she'd make such a spectacle of herself. She ogles the young men of the guard and has Von Rothbart set her up, and dances and smooches publicly with her boy-toys. (The sexually hyper-charged atmosphere that this produces, with its slavering over well-built young men, is another reason the swans, in this context, look masculine rather than avian.) And how does this overt sexuality jibe with her characterization as Sonny's Great Castrating Female? One clever answer might be, she wants him to remain a child so she in some sense will cease to age (the Prince grows up but the Queen does not change appearance). But this is pure speculation.

There follows a scene in a sleazy bar, the kind where you can get anything, and apparently anyone, you want. The Prince has sneaked in incognito. The girlfriend, set up by Lenin, is there again, but the Prince gets drunk, and is such a wimp he doesn't hook up with anybody at all, not with her, not with the fan dancer, not even with one of the randy sailors, who goes off at the end with a guy from the alley. Sig ends up being thrown out, and it seems that Lenin has arranged to have the paparazzi there to take his picture in a drunken stupor. (Why would a Press Secretary be doing things like this? Why would a Queen so obsessed by public appearances allow her son to be publicly humiliated?) The Prince staggers off to a park, where he writes a suicide note and seems about to throw himself in the lake. Enter the satyr/swans, just like what he dreamed of as a tyke, and led by a replica of his fantasy, his Ken doll come to life.

It is at least arguable that the swans are all in the Prince's head: a park bench and light (to which he affixes the suicide note he later tears up) disappear when the swans come onstage (perhaps just to give them room to dance?) and re-appear when they are gone; nobody else ever sees the swans. Besides, dancing with swans just *has* to be a fantasy. In Petipa/Ivanov, they're not a vision, but reality, albeit a reality far from the "real" reality of

castle life. But of course, to repeat the point, by the time the dancing starts in P/I, all the enchanted maidens are women.

From the dances that ensue in Bourne, it seems that what the prince wants is to *be* a swan. Unlike the nineteenth-century Prince Siegfried, that is, this Siggie dances *like* the swans, mimicking their movements. Finally, it's clear, he has discovered (or imagined into life) his "own kind." What a liberation! And he's beside himself with joy when the incarnation (or at least very real imaginary version) of his childhood vision appears. The swan nuzzles him, gives him The Look (Cooper does well to stick to this: he loses some of his magnetism when he opens his mouth to reveal over-large, boyish teeth), and finally cradles him off like Rhett Butler carrying Scarlett up those great stairs to, well, you know what with her. If these are swans, they're swans like Zeus was a swan when he came to Leda, as (in Yeats' words) the "brute blood of the air." There's none of that icky "be true to me" stuff of P/I either: here it's pure physical seduction, with no thought to the future.

At the same time, however, there's an undercurrent of violence in the Prince's encounter with his dreams. The only swan he really gets along well with is "The Swan" (what are the others?), which is to say his dream, Cooper. (Is Cooper the head swan? It's not so clear here as it is in P/I, though he does dance at the front of the ensemble.) The others apparently regard the Prince as a kind of interloper: they circle him, threaten him, and are only shooed away by Cooper. As in the parody ballet, Bourne is mixing in elements of *Giselle*. Here it's Act II (in the parody it was the bit with the sword in Act I): though a Wili herself, Giselle defends her prince against her more ruthless sisters, who are set on destroying him.

Whether the swans are real or not, they are clearly so to the prince, who is transfigured by his experience/vision. A bag lady (Reality?) hobbles on, the Prince tears up his suicide note, kisses the astonished wreck, and flings the fragments of the note all over the ground.

Act III. The party is okay but pretty sedate. The Prince is bored. Suddenly, who should suddenly enter but a smouldering Cooper with his hair gelled up. He vamps all the available women in best tango/apache style: it's fun to watch, because he's very good at it. He knows about kissing women's shoulders, and about running his fingers up their legs, and other good moves. He's still a great looker, shooting all sorts of meaningful glances that I think are probably more visible in the video than they must be in a theater, and slapping his leather-clad thighs. The women respond in kind, grabbing his butt and playing with a riding crop. The stage steams up fast.

The Prince is thrilled at finally being brought face to face with this real-boy version of his beloved fantasy, but gets more and more upset because the guy isn't paying any attention to him—and worse, is actively getting it on with the girls. Finally Sig just can't take it any longer, and makes his move. Hooray! we say! Wimp no longer! This guy's gonna be a normal person yet.

The Stranger/Junior/Odile not only reciprocates, but comes on shamelessly to the Prince. (Indeed, it could be argued that all the female seduction was part of a lengthy come-on to the Prince, to arouse his jealousy). This duet is as sensual as anything that goes on with the women, though it's all largely looks and teasing caresses (we're not talking deep kissing and crotch-grabbing here). There's a heartless aspect to it, as there is in Petipa's Odile role. It's apparent this guy knows he can have his way with anyone he wants. He's raw sexuality that can take any form. Instead of flapping his wings to nail the Prince, as the P/I Odile does, he dips his thumb in an ashtray and marks down his forehead a version of the forelock/beak that had added to his satyr/swan look in Act II. (Because there's been no promise in Act II, Strange Junior isn't trying to make Siggie be untrue to anyone: he's just egging the Prince on. It really is only about getting laid, no more.) The other men are whispering behind their hands at the way the Prince is carrying on. But he's smitten, and doesn't care who knows it. And for one brief moment, it looks as if he's going to close that closet door behind him after all.

Yet then, apparently with the blessing of Dad (or whoever he is: at any rate, his protector), Junior puts the moves on the Queen herself, who instead of being furious, offers him a glass of champagne. He shares a ciggie with her (which makes her seem like Lauren Bacall, and renders even more puzzling her ongoing dumping on the Prince's sexuality). In no time flat, the Queen and her new boy-toy are making out right there on the stage. The Prince jealously intervenes. (Hooray! we say again. Go for it! Defend your turf!) Mom slaps him, apparently out of pique at his trying to steal her lover just as things were getting interesting. And then, more devastatingly, the stud, as if shocked, utterly shocked, that his gestures could have been so horribly misinterpreted, and acting with all the viciousness of a skinhead queer-basher, retreats into heterosexuality as his invincible armor, ruthlessly repulsing Sig and pushing him away. *What?* he seems to be bellowing. You thought I meant *that?*

Whoa, you say. Talk about the stuff of nightmares.

At this point things get really confusing, with several guns being aimed at once and one going off. According to the Web site, the Prince has pulled

a gun, and the Private Secretary has pulled another to defend the Queen. At the end of the act, at any rate, the girlfriend, who has gotten in the middle, is dead. It seems as if the Von Rothbarts, *père et fils,* have been responsible for it all: they smirk and shake hands. (How much of this was planned? Is the Press Secretary plotting to have the Prince's gayness publicly revealed? To what end, especially as Mom seems unaware of it? Oh, that pesky plot.)

Act IV has us back in the bedroom. Reality hasn't worked out so well, so it's back to fantasyland. The Prince is being infantilized (that is, completely castrated). He's dressed in his pjs and curled up in fetal position in his childhood big bed. The program notes tell us he's medicated; what we see is an army of nurses and keepers. They leave and the swans re-appear from under the bed and The Swan from under the pillow. (Dreams, it's clear.) With the oversized bed and the scurrying now rat-sized also-ran swans, it all looks like *Nutcracker* again, and ends back in *Giselle* Act II territory: the swans attack the Prince.

Ultimately, however, in a free-for-all rough trade departure from *Giselle*, they attack his defender too. As if in a reflection of Bourne's piece as a whole, they cannot stand to see one of their kind happy. (Again I thought of Pasolini, who was done to death by one of his pickups.) The Swan dies, then the Prince dies (the program notes suggest suicide, though this isn't evident). All the swans fade away. Mom comes in and cradles the dead body, *pietà-* or *Romeo and Juliet*-style, while in the same space over the headboard where The Swan appeared in Act I he re-appears, holding in his arms a spirit version of the Prince, who has regained his childhood.

No growing up! Bourne seems to be ordering. No coming out! No normalcy! Back into the closet! Back to fantasy! Back to the womb!

Romanticism too was all about the impossibility of finding happiness in the real world of adults. In both the P/I version of the story and Bourne's, that is, reality sucks for the prince, who finds happiness and his Significant Other only in death. Yet here, reality seems to suck worse for a gay man. That is, it seems to suck *because* you're a gay man. Society, or your family, or both (worst of all is Mom), conspire against your figuring out who you are, and when you do, they deny you all satisfaction. Not to mention the difficulty that isn't society's fault, but, it seems, biology's: that straight men who won't give you the time of day are frequently the most alluring objects of all, and that a relationship lasting longer than forty-five minutes with another gay man is apparently as scarce as hen's teeth. My impression is that this isn't fantasy for many gay men, it's reality. (If in doubt, read Paul

Monette's searing *Becoming a Man*, or talk to me about my brother, who died five years ago of AIDS.)

I'm not saying that Bourne should have provided a happy agit-prop Gay Rights scenario, where the Prince comes out of the closet and is rewarded for his boldness by a well-built lover and society's approbation. But it certainly left me shaking my head in wonder. With the mainstream viewer turned off (I assume) by all this overheated fantasy of swoony beefcake, and the gay viewer turned off (I hope) by the ruthless punishment meted out to this poor confused Prince, who's left to like this titillating but ultimately deeply conservative parable? Or have I, contrary to my expectations, just explained precisely why it's going to continue to be so wildly popular?

Ballet Review 1998

Youth, Old Age, and Tom Cruise

SOMETIMES THE MOST DISPARATE performances line up all of a sudden, in a kind of astrological congruence that establishes a pattern where there was none before. One such connect-the-dots was suggested by shows I saw during the extended holiday season. The first was the marvelous new *Harlem Nutcracker* by Donald Byrd, which I caught November 24 at the Center for the Arts of George Mason University in My-Name-Is-Gridlock Northern Virginia. Another was the January 25 performance in the soon-to-be-renovated Kennedy Center Concert Hall of Poland's "State Folk Song and Dance Ensemble" Mazowsze (which, as the press kit helpfully reminds us, is pronounced "Mazofshe"). And the last, Tom Cruise's newest all-too-predictable cinematic vehicle, *Jerry Maguire*, which I saw at my local mall multiplex.

Collectively, these three shows seemed to ring changes on the theme of youth and old age, and on the way performers function as stand-ins for audience wish-fulfillment. Thinkers have been worrying the question of why we go to performances since Aristotle, who suggested we get a kind of emotional enema from tragedy. My take on the matter, based on holiday viewing, is this: we go to all but the rarest of performances to participate in the act of collective looking. We're bonding with the audience members around us, and what we're looking at is almost inevitably a vision of human strength and youth, ourselves as we once were, or would like to be. Best of

all, of course, would be for people to look at us. But if we can't have that, we can at least be part of a crowd looking at someone like us, or possessing something we once had. We not only like what we see, we like the fact that everybody else is liking what they see too. And what all of us see is, in a collective sense, ourselves.

Think of the *Harlem Nutcracker*. This is a *Nutcracker* in which Clara is old, and in which she finally dies. In other words, rather a change from the usual, and a refreshing one. I've always thought Balanchine's New York City Ballet version a diverting enough sweet, but without the profundity some manage to see in it (the unity of the family is restored, etc.). I mean, the little girl, in the company of a little boy, enters (dreams of?) a world made of enough sugar to keep her high for weeks. What you have to identify with is not the childhood itself, but something only a child could find appealing. It's a fantasy of impotence, not an expression of power. Which means, for adult viewers, that it's rather lite fare.

It takes one of those soulful Rooshians, like Misha (Baryshnikov) or Rudi (Nureyev), to give us a bit of profundity in *Nutcracker*, worship of human beings at their apogee. I really liked Baryshnikov's version for American Ballet Theatre, for example. Not so much all that one-for-one Mickey Mousing (or *Wizard of Oz-* ing) of real characters to dream ones, but the fact that the prince was a young man rather than a boy: just the right object of pubescent female desire. Then there's the final scene, where everybody spins across the stage and Clara (I remember an anguished Gelsey Kirkland, back before the drugs took over) stretches out a yearning hand toward the shape of a lighted window thrown across the stage, as if swimming upward toward reality, puberty, and the day. Now *those* are fantasies we can understand.

Byrd's *Nutcracker* is profound like that, only it's the logical flip side of youth dreaming about a coming-of-age. Here Act II, the fantasy act, is the remembrance of a grandmother who, in Act I, welcomes her family and friends to a party, and communes with the ghost of her departed husband. She's also visited by a frightening Death-in-a-cape that scares the heck out of her. The divertissements are remembrance of good times spent with her husband in a Harlem nightclub with a really fantastic floor show (and hence build an Act II that has some emotional resonance, namely a longing for youth). Later, back home, the once-again-old Clara exits (dies) with the ghost-husband, who by now is wearing the same cloak as the spooky Death in Act I. Afraid of the first wearer of the cloak, she goes willingly with the second, looking back lovingly at her children and grandchildren gathered

around the tree, walking out the window while the curtains roil into the room. The two spirits then ascend an invisible staircase behind the scrim in best *Swan Lake* style, or as if merely going upstairs to a ghostly bedroom.

Grandma dead on Christmas morning? Here it's beautiful because it's all done by youthful dancers with some gray spray paint on their hair. They're playing at old age. Even more to the point, Clara's final act is one of benediction of youth, the whole ballet a worship of the youth and strength whose loss she finally accepts. We're looking at the dancers, but what we're seeing is ourselves as we are or once were. To put it in Shavian terms, it's a collective worship of the Life Force.

Cut to a Saturday afternoon after the holidays. Mazowsze. Here I am, with my four-year-old, sitting in the Concert Hall of the Kennedy Center, trying to pretend I'm as Polish as ninety-eight percent of the rest of the audience. The orchestra comes out. So far so normal: the usual middle-aged people of whom orchestras are composed, except these were all in folkloric costumes. Sure, there were a few young ones, but not enough to lower the average age appreciably. An opener of music. Then came dance, and suddenly the stage was filled with young people.

Now wait, you say. Here Bruce has been going to dance all these years and he's only now noticing that dancers are *young*?

In ballet, being young is a biological necessity, like having to be young to play football. You get hurt so much you've got to have young tissues and ligaments to recuperate, not to mention the usefulness of youth for little things like speed and strength. The sex appeal of healthy young people jumping around in any dance, even ballet, is just the same today as it was when the Jockey Club went to the Paris Opera to ogle their mistresses. Nor is it limited to ballet, or to other-sex voyeurism. What men like about football is the sheer male energy of it all. And that means, no octogenarians.

Yet in an art form with its own rigid internal rules, like ballet, the fact of the dancers' youth tends to submerge in the movement for which that youth is a pre-requisite. The situation is different in "ethnic" or folk dance, even a strain as thoroughly pasteurized as that of Mazowsze, created by Tadeusz Sygietynski and his wife and co-director, Mira Ziminska-Sygietynska. Here there's at least the pretense of a link to a world outside the theater. No matter how prettified or athleticized or costumed it is, we must believe that something like this, to music something like what we hear, once graced a wine festival or a wedding or a court. So, suddenly we notice just how young all the dancers are, because of the inescapable suggestion that in

the world outside, it's only the young who are having fun. Or at least, it's the young who are expressing their fun in dance.

I won't deny that it made me rather melancholy. I mean, here were all these dumpy people in the audience looking at basically boring dance whose sole and, in fact, surprisingly sufficient virtue was that it was danced in amazingly colorful costumes with amazing energy by a whole stageful of lithe, unwrinkled, undumpy people. It wasn't so much the energy of the dance that roiled off the stage, but the energy of the dancers' youth. Nor was it in the least threatening. Instead it was valorizing: we'd paid to see them, they were dancing for us, they belonged to us. They were the way we once were, or would like to be. We got to slaver over them collectively and be aware that everyone around us was worshiping at the same altar, an altar on which we too had (or had had) our small place.

Which is where *Jerry Maguire* comes in. It stank, Golden Globes or no Golden Globes. Here was this big-budget movie that was drawing them in at seven to eight dollars a head (this week's take: five and a half million dollars, number one on the charts) because it featured Hollywood's reigning marquee god and most dependable cash cow, yet the moral of which was that you should reject The System that hypes people for no purpose but money. Hello? Tom Cruise, the mega-star whose every flatulence is news, as the spokesman for genteel poverty, integrity, and an alternative to commodification? Not to mention how we're supposed to root for Tom's client to break down and make a fool of himself on a talk show when he's told he's gotten a contract for Eleven Million Dollars (in the context of the movie, barely his deserts) and to clown around for the cameras when he gets whonked on the head at a football game. It's too depressing to contemplate. And too silly to criticize.

Still, it is of some theoretical interest. Cruise (*is* this his real name?) isn't an actor; he's a star. People go to the movies to see him in X, or "as" X. And the more movies he's in, the more he becomes worth watching because he becomes a bigger star. It's the snowball effect of our own attention. If you stick the camera in someone's face and hold it there, the result is interesting precisely because the camera is looking. On the street, with nobody looking, all such people are just average people. That tree in the forest really doesn't make a noise if nobody's around to hear, at least so far as performances go.

Although it's the movie that makes the man, once we're in the theater we tend to forget the medium and believe that it's the person we're interested in. Oh, we sigh, to be (or be with, depending on gender-inclination) Tom Cruise. In fact, what we mean is, Oh, to be Tom Cruise being looked at by us. A lot

of people in the world are as good looking as this guy, and most of them are taller. The only difference is, nobody is sticking a camera in their faces.

We human beings are, finally, rather pathetic. Or do I mean, lovable? We're most interested by the fact of our own collective interest. And what interests us collectively is ourselves: valorization of our own biological power. In a word, youth.

Or at any rate, that's the shape the dots suggested.

DanceView 1997

The Trouble With Giselle

PEOPLE ARE NEVER SATISFIED. When we get a little bit of something, all it does is make us want more. When we get a lot, all we can do is complain that we don't have it all: so I thought after the superb performance I saw February 16 at the Paris Opera of their *Giselle*, a new production of the 1995 version "adapted by" Patrice Bart and Eugene Polyakov in 1991, choreography "after" Coralli and Perrot, "transmitted" by Petipa.

The performances were transcendent. Isabelle Guérin, in the title role, was vulnerable and modest, then appropriately frenetic; Laurent Hilaire, as Albrecht, was virile and pleased as punch that he'd gotten such an attractive toy to play with. When he has to answer his "palace fiancée," Béatrice Martel, who asks him with a gesture what the heck he is doing here dressed in peasant clothes (or at least the velvet and silk stage approximations thereof), his dismissive gesture of "Oh, nothing, just amusing myself" summed up his feeling, and his expression of embarrassment and chagrin at being caught was something I understood all too well. Most of all he was mad at himself. How could he have been so stupid?

Wilfried Romoli was an intense Hilarion, and seemed a man Giselle really should be nicer to. Act II's Myrtha, Agnès Letestu, was both imperious and vulnerable. The corps danced together, and the peasant pas de deux in Act I was enjoyable. In short, it was a lovely evening, made more so by the astonishingly springlike weather outside and the fact that since my last visit to Paris, almost all the monumental buildings have been cleaned; a once dark city (Notre-Dame used to be black) has been bleached blonde. Plus, I had forgotten what a pleasure it is to sit in seats that really are armchairs, and that don't fold up.

But what was most noteworthy about this thoroughly enjoyable evening was that the ballet, for what may be the first time in my experience (and I've seen most of the modern Giselles, from Carla Fracci and Gelsey Kirkland to Natalia Makarova), actually made sense. Or rather, it came so close to making sense that I exited both excited by the degree to which it did so, and bothered by the degree to which it didn't, the degree to which it cohered into hopelessly antiquated configurations. It came so close to being utterly believable, a world I could accept at least for the duration of the dance, that I left thinking that if *this* production didn't quite make it, none could ever do so.

First off, the dancers had really thought about what they were doing. I could imagine them going through Method-style exercises (or whatever the French equivalent of them might be), becoming the character. For Albrecht: What does my room in the castle look like? How often do I come see Giselle? For Giselle: How do I spend my day? Why don't I like Hilarion?

This Giselle really ought to be going out with this Hilarion, who seems like a wonderful guy. He brings her flowers and presents; he gets upset about his rival. In short, he loves her. So why *doesn't* she like him? Well, aside from the intrinsic subjectivity of attraction, he's too intense: his face is always one shade away from a storm cloud, he reacts with a scowl, and he's got one heck of a short fuse. To us, this seems all too comprehensible: the girl he loves is going out with another man, and worse, an outsider to the village. (In reacting as I did, I had to distance myself from the givens of the plot: all of us tend to accept that Giselle loves Albrecht because she's the heroine and he's the hero. She's different from her country sisters precisely because her taste impels her to choose Albrecht rather than Hilarion. Indeed, some interpreters of the ballet suggest that she might be of aristocratic blood herself, the illegitimate daughter of the Duke, begotten during the "first night" privilege of *droit du seigneur*.)

This Hilarion is furious most of all because he sees (if he does not quite admit) the extent to which his rival leaves him in the dust. Albrecht has the body language that Hilarion lacks. Unlike the interloper, Hilarion is utterly devoid of the unctuous ease with women that comes naturally to someone to the manner born. He lacks, in short, Albrecht's polish. Hilarion knows this, and the knowledge drives him wild. Yet because Hilarion has never left the farm, or in this case the woods, he can't quite put his finger on what is different about his rival until Albrecht goes for his non-existent sword. Hilarion isn't cool: even his fury at discovering who Albrecht really is comes

off as an assault on Giselle; in fact, he's just trying to show her that he was right all along.

The Paris production suggested that Hilarion alone really loves Giselle. Albrecht may come to do so in Act II, but it takes her death to bring him to that point. Even there he's thinking of himself. Hilaire enters the forest trailing a vast cape that he drags out behind him in a theatrical gesture and finally lets fall, melodramatically, to the floor. Not even self-effacing before the fact of Giselle's death, he preens to the end. And his Act I fury at Hilarion is the result of the scorn of the aristocrat for the peon. How *dare* this insect stand in the way of his satisfaction? At the end of the act he blames Hilarion (we think: Hey guy, wake up and smell the coffee, it's not Hilarion's fault) and then is hustled away by his ever-eager gofer.

All of which, in turn, suggests that Giselle isn't quite the angel she's sometimes portrayed as. Here, there's nothing wrong with Hilarion, except that he's got a rough exterior. Giselle can't see beyond that, however, and likes Albrecht, who, though dressed like a peasant, is classier. This Giselle is, finally, a nice girl but a bit shallow, delighted by the bauble her rival gives her, and taken with precisely those airs of cold command which Albrecht is unable to shed at the same time as his sword.

The mime in this production was superbly clean. For the first time in my recollection, I really understood Berthe's anguished tale to Giselle's friends of what happens to girls like Giselle if they die untimely deaths. They rise from their graves (here a stoop and a scooping motion upward) wearing their shrouds (here her hand raked over her face), dancing through the forest (the usual egg-beater movement over the head). The music told us this was bad, as did Viviane Descoutures's face; in addition, the lighting became somber and then brightened up again after she was done delivering the bad news. I actually understood Giselle's answer to Bathilde's questioning sweep of the arm ("And what do *you* do, my girl?"): "I spin [her fingers rolled the cotton] and sew [swooping motions of a needle]," which made her appreciation for Bathilde's gown a few seconds before all the more comprehensible.

The problem, therefore, was not with Act I, which was beautifully coherent, but with Act II. At first I thought my puzzled reaction was owed to the excellent glass of champagne I had drunk in the intermission while admiring Charles Garnier's delirious marble staircase. Everything seemed just slightly odd.

The act started out not with the drifting, ethereal *bourées* of a shrouded Wili, as in most of the productions I had seen, but with the more traditional raucous, inebriated men playing cards in a group, upon whom a band of

harpies, er, I mean Wilis suddenly descends. Nothing spirit-like about these energetic girls, who might just have come from the hockey game, leaving their sticks behind.

There wasn't too much that was ethereal about Giselle either. I remember Carla Fracci's Giselle as a waxwork that drifted through Albrecht's arms and out again; one was never even sure she saw her lover. Guérin, by contrast, may be dead, but she knows perfectly well who Albrecht is, although she is, of course, interacting with him within the bounds of modesty befitting the dead. She may not make extended eye contact with him, but it's clear she likes being with him, and is aware of his hands on her body, continually coming back to his embrace.

Myrtha, too, is remarkably human, the first Wili Queen I've ever seen who actually hesitates to pronounce the death sentence. She brings her arm around to make the X and then stops halfway at Giselle's pleas, apparently touched. At the same time it's clear that Giselle knows she can't break the rules; all she's trying to do is stall. She's playing for time. The bell of morning comes as no surprise, it's what she's been racing all along. Myrtha is really ready to make the magic X when the gong breaks her power. But when it does, she doesn't look too disappointed. Is she glad the bell has liberated her from a necessity of her position she has come to find onerous? Letestu's Myrtha seemed a remarkably complex character, almost like an embryonic version of Dostoevsky's Grand Inquisitor. Although she does not herself believe what she preaches, she leads her followers in their nightly death revels apparently for their sake rather than her own.

And this brings us to the problems with *Giselle*. Even with all this coherence, it doesn't make sense. When it does, it seems silly. In fact, the coherence this production offered threw into relief the fundamental lack of coherence in the ballet itself.

The first problem seems to be, *Why should Giselle be any different from her fellow Wilis?* All of the others repulse the pleas for mercy of both Hilarion and Albrecht. Giselle, by contrast, takes Albrecht's part and dances in his place. Perhaps it is that she is so recently dead, and thus not so completely devoid of human feelings as they? Yet surely the fiancés of many of the other girls came to their graves too, and presumably didn't make it home. If they had, Berthe wouldn't tell the story the way she does. And if Giselle's recent death makes her more human, why does this Myrtha apparently resonate to the same set of remembrances?

More fundamentally, *Why is it only dead maidens, as opposed to married women, who turn into Wilis?*

In hopes of enlightenment, I turned to Heinrich Heine original pseudomyth (from *De l'Allemagne*; my translation): "The Wilis are brides-to-be who died before their weddings; these poor young creatures are unable to lie quiet in their graves. In their snuffed-out hearts, in their dead feet remain the love of the dance that they were unable to satisfy during their lives. They rise up at midnight . . . and woe to the young man who meets them; he must dance with them until he falls dead."

Speaking in Freudian terms, we would say that Heine's text makes a transference from sex to dancing: these girls being denied a man is somehow the equivalent of having been unable to satisfy their destiny as dancers. It's an equivalence suggested in Act I, for sure. To live is to dance, dancing is the natural expression of life, love of the opposite sex = love of dancing (all the paired-off peasants dance; Giselle's apparently widowed mother Berthe does not).

In Heine's text, however, it seems that these dead girls are not so much revenging themselves on men as looking for playmates. Errant men (it is unlikely that any women would be out and about alone in the forest at that time) must dance *with them* until they fall dead. In the original, therefore, death does not seem point of the exercise; at most it is the side-effect of the fact that the Wilis are indefatigable and humans are not. All they really want is the company of men. Being dead, however, the Wilis have lost their sense of what is physically possible for humans and what is not.

This, of course, is not what we see in Act II of the ballet, in any version, which seems fully vengeful enough to justify Jerome Robbins' insects-and-guts treatment of the material in *The Cage*.

So here we are at the last and most important question: *What makes these girls such man-haters?*

One thread of tradition suggests, as an answer to all three questions, that they're not just dead maidens, but jilted ones. That's why they're so nasty. And it would also explain why Giselle is different. Her fiancé has repented. (It's probably rare; that would be the reason why the other girls are so hard.) Evidently Myrtha has at least made moves in that direction. But this explanation doesn't jibe with Berthe's mime. She's afraid Giselle will turn into a Wili, and at this point there's no reason to fear betrayal by a suitor.

For decades, trying to make sense of this ballet, I told myself the reason these Wilis were so unlovable was that they themselves hadn't known love. But they're all engaged, and certainly Giselle knew love (so apparently did Myrtha, in the Paris production; she understands what Giselle is asking her, and why). No, it has to be sex they haven't known, not love. The distinction

the ballet makes is before wedding day (or perhaps more to the point, wedding night) and after. Which leaves us where? I regret to say, with the following. Penetration by a man equals salvation from limbo, a limbo moreover dedicated to the destruction of the living.

Women denied the phallus become harpies, revenging themselves on that which they could not get in life. Woman without a man, therefore = a fate worse than death.

I remember hearing Violette Verdy speak years ago about the beauty of *Giselle*. It's a ballet about the love of dancing, she said, and the love of a man. Love of dancing, I thought after this performance, yes. But also about a compulsion to dance that turns ugly. Dance as a great juggernaut that mows down the innocent: a sentence for the dead, an insatiable need to move that kills Giselle, a machine that chews up innocent men. Love of a man in the singular, yes; but also, for those who do not win the race, an equally intense hatred as consolation prize. Deprivation of the male is, it seems, absolute deprivation indeed. Why don't we just erect a giant obelisk stage center and be done with it, like the greased one that is climbed at the Naval Academy each spring by the entire plebe class?

This rather sexist way of thinking is quite in consonance with the world in which the ballet was produced: perusal of the program produces the following quote from the librettist for *Giselle,* and one of the greatest chroniclers of Romanticism, Théophile Gautier, in *Les Beautés de l'Opéra de Paris* (1844; my translation). It hardly needs comment as a prime example of the "poor dear things" view of women that was mainstream until quite recently. "With women, the reasoning faculty is in their hearts; if the heart is wounded, the head suffers. Giselle goes mad."

I'll admit that I positively like some politically incorrect things. But this one gives me pause, because it's so integral to this ballet, and so utterly physical, not to mention so blatantly valorizing of men's most cherished beliefs. Without us, it seems, woman really is nothing. Is this for real? I wanted to ask. As my students might say, It's not something you can, like, relate to. And I wanted to relate to this ballet.

I walked out into the early spring night thinking things chez Giselle unjust as well as silly. This production suggests, *pace* all we have been taught, that the wrong suitor dies: Hilarion was the nice guy, if a bit rough around the edges. Albrecht was a cad. And it was difficult to feel too sorry for Giselle, who after all engineered her own fate by falling for Albrecht. As amenable to temptation as *Faust*'s Gretchen (perhaps because only a female?), she bred within herself the seeds of her own destruction.

As for Albrecht, what fate awaits him? Many productions seem to imply that he will spend the rest of his life consumed with remorse or put an end to his misery. This one suggested otherwise. The friend I went with was of the opinion that Albrecht would go back to the palace and marry Bathilde after all, cheating on her again and again with countless little peasant girls like Giselle. I had to say he might be right. But by then we were speeding away into the night air, windows absurdly open, watching the winking lights of the Bateaux-Mouches on the Seine and Eiffel Tower growing closer, strangely solidified by illumination, on the other side of the river.

DanceView, 1998

Bad Applause: On Men, Marginalization, and the Dreaded Whoo-oop

MOST DANCERS AND CHOREOGRAPHERS feel that there's no such thing as bad applause: more is more. Yet all of us have heard applause *so* enthusiastic that it seemed to indicate an almost unhealthy, feverish approval not really called for by the performance—applause so overblown, in fact, that it suggests somebody should be worried.

Bad applause comes in several flavors. One of the most benign sorts is the kind heard after concerts at colleges or schools by groups who have just finished residencies or given master classes. The hall is, typically, packed with blue-jeaned and T-shirted students. No matter how faded or flawed the performance itself, the audience characteristically goes wild. It whistles, it cheers, it stomps. Of course, the outsider or the critic slinks home feeling ungenerous. This wasn't applause for the dancers as dancers or the choreography as choreography, the outsider thinks. Instead, it was like a birthday party in the theater. Strangers were not welcome.

The mass-market version of this sort of bad applause is equally explicable in its own way. I heard it after the Washington performances of Twyla Tharp's all but embarrassing, sweepings from the cutting room floor vehicle for herself and Baryshnikov, *Cutting Up* (January, at the Warner Theater). The blatantly dressed-up audience had clearly come to see the names rather than either choreography or dancing, and was on its feet mere moments after the final curtain in an ecstasy of cheers. Why shouldn't they

have been happy? They had seen the person they had come to see, and looking suave at that.

Another kind of bad applause isn't so benign, in that it's produced not by the particular circumstances of the performance or its well merchandised star, but by what seems a peculiar blindness to financial—as well as artistic—reality on the part of the choreographers. I hear this kind of applause inevitably at concerts in "downtown" locations; its characteristic form is the cry of "whoo-oop" at the curtain calls that means a mixture of "right on, sock it to em, yeaaaaah, and tell it like it is" that suggests that, for those cheering, this was "their" performance. And the trouble with that is, it probably was—only for them, that is, and for few people outside this group.

The dance world, we know, is composed of people who live largely on dedication and youthful energy alone, and who invariably feel marginal with respect to American society—sometimes doubly and trebly so, being not only artists (already a suspect group) and poor, but as often as not female and/or gay, and shadowed by AIDS. Choreographers today, it seems, increasingly make dances intended for an audience composed of people from this world. Almost invariably, these self-selected audience members show their approval of what they have seen by letting out a cry of "whoo-oop" at the bows. Yet for anyone interested in building an audience that reaches outside the confines of what we might still call Bohemia, bad applause of this sort with its dreaded "whoo-oop"s should be a cause for real concern.

I heard this sound at the end of the awkwardly entitled program of "Jacob's Pillow's Men Dancers: The Ted Shawn Legacy" (Terrace Theater, January 22 and 23). With the question of men watching dance much on my mind, it was with special interest that I watched the program unfold. I was expecting more Shawn (there were live performances of two works, plus film clips), and otherwise simply a grab-bag of all-male dances. Instead, those who conceived the program (former Pilobolus dancer Robby Barnet was credited as Artistic Director, Norton Owen as Artistic Advisor) clearly wished to make the point not merely that of course men could dance, because here they were doing it, but also to show us that we should be worried about men in dance, that this was itself a situation fraught with questions and problems.

To this end, "Guest Choreographer" Ann Carlson contributed a witty opener that lined up the cast, dressed in suits, against a period film of Shawn's *Kinetic Molpai*, a work which returned in a live performance at the end. The dancers talked, a series of the associations that mainstream (i.e. non-dance-world) males have with men dancers. "Fag," "narcissist," "hairy,"

"where do you want it?" they chanted, playing pass-the-baton games with words. It was all great fun, as crisp as a precision drill. But how mystifying, I thought, for someone in the audience who might have shown up as part of the "Dance America" series of which this performance was a part, and to whom it might never have occurred that a greater than average proportion of men dancers are gay—or if knowing, thinking it not worth worrying about.

From this opener, with its mixture of chip-on-shoulder and in-your-face-ism, such an audience member would have concluded that clearly somehow it was. Worth worrying about, that is. The effect of Carlson's framing segments was to turn all the pieces on the program into pieces-to-be-seen-by-the-initiated, where here this meant, those who alternately asserted and were defensive about the gay presence and sensibility in American male dancing. Indeed, the program suggested that the Ted Shawn Legacy was that we should be just as worried today as in the 1930s as to whether men in dance are gay or sissies. What if we just don't care? What if, more troublingly, we just want choreographers to get on with their work and let us judge the results one by one, rather than thematically?

A number of the pieces flirted "daringly" with gay themes. Watch me, they said, I'm baaad. One, Demetrius A. Klein's *The Garden Alone*, took on the look of soft-core gay porn, or a fantasy by a gay student about his straight roommate: starting as a hetero wrestling match, it leads to a kiss by one of the men and a walk-off embrace. The homoeroticism was more taken for granted in the Stephen Petronio piece *Surrender II*, which as a result was less annoying, if somewhat too brief to make any real effect. The most knowing and pretentiously titled piece on the program was the frantically wannabe-camp *Brides of Frankenstein: A Deconstruction of Relationships, Gender, and Sexuality* by Rick Darnell. (Why didn't he just deconstruct everything and be done with it, I wondered?) Costumes were bare chests, knee-length tutus and in one case a black slip, absence of underpants, knee socks, and day-glo sneakers. Are you smiling archly? If so, this was the piece for you.

Under these circumstances, even *Ocellus*, which looked like amoebae under a microscope when it was done by Pilobolus years ago, seemed like the grease-up to an orgy. And by the time a re-enactment of Shawn's *Kinetic Molpai* rolled around as the program's closer—all "walk-like-an-Egyptian," "more macho than thou" posing by a group of bare-chested boys in Shawn's trademark sailor-suit bell-bottoms—it too seemed like an act of camp, like collections of "physique photography" from the 1950s. No wonder, I thought, that this program elicited what I now think of as the mating cry of

the insider audience, that "wha-hoo" whoop that grates increasingly on my critical nerves.

This whoop is a cry of inclusion. It says, the bastards may run things out there, but in here we're in charge. As a result, it's also a cry of exclusion of those who aren't students of this teacher, or who don't belong to one of the well-defined groups that is being spoken to. If it is tiresome listening to mainstream moralizing and self-righteousness, how much more tiresome it is to sit in a dance concert and listen to the marginalized and proud be self-righteous right back. How pitiful, too, because of course their victory is Pyrrhic. The fact that they have to address the subject at all shows how troubling it is for them. Besides, they're preaching to the converted. Everybody else, save a few series ticket holders, has stayed home.

One subgroup of insider concerts consists of works dealing with AIDS, most of which are more earnest than artistic; they won't survive their time. Of course, few dance works do anyway. Perhaps more to the point, that they don't speak to anyone outside the dance world that produced them. For art succeeds by hitting not only the notes, but also their overtones: much AIDS "art" is too crude and immediate to have any overtones. So either it affects you directly or it doesn't affect you at all. Which means, if you lead a life just like the choreographer's, you like and go to such programs; if you don't, you don't.

Schematizing a bit, I would say that AIDS works fall into two categories: sad/elegiac and angry. Elegiac tends to work better in artistic terms (some of Joe Goode's works, for example, or the ending of the film *Longtime Companion*) but angry is the kind that tends to produce the reaction of "whoo-oop." What it says is that AIDS is somebody's fault: Senator Jesse Helms's, fat-cat politicians who are dragging their feet on funding, that of the unaffected, the healthy, the non-marginalized, the non-gay, all of the above. When the ascription of blame is narrow, the viewer frequently wonders why the choreographer hasn't spent his/her time picketing or making Molotov cocktails. When it is broad, mainstream viewers feels attacked. Surely we want to reach them, too? Or are we so caught up in our own concerns that we've forgotten there's a world outside? The answer need not be to avoid art dealing with AIDS, but to remember that not everyone feels what those in the arts world feel because not everyone has experienced what those in the arts world have experienced. Pieces that do nothing but evoke crises by referring angrily to them rather than giving a particularly personal view on them (the more traditional province of art) are comprehensible only to the like-minded.

Sometimes it seems that the more self-righteous a work, the better the insider audience likes it. Bill T. Jones's *Last Supper at Uncle Tom's Cabin/ The Promised Land* two seasons ago elicited these same "whoo-oop"s—and contained what I thought was a peculiarly revolting play for insider audience affection. One of the sections was a "conversation" by Jones, who is black and gay, and whose lover and company co-founder Arnie Zane died a few years back of AIDS-related complications, with a member of the clergy selected especially for the evening. The evening I went it was a Baptist chaplain, the next evening it was a rabbi's turn.

Jones sits at a table with the man of the cloth and tries to embarrass him: Does God hate homosexuals? Why is there AIDS? Why did Arnie deserve to die? The minister at my performance tried his best to hold up his end of the discussion, but his responses were a mixture of politeness (he was just a guest here) and resignation (the stage wasn't his territory). This was a show fight with a straw opponent in which the winner was guaranteed—if for no other reason than that Jones could end the conversation when he wanted and that the minister was, after all, only a character in Jones's piece. Hardly a fair fight, I thought—yet (or precisely because of this) the audience loved it, and "whoo-oop"ed to beat the band at the end.

If I had been Jones, I would have been worried.

DanceView 1993

Hopping Mad

HOW MANY PROGRAMS HAVE YOU SEEN that really made you mad? If you're like me, not many. Not that the opposite extreme is so common either, where you feel you're lucky to be alive and watching whatever performance or performer it was on the stage that night, where you hands ache from clapping and your bottom doesn't feel the seat anymore. Mostly, programs fall in the range from "very nice" to "wasn't really worth driving into town but oh well." The evenings are few and far between where you really feel furious at somebody—yourself, the choreographer, the hall—that the thing even happened and that you were dumb enough to show up.

One of them, for me, was the January performance of the Stephen Petronio Company at the Terrace Theater of the Kennedy Center (Friday the

13th, as it happened). Things started divertingly enough. The first piece, *The King is Dead*, began with Mr. Petronio himself in a filmy white shirt with his very bald head and muscular, hairy legs sticking out. Elvis sang *Only You* on the tape in that voice that manages to grab even a girls-are-great type like me right by the scrotum. Obviously it makes Mr. P. very fluttery inside as well: at least that's the dance he's made. It's fun to watch, with slithering arms, mincing steps, and such narcissistic, dreamy self-absorption that I was simply in awe of the man. I'm here, it said, and I'm queer. I love my body, I love Elvis, I love to show off, and you just know I'm outrageous. It was a dance of nearly palpable archness, full of devil-may-care decadence.

Then followed the rest of the piece, which was Petronio's version of Ravel's *Bolero*, and had no visible point save the mummy costumes the dancers wore (The King is dead, remember). Limited movement vocabulary (arching hips, flailing arms, splatting feet, the feel of MTV) and the Halloween skeleton body-suit that the choreographer appeared in made me fear my date was going to splat me on the way out as well.

Then an intermission, where I enjoyed the unseasonable warmth on the terrace and the truly fabulous view of the lights of Georgetown and the planes coming in to National Airport. Then came an inserted solo not on the program, once again for Mr. Petronio. This time the costume was a high-waisted pair of brown trousers with dangling suspenders, but the real point was the choreographer/dancer's upper body, as denuded of hair as his head. He has a tight, stringy dancer's musculature, and was greased up good. This solo was where my boredom changed to anger. It was painful to watch, for exactly the same reasons the first solo had been fun.

What we saw was a man before the mirror of the audience's gaze, turned to a glistening torso in a spotlight, in love with the smoothness of his arms and chest and neck. I guessed we were supposed to be too. It was masturbatory, although his hand never went near his crotch. That would have been preferable, because more honest. What, I wondered, is he doing asking this hall full of people to watch him bathe in a spotlight and caress his skin? I won't be a part of this, I thought. Or did I miss a level of quotes?

The last piece on the program was a version of *The Rite of Spring* on tape, which was interrupted in the middle for a little sermon on violence to women. There was no visible point or structure to the piece, and all it expressed was the fact that despite the moralizing, the choreographer doesn't like women. The girls were dressed all evening in unflattering bodysuits and swim-teddies that made them look like Russian shot-putters, or in the unisex

mummy wraps of the *Bolero*. They stuck their behinds up in the air, opened their legs, splatted their feet on the ground, and wrestled with the boys.

The really bad news, because it doesn't leave much, is that the choreographer doesn't like men either. (Paul Taylor, in this sense, likes men, and knows how to show them off.) For the *Rite of Spring* number they were dressed in upside-down corsets, and appeared and disappeared like guppies in an aquarium. Never, in fact, have I seen such a mistreated group of dancers of both sexes as those who have chosen to associate themselves with Stephen Petronio. I even perused their bios in the program in search of a clue as to why they would do this to themselves. Save employment as opposed to unemployment (and I found my thoughts drifting to the lamentable financial state of dancers in New York today), I couldn't see any reason. Even Pina Bausch's dancers come off looking better, because the movement in her works at least makes a point, even if it's not pretty, and maybe not true. (According to Bausch, men are macho devils, and women ask for it.)

Apparently, Petronio likes only himself—but he likes himself so well it's supposed to make up for all the rest. Again, I speak as the viewer of a piece of choreography, not as his analyst. Which is what made me so mad about the whole evening. Particularly so, because many of the qualities of this program were also qualities of a vast percentage of contemporary art in general.

Once upon a time, in the never-was Golden Age of art, people thought they had to earn the audience's attention. This they did by excelling at a craft applied to their medium. That was called technique. Paintings "looked like" something; the viewer could judge them based on their closeness to an external world. Music wove pleasing melodies in patterns that could be admired, like Persian carpets. Choreography strove to ennoble the body, make women lighter than normal and men more regal.

We got over that one like the flu. Now we are cured, living in the light of common day, knowing the fundamental post-Romantic truth that the most direct way to get someone's attention is simply to ask for it. The result is the narcissism of much post-Romantic art. ME! it says, look at ME! In some cases it also tries to justify this claim on our attention, and occasionally succeeds. These cases we call great art. In some cases, like Petronio's, the pieces not only don't succeed in justifying the claim, they don't even try. If I'm brassy enough to ask for your attention or have enough chutzpah to pretend I deserve it, they say, that alone makes me different, and justifies the claim. There's only one thing wrong with this reasoning: nowadays it makes them just like everybody else.

Even booing or throwing dead cats would have been dignifying too much what I saw, because it would at least have been interacting. Instead, I wanted to go back and erase myself from the hall, have me not have been there. The most infuriating thing of all was knowing full well that if I met Petronio at a party and told him his dances were ugly and that he lacked all hope in his vision of human beings as aimless, pointless pieces of meat, he would certainly go away beaming. "Yesssss!" I imagine him saying. "Did I really get your goat that much?"

Yes, Mr. Petronio, you did. I was madder than I can ever remember being at a performance. I couldn't believe I'd watched this stuff, that I'd paid $5 for the parking, that I'd hurried with my shower and dinner to get into town. For what? To see some bald guy my own age acting like a cabaret diva? To see young people do deadening movements that made them look awful? To watch meandering pieces with no form, no shape, and nothing but an attitude I can do without? I wanted a refund on my press tickets. A refund on my time, on my good faith. I wanted to get over the horrible feeling of having been violated, taken in, taken advantage of, snookered, conned, and made to watch Mr. Petronio show off his uninteresting body.

It goes without saying that a certain segment of the audience whooped and hollered and carried on when the curtain fell, but I've written about that one too. What a world, what a world.

DanceView 1995

Danspleen

THE FRENCH POET BAUDELAIRE, writing in his celebrated collection of 1857 *Les Fleurs du Mal*, entitled four poems "Spleen" and dedicated a number of others to the same subject. Spleen was one of the medieval humors, along with bile and black blood, thought to lead, when present in excess, to ill humor, a feeling of general displeasure, and a conviction that the world had little purpose. In its garden-variety form of boredom or "ennui," spleen was for Baudelaire the only honest reaction to most of life, the most vicious of the sins and the most alluring.

It makes sense to us that Baudelaire was European. In the United States., our own optimistic, upbeat-despite-everything country, the too-prolonged expression of spleen is considered in bad form. (Baudelaire's American

predecessor, whom he translated and introduced to the French as Edgar Poe, died a drunkard in a Baltimore gutter.) Being splenetic doesn't sell product and so is not a viable market option. We owe it to others, we are told, to put on a happy face, to whistle while we work. Tragedy tomorrow, comedy tonight. Make 'em laugh, make 'em laugh, make 'em laugh.

In this century, only a few out-of-shape old men, marginalized but not completely excluded from the phallocracy, have been allowed to indulge in spleen to their heart's content: Alexander Woollcott and W.C. Fields from an earlier generation come to mind. Nowadays, it may be, spleen has gone existential, and appears in the form of David Letterman, who although not overweight is orthodontically challenged and certainly not beautiful. Letterman, it seems, defines for us the postmodern riff on spleen, being the caustic in search of an objective correlative.

Not fat, not European, and not yet old—not to mention not being David Letterman (nor wanting to be)—I nonetheless acknowledge spleen as my personal sensibility. After too many years of trying to hype up my lukewarm reactions on exiting a dance performance to something approaching heat in order to be acceptable company, I can no longer play the game. It's gotten to the point where it doesn't even seem worthwhile driving into town, much less killing the evening. I'm finally sure it's not me, it's the state of things. And the state of things is bad.

To the extent that my colleagues care a hoot about my public announcement of spleen, they may well think me a traitor. Now—it may appear to any member of the dance world with eyes and ears—is the time for all critics to come to the aid of their art form, to paste on our happy faces and smile, smile, smile. Decimated by shrinking budgets, audiences, and an AIDS-ravaged performer pool, dance needs staunch defenders, not detractors. Who knows, we may be on the verge of a breakthrough to another Golden Age! The last thing we want to hear is that things may really be hopeless. Don't talk in front of the servants or the children! Loose lips sink ships! What if Jesse Helms reads this?

Yet if we were less concerned with having to keep up a good front, many people would, I think, admit that the state of things is bad. When no one else is around, countless New York critics of my acquaintance confide that they're weary of dragging themselves downtown to scout out the newest "emerging" talent that never quite emerges. If they're of my generation, they justify themselves by citing the flagging energy of post-thirtysomethingdom. Yet as a post scriptum, they frequently admit that the performances just

aren't worth it. (The first person, to my knowledge, to say this publicly was Burt Supree, who wrote a piece on it for the *Village Voice*.)

The same, I think, goes in Washington. I like the idea that alternative dance is presented here, since it makes me feel the capital city isn't a complete cultural wasteland. (A recent Sunday feature in *The Washington Post* asked plaintively why D.C. doesn't nurture its artists. It doesn't, of course, and I'd hate to think I'm part of the problem rather than the solution.) Yet I admit that I've largely stopped going to such venues, after years of feeling that I was doing something for the arts by simply showing up. Finally, it got to be too much to think of the really good books I could have been reading or the music I could have been listening to. In our so-busy lives, the choice of participating in one cultural event means forgoing many others. Why should I support living artists just because they're alive? What about the dead ones? When does my responsibility to others end and my responsibility to myself begin?

The pretense that things were okay in the major halls, at least, crashed to the ground during the third program the Dance Theatre of Harlem offered during its two-week April run at the Kennedy Center. At the moment of my epiphany, what was on the stage was *Medea*, by former San Francisco Ballet director Michael Smuin.

In DTH, we have a major company with a number of beautiful dancers, especially among the women, that obviously rehearses meticulously and was dancing at the Kennedy Center to a live orchestra. Such fields are fertile for choreographic masterworks to grow. Instead, this run presented program after program of Smuin and his brothers-under-the-skin, choreography that was mediocre at best and indescribable at worst. If this is the class act, I thought, saints preserve us from the also-rans.

This particular program opened with two so-so works by Royston Muldoom which burned up their potential in the first few minutes. The first, *Doina*, was warmed-over (and over-cooked) Graham, filching everything from the *Lamentation*-like costumes to the ecstatically deep backbends. Only problem was, here the women were required to move around instead of sitting on a bench, and the piece lasted longer than five minutes. The result was that, when they weren't rearranging their profiles, they shuffled like penguins or geishas, inhibited by the fabric tube that sheathed their lower bodies (hooked, it seemed, to their big toes) before assuming another melodramatic pose. Even the pan pipes palled.

Muldoom's *Adagietto No. 5*, which followed, seemed to be about a light-skinned black woman trying to decide if she wanted to go out with the black

guy or the white one. I admit immediately that this reading may have been the result of an accident of casting (Judy Tyrus, Keith Saunders, and Luis Dominguez the night I went). Still, I challenge the viewer to find a better description of this dreamy froth, in which the best things were a few Pilobolus-like shapes. Nor did it help that the audience clearly thought it had come to the circus. Every move that looked hard got applause. (For the record, the girl chooses the black guy.)

Smuin's *Medea* didn't have even this amount of potential. From the moment the curtain rose on a defiant woman standing upstage center under quivering fingers of light and swathed in an outsized scarlet cape, we knew it was going to be a riot of bad taste. Medea (Lisa Attles) jutted her chin a lot and did high kicks and swirled her cape. The two "sons of Medea and Jason" looked and were asked to move as if they were grade-A-beefcake lovers rather than sons (bodies-to-die-for Calvin Shawn Landers and Mark Burns, who made a Chippendales trio with equally ripped dad Donald Williams), simpering around Mom when they weren't gamboling boyishly (and rather homoerotically) in invisible daisy fields so the fillets in their hair hopped up and down. (Is it beside the point to note that in Euripides, Medea's children are quite tiny? Who could imagine this anorexic, if wiry, woman knifing two such imposing adult males?) Creusa (Simone Cardoso), the other woman, was a two-bit street whore who stood on her toes a lot and shook her stuff, so that Jason's agony over her death (here, Medea strangles her to death with a boa-sized rope and shakes the body for good measure) seemed like baffled lust. Hey buddy, I wanted to tell him in consolation, them's the breaks. Take a cold shower and get over it.

It was high camp masquerading as art. Which is to say it was awful, and the audience loved it, and there I was yet again thinking, Can't they get something better than this? I think the answer is, no. The more awful possibility: maybe they don't want anything else. Yet more terrifying, maybe they don't know they *should* want anything else. After all, the program ended with John Taras's boring *Firebird* (there isn't a nonboring version), and the opening-night program had included the sleekly empty *Voluntaries* of Glen Tetley and a robbed-of-oomph version of *Prodigal Son*. (Here at least it's not the choreography that's at fault.) The second program included works by John Butler and Alonzo King. And these are the famous ones!

Everybody knows that the great choreographers are dead, and their legacies being squandered at shocking speed. As an alternative, the Alvin Ailey company (playing Washington at the same time at the Warner Theater) has long ago substituted theatricality for choreographic substance. The house

choreographers of all the major formerly-regional companies produce at best serviceable slop that moves people around on stage. Mark Morris isn't getting any more substantial (some critics will find this view Philistine all by itself), and the Europeans seem to us Americans bred on movement-first choreography to be coming from aesthetic (or rather, unaesthetic) Mars.

The only good news is that Twyla Tharp's latest piece for American Ballet Theatre is a real piece, which suggests that she may have pulled out of her more than decade-long slump. But that isn't enough, I'm afraid. Suzanne Farrell's group coming in the fall? A good performance of something here and there? Do these really justify the expenditure of time and energy on the dancers' part and money on everyone else's? Just between us, isn't danspleen the answer?

1995

A Reader Writes

DEAR BRUCE,

I read with interest your recent piece on "Danspleen," which had followed an equally splenetic piece about hating a concert. I'd like to believe that this run of negativity on your part is something more than the expression of your personal life going awry. If that's all it is, of course, I'll have to conclude you're little better than the post-Romantic "me" artists you decry in the piece on poor Stephen Petronio, who I think is just trying to do his best. And if you think he wastes his time reading critics, you're quite wrong! So yes, you're preaching to the choir, or talking among yourselves—you critics, I mean.

But I'll do you the courtesy of taking seriously your arguments in both of these "downer" pieces. I can't quibble directly with the piece about hating a concert, since it's so clearly an expression of personal taste. Still, I did wonder why you got so excited. I don't think most audience members are looking for what you're apparently looking for in a dance performance. Take me, for example. I went to the same Petronio concert you did, and I thought it was fine. There were plenty of cheers. You said the men and women didn't look gorgeous. Obviously you and I have a different aesthetic for the beautiful. What we saw on the stage was funky, and athletic. What more do you want? Anyway, there were lots of other things to like about the evening.

The hall is just the right size, intimate but not tiny. And at intermission there's that great view of Georgetown and the planes coming in to National Airport.

I know you'll think these aren't good reasons for liking a dance concert, but I'm sorry. Athletic bodies, a nice score with a beat, some movement: that's what people want in the theater, not high art. (I know there are choreographers like Liz Lerman who use fat and old bodies, and I've read about the Judson Church people who said "no" to flashy technique. But honestly I think such people are swimming against the stream, and I don't think they will ever sell enough tickets to matter.) You'll say, I know, that this is putting MTV onstage. Okay, it is. Why not? It's full of energy, and helps people forget their troubles.

Your demand that the dance stage offer you the same jolt of Great Art as Shakespeare or Euripides (and anyway I bet if you'd stayed home you would have read Tom Clancy instead, rather than those guys) is misguided. Frankly, it looks to me as if you're caught in that old New Critical-phallocratic Masterpiece trap that we in the postmodern generation have avoided. Go with the experience, I say. Don't be afraid to have fun. But then again, I don't think you so-serious critics know what it means to have fun, pretending that your personal views matter to anybody who might have gone to a performance and loved it. Why should they read your piece about how awful it was? How do you think that makes them feel? Either angry, or dumb, I bet.

To put things in your vocabulary, I might say: it is unrealistic to ask an art form virtually lacking in recorded history to produce concerts with the same proportion of masterworks as a symphony concert, or a class in literature. In the case of the more textual arts, we can save up many works from a great period of time and, if so inclined, present a small selection of masterworks (that concept again). In the case of dance, which is expressed through nothing less personal than the whole body and is passed on from body to body, we are all the time creating the new. You seem to be asking the question, Where is the current Shakespeare of the dance? (Remember how much hot water Saul Bellow got himself into by asking where the Tolstoy of the Zulus was? You white males never learn!) In literature, which can store the print, it was enough to have a single Shakespeare in history. In dance, Balanchine has been dead less than fifteen years, and the pieces already may be danced so differently that the original is unrecoverable. The other arts are accretive: they build up a library of masterworks. In dance, if you're not at

the crest of a wave, you're in the trough. That's the way it is, as far as works go.

You have to stop asking that dance come up to the same purely formal standards as arts with libraries. In music, you can mix together a little Mozart, a little Brahms, a little Tchaikovsky, and call it a program. A dance program, by contrast, is comparable to an issue of a literary magazine with pieces all from living writers. You hope for competence, and are happy with a little spark besides. If you don't like words for their own sake, you don't read literary magazines. If you don't like movement, don't go to a dance concert.

In fact, I have to say that you strike me as rather inhibited as well as far too serious. Why not enjoy nice bodies moving? You act as if foxy women and ripped guys from Dance Theatre of Harlem were something to object to! Of course *Medea* is about sex, but isn't everything? What is this Puritanism? Or this loading of demands on what is really an innocent spectacle? Everybody knows the choreographer isn't anything but the person who organizes the movement. The fact of movement itself comes first, along with the sight of the dancers being on stage. Way down the line comes the choreography. Ask virtually any audience member who choreographed the piece they've just seen; they'll be hard-pressed to say.

Which brings me to my last point. The viewpoint of the critic, who sees scores of performances to the average viewer's one or two, is exceptional, and you condemn yourself to irrelevance if you parade it too openly. I bet most of the audience at that Harlem performance you hated had never seen Graham's *Lamentation*, or anything else by her. As far as that goes, anybody could tell that a lot of people were there for another reason entirely, namely to support a black dance troupe. They surer than heck weren't sitting there picking apart that poor piece because it was "derivative." Isn't their viewpoint worthwhile? Maybe they could identify with the girl caught between two guys just because it was a girl with two guys, and one was white and one was black. Who knows? Does it really matter as long as they enjoyed themselves?

Critics haven't even paid for their tickets, and they're the pickiest of the lot. Talk about an entitlement mentality! All they can see are the ways in which the performance departs from their personal ideals. Your average audience member doesn't have an ideal, and so is satisfied with what s/he gets—I won't say with less, but, well, with different things. To most people in the audience, it's all a miracle: the dancers, the music, the scenery. All those things set you critics yawning, because you're looking for the tiny hair

of difference in this work, in this performance, from the thousands of others you've seen. Don't you see that your education brings you farther from the audience, not closer to it? No wonder you critics end up talking largely to yourselves.

Sincerely,
A Concerned Reader

1995

The Reek of the Human

THE CRITIC JOAN ACOCELLA, WRITING in a recent article for the *Village Voice*, points out the intuitively obvious but somehow paradoxical fact that audiences react more enthusiastically to bad dance convincingly performed than to good dance served unenthusiastically and lukewarm. What floats our boats is the performer rather than the performed. This shouldn't surprise any student, amateur or professional, of Hollywood's ongoing stream of diverting pap whose only reason for existing is the worship, in large-screen format, of the faces of a few iconic actors. Being people, we react to people, whatever they are doing. And although it seems logical that this should be so, it is at the same time infuriating for those of us who, over the years, have been drawn to the modernist dream of making dance more than a mere vehicle for the expression of an individual's personality. This was, after all, the goal of those messianic souls of the early twentieth century who had hoped to make dance a major art form, something that would rival Milton or Mozart—or, in the case of Miss Ruth, express the soul of the Mysterious East.

Ruth St. Denis, that is, as she was called by the producer David Belasco, since it sounded classier than mere Ruthie-from-New-Jersey Denis. (Mind you, I don't disapprove of stage names. Tell me Suzanne Farrell doesn't sound better than Roberta Sue Ficker, or Merrill Ashley scads more patrician than plain old Linda Merrill.) The Kennedy Center's program of dances by Miss Ruth, that so-seminal figure of American modern dance, and her sometime husband and collaborator Ted Shawn (January 30 and 31, presented, as part of the series "America Dancing") served to highlight once again what seemed the ineradicable contrast between dance and dancer, form

and vessel. For Miss Ruth was a charismatic dancer in her own time, famed for her beauty and rendered exotic by the Other Lite solos she created to set it off. How would vehicles for the showcasing of one dancer's physical allure fare in re-creation?

The program was called "Denishawn Repertory Dances," to include the name of the couple's famous school and to distinguish the offerings, largely solos by and initially for either St. Denis or Shawn, from the lavish spectacles they concocted either for the movies (it's Denishawn dancers who descend the great steps of Babylon in D. W. Griffith's *Intolerance*) or for Broadway (such as an Aztec-inspired spectacular in which a young dancer and Denishawn student named Martha Graham took the lead). Denishawn the school, of course, is still widely revered in dance-historical memory as the crucible for greater talents than either of its co-founders, such as Graham, Doris Humphrey, and Humphrey's partner Charles Weidman. Shawn is known independently from Miss Ruth as the founder of Jacob's Pillow and as the leader of a group of men dancers that toured during the 1930s with a repertory that included macho-type sports and martial-arts subjects, called (with an admirable attempt at truth in packaging) Ted Shawn's Men Dancers. Of Miss Ruth there remain as well a number of film clips, moving her middle-aged but still frigidly beautiful face and body through a number of her solos, and a few duets with a balding Shawn.

The purpose of this program, one felt, was to give the Shawns their due as choreographers. If their works would work on other bodies, then maybe they would have a chance of being more than historical names. (The first program in the Kennedy Center series was devoted to Isadora Duncan and included works similarly "remembered" by disciples of her disciples, the so-called Isadorables.) Yet it made for pallid fare, all these fake Javenese (St. Denis) or fake Japanese (Shawn) or fake Indian (St. Denis) or fake Cretan (Shawn) dances. Equally pallid the few abstractions, St. Denis's *Schubert Waltzes* or Shawn's floor exercises. The producers even seemed aware of just how much these attempts to resurrect a vanished sensibility would fall short of conviction, as the whole program was presented under a lecture rubric, with slides and a voice-over (an unbelievably wooden actor whose English sounded like delivery from phonetic script).

After all, we live in a vastly different world from that of the Shawns, one where we can ourselves go all these places that "inspired" their pieces, even if only with the American Express tour, and where "real" dances from Out There appear regularly on our stages. The Shawns' cultural tourism now seems as innocent and as hokey as a National Geographic of the same era,

full of bare-breasted "savages" and the thrill of the inaccessible. (Both Shawn's and St. Denis's dances key to a kind of chaste eroticism, St. Denis's with frequent coy turns and much batting of eyelashes, Shawn's with lots of bare chests.) It may look like camp, but it's unintentional—which means, it's not camp at all.

A more sympathetic viewer might propose that we were simply catching these works at a bad position in the wheel of Terpsichorean fashion. (Or fashion of other sorts: just yesterday I asked my mother if she liked my new, rimless glasses: "Sure," she said. "That's what I went to college in.") One day it may seem fresh again. Indeed I can see the end of our curiosity regarding (say) all-night Indonesian dance dramas. We lead other lives, socialize in other ways, and don't know much about the *Mahabharata*. When we've had our fill of the "authentic" (or as close to it as we can come on our Western stages), who knows? We might find Miss Ruth's touch-o'-exotic solos just the ticket.

Which left only the performers. Or rather, one performer, Jacqulyn Buglisi, somehow reanimating the otherwise so-dead shells of St. Denis's *Dance of the Black and Gold Sari* and *Serenata Morisca*, the latter having served in its time as a vehicle for the young Martha Graham. Jack Clark, the male dancer who stood in for Shawn, had neither physique nor presence and seemed an embarrassment. (One problem may have been that our dancers today are much more buff than Shawn or his boys ever were, so that unfairly enough Clark's authenticity in the body department was a real liability.) Dancers (or their lack), at any rate, rather than dances. And why should this be troubling?

Well, because dancers die, and we don't want to believe that dances necessarily do. Or that if they do die, that they can be "revived" (as we say, tellingly), or passed down. We know it's not so, that dances can't even survive a decade or two if the spirit is lacking (*cf.* Balanchine or Graham). But if something other than fragile memories doesn't live on, how to make sense of any more than the moment in dance? We know it all exists "at the vanishing point," but we still tell the story of the eternal (or at least potentially eternal) artwork, animated by ever-mortal dancers, the urn that a passing poet can call into fragmentary life, recorded in a reaction that outlives its creator, like Keats's "Ode on a Grecian Urn," remaining "in midst of other woe than ours/ A friend to man."

But perhaps it should all be seen under much less tragic stars than any of the above, Shawn and Miss Ruth presenting merely another case of excellent midwives but very ugly babies, superb editors but lousy writers,

good bridesmaids but perfect horrors as the groom. Which brought me back to my somehow melancholy admission that it's performers that push the audiences' buttons, not works. The opening program of the Alvin Ailey American Dance Theater (Kennedy Center, February 13) brought this point home with a vengeance. The piece after which the audience screamed loudest was the trashiest but most "intense," Lar Lubovitch's *Fandango*, set to Ravel's endless *Bolero*.

It was a duet for a man and a woman (Elizabeth Roxas and Leonard Meek), dressed in midriff-baring Cher-style tops and leotard bottoms, who fondle, twist, couple and uncouple, stare at the audience, get hot, get on top, get on the bottom, join, unjoin, touch, separate, and so on for the interminable length of this so-badly-in-need-of-euthanizing music. (I love Ravel, and, I hasten to add, some of my best friends are French.) But the performers looked as if they believed in what they were doing, and of course it was all faux-sexy in best chorus-boy and -girl style—dancers' sex, yuk, I thought—and so the audience was on its feet yelling "bravo" before the music had finally reverberated its last. (Three women near me were even getting the adjectival agreement right, and screaming "bravi.")

As an Apollonian-inclined white male, I was similarly unmoved by the program's opener, Judith Jamison's shamelessly audience-pandering *Riverside*. It's a good thing Jamison's black, I thought, noting the work's pulsing drums (music by Kimati Dinizulu), jungle-liana-like backdrop, its life-in-the-forest movement allusions (washing faces in streams, for example), and its jazz-inspired body language. For a nonblack choreographer, it would have been thought pandering to stereotypes and hence racist out the wazoo. Which may be why the couple of nonblack dancers in the company just didn't seem to "get" the movement, although they, too, were given their turns in front. Everybody else was wonderful, however, and despite myself I felt my pulse racing. The piece was enthusiastically received by those around me while I sat there nursing my paradox.

Only the program's closer, Ailey's now-classic *Revelations* (1960), silenced me, with its new generation of dancers breathing life into something which seemed made on their bodies for the first time. It's the illusion we're aiming for in dance, something like Huck Finn's belief that actors in plays made up the words as they went along. It happens so rarely, great performances in great choreography, and so randomly and unpredictably, that perhaps we should think of its occurrences as the choreographic

equivalent of Grace, unmerited and miraculous. Perhaps this thought will help us teach ourselves, like T.S. Eliot, to sit still.

Confessions of an Apollonian Male

IN A RECENT ARTICLE I CAME OUT of the closet and declared myself an Apollonian. One of those closets with the door wide open, I fear, and an admission that will surprise nobody who's been kind enough to follow my musings over the last several years. The reference, of course, was to Nietzsche's seminal dichotomy—useful just insofar as most such great sweeping dichotomies are useful, which is to say helpful when selectively applied—between the Apollonian urge and the Dionysian, as sketched out in *The Birth of Tragedy from the Spirit of Music*, the philosopher's early apologia for Wagnerian music.

Nietzsche thought, at least at this point in his career, that Wagner incorporated once again into music the spirit of the orgiastic god of wine, Dionysus, sorely needed in the Western sensibility, he thought, since its virtual elimination by the all-too-Apollonian Socrates, that purveyor of cold rationalism. The Dionysian: the hot, the sweaty, the impulsive, the emotional (my extrapolation), as befitting the god worshiped in drunken revels. The Apollonian: the cool, the unflustered, as befits that associated with the physically beautiful but somewhat remote god who drives the chariot of the distant sun. On the side of the Apollonian: structure, pre-meditation, complexity, emotional distance. On the side of the Dionysian: self-expression, impulse, the direct expression, emotional involvement.

If these poles seem eerily close to another of the great dualities, namely Romanticism and Classicism, or perhaps, too, to Schiller's "naive" and "sentimental," there's a reason. Namely, that we're talking here about yin and yang, the two extremes of the universe separable really only in thought, and hardly at all in reality. We can call them what we want, even (say) Male and Female. Still, the Nietzschean formulation of the gamut of possibilities is as good as any, and can serve as the basis for a diverting parlor game dividing the world into these two categories. Take fruit, for example. Pears: Apollonian; figs, Dionysian. Or life stages. Youth: Dionysian; old age: Apollonian. Furniture styles. Art Nouveau: Dionysian; Shaker or

Chippendale: Apollonian. Poets. Walt Whitman: Dionysian; Elizabeth Bishop: Apollonian. Even, well, choreographers. Balanchine: Apollonian; Bill T. Jones; Dionysian. Lucinda Childs: Apollonian; Judith Jamison: Dionysian. Merce Cunningham: Apollonian; any performance artist you can name: Dionysian.

If Apollonians could carry cards to attest to their status, I would. Or rather, I wouldn't have to. This so-fundamental fact about my choreographic orientation, as a viewer and critic, determines the way I react to works. As an Apollonian, I find choreography whose principal purpose is to make our blood pump a minor pleasure at best, comparable to the undeniable animal heat generated by stepping into a crowded disco full of boys and girls with their shirts off. One step up is movement whose primary purpose is to show bodies doing "neat" things. This seems self-indulgent and weak, lacking perceptible form. As an Apollonian, I find trivial most of the pieces, so ubiquitous nowadays, that take their structure from (usually badly written) texts. As writers, most choreographers make good plumbers.

Given the choice between a text by, say Willa Cather and one by Guillermo Gomez-Peña (MacArthur don't-call-it-"genius" grant or no), you can bet I'm not going to drive into town and find a parking place for Gomez-Peña when I can flop on the couch and open Cather. (Her astonishing novel *The Professor's House* is still spinning in my brain as I write.) As an Apollonian, too, I cherish the distance art allows us for our contemplation (this makes me a post-Kantian too, but I don't want to multiply the categories) and resent the attempt by people without the patience to construct something that will move me on its own to short-circuit things by batting me over the head with the point I *have* to get. Not to bitch and moan (Naval Academy synonym for whining), but I spend many of my evenings correcting undergraduate papers. I'm not about to sit in a darkened theater and be exposed to more half-baked platitudes. Show me what you want to show me and let me decide.

When I teach poetry to freshmen, they always ask, "Sir [they're polite at Annapolis], why couldn't the poet just say what he meant?" To the largely technical minds of my students, it seems unfair that the poet has "hidden" his meaning when s/he could have come out and told us what s/he wanted us to know. What I try to explain to them is that the poem *is* what the poet was "trying to say" (another of their favorite locutions). There's usually *not* a bottom line, and if there is, it's usually trite. It's not that art, or poetry, is the tease of half-hiding something; rather, it's that half-suspended state of complexity, the "on the one hand, on the other" limbo that is so frequently

the sensation of really great art. (I'm not being New Critical here, at least not totally. Visceral art exists too.)

Such an undergraduate understanding of art seems, to my Apollonian self (beginning to merge, the reader will note, with my professorial self), to dominate the "downtown" stage of our time. Instead of the 1960s paradigm of Jules Feiffer's long-haired Bennington student "expressing" herself, we in the 1990s have the marginalized and proud explaining it all to us. To today's viewers, it undoubtedly looks like boldness and clarity to cut all the tenebrous nuances such as movement and get right to the moral, or keep the *real* message thinly clad. So much easier to give the bottom line, they must think, like my students. To me it looks like an inability to sustain the hard center that gives it all a point, a kind of premature ejaculation on the stage.

Which is not to say (I hasten to add, somewhat wearily, as this is the most misunderstood point of us Apollonians) that there's not great art with a political content or that indeed all art isn't political. Still, the converse isn't true, namely that if there's a political content, the result is art. Too many people today seem to think that all you have to do is have the moral and the rest will take care of itself. Don't they know the world is full of morals, most of which are uninteresting, even if they can claim somebody's deep allegiance? Conviction is cheap. Every picketer in front of an abortion clinic or a courtroom has a conviction.

The "new," the untried, the marginalized all march under the banner of the Dionysian, that vocabulary provided for us by the Romantic movement, of which the Beats and the "generation of '68" are only the most recent avatars. The vocabulary is that of authenticity, of true self-expression, and of fidelity to an individual's or a minority's point of view. Institutions, by contrast, are always Apollonian in nature, or tend to that pole. Things that can be institutionalized, from the steps of Western classical ballet to the codes of societal conduct, presuppose predictability, and predictability by its nature precludes the momentary expression of evanescent feelings.

Critics tend to be Apollonian. After all, critics do their expressing in words, perhaps by definition somewhat more Apollonian a medium than body movement. They believe it their job to compare what they see with things they remember from as long as they have been looking, and to fill in from history books before that. They go to a lot of performances, so the mere fact of sitting there looking at people moving has less intrinsic interest than for most viewers. They're less impressed by the things that will affect a local, partisan, or unschooled audience, including pyrotechnics and cheap appeals to the viewer's weak spot. Frequently, they sit looking at

performances while composing their lead in their heads or scribbling it on the pad of paper in their laps.

The job of critics is to make connections, comparisons. The aim of Dionysian artists is to make their sensibilities paramount. We put in relation, they try to make themselves stand out. The desire of the artist is to intoxicate us, in best Dionysian style; our job is to analyze it in clear Apollonian sentences. Most audience members are Dionysian too, at least in this era of increasingly uneducated viewers. They want a jolt for their money, not the big picture.

This may sound like a plea for understanding for critics, or an admission of our own increasing irrelevance, in theoretical as well as economic terms. (Everybody knows criticism is disappearing from daily newspapers or turning into Friday pieces that are meant to sell tickets, not comment on a performance that's happened.) It's both of these, but it's also a lead-in to pointing out that precisely because critics tend to be Apollonians, they need to believe themselves just as Dionysian as the artists they write about. Letting it all out or lecturing the audience looks like so much more fun. Yet such posturing is by definition in bad faith.

The spectacle of virtually the entire dance critical community rising to condemn Arlene Croce's now-celebrated refusal to go see Bill T. Jones's piece *Still/Here* and the fact that she wrote about that refusal is one recent example of just such bad-faith slumming. Yet nothing seems more logical to me than Croce's pointing out, implicitly, that we can't be everywhere in any given evening. Everything is a choice. Do I read Shakespeare or go to yet another dance performance? If it's by somebody whose last works seemed self-indulgent and whose press material (usually the place where a piece is presented in the most glowing possible terms) is discouraging, I'd say that Shakespeare, or even Agatha Christie, has it hands down. We don't owe self-proclaimed artists our presence, and we can make educated choices about what is likely to appeal to us. We can, if we're powerful enough and are allowed to write what we want, even write about the fact that some pieces are prima facie so unappealing that we simply deny them our presence.

That's what seemed to stick in everybody's craw. "Bruce," a colleague with whom I was arguing this point insisted, *"She didn't go."* Right, I said. Her right, that is, as a viewer. As an Apollonian, I resent the heck out of the Dionysian assumption that artists all have us by the you-know-what and can lead us wherever they want us to go. No, I say. You have to make me *want* to go to your piece.

But that's my Apollonian nature again. Deciding not to go is a legitimate critical comment, not to be confused with simply not going. It's like Rauschenberg erasing a de Kooning drawing and exhibiting the result as his own artwork. A strong distaste for Jones's self-serving histrionics plus a breathy press release would nail me to the couch any night with a book in my hand.

It's quintessentially Apollonian to feel, as I do, that artists are there to serve (read: interest, amuse, enlighten) the audience, not the reverse. In principle, I am interested in what you do, I want to say to them, but only if it's interesting. Prove yourself: that's the way you get my allegiance, not by demanding it from the stage apron, or in print. You want me to pay attention to you? Fine. Give me one good reason why I should, other than that you want me to. Above all, don't let me wake up the next morning with a hangover and a feeling of having been conned.

You have to seduce the audience, you can't rape it.

Yes, But IS IT ART?

I LOVE NEAR-ART. I MEAN THINGS like the flights of birds (on which Ann Tobias wrote in *DanceView* an issue or two ago), midshipmen parades here at the United States Naval Academy (on which I wrote several years ago), or the Quebec-based Cirque Éloize, that put on a program at Lisner Auditorium in Washington, D.C., on Valentine's Day weekend. Military parades look as if they should be the same as Balanchine's *Union Jack* or a contemporary piece out under the trees. By the same token, something like a circus, which we ordinarily wouldn't think of calling "art," gets put on a stage and tarted up with lighting and special effects, and suddenly it looks like a dance performance. After all, people on the dance press list get invited, and we get photos and publicity material. It sure looks as if it should be art. If those theoreticians are right who argue that the pedestal makes the art art (Arthur Danto comes to mind), then it *is* art.

I sat there in the best of moods. I really like Lisner, with its art deco curves and its fire curtain by John Twachtman (more of his work in the Phillips Gallery). It feels like reentering my childhood: this is where I first saw Paul Taylor and Martha Graham. After all, for many years it was *the*

Washington performing space for dance, back in the prehistoric (read: pre-Kennedy Center) days. Judging by the composition of the audience, I think it's safe to say that Lisner will be part of many other people's childhoods as well. Most of the people present could have passed under the height limit for the Ocean City bumper cars with room to spare.

Before many minutes had passed, I found myself in serious taxonomic difficulty. Cirque Éloize, I realized, qualifies as a circus only if you've already accepted as a circus something like Cirque du Soleil, also from Quebec. Unlike Ringling Brothers, this new breed of circus lacks animals and is characterized by lots of virtuoso body stunts, booming music, and lighting like Jennifer Tipton's for Twyla Tharp's *In the Upper Room* cutting through the output of an overworked fog machine.

There was another nomenclatural problem. I had assumed this particular Cirque was named after the little girl who lives in the Plaza Hotel, or her French-Canadian namesake. In fact, it turns out, Éloize is the local name for shooting stars on the islands whence the circus's members come. Cirque Éloize, perhaps in this way justifying the name, turns out to be largely about the six male gymnasts who form the core of the troupe. Indeed, the whole afternoon was a wildly macho show, which was amusing in that a large proportion of the audience seemed to consist of little girls, including mine. If only the little boys who'd turned up their noses at the thought of a circus in a dance theater had known, I bet they'd have been there in droves.

This much was like an old-style circus: all six guys juggle, both alone and in a circle, the latter as sort of an acrobat's version of an encounter group. Then they get on each others' shoulders and juggle some more in two layers.

Then the music swells and out comes one guy on a bicycle, who rides it every way but normal, front, back, upside down. I was disappointed that the wheels were always touching the stage. Shouldn't he have figured out a way to ride it on the curtain?

Then there was the rope act. A buff little guy with a shaved head shimmies up a rope and proceeds to hang upside-down, by his heel, by his waist, by his hand, sideways, rightways. He had a round Styrofoam crash pad that was moved in and out so expertly by invisible hands that it looked like a necessary prop, sort of like the dancing tire in Tharp's tiresome *Bum's Rush*. (Have they been looking at too much Tharp recently? Or she at them?) Not to forget the ladder act. The secret of staying upright on a stainless steel ladder is to keep it rocking from side to side. Now you know.

What held all these stunts together, after a fashion, was a great deal of really stupid, unfunny stuff involving the sole woman in the troupe, a faux-Spanish-speaking faux-diva introduced in an unvarying basso profundo voice as "Fran-ces-ca," in turn pursued by a wild-haired man who was to clown what this Cirque is to circus (no red ball on his nose). This guy had circulated in the audience before the show, at one point asking a well-dressed youngish man near me to blow up a balloon with a plunger to the point where it exploded, scattering talcum powder all over the man's nice sports jacket and suede shoes. The man obviously felt obliged to pretend he was amused. My daughter, three rows away from the explosion, was terrified, and I, who have my sartorial pretensions as well, was furious at both the "clown" and the "circus" on the man's behalf because of the powder that had ruined his clothing. Everybody together, laugh.

The original Pilobolus, I remember hearing at one point, was "discovered" doing a few of its contact improvisation-influenced pieces interspersed with song and dance numbers. The first advice from the pros was to lose the stand-up stuff. My advice to this cirque is, lose Francesca and the "clown." But if they took my advice, what would we have? Something closer to gymnastics on a stage than before. And for that why not go to a college near you to a real gymnastics meet?

The Navy gymnastics team practices on the other side of a divider from the weight room I go to. Sometimes I watch them. They're amazing, beautiful, exciting. Sans the music and the fog machine, natch, but is that a difference that makes a difference? How was this anything more than gussied up gymnastics with stupid filler? Should it have been on a stage? Should critics have been there? Was it art?

Some theoreticians would dismiss the question or say that it had to be art because somebody was saying it was art, or it had to be art because it took place where art takes place (the museum-and-pedestal argument). I think we can say just exactly why the stunts that composed Cirque Éloize are *not* art. It has something to do with the same way a piano student's painful lurching through Czerny isn't art. Or, closer to the Cirque, the way neither the Olympics nor the Navy gymnastics team is art, fun although they are to watch.

In the case of the student piano recital, what the audience of sweating parents is hoping for is a personal best by the individual. Will little Johnny or Susie get through the piece? Play these notes? In the case of sports, things are somewhat different. What we are rooting for is not a personal best, but a best of the action, whoever achieves it. In sports, that is, the parameters of

the action are very circumscribed indeed. Can the power-lifter lift X large amount of weight? Can the runner cover the distance in X small amount of time? Can the figure skater make the preordained patterns? At least, these are the questions a true sports fan asks, which is not to deny that viewers at the Olympics or the local football game frequently root for people for utterly chauvinistic reasons rather than sports-related ones.

We do sometimes speak of an athlete as being an artist. That happens when we've mentally entered the world of their striving, where there is room for variation, rather than staying on the outside as spectators. It's a lot easier to cross over into that world in sports than it is in art, although (say) dance critics who themselves are dancers do a pretty good job of seeing things from the performers' point of view. (This is what characterizes the reviews that Deborah Jowitt writes for the *Village Voice*.)

Physical movement is art when the parameters of the actions themselves are expanded. In sports, the parameters of action don't expand. Another way of saying this is, in art we can be surprised. In sports, by contrast, we can only be pleased. Our expectations have been fulfilled, or even surpassed, but surpassed in predictable ways: more weight, fewer seconds.

In the case of the Cirque Éloize, actions *were* expanded, which is why it may have seemed like art. They just weren't expanded enough. We were surprised a little, but not very surprised. Our reaction was, gosh, is he *really* doing that?

I'd be really impressed if my daughter were to juggle three pins. But I wasn't too impressed to see these professionals do it. I knew that juggling existed in the world, and had even seen the odd example. Logically, therefore, I was prepared for them to do it standing on each others' shoulders, then with guys on their shoulders in three layers. It was something new, but it wasn't new enough. Why not four layers? That'll be the next permutation. Ditto rope tricks. I got the idea fast. After all, I'd had to haul myself up a rope in gym class, and could imagine the inventive things you could do with a rope. This guy was doing them, and doing them very well. Lights, music, drum roll . . . very nice. The tricks were a series of dead ends. The point was reached when the action was completed. What we saw were good performances of tricks, which is to say, sports. Performances, that is, but not works.

This distinction between performance and work is by no means an absolute one. The distinction is like looking out your diningroom window at night. You can see out, to a degree, but you also see the room reflected. The stronger the light, the less outside you get and the more inside. The trappings

of art (venue, production values) serve to opacify the window, make us see more the surface of the experience and less the individuals doing it. Many contemporary artworks (so-called or really so) are playing in the gray area of reflections, as if intrigued with the discovery that the scale of combinations of these two worlds, like the trajectory of the arrow in Zeno's paradox, is infinitely divisible.

Nowadays, that is, we are surrounded by works inside museums made of junk from outside, works outside museums of perishable materials, transitory works, site-specific works, and conceptual works. All are walking the line between performance and art, transitory and permanent; in another metaphor, they are trying to stand on the reflecting surface of water without falling in. Some works made by people who can calibrate precisely are held up by surface pressure, and succeed. Nobody would ever think *Esplanade* wasn't art because it incorporated walking and running; Robert Rauschenberg makes art out of newspaper pictures; Jasper Johns painted flags. Those that are too heavy, by contrast, become once again non-art and sink; Elizabeth Streb's sweat-drenched "I can't believe they're doing that and not getting killed" group Ringside comes to mind. The debate continues as to whether Andy Warhol sinks or floats.

It's an indication of just how great the divide has grown between art and popular culture that a century ago, in a world with vaudeville, music halls, and local live entertainment, Cirque Éloize would have posed no taxonomic problems at all. In our postmodernist world, however, this middle area has thinned out to near vacuity, leaving only the uncomfortable attempts of groups like Cirque Éloize to bridge the chasm. Performance of stunts, however, does not equal artworks.

It was undeniably fun to watch. But because the stunts were just stunts, tarting them up with the trappings of art (stage, lighting, etc) only served to make them disappointing. I've been much more impressed watching a guy on the rings back in the gym. With no expectations of seeing anything really new, the focus is once again on the performer. No frills, no expectations, then suddenly, Wow, I don't believe he's doing that!

This Cirque was trying to look like art. It came a little way up toward *being* art, but finally fell back. And I didn't like the pretensions of the attempt. The trappings of art, in other words, serve to prepare our expectations; they don't in and of themselves create the artness of the performance, since those expectations can be disappointed. In fact, we can

be disappointed precisely because of the expectations. At Cirque Éloize, I was.

Docent Spiders

A PHILOSOPHICAL MAXIM: the world is one.

It sounds like Wittgenstein, or perhaps a pre-Socratic monist, or a pantheistic (and hence heretical) Muslim. Actually, it's my very own. Events we experience in our childhood, as Freud insisted, influence us all the way to our grave; something that happens in the morning determines our reactions to events that occurs in the evening. For example, an experience I had one morning before Christmas, trying to infuse a little holiday cheer into a Saturday with my daughter, determined what I saw that night at the Kennedy Center performance of Eliot Feld's company Ballet Tech.

That December 4, it was chilly here in Annapolis. The knowledge that, should we stay indoors, we would be spending the afternoon watching Barney videos impelled me to go for the coats and scarves and hit the streets of our tidy hometown, decked out for Christmas to make the most of its brick-work colonial heritage.

I steered us toward the fabled Hammond-Harwood House on Maryland Avenue near the gates of the Naval Academy. At least it's fabled in local lore, although to be sure I'd never quite understood for what, save a door that the plaque outside tells visitors was called, by some pundit contemporary with the house, "one of the most beautiful doors in America." I figured it had to be better than a purple dinosaur. Perhaps I should have drawn some conclusions from the fact that I had been in Annapolis for ten years and never been impelled to enter this house.

Hammond-Harwood House, furthermore, was offering "An Eighteenth-Century Christmas," with special decorations. It sounded like fun for a little girl, I thought, fondly imagining I knew not what, and at least tolerable for Dad. Yet when we arrived, I was surprised to see no one at all outside the house. I thought I must have misread the date on the banner over Main Street announcing the event. Had I missed the festivities?

I pushed open the door, which for an instant I thought was locked, and entered the hallway. There were two young women at the desk, and their

welcome suggested to me that I had not, in fact, misread the banner. We got smiles, a sticker, a little polite banter while I fished for the money, and were told to start over there, please, docents were in each room. We were the only visitors.

My first thought was that the Eighteenth-Century Christmas to which the banner referred was in scant supply. In fact, it took the form of a few flower arrangements, variations on the by now over-familiar Southern-States Christmas motifs of boxwood and magnolia leaves with fruit. Some of these were set demurely in the centers of tables, some wedged saucily if somewhat precariously in angles of the molding. Each room, I learned, was "decorated" by a different garden club.

I noted that the furnishings of the rooms were tasteful, if somewhat drab and of course, not original to the house, as the docents, the women there to explain it all to us, had to admit. Alexandra and I, or at least one of us, tried to look interested as one young woman after the next gave us exhaustive information about the history of the house, the genealogy of the families that had built it and subsequently lived in it, the reasons the rooms had the names they did, and a thousand other details that only a Ph.D. candidate could have been remotely interested in. Because we were the only visitors, however, we clearly had to smile, if a bit stiffly, and look interested.

Not, for that matter, that the docents seemed any more interested than we were. The one in the upstairs front bedroom (called the "study bedroom," we learned, because it was located over the study) abandoned all pretense to greater knowledge from the outset and simply read from the card she had in her hand. She had a Carolina accent and the big hair and mannerisms that made clear her membership in the Junior League, and appeared determined to give us all the knowledge we were entitled to for the price of admission. We heard about Mrs. X, the last surviving member of the house's original owner family, who had died in this very bed, about the potty chair disguised as a wing chair (this part she pitched at Alexandra, who seemed only mildly interested), about the picture over the mantlepiece, and about the bedspread.

The momentum of this onslaught of information was, however, regularly interrupted by sudden panic attacks on her part as Alexandra stepped off the matting designed to shield the floor from the non-existent throngs of tourists. Things came to a real head when her (well, okay, probably sticky) little hand touched the sacred bedspread. At this our docent lost it. An arm shot out and latched onto Alexandra's. "Oh no, no sweetie. They don't even let *me* touch that," she tried to explain a moment later, as if realizing that her vise-like

grip and split-second reaction time might seem a bit *too* ruthless, even for a steel magnolia.

"I think we'd better move on," I offered. It was clear that our docent's determination to do her duty by the study bedroom of the Hammond-Harwood house had evaporated. I smiled regretfully, attempting to convey that if I had not had my daughter with me, I would of course have been delighted to stay and hear all the particulars she cared to read, and ushered Alexandra into the next room.

The experience here was no more successful, with an increasingly-desperate docent trying to impress on Alexandra the amazing fact that the painting on the wall was of the doll, the *very* doll, this *same* doll, that nestled in a miniature bed before it. I decided the woman was merely stupid. How can a five-year-old be expected to understand that objects go in a thousand directions at the death of their owners, and that reuniting two things from two hundred years ago is in fact a small, albeit palpable, victory of human perseverence over the chaos that otherwise dominates our lives?

Feeling increasingly like a fly that has blundered into a nest of spiders, and finally admitting that there was very little to interest either little girls or their Daddies, I effected a quick escape down the staircase and out of this house full of people intent on making me aware of things I didn't care about. The visit was partially redeemed by a cookie and a glass of hot cider in the eighteenth-century kitchen (where, blessedly, the woman presiding was just there to give out the eats, and did not attempt to wax historical regarding the contents or situation of the room). We exited into the chilly air, with Daddy vowing to allow twice ten years to elapse before he would again set foot in the Hammond-Harwood House.

We then went home and watched Barney.

That night, Eliot Feld. In fact, it was Eliot Feld from the moment I walked into the theater. I'm told it's a given of Ballet Tech performances nowadays that they start with an open curtain, with Feld plus dancers warming up/doing last minute work on stage. (The explanation I heard had to do with the fire at the Joyce Theater. Having performed without a curtain, Feld decided he liked it.) It was fun watching this tiny gray-haired man in street shoes and blue jeans sketching gestures that an instant later were magnified by younger, sprier legs and arms into larger versions, like reconstituting dried food by adding water.

I was a bit suspicious at first, I admit, at this pretense of letting us watch rehearsal and warm-up. Was Dancer X actually listening to Feld, or had this all been planned beforehand? In any case, it set the tone for what was

essentially a Brechtian aesthetic, which became more pronounced as the evening went on and the cyclorama disappeared entirely to show piled-up props for the second of the evening's Kennedy Center commissions, *Partita for Two.*

At the advertised time, however, the stage cleared, the house lights dimmed, and the recorded strains of Stephen Foster filled the hall. The first piece was beginning, *Doo Dah Day (no possum, no sop, no taters).*

It was an utterly outrageous piece. Within seconds I was in ecstasy.

The dancers, most of whom are nonwhite, were dressed in versions of leotards in earthtone camouflage, their hands all but covered by trailing cuffs like lace that flapped as they walked. And how they did walk!—with their behinds stuck out and their heads stuck forward in a simultaneous evocation and deconstruction of the blackface parodies for which Foster, bathed in the glow of nostalgia for the ante-bellum South, had once composed his melodies. The songs were performed "straight," as high romantic ballads, but the dancing shot their pretensions all to hell.

Dancers came out in mirror pairs, like something from a pickaninny version of a Marx Brothers' movie, flapping their ineffectual hands (nothing is so depersonalizing or emasculating in dance as having the hands obscured or limpened: see Paul Taylor's *Cloven Kingdom* with his broken-wristed evening-clothed men whose impotence is held before their bodies for all to see), their heads thrust forward as if to kiss with exaggerated lips, feet splayed on the stage, butts protruding.

We aren't even supposed to *know* about these things, I thought, all my politically correct neurons on stun, much less be seeing them referred to on stage—even if the intention is to puncture them. For a brief moment, Feld seemed like God. It was hilarious, interesting to watch, and definitely not for the fainthearted. And *this* from Eliot Feld! His amazing debut (*Harbinger, At Midnight*) back in the "dance boom" days had set the dance world abuzz. But for decades he had produced thin, watered-down if respectable pieces that most people I know went to out of a feeling of obligation rather than with any anticipation. This was a near-masterpiece; at any rate it was something good, something new. Not to mention the good-press angle of his dancers coming from the inner city.

To be sure, there were problems. This piece was just a bit too influenced by Pilobolus. Feld had his dancers intertwining, forming depersonalized buggies. The double crotch-lifts that held the women up to public scrutiny were vulgar. The man-handling that Marie Yip bore at the hands of Jason Jordan was positively painful to watch. She was pushed from stasis to stasis

with her legs locked in lotus position, and I cringed each time this beautiful woman (her hair provocatively down, a reproach to the skullcaps that had dehumanized all the other dancers) was pushed and treated like a sack of potatoes, or a strangely shaped toy.

Furthermore, the piece's odd closing, to *Reborn Again*, where Jassen Virolas, stripped to the waist, did what seemed an Alvin Ailey homage, ("I been 'buked," I wanted to sing), seemed tacked on. But by that time, I didn't care. Such a load of movement invention in one piece I hadn't seen in a long time. In fact, my mood at the end of *Doo Dah Day* was so good that the thinner fare of the Kennedy Center commissions, *The Last Sonata* and *Partita for Two* (a solo for Patricia Tuthill and a duet for Jason Jordan and Virolas, respectively), failed to dampen it.

This, I thought as I went outside into the evening cold, was what art was about: being interesting. More to the point, I thought, with the morning's fiasco fresh in my mind, art was about being interesting and *not demanding that one acknowledge it as such.* There were no docent spiders to whom one had to be polite, no ant-viewed explainers trying to impress on one at any cost the great importance of what they had to impart.

Here, I got to sit in my seat in the darkness and simply watch. If what I saw was good, I could enjoy it. If it was bad, I would be disappointed. In either case that was the end of the transaction. No one came to the footlights and told me what to think (I don't stay for post-performance discussions). No one lectured me as I watched. They offered, I consumed.

That, I thought, is what makes art art, and the rest of the world the rest. In the world, we are caught in vises of socially-determined reaction. Someone gives us something, we must respond, if only formulaically. In the production and consumption of art, by contrast, we, the consumer, don't have to please anybody. Which means, we don't have to *do* anything with it. The faceless, personless art object (which may be conveyed by people with faces) is formed, handed over—or rather, sought out; I had to drive into town, just as I have to open a book— consumed and digested.

We do not react. Or if we do, the reaction is subsequent, as in these words, not part of the transaction itself. Even applause in the theater is understood as being subsequent to the work, not part of it. We need not join in if we don't feel like it.

The reason art exists, and the reason we keep producing and consuming it, is to make possible this peculiar relation, the situation where we do not have to interact. We perceive, we take in, we clap if appropriate to the art

form (not for books, nor for movies, unless we are at a premiere with the director and stars), and then we leave.

This situation of not having to react, not having to make someone else feel good, is liberating to the audience members. Of course, some artists (I believe the lesser ones) have always felt uncomfortable with the merciless givens of this relationship, where the thing they produce, and not they themselves, must do the talking (or rather, the showing). Many are only too glad to beat us into submission with intention, words, stories of what was meant. The wise audience member, who wishes to preserve that peculiar relationship between people through the work we know as art, will just say no.

Just do your thing, I want to say. Or if talking is part of your thing, talk. But don't expect me to respond afterward, unless I feel like it.

Which is also why I don't want to know anything about the dancers, why I don't care to know facts about an author's life (unless it will somehow help me understand the work, which usually isn't the case), and why history of the arts is not the same as experiencing them (remember the horror of droning undergraduate art history lectures with slides, paintings reduced to data for the upcoming exam?).

Art is not the same as the world, although it is part of the world. Art is a particular set of circumstances in the world, those circumstances where we relate to other people through the quasi-impersonal object known as the artwork.

How wonderful it is that we do not have to make small talk with the artwork. How wonderful not to have to paste on a steely smile and pretend to be interested. At the same time, how wonderful when we *are* interested. The sensation feels like interest in the world itself, the artist having created something that, although quivering with the breath of the human, is itself not completely human. It took the docent spiders of the morning for the evening to remind me what art really is.

1997

Notes and Queries

JUST WHEN YOU THINK IT'S safe to be a grump, when you're convinced there's no reason to get out of bed in the morning or drive to a dance

program, that's when you get hit by back-to-back weeks of the Australian and Pennsylvania Ballets (this past October at the Kennedy Center). A solid performance of *Don Quixote* from the Australians made me think it's only the dance capitals of the world that are suffering from exhaustion, while the once-maligned provinces are doing fine. This was followed a week later by a rendition of *Serenade* from Philadelphia that was so beautiful I cried. A Christopher d'Amboise piece on the same Pennsylvania program, *Golden Mean*, was hands-down the best faux-Balanchine I have seen, the piece Balanchine should have made right after *Agon* to mine out the vein. It kept me on the same high that I had been put on a few days earlier by a beguiling although over-long piece by Stanton Welch for the Australians, called *Divergence* and set to Bizet's *L'Arlésienne*. Welch showed that there are people out there coming up with new ideas that work, and we don't have to be contented with our own over-hyped, now-aging Wunderkinder. Champagne all around, please, *garçon*.

Not that the two weeks were perfect. The fire under the opening night Kitri was a bit low. And *Don Q* in anybody's version (this was Nureyev's) is far from being a substantial ballet. The opener for the Australian triple bill was a ho-hum international-style piece called *Catalyst*, by one Stephen Baynes, all glistening unisex costumes and choreography—and with pretentious program notes to boot, all about alienation and how dancers function as catalysts. In your dreams, buddy, I wanted to say. The headliner of the Pennsylvanians, David Parsons's Kennedy Center commission, *Mood Swing,* was only intermittently amusing, and committed the gaffe of having not one but two sections where the dancers pretended to laugh all the way through. Still, I went right home and threw away my T-shirt that says "Been There, Done That." Clearly it's too soon to think about moving to Tahiti after all.

There was, however, a troubling element on the Australians' mixed bill, but one that provided much food for thought: a piece by Graeme Murphy called *Beyond Twelve*. Maybe I was too high on the evening, or perhaps I drank too much of the excellent Australian wine served in the impromptu press lounge under a stairwell during intermission. For whatever reason, I didn't read the program notes before seeing the piece. This turned out to be unfortunate.

My initial reaction was to be charmed by the David Hockney-style backdrop (Alan Oldfield), by the Ted Shawn-like sports choreography for the group of footballers, and by the mother in drag, hammed to perfection by Stephen Morgante. The chunky blond son (Marc Cassidy) roughhoused with

the other guys and was in turn knocked around by his mother. He and his sister did dumb brother and sister kind of stuff. The father was henpecked. Abruptly, one of the football goal posts was given a crick that turned it into a barre, and we were in a dance studio, where a lanky dark-haired boy (who was he? I wondered briefly, then gave up) was clearly more interested in the girls than in dancing. Perhaps as a symbol of his interest, the goal post became erect again.

The boy had an interlude with a woman (Vicki Attard) that was echoed behind a scrim by the mother and the blond boy, gender roles reversed: as the ballerino manipulates his sweetie, so the aggressive mother manipulates her son. Something kinky was clearly going on, what with the butch mother, the ineffectual father, and the son's blatantly adult physique squeezed into his footballer shorts. I was intrigued. And this from Australia, home of macho! The dance studio disappeared, and in came a Christopher Reeves stand-in (Steven Heathcote) who evidently had the hots for the chunky blond boy still running around in his shorts and showing off his thigh muscles. The dark-haired danseur tries to protect the little guy, but after a while evidently decides it wasn't up to him. He and Superman shake on it, and Chris gets his hands on the younger man. All of a sudden, Chris drapes a towel around his neck and walks into the empty stage, back wall showing. End of ballet, with flowers for the ballerinas, including the mother.

Geesh, says I, heading to the source of the wine. It takes those ballsy Aussies to show us gender-bending that's taken for granted. A little bald, perhaps, the reversal of stereotypes of having the chunky footballer turn out to be the one interested in older men, while the lanky ballet dancer can hardly keep his hands off the girls. A little puzzling, too, why the dark-haired one was so protective of the blond yet would shake hands with Superman and decide to give the younger one up. Life is rarely as simple as we think it's going to be. You can start off playing rugby and end up being Superman's kept boy. A bit unsavory, but hey. Did this jibe with the Hockneyesque sun-drenched suburbia? Or was the point the ironic contrast?

Imagine my embarrassment when I opened my mouth to the other critics. If only I'd read my program! Then I would have understood that the blond was the title character, "beyond twelve" (years of age), the dance student was "beyond eighteen" and Superman was "beyond twenty-five"! I would have learned that the inspiration for the ballet "comes from the real experience of dancers" and that it has something to do with "the abrupt termination of a career." As in, the boy starts off playing with the guys, goes to the dance

studio to meet girls, throws off his stifling mother, and makes peace with his non-dancing adult self.

What a dope I felt. Or perverted. I mean, here it was all so normal and aboveboard, and I thought I was seeing an essay on gender construction. I wanted to slink off to some other stairwell. Instead, I took a sip of wine and started trying to think up excuses for myself.

None seemed available. It's not as if we critics aren't trained to spot these three-faces-of-Eve roles, or that we've never seen ballets where the people in the story weren't doing what the dancers on the stage were doing. There's the dancing and non-dancing pair in Balanchine's *Seven Deadly Sins*. The audience members at Robbins's *Concert* don't really get up and do those goofy things. And Martha Graham presented three aspects of Joan of Arc in *Seraphic Dialogue*, not to mention similar conceits in works of other choreographers from the 1940s—She Who Somethings, She Who Something Elses.

Suddenly, I had the explanation to my reaction; my self-esteem was saved. It was the handshake. The lanky dark-haired ballet boy shakes hands with Superman before delivering up the chunky one—er, I mean, their common younger self. This is an immediately recognizable action of collusion between two distinct people, usually men. (In France, that land of many handshakes, the gender rules for this are absolute. Men greet or take leave by shaking hands with the other men and giving air kisses to the women.) You can't shake hands with yourself, not even one part of you with another part. It's one of the few gestures we have that immediately and irrevocably telegraphs two distinct people, usually two males, momentarily bonding rather than aggressing.

Or was it the hair color and the so-different physiques of the dancers that prevented me from seeing these were the same person? Nowadays, with non-traditional casting in plays, it's hard to know what we're supposed to register and what we aren't. Is (say) a black actress black just as an actress, or is she black in the play? This is a question raised by the much-praised recent Lincoln Center production of *Carousel*. The actress in question plays the female sidekick Carrie, who has a number of good songs. I had about decided she wasn't "really" black, because if she had been, more would have been made of her very white husband, Mr. Snow. That is, until their children were shown in the last act, and turned out to be a realistic and carefully-chosen spectrum of tans. (Why not a family of Asians?) So she was black in the play after all, I thought. Which meant what? That this was a very advanced turn-

of-the-century small town? Usually hair color doesn't matter, but if the point is that two dancers are the same person . . .

I was reminded of one of the late films of the surrealist master Luis Buñuel, *That Obscure Object of Desire*, where two very different actresses switch in and out of the same role, with absolutely no comment from the film on the changes. There, it's funny. Onstage, it was just puzzling. The costumes weren't even the same! Even the fact that the three boys dance in a downstage line (overlaps being one of the few ways we have of showing shadow roles on the stage) didn't do it for me. Here the dance was too complex, and anyhow Balanchine arranges lines of dancers down the middle of the stage in a similar way and they don't represent replications of the "same" girl. On the other hand, I thought, when we in the West first saw the *Kingdom of the Shades* act from *La Bayadère* it seemed about a lot of virtually identical girls. It turns out, we learned when we finally saw the whole thing, that it's really one girl, fractured and multiplied in the hero's dream.

So sue me, I didn't get it. The question is, whose fault was it? Mine or Murphy's? Maybe I just need to get over my hang-ups with hair and skin color and body type. (I always have trouble with nontraditional casting. Recently I saw a Michael Kahn production of *Henry IV* with some female soldiers. Were they "really" women? Or wasn't I supposed to notice?) Maybe Murphy needs to think about the implications of the handshake. Or about how to telegraph "same character, different bodies" so that people get it without the program notes. Or maybe I need to get over my New Critical presupposition that it's all in the work itself and read the darn program.

All I know is, I prefer my mistaken viewing of this piece to the correct version, which I think is pretty banal. The body doesn't lie, Graham liked to say. I want to add, what you see on stage is what you get.

New Dance Review 1995

II

Modern Masters

Taylor at the American Dance Festival

THE FIRST PIECE ON THE PROGRAM at the Paul Taylor Dance Company's American Dance Festival performance of June 30 was *Roses*. It seemed a work of such transcendent beauty and harmony that when it was over I just wanted the world to go away for a while and leave me alone.

The first section of the work is set to Wagner's *Siegfried Idyll*, and is the gorgeous lollings about and play for five couples who seem to have fed on ambrosia. The women cradle the men's heads in their laps, and then the reverse. The men kneel before the women, both facing in the same direction, the women's fingers brushing their temples. They dance, each pair singly and in combinations. The women float up onto the mens' backs, and then down again. The music changes to the *Adagio for Clarinet and Strings*, and Christopher Gillis and Kate Johnson, dressed in a white variation on the other couples' gray tights and black dresses, dance a luminous continuation of this same motif of meditative trust, unhurried languor, and eternal youth. If the title of the piece suggest Herrick's advice to "gather ye rosebuds while ye may," it is clear that these favored of the gods need not hurry their pleasures, for they will live forever. [Later note: Gillis died soon after.]

This harmony is also the vision of *Esplanade*, the program's closing work, and one of Taylor's all-time greats. From the walkers who change direction two by two in the first movement as if suddenly moved by the same irresistibly delicious urge, to the glorious abandon with which the runners of the last movement fling themselves on the floor and the women hurl themselves into the air just where they know the men's waiting arms will be, this is a dance about community, about trust, about the joy of togetherness.

All except, that is, for the second movement, that mysterious braid of altering configurations that begins with a trio for a man, a woman, and a woman dressed as a man (Kenneth Tosti, Linda Kent, and Karla Wolfangle).

Who is longing after whom? And why can't they get their desires? Unforgettable, at any rate, the extraordinary last image of this movement where human beings turned to bestial crawling backs cluster around the woman-as-man in a milling knot under the spotlight, eternally circling. Clearly Paul Taylor knows that there is darkness in the human heart.

And it was this darkness, along with some outright comedy, which formed the subject of the program's most recent piece, *Danbury Mix*. (Is this odd combination of the two extremes the "mix" of the title?) Set to several assorted movements of pieces by Charles Ives, the work was initially done at the New York City Ballet for their recent American Music Festival.

Collectively speaking, the characters in this work are two. One is the woman in silver lamé society pajamas who, at the beginning of the piece, struts arrogantly forward at the prow of the second character, the many-limbed proletarian mass behind her. A woman tries to stop her by encircling her feet. Like the sleepwalker in Balanchine's *La Sonnambula*, she steps over the ring formed by the body and continues on. But several movements later she has lost all reserve and is running onstage and stomping with the same ghoulish abandon as the rest of the dancers. She even ends one of the sections turned upside down with her legs spread and her head invisible in a mass of the muscular young men, who seem to be displaying her as a trophy. The curtain comes down on her posing alone, stage center, to a backdrop of Warhol-like black and white American flags. But before this happens the dancers have interjected a rah-rah football kind of dance (to one of Ives's fragmentary American tunes) and done take-offs of "Grecian" postures from *Afternoon of a Faun*. Difficult to say what was going on, or why; the piece was nonetheless fascinating to watch. A second viewing of this piece the following night made clearer, however, the extraordinarily close connection between the dancing and the music in which aural mess alternates with clarity of structure and appeals to traditional tunes, and hence movements.

The program on July 2 brought two new works from the spring season in New York, *Brandenburgs* and *Counterswarm*, as well as the 1986 *A Musical Offering*. The first belongs to Taylor's "classical" category, a seamless arrangement for nine dancers of the now standard Taylor vocabulary, set to movements from two of the title concerti. At times it seemed as if Taylor had been thinking of Balanchine (the quartet for Christopher Gillis and three women that echoed *Apollo*), and although it has both fast and slow movements, it is done in a single mood, and with such self-evident taste, that it has precisely the feel of a masterpiece made to order that Balanchine works sometimes have.

Counterswarm, set to music by Ligeti, seems like a cross between Robbins's *West Side Story*, Petipa's *Le Corsaire*, and Doris Humphrey's *Life of the Bee*. The swarms in question are two: a red one and a purple one, whose head couples fight in varying insecty ways; the creatures move like wasps and put their hands on their collarbones like the pirate in *Le Corsaire*. The space age harem costumes by Santo Loquasto underline the latter thought, and the movement is like nothing ever seen by human eyes. *A Musical Offering* is another "strange" work. (Taylor has been quoted as saying that he makes two kinds of dances: pretty ones and ugly ones.) The project suggests Robbins's *Goldberg Variations*, the movement suggests the Frankenstein-like lurchings of paper dolls with interspersed Pharaonic crossings of fisted hands over chest, and the costumes suggest Roman centurions. The movement invention is staggering (especially in Gillis's solo) and the viewer is left wondering just where Taylor gets his ideas, and why we are so lucky as to be alive when he is putting them on the stage.

Washington DanceView 1988

Toward a Theory of Taylor

SOMETIMES THE WORK OF A LESSER choreographer can illuminate the work of a greater one by exhibiting in more evident and less complex form a pattern that had to compete for our attention in the more important work. For me, in particular, it was a recent program of pieces by Jawole Willa Jo Zollar and her group Urban Bush Women at the Kennedy Center's Terrace Theater that formed the mental mold into which Paul Taylor's 1994 spring season in the Eisenhower Theater, suddenly, and somewhat surprisingly, fit. And this, in turn, abruptly caused a precipitation of the hitherto inchoate reactions I had had during two decades of Taylor watching.

The striking thing about the Zollar works on this program was that virtually all of them offered mimetic situations of a time and place in the real world in which people were (nearly) dancing: the playground, Rastafarian rituals, girls being silly in the dorm on Saturday night. We saw a community both on the level of the signifier (the dancers on the stage) and the signified (the quasi-real dance situation they mimed). These two layers of togetherness rubbed together and kept the audience cozy, producing a palpable warmth that oozed off the stage and wrapped itself around us.

A month later, at the opening program of Taylor Company's D.C. season, I felt myself caught in a déjà vu. Once again I saw the stage filled with young people dancing for each other as well as doing the piece, boys and girls giving each other big grins as they sailed by, interacting by forming the relentless clockwork intertwining of patented Taylor moves (head-bobbing arm swing, one-leg-crooked-and-arms-in-a-lyre pose, rock-a-girl-on-each-hip), and obviously loving every minute of doing so. Here too the warmth of the implied world of people enjoying dancing suddenly seemed central, so that, even though I could not identify what I saw as (say) boys and girls on the playground, I was just as sure as I had been in the Urban Bush Women concert that what I was seeing was at least a theatrical version of a window on the world.

The particular program-opening piece that produced this reaction was *Mercuric Tidings*. I knew that when *Esplanade,* the program's closer, rolled around, I would see people delighted with their own wit as they marched busily onto the stage and changed direction at right angles, jumped over one another, flung themselves into one another's arms, and grand jetéd across the stage with huge smiles, eating up the air. And it was the connection between these book-end works that encouraged my thoughts in a schematic direction, toward defining what is present and what is absent in the best of Taylor's works.

Both *Mercuric Tidings* and *Esplanade*, I thought, are members in good standing of what we might call Column A of Taylor works, the pretty ones. Into this category fall such pieces as the early "barefoot ballet" *Aureole*, the more recent and very swoony *Roses*, as well as *Arden Court* and virtually all of the others that people immediately mention as being among Taylor's masterpieces. Column B of Taylor's works is the flip side of Column A, containing the ugly ones: things like *Speaking in Tongues*, *Last Look*, *Danbury Mix*, or *Big Bertha*. There are, in addition, Column C works, the witty ones: *3 Epitaphs*; *Cloven Kingdom*; *Lost, Found, Lost*, as well as the Column D ones, the movement-premise ones, the ones that look like a precocious child's game of "what if." What if people couldn't use their arms to interact (*Counterswarm*)? What would it look like to have full-sized men do a whole dance while squatting, playing dwarves (*Snow White*)? What would it look like if the people on a Grecian urn stepped off, or a Minoan snake goddess came to life (*Images*)?

Of course, we not only murder to dissect, we also distort through schematizing, useful although this may be for setting our thoughts in order. Not all of any given Taylor work will necessarily fall under a single rubric,

and there may well be critical disagreement regarding which column a piece principally belongs in. Part of *Spindrift* is a movement-premise work: what if people communicated using as phonemes bits of dance movement? (It made me expect a future work in which Taylor exploits this premise even further, showing us people "growing up" by speaking words, then phrases, then whole paragraphs.) This piece is also, during this very section and because of the premise itself, a witty (Column C) work. It is, furthermore, at times an ugly (Column B) work—people are mean to each other—as well as a pretty (Column A) one, a celebration of community. (To give my vote, I think it's primarily Column B.)

Still, if *Spindrift* is all these things, it is so at least separably, and the taxonomy, or one like it, remains useful. For despite overlaps and gray areas, the striking thing about Taylor's *oeuvre* is that so many of his works do fall so neatly into distinct polar groups, with the greatest distance being between Column A and Column B above, the pretty and ugly pieces. Although we enjoy all of the columns, I think I speak for more than myself in saying that we love the pretty ones.

The movement vocabulary for these pretty works is, as I suggest, fairly well set. We know a "Taylor" movement when we see it, just the way we know a "Graham" movement. I mean here the movement of, say, *Arden Court* or *Mercuric Tidings*. But the interesting thing is that this kind of movement functions for Taylor—unlike Graham with her equally distinctive movement—merely as the "high" version of the choreographer's language, like Tuscan Italian, or Hanoverian German, rather than being simply what comes out when the person opens his or her choreographic mouth. It is in this language that the exulted things are expressed. Taylor can express less than exulted things as well, but indicatively enough, these always come out in another language, or rather many languages, what we might call movement dialects. Nearly every one of those Taylor pieces (usually Column B) at which we turn to the person next to us and say, "Wasn't that strange?" is a new dialect. Its movement vocabulary is discernibly different, it's not pretty, and Taylor tries each one only once. They're his party tricks, his funny accents.

The original title for T.S. Eliot's *The Waste Land* (taken from Dickens, apropos of a character in *The Pickwick Papers*) was *He Do the Police in Different Voices*. The interesting thing about Taylor is that, like the ventriloquist Eliot (who implicitly quoted from so many sources we're still seeking to identify them all), he do dance in different voices. But he never confuse(s) the panoply of these different voices with the "high" version of his

choreographic language to which he returns again and again. The sense of togetherness of a signified world that suddenly seemed so strong in the Eisenhower Theater is characteristic only of Taylor's pretty works. What we see is not merely dancers dancing on a stage. Behind this we see the suggestion of a real world in which all people are young and athletic and like to dance. The implication, moreover, is that this world of togetherness in motion is a real one, a continuous world glimpsed through the window of the individual work that can, in the next work that functions as a window upon it, be glimpsed again. We believe in his world of happy young athletes who like being together.

I think it is some form of this togetherness—what I was calling "warmth" at the Urban Bush Women concert—that generates the intense love many of us feel for Paul Taylor. We enter into the fantasy that there is a world in which these things are the case, just as we enter into the fantasy of a Hollywood film that there is a world, otherwise like our own, in which everyone is sexy and does exciting or dangerous things.

The reason we love Taylor is not that he's so inventive, or so funny. For his inventiveness we admire him; for his humor we laugh with him. We love him, however, because in his pretty works, those in the "high" dance idiom, what he's giving us is an implied world in which men and women relate to one another in movement in certain ways that we find appealing.

It is rare to pull off such a feat of constructing two layers of community defined by motion (signifier and signified, dancers and people dancing) that reinforce one another. Nineteenth-century story ballets, at least the ones that have survived, don't offer a continuously signified movement world, even when they about dancing, like *Giselle*. Instead, they offer a series of different mimetic worlds, defined by the same sort of movement. (In Zollar's works, the mimetic worlds are different, and the motion we see is so too: both the signifier and the signified vary.) Most Cunningham works give us only bodies moving—the layer of signifier. Sometimes, of course, we can see hints of reference to a mimetic world in Cunningham; more usually we just "bring our own." But because these are fleeting—and virtually non-existent in the works of, say, Trisha Brown—the pieces do not seem for us windows on a constant world of movement, and the two layers do not set up the reinforcement effect we see in Taylor. In Graham, the mimetic world is only rarely about people moving (and when it is the result is slight, as in *Acrobats of God*, or ponderous, as in the early parts of *Acts of Light*). Moreover Graham, although she had her lighter moments, did not do choreographic dialects. Everything is the same vocabulary.

I'd say that Graham, in terms of Isaiah Berlin's famous dichotomy, is a hedgehog rather than a fox, someone who produces variations on the same idea. Taylor may seem a fox by contrast: someone who does many different things, depending on circumstances. But he isn't really; he's a hedgehog at the center too, namely in his Column A works. He defies the dichotomy, in fact: he's both fox and hedgehog.

To find a phenomenon even roughly comparable to Taylor's achievement, we must look at the less plot-driven moments in the ballets of the classical or neoclassical masters, working in a received idiom that they fashioned to their own ends: Bournonville, Petipa and Ivanov, or Balanchine. Of this list it is Balanchine whose works, because of their relatively greater focus on the movement at the expense of other mimetic factors, give us most intensely the same sensation as with Taylor of being offered a window onto a continuous and independently existing world defined by bodies in motion. In Balanchine, as in Graham, each work is in a sense too interesting in itself: the window is less transparent than in Taylor, and has too much of a surface of its own (too much, that is, to allow lucid perception of this mimetic world). Although we can talk about the athleticism of the dancers in Balanchine's works and the way men and women relate, these seem more ancillary issues than they do in Taylor, a means to an end rather than the end in itself.

In some profound way, we are seeing in Taylor's pretty works not only dancers who happen to be twenty-one years old because that's the best age for dancers. We are seeing twenty-one-year-olds dancing with each other. An older person on the stage in Taylor would break the sheen. It would not do so in, say, Balanchine, because in Balanchine the dancers just happen to be twenty-one, rather than being necessarily so. Their relationships with each other are complex, adult relationships, so their precise age is irrelevant. (The *Agon* pas de deux needs youngish people to be this flexible—or Allegra Kent at any age—but it's not kid stuff.)

It says something about Taylor's importance that in order to get a suitable figure to compare with him in this way, we have to evoke the century's greatest choreographic master. Yet the bad news is that, precisely because there are certain similarities between Balanchine and Taylor, we get a sense of how Taylor (perhaps not unsurprisingly) comes up second best, or even, behind Graham, third. Or more importantly (rankings being not only old-fashioned but counterproductive) we begin to understand why this is so.

My thought here was given form by Keats's "Ode on a Grecian Urn," which I had been teaching to freshman only the week before. The narrator in

the "Ode" looks at an urn and considers the advantages and disadvantages of the scenes it portrays. A young man is playing a pipe beneath a tree, and will do so forever. The trees beneath which he sits will never be bare; a young man chasing a girl will always be only a step away from a kiss, which he will forever desire, caught for eternity in the delicious moment of anticipation. The love of these people, in fact, will be "forever panting and forever young"—by contrast to real life, where, according to the poet, passion leads to "a heart high-sorrowful and cloyed,/ A burning forehead and a parching tongue." In real life, that is, we can achieve the goal of our desires—but the result is that we're made sick precisely as a result of getting it.

Taylor's world, I realized sipping my wine in a pliable plastic goblet here in the promenade of the Kennedy Center (invaded by yet another group of noisy Boy Scouts on tour of the sights in the Nation's Capital and gawking at us culturati—Look, boys, real concert-goers!—as we looked accusingly back at them), is an urn world. Some of his works are blatantly so: *Roses*, for instance, is about love set in the mode of midsummer with no hint of fall, the aging process, or satiation of desire.

Of course, what I'm characterizing are the allegro movements of these works. The slow movements (the adagios from concerti or actions on the edges of other works) are sad, and some works (like *Sunset*) are so in even larger chunks. To return to the schema, we may call them Column A'. They are the flip side, the Janus-face, of the Column A works, one side implying the other. The form the sadness takes in Taylor is consistent with the sadness of the urn world. People long after other people, who are uninterested in them, or who leave. Think of the recent example of *Company B*, or of the strange mismatches in the slow movements of *Esplanade*. The flip side of being eternally in love is being eternally out of love, eternally longing. Taylor's sadness is the logical contrary of his joy. Both are urn emotions, and taken together they still leave out a great deal of what we know to be reality.

Esplanade, which closed the program after I had drained my drink to the bottom of the goblet, whose transparent plastic foot fell off into my hand, and bid the Boy Scouts adieu almost served as a primer for my point. Either the people are being buoyant and young, full of trust and love and joy, or they are longing to connect, longing to join. The attempt of the half-naked arrival in *Spindrift* (on the week's other program) to belong is emblematic as well. People in Taylor want to be with others, either a collective other, or

one individual other. If you don't achieve this, that's sad, in the same way that unrequited puppy love is sad, or the end of senior year in high school.

What's missing in these Column A (or A') works is what Keats conceived of as human (as opposed to urn) passion: passion that actually gets its goal and ends in weariness, or that is satisfied and requires the person to go on to other things. Taylor's "pretty" works are so beautiful precisely because they take as something close to their primary content this urn-love, along with its logical contrary of loss or unconnectedness—and completely avoid the more terrifying, and more mundane, truth that frequently we do get what we want, and have to admit that it wasn't worth the trouble, or that now we want something else.

We love Taylor because he gives us entrance into an urn world. He lets us all be Keats's narrator at the beginning of the poem, before this narrator starts to list the reasons why we can never actually enter this world of the urn, still caught in desire. The more impossible the thing we ostensibly desire, the more intense our sensation of desiring it. In just this way, I think we desire Taylor's world. It seems possible for us, but isn't really. That's why we love it—and by extension, its creator.

I've been emphasizing the unisex pleasures of this urn world. All its denizens are beautiful; all like climbing over each other, or catching each other, or showing off for each other. Yet I think there is another reason that many of us find Taylor so appealing. He gives us bipolar gender roles that, despite all our sexual liberation and political correctness, I suspect many dancegoers of whichever gender and whatever sexual orientation still believe lie under the surface of the world.

In Column A works, the boys are full of beans, and the girls are sassy. When the boys are with boys, they cavort and show off to each other. When the boys are with girls, the girls turn kittenish, the boys protective and manly. The movement Taylor gives the men is often heroic: all those lion-like leaps, those wide chests, the upper-body lyres with a half-twist in the waist to minimize the butt like poses in fitness magazines, the way women crawl up mens' bodies and nestle in their chests.

It's not that the women are always in thrall to the men, or have a humdrum movement palette. The women can be peppy, lyrical, intelligent. But we never get the sense in Taylor that we get in Balanchine that, as Balanchine is quoted as saying, "ballet [or modern dance] is woman." In Balanchine, the man shows off the woman. In Graham, the man tries to crush the woman. In Mark Morris, genders blur, or are kept apart by main force in cartoon-like versions of polarity. In Taylor, the man shows off for the

woman, that is, when he's done showing off for the other guys. Women are a fine distraction in Taylor's world, we think, but men would also be okay without them.

Taylor's mimetic world exhibits the same gender-polarity as the routines of cheerleaders at football games. It is certainly no accident that Taylor is one of the few contemporary choreographers to attract viewers outside of the normal dance audience. His view of men—strong and graceful; protective and at the same time utterly in charge—is, I think, valorizing to many mainstream men and attractive to many women.

Taylor showcases male physique as a way of sharpening the bipolarity of gender roles. His men look good to begin with, and he moves them so that they look even better. His choreography flatters his male dancers' bodies the way the camera flattered Marilyn Monroe. (It does not similarly worship the women, although it does frequently spotlight them.) In Taylor's choreography, male muscles matter. As my students at the U.S. Naval Academy tell me constantly, men are different from women in that men can bench-press more, a fact signaled in shorthand by their more massive chests. They have stronger legs too, with the result that they can get over higher hurdles on the obstacle course. Taylor too treats physique as a shorthand for difference in action, the action which defines the world that we're being invited into.

Still (or do I mean "therefore"?), the world of these works is pretty. And of course, it's a lie. To be sure, all art is a lie in the sense that it's an idealization of something, even if only in the act of greater importance conferred upon it by our attention. More to the point, because the mimetic world that Taylor's Column A works offer is right there on the stage, it is presented to us as real. Of course we find our own lives drab by comparison, and ourselves to boot—that's the point, the reason that the works function as fantasies. (By contrast, we never conceive of the world of Balanchine's works continuous after the work is over, or being something we could enter.)

Taylor's pretty works are seductive. But, at the same time, I found myself willing to admit for the first time that I find them the least bit tiresome. Perhaps it's because all of a sudden I'm within spitting distance of forty. Sitting in the theater and seeing that I'm being invited once again to take a peek through the window at this world of gamboling youths caught in the high sun of endless summer or dejected in the melancholy of dawning autumn, admire these athletic and courtly boys and indefatigable and kittenish (if sometimes momentarily stymied) girls or their sad-face twins, I wanted to excuse myself and go read Baudelaire at his most splenetic.

Probably somebody who him- or herself is caught in the haze of love and power of young adulthood is too young to really love Taylor's pretty works. Suddenly I wonder if I'm not too old. Or should I wait twenty years and try again, at which point it would seem mere fantasy? Maybe our reactions to Taylor go in age cycles.

Which brings me back to the observation that Taylor works polarize into pretty and ugly, "high" works and dialect ones. We can see why—it must be tiresome to visit so often this so perfect, so beautiful (and so impossible) world. There's something a bit stifling about this "high" language. And the result is the witty or movement-premise pieces that get the mischief out of Taylor's system long enough for him to go back and make yet another piece about urn love.

Finally, of course, Taylor's world-view is not found in any one work. Instead each of his different clusters of works gives us one facet of the story, rather than the story as a whole—and so falls slightly short of being the transcendent masterpieces it might be. What, I wondered, would it be like for Taylor to offer a world in which some of the ugliness that swells to such brutal stylization in the Column B works could enter the Column A ones, possibly in the form of an acknowledgment of the disappointment of achieved desire, rather than being frozen at its peak or thwarted? This would be so unlike the Taylor we know and love we can't begin to say what it would look like.

New Dance Review, 1994

Keats, Taylor, and the National Gallery of Scotland

LEARNING FROM ART ISN'T THE SAME as enjoying it. I first realized this several decades ago on a browse through the National Gallery of Scotland, which is a nice little museum that seems to consist of one minor example of everyone you've ever heard of. The experience was rather like getting a thali in an Indian restaurant, a big plate with tiny tastes of everything, a condensed version of the much longer version of the same text I'd laboriously worked through in Washington's National Gallery and the Louvre: a bit of Renoir, a few Dutch interiors, a *soupçon* of English eighteenth-century portraits.

I enjoyed that afternoon in Edinburgh, but I didn't learn anything from it. All it did was confirm what I knew already, tell the same old story of the development of Western art that's told all over. Perhaps I was a bit disappointed. Regional museums (I suppose the Scots would be horrified to hear themselves referred to as "regional") frequently have a slightly different take on things, and hence do tend more consistently than the standard large capital-city galleries to be interesting, in this technical sense. You go to Stuttgart to see Swabian masters, for example, or Toulouse-Lautrec in Albi, or the entire Sienese school in Siena. You can learn things in major galleries too, because there you'll find (say) the religious works of a painter not known for his religious works, or the early works of another that are stylistically at variance with the works of his maturity. You can't learn anything from a museum, however, that's just trying to tell the same story as everybody else, only with minor paintings.

You can learn or not learn things at dance programs in a similar way, I reflected after the luminous March 1-5 performances by the Paul Taylor Company at the Kennedy Center. The programs included some masterpieces: *Brandenburgs*, *Company B*, and *Dust*, a dollop of frippery, *Offenbach Overtures*, and two new works, the insubstantial "Indian" piece (actually more Southeast Asia) *Prime Numbers*, and the drenched-in-nostalgia *Eventide*. The new pieces were the draw; in fact I was looking forward more to *Brandenburgs* and *Dust*, the second of which I had somehow never seen.

I went away thinking again what a great choreographer Taylor is, and I enjoyed seeing all the new dancers in the company despite the absence of the old stalwarts. But the fact of the matter was that I wasn't really very interested by either program. I'd seen beautifully performed masterpieces, but I hadn't learned anything that I didn't known before. Once again I thought of Keats, this time his "Ode on Melancholy," to explain the relationship between the two emotions, sunny and sad, that are the Janus faces of Taylor's "high language" Column A pieces.

The presupposition of the "Ode on Melancholy" is that we should want to taste melancholy, and so must seek it efficiently. The paradox of the poem is that melancholy is best tasted not in negative, shadowy, things, but in sunny ones. When the melancholy fit falls, the poem's narrator tells us, we should "go not to Lethe, neither twist/ Wolfsbane . . . for its poisonous wine." We may think we'll find a cognate to our mood in these things, but in fact they are too strong. They "drown the wakeful anguish of the soul" that is necessary to sensing melancholy. Instead, we should "glut [our] sorrow on a morning rose" or "feed deep" upon our mistress's "peerless eyes." For our

mistress "dwells with Beauty" which, as the narrator points out, "must die." The perfect rose is teetering on the edge of rottenness. The hand of Joy is "ever at his lips/ Bidding adieu." The greater the perfection, the more imminent its dissolution.

This is the nature of Taylor's perfection, and of his melancholy, his pretty pieces, and his sad ones, A and A'. He shows us the perfect rose, over and over, and then hints at consciousness of its transience, which is expressed as melancholy. Usually in Taylor the melancholy is expressed by not having: not having a partner, that is, or by failing to connect. From the point of view of choreography, however, the problem with trying to evoke this melancholy is that it lacks what T.S. Eliot called an "objective correlative" (he was explaining why "Hamlet" was actually, despite centuries of adulation, a bad play). We are melancholy in a state of perfection because of something we know, not because of something we see, something understood rather than something there before us. We see that the people aren't connecting, but we haven't the faintest idea why.

Which may explain why I was so impatient with *Eventide*. All that Vaughn Williams steeped-in-brandy viola music (*Suite for Viola and Orchestra*), the sepia-tinted rustic lads-'n-lassies scrim by Santo Loquasto that positively screams nostalgia, even the work's title—all those lovers walking and parting at end of day. Here everybody has a partner; the problem is not in their actually losing the other but in knowing that they will some day lose them, through death or old age if nothing else. How quickly I tired of it, learning nothing about Taylor that I hadn't known before: his high-language alternative to delirious joy is bottomless sadness, and this for no visible reason. *Why* can't these people be happy together? We'll never know. At least in most of the works we can see that the boy athletes aren't getting the girls (or recently, the other boys: *Company B* comes to mind), although that's always the end of the line. We don't know why, and are supposed to think it sad. In *Eventide* we saw pure melancholy, like trying to put a fear of the dark on the stage, evening used as a metaphor, as so often in art, for old age and death.

I sat there at the concerts checking off the columns. *Eventide* was a one-note dance from Taylor's color pot labeled "longing," which is to say A'. *Dust* was one of the strange tangled I-don't-believe-I'm-seeing-this-and-it-was-all-so-complex-I-want-to-see-it-again-right-away dances from Taylor's Column B. *Brandenburgs* was more happy people, Column A in the sunny mode. (Having just seen the Australian production of *The King and I*, I think

of *The Small House of Uncle Thomas*, which introduces the "happy happy people" of Uncle Thomas, Topsy, and Eliza.)

I know how ungrateful I sound. Taylor is one of the masters of the age, and it's a joy to watch his dancers move. Usually it's a joy to watch his works, certainly when they're Column A. The sad ones are sad, and the weird ones are unfailingly inventive. In this *fin-du-vingtième-siècle*, this is as good as it gets, and it's pretty good by anybody's standards. I can't say that Taylor has lost his touch, or that he's repeating himself. All I can say is that nothing I saw, even although most of the works were new to me, changed the topographical map of Taylorland in my head. In short, I didn't learn anything.

DanceView 1997

FranceDanse: Oui Merci

THE KENNEDY CENTER OPERA HOUSE was draped with bunting for the opening night of the Center's much-publicized French Dance Festival, FranceDanse (March 16- 28), and the planters up and down the hallways sported pairs of the tricolore, stuck in the dirt with the tree roots. French seemed the language of choice among audience members at many of the events, and a pleasant air of cosmopolitan artistic excitement hung over all.

The keystone company was the Paris Opera Ballet, which took over the Opera House for Wednesday to Sunday performances both of the Festival's two weeks. Its first program was a mixed bill of French works from the 1940s, including two works by Serge Lifar unknown to most American viewers, *Icare*, Icarus, and the plotless *Suite en Blanc,* Suite in White.

At first viewing, at least, *Icare* seemed a piece of overblown silliness from the same school of hothouse French narcissism as the contemporaneous works of Jean Cocteau, a dated piece that has hung around simply because the dancer in the title role gets to be lithe and on stage a lot. The title role was danced, in the March 21 matinée I saw, by the troupe's director, Patrick Dupond, who was required to look like a combination of a Hopi medicine man with his attached arm-wings and the Bluebird from *Sleeping Beauty*. (His costume revealed the fact, as a woman with binoculars in front of me discovered, that he has a blue star tattooed on his left shoulder. The mark of the *étoile*?)

In the original myth, as recounted by Bullfinch, Icarus and his father Daedelus were shut up in a tower by the King of Crete, for whom Daedelus had built the famous maze of the Minotaur (in French, *dédale* means "maze"). The father fashioned wings of wax and feathers for both himself and his son so that they could escape. Icarus, less careful and perhaps buoyed by youthful pride, flew too close to the sun, and fell to his death as the wax melted. Lifar eliminates the father's wings, and the tower. Icarus is taught to fly, but simply because he is in love with flying—Icarus, therefore, as Romantic artist, following his muse.

He starts off playing with a bow and arrow, clearly fascinated with the arrow's flight; Dad shows him a bird (a dead one), which gives him other ideas. From there, Icarus graduates to his own wings, which he must learn to use; as if riding a bicycle, he flies and falls, and has to be dusted off and set on his way again. The metaphor is close to the surface here: to fly is to dance. Lifar, it seems, denies Icarus any more immediate reason for his obsession because it's supposed to be self-evident. Furthermore, to dance is to live. Trouble is, to dance/fly is to die as well. *Giselle* in short form?

Despite Dupond's convincingly Apollonian appearance and movement (a little trouble with the elevation nowadays, perhaps), the pony-tailed girls in the over-the-shoe leotards and the thumping group of boys seemed merely silly. Another choreographic problem: how to show flight? Lifar's solution: Dad merely looks offstage and follows an arch with his eyes, like Prince Siegfried looking at the swans. Icarus arrives back at the roost by sliding down a ramp to the stage, and conveniently comes back to the stage for the final crash.

The program's closer was the pure dance *Suite en Blanc*, which opens with a breathtaking arrangement of white-clad dancers in front of a black scrim and up the stairs and walkway of a low black balcony. It was beautiful, but brittle, a bit like a Cecil Beaton photograph. A program essay by Arlene Croce emphasized the piece's kinship to Balanchine's *Palais de Crystal* (known to New York City Ballet audiences as *Symphony in C*, and made for the Paris Opera Ballet at about the same time as the Lifar), but there is more musicality and interesting movement in any two minute portion of the Balanchine than in the entirety of *Suite*.

Critics around me spent the intermission speculating on what might at one point have tied the piece together, such as particular dancers given steps characteristic to them, or references to repertory. At this distance in time, however, the piece seemed like soulless neo-classicism, mere steps to fragments of movement—a Parisian version of the Danish *Études*. As a

vehicle for the company's superb men and impressive women, however, the
work was a hit.

The Lifar pieces sandwiched an early offering by Roland Petit,
astonishingly polished for a 23-year-old, the absinthe-and-fate ballet *Le
Rendez-vous*, The Meeting, complete with a scratchy night-club song *à la*
Piaf and seamy photographic back-drops by Brassaï.

Its plot conceit, by Jacques Prévert, was as swooningly silly as that of
Icarus. A young man's death at the hands of "the most beautiful girl in the
world" is foretold in a horoscope, after which a white-faced figure in tails
and a stovepipe hat forces the young man to accept a razor. In the final
scene, a woman with incredible legs and a Louise Brooks hairstyle, who
suddenly appears to him on the street, slits his throat. With its opening
number in a dancing hall, *Le Rendez-vous* seemed like a French version of
Jerome Robbins's street ballets mixed with Anthony Tudor's city-gritty
Undertow, from a few years earlier, seen in the recent Kennedy Center run
of American Ballet Theatre (in *Undertow* the boy kills the girl). It was
impossible to take the girl seriously after having seen Gene Kelly and Stanley
Donen's fabulous sendup of this sort of character (complete with hairstyle)
in the "Gotta Dance" sequence of *Singin' in the Rain*—the gangster moll,
danced by Cyd Charisse.

A bit hysterical, all this, but somehow (if you're in the right mood),
sublime. Ah, la France. Or at least, la France of mid-twentieth century.
Another France, purportedly from the late eighteenth century, was on display
in the "original" version of the 1789 ballet *La Fille Mal Gardée*, The
Badly-Guarded Girl, known to most viewers hereabouts in the version by
Frederick Ashton. The director of the Alsatian company Ballet du Rhin
(Ballet of the Rhine, as in the river), Jean-Paul Gravier, and the Swedish
choreographer Ivo Cramér have gone back to an annotated continuity found
in Stockholm to produce what they are claiming is the first version of this
venerable and much-worked-over piece.

As always, claims to be offering the "original" of anything in dance
simply set scholars nit-picking; this production was no exception. Some
critics felt the kicks were too high and the skirts too short for it to qualify as
"original." The music is pure conjecture, and of course the costumes—as
well as the precise steps—are merely "in the style of." Most audience
members, unworried by such scholarly trivia, wanted to judge the production
based on its look and effect. As one audience member listening to the initially
rather tepid response from others, I would call the result a qualified success.

The eighteenth-century tunes that made up the music—canned, in the Eisenhower Theater's production (and indeed, what orchestra could stand playing this pleasant drivel night after night?)—started and stopped, as did the action, the dancers frozen in postures for applause that never came. A good deal of the movement seemed like rarified social dancing: square dancey type things for the peasants, for example. The wooden chickens on strings were several shades less witty than Ashton's human-sized dancing chickens in clogs.

The costumes and make-up were an uneasy mix between stagy and realistic. Only at the end where the cast lined up at the footlights to give the moral—*Il ne faut désespérer de rien, il n'est qu'un pas du mal au bien* (Don't despair, between a bad situation and a good one there's only one step)—with their heavily made-up faces in the flat lighting, could I sense the attempt to give the "feel" of an eighteenth-century production, like Ingmar Bergman's Drottningholm Court Theater film of *The Magic Flute* (where the moral is delivered in a similar fashion). The fact is that post-Romantic ballet, with its toe shoes and its greater elevation, offers more interesting movement than this, so that what we were asked to look at seemed boring. And if the audience's heart was ultimately won over, as it seemed to be, I think this was simply from seeing the young lovers outwit the oldsters. The production was not enough of a period piece to seem charming for that reason, and not enough of our time to fly on its own.

Where were the moderns in all this? Very much in evidence. The festival opened on March 16, in fact, with the Marseilles company Plaisir d'Offrir (Joy of Giving), offering a wittily entitled piece by Michel Kelemenis, the company's director: *Cités Citées*, Quoted/Mentioned Cities. The program notes spoke of the movement having relation to specific geographic places, but this seemed like so much misleading window-dressing, or intention falling short of act. We saw what looked like an ongoing conversation between the dancers, carried on in semi-street-movement vocabulary, a seamless suite of repeated interaction situations for various combinations of the group.

Their contact was between humans (always a plus as far as I'm concerned: I don't like seeing dancetrons). They smile at each other, look one another in the eye, and pair off in gender-various couples. The vocabulary of their communication isn't spectacular: they clap, they look at the audience, they jump. They like each other, and they're getting on with their lives, making contact in a language that we simply aren't privy to. As a result, it was difficult to get too interested, the way you never get involved in something half out of earshot; but on the other hand you couldn't look away.

It reminded me of reading Gertrude Stein, or listening to the radio set between stations. I liked the sensation, but I'm not sure my reaction had anything to do with what Kelemenis intended.

The two contemporary offerings of the second week were less gratifying. (I missed the program by the Compagnie De Hexe/Mathilde Monnier which presented a piece by Monnier on March 19 and 20 called *Je ne vois pas la femme cachée dans la forêt*, I Don't See the Woman Hidden in the Forest.) The set was the most interesting feature of the Compagnie Preljocaj's *La peau du monde*, The World's Skin (March 23 and 24)—choreography by Angelin Preljocaj—a narrowing slope of curving tan ridges across the back of the stage that did in fact suggest the sand dunes to which the program notes referred. The cast appeared behind the dunes, slid down them, and used them for the most interesting image of the evening, one continuous line of people striding in silhouette from right to left while others pushed themselves across the floor in the opposite direction on their backs, seemingly infinite in number in an unbroken chain. Otherwise the movement, which included a lot of stamping and which reminded me of the reconstructed Nijinsky *Rite of Spring*, seemed random as well as dull, and the pretentious program notes having to do with horses and centaurs and the transformation from one to the other (say what?) were as much a mystery as the movement.

The last company to appear at the festival was the Compagnie Bagouet from Montpellier, which presented two pieces, *Les petites pièces de Grenade*, Little Grenada Pieces, and *So schnell*, So Fast, by recently-deceased choreographer Dominique Bagouet, in a program on March 26 and 27. I stayed only for the pre-intermission fare. It made me angry, and I was too afraid that after the intermission things would seem simply *so langsam*, so slow.

Angry, that is, because the work was afflicted with the same overblown posturing that affected many of the festival's offerings, the same cult of *génie* and *gloire* that (I would say, essaying a generalization) typifies far too many artistic products of the Continent nowadays. Here this posturing took the form of impertinence. Unbelievable, I thought, that we should be expected to get dressed up, drive into town, park, and sit in our seats to see a group of people do squiggly random gestures. Street movement is more interesting. There were what seemed contact situations in the dance studio: two dancers neck a bit stage right; a handful of dancers sit on the sidelines and watch someone do a solo. A few dancers do fast-fast gestures in front of other dancers doing slow, sinuous movements, and then join the ones doing the sinuous movements. The movements were funny. The dancers' faces

twitch, their arms flop. But why should we be watching them? Or more specifically, why should we be watching these dancers do these particular things? Here, the fact of attention comes first, as a given; the question of whether the piece deserves our attention is secondary.

I left wondering if this were not at least partly an effect of the French government's generous support of choreographers, offering a degree of financial security of which Americans can only dream. Bagouet's company, for example, works at the Choreographic Center of Champigny-sur-Marne and Val-de-Marne, one of the dozen nationally-funded Choreographic Centers established across the country. Bagouet's kind of squiggly minimalism, whose only unifying factor seems to be that it expresses his own sensibility, seems too close a kin to countless similarly "cutting edge" opera and theater productions I've seen in subsidized houses across Germany and France. Because the production of the work itself is a given, all the "creators" have to do is fill a pre-existent frame, not craft pieces that stand on their own. The result is frequently a kind of empty, rather jaded avant-gardism, dependent for its very existence on that financial and social structure whose solidity it scoffs at.

Of course, many American ensembles of the "downtown" sort, living perennially on the brink of starvation, produce products that are just as vacuous. On this side of the Atlantic, however, I think the vacuity (or more often nowadays, stridency) is due to the fact that our alternative artistic culture is so rarely forced to get out of its own head—it's so marginal. On the Continent, by contrast, we see the bizarre spectacle of the institutionalized avant-garde—a Joseph Beuys, for example, with his vitrines full of burlap and fat, who drew a hefty salary at the State Art Academy in Cologne. The effect, at any rate, is the same self-indulgence on both sides of the Atlantic, here because the art is so marginal, there because it's subsidized.

Or maybe I'm wrong; maybe it's simply because there aren't enough good choreographers to go around. As virtually all the performances showed, the world is full of really good dancers. Now if there were only people with good ideas about how they should move.

None of which touches what was clearly the festival's artistic highlight, namely the last act of Rudolf Nureyev's staging of Marius Petipa's *La Bayadère*, originally from 1877, which formed the second week of the Paris Opera Ballet's repertory. (The opening night started with a brief tribute to Nureyev, who died last year, by Kennedy Center Board Chairman James Wolfensohn.) Although Nureyev is credited with choreography "after"

Petipa, it would be more accurate to speak of Nureyev's editing and presentation job. Few surprises here: Nureyev has preserved virtually all of the accreted layers of the many *Bayadère* productions, with very little of the major tinkering and re-conceiving that marked his version of, say, *Swan Lake*. (The program notes, listing these layers, were superb.)

The last act is the famous *Kingdom of the Shades* sequence, which has been presented in the West since Nureyev first mounted it in the early 1960s, and which contained more real dancing in its fewer than thirty minutes than the entire rest of the festival put together. Thank you, Marius Petipa. Thanks are due as well to the "technical limitations" (so the program) that prevented Nureyev from staging the original ballet's subsequent closing act (absent from virtually all productions save the original) in which the temple falls down.

The problem with this ballet is that it consists of a single sensational "white" act surrounded by a handful of others drowning in their own syrupy exoticism. We have been well served by those kind souls who simply excerpted the one good act and forgot about the rest. Sure, it's fun seeing what the whole thing looks like, although the Kirov brought its version a few years ago to Wolf Trap, and Natalia Makarova put on a much re-arranged one on Broadway. But it's just not viable as a full-length ballet, at least not in the West in the 1990s. The story lacks a dramatic center, without the integrity and weight of *A Folk Tale*, *Swan Lake*, or *Giselle*. The story is simply ridiculous, too much a pastiche, even in its own time (the prince is in love not with a swan, but with a temple dancer; his fiancée has the dancer killed with an asp rather than letting her go mad). I kept waiting for the Marx Brothers to pop out from behind a scrim. Worse, the choreography isn't there: the first act lacks compelling numbers, except for the embarrassing knife dance by the half-naked and turbaned "fakirs"; the wedding divertissements in the second act are largely uninteresting except for the traditionally interpolated Dance of the Golden Idol. Of course, a really hip critic could explain to us why pastiche, a favored postmodernist form, is right at home in the 1990s—why *La Bayadère* is so bad it's good. But here it wasn't being presented as camp, and sitting through it isn't the same as theorizing about it at home.

The good news is that it all looked sumptuous (decor by Ezio Frigerio), and was danced as if it really was a masterpiece—the night I saw it, by Laurent Hilaire as the Prince Solor, Elisabeth Platel as his spiteful fiancée, and Isabelle Guérin in the title role. Yet silliness it remained, with its salaaming courtiers, its "Negro" children clad in brown woolen underwear

and ski masks, its romantic triangle with the "Grand Brahmin" just as infatuated with a lowly temple dancer (in actuality, holy prostitutes in Hindu temples) as the prince is. Okay okay—so ballet, like opera, isn't supposed to make sense. After all, the women will always wear tutus and dance on their toes. Nonetheless, there is such a thing as internal consistency—which *La Bayadère* sadly lacks. This production did nothing to straighten out the mess.

A program note by Frigerio, as if to defuse the objections of the politically correct to its generic Eastern exoticism, warns us that he's set the work in a nineteenth-century dream of the Orient—that, in other words, it's not even trying to be authentic. You're telling me, I thought. (You don't have to be politically correct to look askance at this ballet, although it probably helps.) The prince is presumably a good Muslim boy; at least Dad, the Rajah, lives in a Mogul palace. Nonetheless, he's carrying on with a Hindu girl, and one of the lowest caste at that. But then again, the Brahmin priest is doing the same thing—which is not merely rare, but unheard of. And of course its very plot conceit, full of Western-style Romantic love and scorning of social boundaries, is simply out of place in (pre-modern) India—or even "India."

Then suddenly, after all of this nonsense, comes the dream of the *Shades*, here robbed of some of its ethereal air by the lush jungle sets in which the scene is played out and by a tempo that was perhaps a "shade" too brisk. Not that logic holds sway in this act either: the hypnotic entrance of identical white-clad dancers is a refracted replication of the Prince's now-dead love, a sort of Wilis of the mind. Notwithstanding, a white-clad version of the dreamer himself (in a later interpolation) dances with one particular token of the type as a character in his own dream, while the other cloned refractions look on from the sidelines. Don't ask. It can still be sumptuously beautiful and, as danced by the superb Paris Opera corps of women, was so. In short, sublime rather than the sublimely silly.

I left thinking, FranceDanse: oui, merci.

DanceView 1993

Balanchine at Opryland

OPRYLAND, THE HOME OF COUNTRY MUSIC, has once again played host to George Balanchine, the Master of American Classical Ballet. The occasion was the three-day taping of Balanchine's moody 1980 masterpiece, *Schumann's Davidsbündlertänze* with dancers from the New York City Ballet.

This was CBS's fifth taping at Opryland. The network's Artistic Director, Merrill Brockway, had also taped many of the nationally televised Dance in American programs in Nashville for the Public Broadcasting System.

For the dancers, of course, Opryland was just a television crew at the end of a plane ride. The conversation going on behind me was about whether they could get a 6:15 plane home, and what there was to see in Nashville. Andrew Johnson's home, someone thought. At least they got the initials and first name are right; in fact it's Andrew Jackson's. The two were very different sorts of presidents.

Perhaps such distance from the local culture is good. Certainly there seemed little connection between the lines of people waiting in the muggy September afternoon for Opryland rides and the twisting, emotional intricacies of Balanchine's ballet that I came, or rather stumbled, upon through a door that opened onto a dark and empty hall and a glowing stage.

The set was draped with translucent curtains and intertwined with gnarled tree branches set before a backdrop of a great flood, a cliff and a castle made of dreams, for which set designer Rouben Ter-Arutunian took his inspiration from the paintings of the German Romantic Caspar David Friedrich. At stage right was a grand piano, where NYCB pianist Gordon Boelzner played Schumann. And across the floor moved four couples, in ballet versions of nineteenth century clothes—whose pairing, breakings-apart, meeting and leave-takings seemed attempts to braid the flowing waters of undefined emotions.

There are no program notes, and no direct indications of biographical connection in the dance itself. Still, it is clearly—at least to an extent—about Schumann the man, his relationship with his wife Clara, and his alienation from the musical world of his time (including the "Philistines," that his imaginary *Davidsbund*, or Circle of David, was to combat) and his ultimate madness and early death. Even Balanchine, normally loath to talk about his work, is willing to agree to this much. Karin von Aroldingen ("Clara")

covers her face and weeps, and finally Adam Lüders ("Robert") leaves her alone on the stage at the dance's end. At one point, he is threatened by several great top-hatted silhouettes of men carrying oversized quills who enter, stand and leave: the Philistines, we assume.

One grabs at these few concrete associations. For who are the other couples? Friends, perhaps (at one point all the men "drink a toast" together), or other aspects of the central relationship, or the imaginary characters of the *Davidsbund*, to whom Schumann gave names and personalities. Certainly they are at least dancers, men and women on the stage.

Yet this last answer to the question of, Who are these people?—usually the "right" one with Balanchine—seems too easy an out with this piece. For the relations between the lead couple and theirs with the others appear emotional rather than formal or expressible in terms of pure dance. But what emotions? Perhaps those occasioned by the approximations and half-victories of life—their motions inconclusive, dreamlike, as if grasping after points they never reach, swirling away as if deflected by shields.

The movement here is classical upright equilibrium with the center punched out. Leaving what? Emptiness, a sense of half-disorder that pervades each moment of the entire dance. This effect is one of the movement itself, not of the romantic sets, costumes and music. And the effect of uncertainty this movement creates contributes as much to the piece's mood as the music, sets, or "story." This seems a modification of the classical ballet motion, one new for Balanchine.

He has altered the nineteenth-century technique before, in a formalist direction: ballerinas stand in arabesque and crook their feet, dancers twist pretzel-like around each other. But this new change is in the service of his "expressive" vein.

I stayed for four hours and watched about seven minutes of dance: a solo each for Suzanne Farrell and Karin von Aroldingen, and a dance for three of the four couples. I would have waited that long in order to see the forty-five seconds of Farrell's solo alone. For Farrell, sprawled behind me on an Opryland bench, is one of the glories of this "Golden Age" of dance. She moves in a way that is so controlled it can allow a touch of what I can only call gawkiness—a fluidity of line and of whole that allows the motions of her parts within it to be slightly angular. This makes her solos particularly satisfying.

Balanchine knows this, of course. He is fond of putting Farrell on to play with her arms (*Vienna Waltzes*) or twist in the self-absorbed flirtations of a gypsy girl (*Tzigane, Brahms-Schoenberg*). And out of context, as I saw

these forty-five seconds—interrupted by the make-up woman, by the sound man, by Balanchine dancing a few steps to make a point—they seemed a beautiful distillation of her motion, the essence of a taste that is even more fine than in the normal dilution of a program. Coleridge's definition of beauty was "multëity in unity," by which he meant you could see the parts as well as the whole. If we accept this definition, we must conclude that Suzanne Farrell is the most beautiful dancer in the world today.

The difference between forty-five seconds and the hour it took to tape the dance was the gap in which Balanchine and Brockway, choreographer and director, turned the fact on the stage into an artifact on a rectangular screen. They worked out camera placement and movement for each motion of each section. Balanchine looked at the monitor and either agreed, or asked for changes.

The art of making this jump to tape is an exacting one. How to strike a balance between the front-shot spectator view and the fragmenting mobility of the camera? At one point, Balanchine decided that a section looked "uninteresting, banal," and moved the three women behind the camera so that as they stepped forward, they seemed to surge out of nowhere.

This is working with the limitations of the camera eye, rather than against them. The final criterion was always; how does it look on the screen? And Balanchine was willing to alter, re-arrange, almost re-choreograph, to make an effect striking to the eye.

Vanderbilt Register 1981

Guilty Pleasures

I WONDER IF I AM ALONE in my strange relation with the works of George Balanchine. Sometimes they seem one of the few reasons for getting out of bed in the morning. Sometimes, on the other hand, I leave the theater thinking, Is that all there is? Not in the sense that I have been cheated, but simply in the sense of "yes, but." Life, I think at such times, is so much more than these exquisite and utterly self-contained patterns to music. They make me want to go out and chop down a very large tree (which I've never done), or eat a steak (which I rarely do), or run around the track (which I do all the time).

It's the same feeling I get after seeing too many paintings by Boucher or Klee, or spending all afternoon in the Nymphenburg palace in Munich, with its outbuildings full of silvered curlicues in ornate patterns, or looking up from yet another brow-furrowing session trying to decipher a passage of *Finnegans Wake*. It's beautiful, it's complex, it's intelligent, I say—but isn't it precisely a bit too much of all of these things to have much relation with life? And then, as often as not, I talk myself out of these doubts, and am soon back to giving thanks that there was such a person as Balanchine, that I saw his works while he was alive to produce them, and that I am here to see them now, in whatever shape they might currently be in.

I had all these feelings after the first weekend of the mammoth "Balanchine Celebration" of the New York City Ballet (May 4-June 27), bursting with offerings that ranged from the cold classicism of the *Sinfonie Concertante* to the moody mysteries of *Serenade*, via the muscularity of *The Four Temperaments* and the grotesqueries of *Prodigal Son*. Caught between a high and a low afterward, I wondered: How can these works seem at once so enthralling and so infuriatingly self-sufficient, simultaneously so audience-friendly and so aloof? In terms of audiences, this becomes: How is it that the almost fanatically loyal audience at the New York State Theater goes night after night, season in and season out, when the audiences in many European countries (or indeed, in many American cities outside of New York) see Balanchine as simply one option among many—or worse, react to his works with a yawn? Why are reactions to this man's work so widely divergent?

Allowing my mind to drift in search of an answer, I found myself thinking of the ingratiating film *Children of Theatre Street*, about the Vaganova Institute in St. Petersburg, with narration by a rather disingenuous Princess Grace. Or more specifically, of a brief interview with an old woman who had worked in the Maryinsky (Kirov) Theater for decades as keeper of the photographs and memorabilia. She had, it turns out, graduated in the same class in the Imperial Ballet School as Balanchine. "Ah yes. Balanchivadze" she says in Russian. "Or Balanchine, as he is called in the West. He invented a new genre of dance—miniature ballets [miniaturi balletnyi]"—which the Princess translates into French, *ballets miniatures*.

Clearly the old lady means it admiringly, but at the same time is trying to put Mr. B's works in perspective—a perspective that might, I thought, begin to give us some answers concerning their strange nature.

In Imperial Russia, a ballet had to fill an evening, have a spicy plot (preferably set in an exotic clime) and end with a great bang—or at least the

death and transformation-into-an-angel of the heroine. What, no sets? No costumes? No plot? Clearly the result would, from the nineteenth-century point of view that the old lady is still expressing, be at best only miniature ballet, in some sense a minor art form—perhaps finely wrought, but at the same time peripheral to more basic things, dessert rather than the main course.

In story ballets, the plot and psychological interaction had justified the steps, at least in the "real world" acts. The divertissements, the fantasy acts, and the finales could be more abstract; it is no accident that this is where Balanchine found his link with Petipa. Yet structurally speaking, these parts are only possible because of the more prosaic ones, as interludes. With no over-arching plot, how to justify any given sequence of movement rather than any other?

Balanchine's answer—an answer that he gave again and again throughout his long career—was as simple as it was brilliant. He would have dance that was structured by the piece of music to which it was set, rather than by a plot. (Other people did it before Balanchine, but never to such good effect or so intensively.) The music had always been there, but Petipa was as productive working to Minkus as to Tchaikovsky—and in any case it was only in transcendent works like *Sleeping Beauty* where the dance and the music seemed to work together to produce the final product. Dance structured by music—an astonishing idea, yet one that we have come to take so completely for granted that when Merce Cunningham threw it out again and made dance structured not by music but by chance, the I Ching, or by nothing at all save itself, it seemed a stroke of genius all over again.

The question of the relation of Balanchine to Petipa is an important one, because it directly addresses the question of the relevance of works to their world. And this is one that is pressing with Balanchine—for we wonder, will Balanchine continue to have an audience? Why did he have one to begin with? Petipa, to use this single name as a short form of all late nineteenth-century Romantic story ballets, clearly fit into his world. What he made appealed to a certain well-defined high-bourgeois/aristocratic societal audience. He provided something the people he was producing for wanted, in this way a product like Italian opera in Italy, or Viennese operetta in Vienna, or Hollywood movies in the USA.

What of the audience for Balanchine? Does he fit into his world? Can his works be transported off the island of Manhattan? How did this European movement style flourish on these shores to begin with? Will there continue

to be an audience for Balanchine? Was, in sum, the Balanchine celebration the last gasp of a dying aesthetic or a springboard into the future?

In some sense, these questions have very practical answers. The works will have an audience if an audience is built (here we are talking ticket sales, and marketing); they will travel outside of midtown Manhattan if people take them outside (witness Miami City Ballet and Pacific Northwest Ballet), where they seem to be doing very nicely; the local audiences will come if the dancers appear who can convey the works convincingly. But these questions have their metaphysical side as well. For it is arguable that Balanchine should not have flourished on American shores at all, lacking a ballet tradition as we do. It's as ridiculous as if Orlando di Lasso had managed to compose his works in the Australian outback. The miracle is that Lincoln Kirstein (whose birthday was celebrated on opening night) managed to build an audience of this many people in even one city for something as difficult and as intelligent as Balanchine's works. Was this merely clever management, or was it due to the works themselves?

For Balanchine was constantly situating himself with respect to his own tradition—re-writing history in his image. He made many works that "look like" sparer versions of Petipan fantasy acts, tightened, stripped down, and lifted out of the context of their larger plots: in the programs I saw the first week-end, *Theme and Variations*, *Tschaikovsky Piano Concerto No.2* [ex-*Ballet Imperial*], and parts of *Symphony in C* fall in this category, as do *Gounoud Symphony* and *Donizetti Variations* from programs I saw later in the run.

Yet I must admit that it was during the Petipan pieces (understood in this sense) on the first weekend's programs that I doubted most strongly that the work of George Balanchine had a very long future life, and this for purely structural reasons. For they ooze a sensibility that, however charming we may find it—with its worship of the woman by the man, its formulaic patterning on the stage, its rigid hierarchy of principal, soloists, and corps—is definitively not of our time, not of our place. The miracle is that it ever flourished in chaotic, brassy New York at all—save as a sort of fairy tale for jaded adults, drenched with the air of another time, another place. Escape dance, in other words, *ballet miniature*, the Fabregé Easter eggs of the cultural world.

The relation of Balanchine to Petipa can, I think, be farther clarified by comparing it to the way nineteenth-century landscape painting of the Barbizon School developed from the paintings of late Renaissance Flemish artists such as Joachim Patinir. Landscapes had figured in the distance in

many Renaissance paintings—think of the tiny blue world behind the *Giaconda*, the Mona Lisa. In Patinir, the foreground figures that provide the ostensible subject of the painting become smaller, and the backgrounds are filled with complex landscapes. Yet although these landscapes are meticulously painted, they are somewhat ethereal. They're dreamscapes, and they're not what the picture is "about."

In art historical fact, we know that the frame-filling landscapes of the Barbizon School, painted outdoors in nature, developed from such painters as Patinir. What had been merely decoration became the whole message in the much later painters. Still, landscape was considered minor painting until the twentieth century, when finally the old hierarchy of painterly value was definitively overthrown. Great room-dominating history paintings, formerly considered the most serious sort of art (which could of course contain in corners still-lifes or landscape paintings), were abandoned, and the hitherto minor arts of landscape and still life increased in value, shooting to the top of the charts. *Peinture miniature*, we might say: the transformation of a minor element into the whole show, the abandonment of the edifying or crowd-pleasing story, the stripping away of irrelevant elements, a tendency toward abstraction. In short, an alteration from the high-bourgeois sensibility to the one we call modernist—a transformation of the artwork from something valorizing the social order to one that expressed only the artist's sensibility in abstract, quasi-objective terms. (The Romanticism of a hundred years before had also been an expression of subjective sensibility, but in realistic terms.) Look only at a Petipa ballet like *La Bayadère* to see the shining landscape at the corner that, for the modernist sensibility, needed to be freed of the rest of the painting: the famous *Kingdom of the Shades*, that was so luminous in the recent Paris Opera Ballet/Nureyev production of the full-length ballet at the Kennedy Center in Washington.

Balanchine expressed his modernism in staging only one of the white acts of *Swan Lake* and calling it by the title of the whole; he did so again when, briefly, Fokine's neo-Romantic *Les Sylphides* was presented by New York City Ballet under the original Russian name of *Chopiniana* and danced in practice clothes. It is relevant too that the full-length ballets the company danced were the frothy-fey French *Coppélia* and the abnormally pretty *Nutcracker* rather than anything heavier, and that Balanchine's own forays into evening length works were few and far between.

This stripping away of dramatic context has its price. What a jolt it is to come off noisy Columbus Avenue and be plopped right into *Swan Lake*, Act II, with no easing us into the piece at all, such as Act I usually effects.

Playing the naive, we might wonder: Who are these hunters? Why is this man infatuated with this woman? As a colleague with whom I was sitting remarked, "it's not *Swan Lake*—it's a suite of dances to Tchaikovsky." In the case of a truncated *Swan Lake*, at least, we can fill in the rest from what we know. It's like reading only a chapter of a well-known work. In *Liebeslieder Walzes*, by contrast (on the program the same weekend), we have the same hints of relationships, and no larger context at all. What you see is what you get. I found it frustrating. The women flirt with the men or turn away, the men are impassioned and run after them. But why? And why should we care? The whole thing, I thought (giving in to a retro sensibility I didn't even know I had) cried out for a more explicit dramatic context that would give some substance to these emotions.

The works of Balanchine in the Petipan dialect, despite their exquisite nature, are truly *ballets miniatures* when stripped from their (real or imaginary) dramatic contexts. His reputation cannot rest on them. They are both his homage to his youth and his revenge upon it, both a re-creation and a rewriting. His youth, not ours, so that we can merely appreciate, cannot in some fundamental sense share his concerns. They're not Petipa, in other words, they're a modernist rewriting of Petipa—the way Stravinsky loved to take earlier composers like Pergolesi and Gesualdo and make us aware of them by throwing in wrong notes and ascerbic sonorities. They're the Cindy Shermans of their day—or she a late-late modernist of ours.

In such pieces, all we are left with is the pure dance. Isn't that a neat way to partner, look at those daisy chains, what an ingenious pattern, isn't Darci dancing well tonight! And this, I think, is not enough for truly substantial art, this obsession with the medium itself that renders dull so much modernist abstract painting. (In the Metropolitan Museum before a performance, I overheard an earnest docent trying to overcome the skepticism of a group of surly visitors in a room full of Clyfford Still's repetitive blotches. Appreciate the reds! she insisted. Look at the way the paint is applied! Oy, I thought, are we really reduced to this?)

Nor, at the other end of the scale, can Balanchine's reputation rest on his heart-on-his-sleeve Romantic works, such as *La Sonnambula*, which I saw during the Celebration's first weekend, or the Edgar-Allan-Poe-esque *La Valse*, or even parts of the awkwardly-entitled but highly interesting *Robert Schumann's Davidsbündlertänze* from later in the run (the critics with great quill pens, the madness).

La Sonnambula, for example, with its dramatic unclarities that go beyond mere ambiguity so that few companies seem able to make it make

sense, is a Romantic five-acter condensed to less than half an hour, complete with divertissements. Ultimately, works like *Sonnambula* seem period pieces. For the twentieth century, they're a bit creaky. So too for *Cotillon*, re-created recently by the Joffrey Ballet. Of course, virtually all modernists *are* closet Romantics, but we simply forgive them their excesses and move on.

It is neither the works that I am calling, on the one hand, the Classical or Petipan works, nor those, on the other hand, we may qualify as the Romantic ones that will, I think, come to seem the most substantial of Balanchine's work. (Then of course, there are the silly but fun ones like *Union Jack*, *Western Symphony*, and *Stars and Stripes*.) The works that pull us in like giant magnets, I think, are those which we must call modernist. I mean, from the first weekend, works like *Apollo*, *The Four Temperaments* or the revived *Haieff Divertimento*—or, from the later years and programs, *Monumentum*, *Agon*, or indeed virtually anything to Stravinsky, not including the strange Grahamesque *Orpheus*. (The music to these works is heavily but not exclusively modernist too. *Concerto Barocco*, set to Bach, is clearly a modernist piece in this sense.) The swimsuit ballets, in other words, so-called because of what became in later years the inevitable female costume.

These are works which take their ostensible justification from the music. If we stop the choreography at any point and ask, Why should it go on? the answer is always, Because the music isn't finished, and so the dance isn't either. (This reasoning is specious, of course; the music doesn't need the dancing to complete it.) This doesn't just mean that the dance goes on for as long as the music does, although this is precisely what it does mean in the dozens of mediocre international abstract ballets that have proliferated since the 1960s show. They lack plots too, and also are set to works of classical music.

Many of Balanchine's are great works because, first of all, they move as the music moves: new theme, new dancers; development of theme, development of movement. (Many international works are stupid in this sense; their choreographers evidently have tin ears.) Not all the time, of course—Balanchine isn't Mickey-Mousing to the music—but just often enough to make clear that he's listening. Much is sometimes made in critical circles of Balanchine's relation to the music; too much, I think. Balanchine doesn't "interpret" the music (as is sometimes claimed), or provide dance equivalents (I can't imagine what this would mean). But he does know where the themes are and how they develop—how the music "works."

Furthermore, the individual steps and their arrangement into patterns are simply amazing as well. Sometimes we just don't believe what we're seeing. The steps are like luminous individual phrases or unforgettable lines in poetry; the interesting patterns (such as the ubiquitous daisy chains) are the stanzas. And, as in poetry, I think that it's the individual steps and sequences that remain most solidly in our memory when all the structure has faded: the pretzel-twists of *Agon* or *Bugaku*, the back-to-back squatting crab-walks of the revelers in *Prodigal Son* (it seems likely he got this move from Russian folk dancing), the boy manipulating two strings of girls like water grass in *Tschaikovsky Piano Concerto No. 2*, the frictionless drifting bourées of the sleepwalker in *La Sonnambula*, the floor-stabbing phalanxes of vampire-type females and the up and down square arms of *The Four Temperaments*, and the great eagle-bloodpulsing-bullfighter solo of *Apollo*. At moments like this, I think of Emily Dickinson's rule for how to tell a real poem: when you feel as if the top of your head is going to come off.

The movements, that is, are intrinsically interesting; they look neat. Frequently, you smile when you see them. The fact that they come so unceasingly in Balanchine's modernist works is what makes the experience so dense. Like all modernist works, such pieces are self-reflexive: if you aren't conceiving of the movement as movement (rather than a means to some other end), you don't like Balanchine. What was that all about? you come out of the theater asking. In fact, their density is a quality of their self-reflexivity. If little else is going on other than movement, that movement had better darn sight at least be interesting.

In many Balanchine ballets, something else *is* going on, only we usually can't figure out what, and it's not enough to power the piece. As in *Serenade*, for example, or the decadence-tinged *Liebeslieder Walzes,* or *Le Tombeau de Couperin* with its hint of neo-Classical nostalgia. (Sometimes what's going on is more or less submerged comedy, as in the parodies of American clichés in *Stars and Stripes*, or English popular culture in *Union Jack*.) These are qualities of virtually all modernist art: brevity or smallness of scale, great density, and self-reflexivity in a parading of qualities of the medium. In music, Schoenberg and then, even more rigorously, Webern, were rejecting those great structures of soaring sound that constituted the Romantic symphony (itself already an over-loading of the neo-Classical arrangement of keys and motifs that had nearly burst with the weight of sheer beautiful sound—and finally fell apart in the symphonies of Mahler and Bruckner) in favor of a more spare structure that was generated by an arrangement of pitches in the scale. *Musique miniature.*

In literature, T.S. Eliot finally contrived to write the history of Western civilization in the quotations and fragments of *The Waste Land*—about five pages long. Gertrude Stein had for decades already found herself unable to write stories, and had fallen back on arrangements of words; later she was to conclude that the real unit of longer composition was the sentence rather than the paragraph. In England, Virginia Woolf, after a false start with conventional novels, decided that the form was dead; her response was a mixture of instantaneous sensations and autobiography. Even long works, like Joyce's *Ulysses*, was made as if an amalgam of a billion tinier, dense structures. *Littérature miniature.* Klee, Mondrian, Braque: *peinture miniature.*

In the similarity of Balanchine's most meaty choreography to the other masterworks of the modernist movement lies both their positive and negative aspects. Because Balanchine's most overtly modernist works are so dense and so brief, as well as so self-reflexive (about movement itself), they suck in an audience in a way few other kinds of art can. They draw the gaze the way the dense bodies of burnt-out compacted stars draw in light and appear to us as black holes. They slip away like films through a projector and leave us instantly hungry to see them again. Their rules are rules of their worlds alone.

This is good. Yet at the same time it is bad. For what it means is that Balanchine's most clearly modernist works, like all modernist works, are, for lack of a better word, effete. (I can't believe that I'm ending up sounding like my fellow Marylander, former U.S. Vice President Spiro Agnew; remember him and his criticism of "effete intellectual snobs"?)

All modernist artworks (here my Marxist side) show the breakdown of a common social order, even if they don't talk about it. What this means in practical terms is, no more evening-fillers (foregrounding the common public time spent in the theater) based on common longings for exotic climes. Instead, knotty dense structures meant only for isolated individuals. Modernist artworks are abstracted from a world, asocietal. In some real sense, they have no time and place: they can be put on now, in three hundred years, in a cow barn, in a palace. Provided, that is, that we are willing to spend our time looking at works that float free from their worlds in this sense, works that are primarily about movement and not about some other thing. Perhaps Balanchine's modernist pieces are in fact quintessentially art for Manhattan, that city with no past and little commonality among its teeming millions—and the fact of their having been made here quite logical indeed.

This is intended as an explanation of why we may sometimes feel that even these densest works of Balanchine are, in their own way, sublime but unsatisfying. At times they seem only an escape from the world, their enjoyment the ultimate guilty pleasure. Sometimes I want to defend them to the death, even play watchdog to their transmission, like some of my other critic friends. Are they being danced right? What shape are they in now that Mr. B has been dead a decade? I wax passionate and poetic. Other times, the world around me seems far too demanding and too chaotic to allow me to spend my time with such gorgeous baubles as these. Because they're so perfect, they're even less of this world than most artworks.

Or are they simply the most consistent? Perhaps they admit openly what other artworks only hint at: their own inability to change anything or do anything but be themselves. Which, in turn, is the source of the feeling we sometimes have that artworks matter more than anything else, because they avoid the petty straining and bickering of the world. As Keats pointed out, you can't have it both ways. The more perfect the world on the urn—or in the New York State Theater—the less it has to do with the world outside. Art (or at least the greatest art, such as that of Balanchine) is both above us, and beneath us.

DanceView 1994

Love in a Cold Climate

OURS IS A COLD CLIMATE, this increasingly barren post-dance-boom world of the waning twentieth century—punctuated, like the last act of *The Cherry Orchard*, by the repeated sound of the fiscal axe, and disintegrating, it seems, into the chaos that follows every great achievement as inexorably as night the day. The love is ours too, or at least mine: for the Miami City Ballet, which brought its transcendent evocation of Balanchinian classicism to the Kennedy Center April 25-30. Mere applause until I had no hands left was an inadequate response to the week-end performance of *Jewels* I saw, so I merely laughed out loud. (I clapped too, because the dancers couldn't see me out there in the mass of screaming fans.)

How was it possible simultaneously to be in love with so many beautiful girls and boys of the Miami City Ballet, the gorgeous world of *Jewels* they had evoked onstage, and the ballet master without whom it wouldn't have

happened, Edward Villella? Most of all, to love the creator of that world, not dead at all but triumphantly alive that beautiful Saturday afternoon on the banks of the Potomac, as if disembodied and floating among the trees on the terrace, suddenly in full spring bloom, and among the dancers on the stage? News headline for a tabloid: **Balanchine Sighted in Washington!** And, I assume, in Miami as well when the company is at home.

That Balanchine isn't, after all, dead . . . how self-evident this ought to be, less than fifteen years after his death. Yet how miraculous it seems in the climate of our current ice age. Of course, his spirit lives on in other cities as well, places like Seattle, San Francisco, Chicago, and even on occasion New York. Indeed, reports of his death may even turn out to have been greatly exaggerated. But never, it seemed, had the mediums who invoke his ghost been as powerful as Villella, bringing to the Kennedy Center for the first time his ten-year-old company, the youngest of the "baby Balanchine" companies.

The performance of *Emeralds* was transcendent. Transcendent of our mortal coil, our own earthly existence, of all our cares and all our woes, transcendent most of all of the dance climate of our times. I almost don't trust my own reactions, for it seemed to me that Sally Ann Isaacks was fully as musical, fully as liquid, fully as ethereal as Violette Verdy, lo these many decades ago. It can't be true, yet it seemed to me that afternoon it was. And her partner Kendall Sparks, although a tad short, swelled into true princely height through his demeanor alone, his attentiveness to his ballerina, and the nobility he oozed at every step.

Emeralds, I wanted to say after this viewing, is most efficiently described as a ballet for throats. I mean, specifically, swan-like female throats. Here I refer not only to the fact that I was sitting closer than I have ever done for this ballet (my adolescent and young adult viewings were from the second balcony at the Saratoga Performing Arts Center or the New York State Theater), and hence considerably lower than the dancers. Nor could I ascribe my obsession with the ballerinas' exposed body parts merely to the undeniably agreeable sensation of lust generated by seeing so many heart-stoppingly beautiful women all at once.

No, I mean this as a metonymic image for the ballet as a whole: the regal pose of the slightly elevated chin that avoids haughtiness by millimeters, defining the body language of the entire work. *Emeralds* is a ballet of a race of gods, men and women born to rule, yet never having to sully their hands with the mechanics of governance. It is at least first cousin to the world of indolent immortals evoked by Paul Taylor in his pretty pieces. Yet the difference between Balanchine's gods and goddesses and Taylor's helps

define what I saw that afternoon at the Kennedy Center. Taylor gives us works where physically perfect, high-spirited creatures cavort in the sun of early morning (works like *Aureole* or *Esplanade*). Or they loll about in the over-ripe days of late July on Mount Olympus, in a sun of 2:30 in the afternoon (works like *Roses*), as if blossoms so full that, were they not immortal and hence immutable, they would in only a moment pass their maximum point and tilt into the slide toward putrescence.

In *Emeralds*, by contrast with both of these, the divinities are not limited to a specific time of day or season, neither early morning nor impending evening, summer or spring. They are capable of functioning as they do at any hour, any part of the cycle of seasons. They have lives of their own, and are not merely the limited embodiments of what we take to be the optimum moment in our own lives, the wish fulfillment alternative to us lower beings. They inhabit a world parallel to ours, if higher, one as fully nuanced, as complex, and as variegated.

What they are most fundamentally, is unhurried. (In this alone they contrast to our world of traffic jams, departing school busses, reports to finish and cups of coffee to gulp down.) We see, in the lead role, a goddess with arms that are as liquid as ribbons in the breeze, as light as butterflies (and with the time to sun themselves in the air), the time to be promenaded in a leisurely fashion about the stage by her cavalier (stunning Marjorie Hardwick and attentive Douglas Gawriljuk). They have burned off the excess energy of their youth, and do not yet threaten to grow weary under the weight of their own immortality. Far from merely hanging out like the pampered rich gorging themselves on chocolates, they go about their business of moving, interacting, constructing patterns, and attending to each other. Although they have unlimited time, they are nonetheless busy, although busy doing things unrelated to what we do here below. They are what we can only imagine being, and will never attain: engaged in their lives, devoted to things outside themselves but at the same time in control.

Once again, that afternoon, I knew why, as an impressionable adolescent discovering dance, I had been ready to kill for Mr. B, should he require it. (Instead, to my shame, I once let him hold the door for me when, charging about backstage one evening at the Kennedy Center in search of my brother, then a a 'cellist in the opera house orchestra, I nearly ran him down). At the end of *Emeralds* my skin was on fire with what I had hitherto known only as sexual desire. Yet inside I was as chaste as ice. I had a momentary desire to leap on the stage and transubstantiate into the world not only of the dancers but of the choreography, hoping that my rude blunderings would somehow

alter through the passage into this green sea like a character in a Cocteau film passing into a mirror or the boundary of an enchanted castle. Yet I was sufficiently in control of myself to stay in my seat, perhaps knowing that the only way I could keep the illusion that this world was real was to keep still, as breathless as the thousands of equally captivated people around me.

Rubies was fun, and energetic; nobody dances it better nowadays than Miami City Ballet. Maribel Modrono and Marin Boieru were full of energy. Modrono was closer to the caliber of Pat McBride than Boieru was to Eddie Villella, the dancers on whom the piece was originally made. Surprisingly, given the fact that Villella was coaching him, I thought Boieru didn't "get" the pumping hands-together gestures that evoke holding the reins, or jump-roping: here they seemed merely rhythmic equilibrium to the back-bent upper torso. Long-legged and luscious Balanchine-body-to-die-for Myrna Kamara, as the second ballerina (the one handled, in one of the oddest combinations in a piece full of visual shockers, by four boys, each attached to a limb), was a revelation; no wonder Villella was hugging her tight in the city-of-women promotional poster for the company, one dark-suited man in the center of a gaggle of his gorgeous and brilliantly-attired half-naked ballerinas. (Can we still do this? I wondered. Then: thank God we can.)

In the performance I saw, Mabel Modrono (Maribel's sister) danced *Diamonds*. About halfway through, I put my finger on what seemed the slightly off-key note of her performance and realized she was substituting steeliness for a more centered elegance. My sense that this was so was strengthened when, at the kiss her cavalier (Franklin Gamero) plants on her hand from his position of kneeling adoration at the end of a section, she whipped her head around and stared at him as if he had committed an affront, rather than acknowledging the homage as she should have done with a gracious inclination of her head.

Diamonds was haunted perhaps most strongly by the problem of seeing the piece's original dancers moving invisibly behind the dancers on stage. It's inevitable, I'm afraid, when the originals were the dancers they were. There's Farrell, of course. But nobody will ever dance like her, so we just accept the loss and go on. Here, it was Gamero who seemed shadowed by the height, carriage, and understated leonine grace of a young Peter Martins. While I forgave Gamero his lack of inches, I am not sure I could forgive the fact that, although an excellent and tasteful dancer, he is also several degrees of aristocracy shy of Martins.

Perhaps most important of all for the performance as a whole, the corps for all three pieces was astonishing: everyone was listening to the music,

beautifully conducted by longtime American Ballet Theatre conductor Akira Endo (who led the orchestra in a series of sparkly shirts, color-coded to the movements), everyone paying attention to finishing turns properly and extending limbs into the deep crevasses of places where limbs hadn't thought they could go before Mr. B asked them to. The lovely Karinska costumes, re-created by Haydée Morales, were as beautiful as ever.

Why not the original décor, I wondered? where a lacy drop from the ceiling quivered with heavy jewels, like a great spider web heavy with dew; the jewels changed colors for each act and made the stage seem like the bodice of a dress under an encrusted collar, or the inside of a jewel box. Here, in Tony Walton's rather pedestrian rendering (the only hint of mall culture in this entire otherwise divinely inspired production), we had a cloud of tiny lights like what upscale hotels put on their trees outside at Christmas, swirled like a nebula for *Emeralds* and developing ticky-tacky flat chandeliers in *Rubies* and *Diamonds*. There was even a burst of white lights simulating fireworks at the finale. Walton's designs reminded me of the blue twinkle lights that were strewn behind Michelangelo's *Pietà* when it was exhibited at the 1964-1965 New York World's Fair. At the time I remember not understanding the cries of outrage; I thought the lights were pretty. In my own defense, I should note that I was twelve years old at the time. Some years later, in Saint Peter's, I realized that the sculpture really does look better without them.

How good a piece, as a threesome, *is Jewels*? I've had times when I thought the connecting thread only a sales ploy (which it clearly was) that cheapened three good ballets by trying to Upper-East-Side them, and the claim for this ballet that it was the "first evening-length abstract ballet" only an old-wine-in-new-bottles public relations stunt (which is probably true too). That afternoon, such objections seemed trivial. You appreciate something differently if you're in danger of losing it, and more if you thought you had lost it. It's chauvinistic to call this company a national treasure (which it is), or a Florida jewel (it was presented in the context of a Kennedy Center "Festival of Florida"—talk about burning the midnight PR oil on that one), or an international sensation—a real one, not like poor tatty Sally Bowles, the "*internationale Senzation*" in *Cabaret*.

It does the system good to see discipline, beauty, quality, youth, hard work, and elegance all rolled up into one. Die, MTV. Die, you vulgar Madonna creature. Die, Mike Tyson and Roseanne and O.J. and all suburban malls and Pac-Man (unless he's already dead; I admit being not on the cutting edge on such things), and the word "like" used as verbal filler and

... Well, you get my drift. These things won't die, of course, they'll only be replaced by the next generation of over-hyped vulgarians up for *their* fifteen minutes, and I'll have to get used to it. But that afternoon, watching Miami City Ballet, I forgot all about them. And that may be the best we can do in our otherwise so-tattered celebration of consumerism and packaging and artistic decline that we call the Western world at the end of the twentieth century.

Compared to this heady experience, the opening program of the company was small beer. The headliner was the final product of the Kennedy Center's initial commission series, Lynn Taylor-Corbett's *Mystery of the Dancing Princesses*. The work is presumably based on the Brothers Grimm tale of twelve (here five) princesses who disappear mysteriously to a nether realm at night and return the next morning with their shoes in shreds, although the program quotes Anne Sexton's reference to the story, with her comparison of the worn shoes to jockstraps. (Think about that one for a while, or rather, don't.)

The best part was the elegant post-classical score by Donald York, sounding as if made by the ghosts of all the gifted minor composers of the past three hundred years. That, and the stylish opening of the ballet, where five princesses displayed like grave statues in white shrouds/nightdresses were tilted up on their beds behind a gauzy scrim. The king passed from princess to princess, and his hapless servant (who later wins the princess of his choice where all the suitors have failed) places a pair of dancing shoes on a pillow at each princess's feet while a spotlight comes on over her. They slit their shrouds like chrysalises, and come to multi-colored life, leaving the dresses behind them on the beds. Or are they just dreaming?

The rest of the ballet had echoes of Paul Taylor schlock (*Snow White*), of *La Sylphide* (the old Madge-like crone who tests the tolerance for the underprivileged of each suitor by asking him to buy a flower; all refuse, and die as a result), of *Giselle* as well as of Robbins's update on *Giselle*, *The Cage* (the predatory females polish off male intruders in both), and of Balanchine's *La Valse*, a dance with a death figure set to Ravel's music that has been described as "waltzes poisoned with absinthe" (York's music offered a good approximation).

There are several ideas too many at work here. The premise is that as each suitor dies, he becomes one of the death-figures in white masks and wearing black that serve as the princesses' cavaliers (which the program called, wittily enough, "underworldlies"). A conundrum for Ms. Taylor-Corbett, which I think is fully up to the scholastic question of what body

cannibals, whose bodies themselves consisted of the bodies of other people, would be resurrected in (final scholastic decision: they wouldn't be resurrected at all): if all the princesses' cavaliers are the dead souls of suitors gone underground to see where the princesses danced their shoes to tatters at night, who were the princesses dancing with before the first suitor came? Yes, Ms. Taylor-Corbett? We're waiting.

The creeping servant (Boieru) who later steals the show and gets his girl is meant to seem comic, as is the way he and the king shrug and shake their heads after each of the other suitors is gone and they throw the deceased man's hat into a compartment in the throne under the royal buttocks. So too the full-of-themselves bravado of all the suitors (one has a variant on this: cold command—or is it merely Latino machismo?—he has a moustache), so you know they're just dumb enough to drink the fatal potion that knocks each of them off. The crone seems oddly in control of things: she comes down to the nether world and spouts off fire from her fingers. Is this world her creation? All of this is just her test of who'll buy her wares? Frankly, it seems a bit heavy-handed on her part. Maybe the guys just don't want her stupid paper flowers.

Whatever pretenses to coherence the piece might have had vanished when the successful suitor calls the unsuccessful ones back to life. Despite the princesses's so-clear narcissism, they agree to marry the boys after all—except one, perhaps for choreographic variety. And what's the implication of Boieru's elevation from schmuck to prince? He functions rather like a Cinderella in drag, only the point is that the Cinderella story only works in one gender direction. (In Grimm, it's a stranger who answers the question for the king, no aristocrat but one of nature's noblemen.) And *what* was going on with the "eating" princess, the Princess in Rose, Myrna Kamara, who can't keep her attention on her suitor and keeps snatching at trays proffered by the "underworldlies" to the point where she has to go off stage and vomit? I mean, really.

The program's opener was a not-awful piece in the post-Balanchine tradition by Miami's house choreographer, Jimmy Gamonet De Los Heros, called *D Symphonies*. We could see evidence of the choreographer's interest in the computer program "LifeForms" (see program notes) in the 1-2-3-4 jerks of arms and legs at strategic points, especially in the first movement. Still, it's a trick Balanchine played occasionally, presumably without the computer, as for example in *Serenade* and in *Diamonds*. Here, in greater profusion and with more jerkiness, it made the dancers seem like a raft of escapees from *Coppélia* or a dance galaxy far away, and the ballet itself like

a busy clockwork machine, intricate enough but as cold as the doll herself. I kept wanting Swanilda to come in and kick the whole thing over. In later movements, Gamonet De Los Heros varies the jerks with some shimmies and liquid melts, and the whole carries busily on like the music to which it is set (by two sons of J. S. Bach). Still, it was nice, and it was intelligent, and it was not vulgar. And that goes a long way nowadays.

The best choreography on the first program was by . . . the envelope please . . . [drum-roll] . . . Oh all right. It was by Balanchine. I mean both the son-of-Petipa *Tchaikovsky Pas de Deux* (danced with brio by Gamero and Iliana Lopez) and the entirely Balanchine *Western Symphony*, which in the Miami rendering positively crackled with verve and fun, and put us in the mood for the *Jewels* that was to come.

Western Symphony always makes me think of Balanchine as one of Nabokov's hapless Russian émigrés, like Pnin or Humbert (for whom, in fact, he may have served as a model), washed up on the shores of an America they find alluring but at the same time utterly baffling. All the standard "Western" poses are here, from the thumbs-in-the-belt cowboy swagger of the boys to the leggy dance-hall hostess come-ons of the girls. It's all very tongue in cheek, as mocking as it is loving; the Western affectations are only that, and the European sensibility is only millimeters below the surface. The female vision of the adagio movement (Paige Fullerton) drifts out with her hands cupped over one another like Giselle being called from her grave, and aside from the camp and the visit to the Conway Twitty Western Store for Choreographers, it's otherwise business as usual, full of extensions and kicks and daisy chains. Is it a supremely knowing take-off? Or faintly embarrassing kitsch?

For the projected last issue of New Dance Review, 1995

Petipa's Prodigal Son

IT SEEMED FITTING THAT THE KENNEDY CENTER, in our nation's capital, should have been the producer for the week-long run of two eagerly awaited programs advertised under the name of "Suzanne Farrell Stages Balanchine" (Oct 17-22). The production, after all, was eerily political: a favorite son (or in this case, daughter) with a high degree of name recognition, being finally given the chance to test the waters on her own, like a general wearing a business suit and turned into a baby-kisser.

The audience came well disposed toward a dancer whom most viewers of my generation, knowing "Maria" and "Tanny" only from photos and reputation, consider *the* consummate Balanchine ballerina. More reason for well-wishing in the fact that our girl Suzanne (*née* Roberta Sue Ficker) had given us a tantalizing taste of success in her new role by her successful staging of Balanchine for the Kirov a few years back. In the meantime, everyone knew, she'd been fired from the New York City Ballet by her former partner extraordinaire, Peter Martins, so that the offer by the Kennedy Center to set her up on her own seemed like a competing bid, a rival party testing for support.

The thought uppermost in the minds of the cognoscenti was, therefore, What would Suzanne look like under the grueling glare of the spotlights highlighting not a known company, but instead dancers with little coherence as a group save the fact of her leading them?

The good news is that the general turned out to be just as successful in a news conference as in the war room. No Michael Dukakis syndrome here, no meltdown before the cameras, no discovery of unpaid Social Security for illegal nannies. The nomination sailed through with hardly a hitch, and we who had worried so much were left breathless with relief. The two programs were at best wonderful, and at worst predictable. Not to mention the more fundamental pleasure of seeing two back-to-back all-Balanchine evenings, something that we might have taken for granted during the period of Suzanne's heyday as a dancer, but that in 1995 seems a gift from the gods.

As advertised, this was one woman's "take" on Balanchine: not only in the dancing, but through her choice of works. The Balanchine presented by Farrell was Petipa's Prodigal Son: playing at rebellion, but finally submitting to the authority of his spiritual father, whom he understands so well he can up the already not inconsiderable dancing ante to faster, denser, more complex without overthrowing any fundamental presuppositions. We saw none of the pretzel roles that are among Balanchine's most original works (*Agon*, say, or *Bugaku*), and had only *Monumentum Pro Gesualdo* and *Movements for Piano and Orchestra* (set to Stravinsky, Balanchine's most clearly modernist collaborator) to represent the so-central swimsuit ballets. As far as that goes, only the brief but dense *Movements* contained any of the Balanchine-trademark funny positions thrown in from jazz or tap to liven up the movement repertory (toes-up feet, praying-mantis-like arms with wrists held in to shoulders).

Virtually all the pieces Farrell presented were danced in non-swimsuit costumes and contained some reference to place (*Scotch Symphony*, with its

kilts, a castle-on-a-hill backdrop, and sylphlike movements of the female lead, danced gracefully by Elena Pankova), many literal gestures (the last work Balanchine did for Farrell, *Mozartiana*, complete with gestures of prayer and adoration), borrowings from folk dances and mime (*Tzigane*, where Maria Calegari did a fine job as the gypsy without achieving Farrell's loose-jointed sensuosity). Not to mention the overt story ballet *Slaughter on Tenth Avenue*, made as part of the 1930s Broadway musical *On Your Toes* and revived for Farrell.

Farrell's Balanchine was, for lack of a better word, a bit corny. The "stay back" gestures of the sylph's male protectors in *Scotch Symphony* have always seemed to me like campy Mickey-Mousing to the music's fate-heavy chords. The prayer-miming of *Mozartiana* (surely a bit *too* evident for a section of Tchaikovsky's music entitled *Preghiera*?) gave us a taste of Balanchine's rather puzzling return to literal symbolism of his last years (*cf. Robert Schumann's Davidsbündlertänze*, with its quill-wielding Philistines, or the angels with wings that appeared on stage to Tchaikovsky at about the same time). And only a light heart can help us see the silliness of *Slaughter* as anything other than dumb (the Strip Tease Girl, lying "dead" on the stage, reads and passes to the Hoofer a note saying that when he ceases dancing in this show-within-a-show, he will be shot for real, so that he keeps telling the orchestra to play his music and keeps on dancing). The wooden rendering of the Hoofer by the Washington Ballet's John Goding (who with his home company is even inexplicably showcased in such roles as Balanchine's *Apollo*) didn't help matters.

Thus it was not the acerbic/modernist "make it new" Balanchine Farrell staged, but the Balanchine serenely assuming his place in the pantheon. Perhaps this choice of repertory was understandable; these were roles made or re-made for Farrell herself, and she taught what she knew. Or was this emphasis on Tradition simply a gesture of adoration on her part as sincere as the supplicating prayer-hands of the lead in *Mozartiana*, here danced by American Ballet Theatre's sublime Susan Jaffee?

Jaffee was, in fact, the star of the two program run, the only dancer whose steely but pliant limbs evoked that odd combination of disjointedness and flow that had characterized Farrell's own dancing. She left me breathless in *Mozartiana*, despite the cold background corps work of the Washington Ballet dancers behind her, and made me smile ear to ear at her re-appearance at the end of the second program's *Chaconne*, where she and Peter Boal (her fine partner for *Mozartiana*) provided the spunky second couple.

Not that approximation of Farrell's dancing was the criterion by which the female leads should be judged. We all know how unfair it is to compare the new generation to the old, or to assume that the first interpretation of a role (or the one we remember best) is necessary the definitive one. Still, it is legitimate to note what is lost or gained through transformation of the movements by another's body. Although Jaffee reminded one at times of Farrell, what she had in common with Farrell was not so much a way of moving as an apparent sense of absolute conviction in what she was doing that went deeper than mere exhibitionism. In *Mozartiana*, Jaffee displayed flawless line, real fervor, impeccable attention to the details of arm and foot placement, and a beautiful back and neck. Best of all, the viewer, as he or she watched, was conscious not of all of these constituent aspects, but instead of their sum: the performance, or even better the illusion of the work, itself.

Not all the dancers lived up to this standard, and not merely because they didn't look like Suzanne. Some did, or almost. Calegari was fine in all her roles, and superb in *Monumentum* and *Movements*. I missed the edge of vulgarity that Suzanne had brought to their common role in *Tzigane*, Calegari's pelvis not jutting quite as much as Farrell's, the sweeps of her hands not quite so harsh. This, after all, is a spitfire who, at the end of her solo, demands money by touching her palm and then casts a "hex" on the non-payers by flinging out her hands. By comparison with Farrell, Calegari seemed too much the lady, someone slumming from Park Avenue rather than a hellion used to camping out in tents.

The "Suzanne" role in *Chaconne*, which closed the second program, was, alas, danced by Marion Jäger, partnered by her husband Tamas Detrich, both of the Stuttgart Ballet. To be sure, both are perfectly fine dancers. And I congratulate the couple on the birth of their twins in 1992, duly noted in the program bios. Certainly I enjoyed watching a ballerina with some physical substance (read, healthy un-anorexic limbs and even appreciable chest development).

Perhaps it was Jäger's pasted-on smile that suggested to me she just didn't "get" the ethereal, distanced position of the Balanchine ballerina, the Zen aspect of servant to the work that seems particularly important in a work such as *Chaconne*. Perhaps it was the way Detrich picked up Jäger and put her back, the way the line was lost in all those sublime traveling lifts of the pas de deux where she touches down every once in a while on the stage with a single toe like Pegasus. Perhaps it was the fact (all right, I give up) that she wasn't Suzanne and he wasn't Peter (the old, "good" Peter) but just two

dancers sucking up to the audience and doing their lifts and jumps on the stage for applause. Anywhere else, this would have been fine. Here, it wasn't.

The biggest surprise among the dancers (Jaffe after all was a known commodity) was Washington Ballet's Hagop Kharatian, an Armenian artist with a whippet's body and a rare dramatic flair. The grapevine tells us that prior to these performances he had danced no Balanchine; I can only hope that this sudden exposure gives him the overnight success he so richly deserves. Kharatian's body is striking, although a bit odd. He is extremely tall, with broad shoulders, a tiny waist, and what those of my students I took to the second performance identified as a "bubble butt" floating above Nijinskyesque big thighs.

Despite (or because of?) this not-completely-classical body, Kharatian sets the stage on fire. It's evident that at every moment he's a man partnering a woman, a human being caught in a complex physical relationship as well as a dancer on the stage. In *Tzigane,* he grabs the head of his gypsy paramour with his fingers down over her forehead and yanks it back as if he is going to hurl her to the stage and have his way with her then and there. In the so-intellectual *Movements*, he makes showing-off gestures with his hands at Calegari from a half-crouch as if to say, "look at that dame go." Youth, vigor, and testosterone ooze from every pore: a new way of dancing these otherwise rather sedate male Balanchine roles, but a super one. Next time, *Prodigal Son*?

Kharatian brings to the Washington Ballet line-up something it desperately needs: sass and spark. The phrase critics repeatedly fall back on to describe this troupe is "well-schooled," in homage to Grande Dame Mary Day, the company's Artistic Director, which of course implies both praise and faint blame. Certainly the Washingtonian corps for both programs was synchronized (which New York City Ballet rarely is nowadays) and careful. At the same time, it seemed a bit bloodless, so that in *Mozartiana* I had the sensation of watching real dancers (Jaffee and Boal) in front of a filmed background projection. Perhaps because the movements demanded in the two Stravinsky pieces were more fragmented, the Washington dancers were shown off to better effect. And, perhaps predictably, the Washingtonian women did a wonderful job embodying the cool near-goddesses of *Chaconne*.

Watching them, I thought of one critic's reference to soprano Elisabeth Schwarzkopf's "carefully veiled emission of tone": there *is* something carefully veiled about the dancing in this company that makes me long to yell out loud and go get sweaty. Nonetheless, it smacks of looking for something

to criticize to fault them for being so careful in their work with Farrell; probably they were the ideal troupe for this program under the circumstances.

I have the sense of having looked so intensely at this event that small quirks may well have taken on the false status of real problems. If we had had less riding on these stagings, I think everyone, including me, would have come away simply delighted. As it was, there was plenty to feel satisfied about, not the least being the sense of our own relief. Perhaps the thing to do now is leave the event alone. It happened, it worked, we enjoyed ourselves. That should be enough. Now to the next step, whatever that might be.

DanceView 1996

Looking Backward

ALTHOUGH MOST OF THE PIECES PERFORMED by the Nikolais Dance Theater at the Kennedy Center (September 20-24) were made in the 1980s, the entire two-program week seemed to unfold under the sign of nostalgia, encouraging us to look backward rather than forward. Nikolais, after all, had received the most recent Kennedy Center honor for his life achievement, and these appearances by his company, the first of the season in the Terrace Theater, seemed the logical result. It was, moreover, the three oldest pieces offered—*Imago*, the Suite from *Kaleidoscope*, and *Tensile Involvement*—that provided most of the evening's most striking moments, and all of the happy ones. For they seemed relics from one of the most productive and creative times in American cultural history: New York at the heady height of the 1950s and early 1960s, that American version of Paris and Berlin of the 1920s and 1930s, the Age of Rauschenberg, Red Grooms, Cage, Merce ascendent, Abstract Expressionism, and the New York Poets.

How else to react to the final section from *Imago: The City Curious* (1963), a mixture of Oskar Schlemmer's legendary costume play with motion *Triadic Ballet*, Ferdinand Léger's film *Ballet Méchanique*, Balinese shadow puppetry, Calder-like sculptures, and sheer artistic exuberance, than by seeing it as a summation of the Greenwich Village art scene of the late 1950s? There was a parade for three potentates in shoulder to floor cloth tubes attended by Janissaries carrying stained glass lily pads on umbrella poles who paraded around, made wonderful small-then-large-then-small

shadows on the back wall, twisted their hand into Siamese shadows, and made the viewer long for this time when light-heartedness seemed possible, and experimentation an end in itself; for us now only an image, a memory, and a dream.

And it was the 1950s that provided the most eerie and beautiful moments in the two programs, the first two sections of the Suite from *Kaleidocope* (1957), *Discs: Statement of Presence*, and *Pole: Mythical Journey*. The gag in the opener is that the dancers, dressed in glistening Buck Rogers leotards with Greek warrior helmets, all have a heavy metal disc strapped to one foot that they manipulate in cacophonous unison. (I mean "gag" in the way that Paul Taylor uses the premise of armlessness in *Counterswarm*: as a conscious physical handicap that provides the givens for the dance's logic.) The arms are basically non-functional here as well, and the work becomes a dance with and about this strange foot-shield. The dancers hold it up before the audience, balance on it, beat the stage, and protect their bodies with it—all in relentless uniformity, so that there is something menacing in the very facility with which they do it.

The second part is based on another such "gag" as well: two dancers (James Murphy and Sheila Lehner), still in body stockings, are attached to each other by a pole they cup in their hanging right arms. They sway with this pole, walk with it, impale themselves upon it, and use it as an aid to let the woman balance on the man, all in strange slow motion, so that it seemed a sacred and yet lethal appendage to which they are chained for eternity.

If *Imago* was shadow-play from this earlier era, clearly its modern descendent was *Crucible* (1985), the opener for both of the two programs. For here a line of dancers is hidden behind a ramp of mirrors that stretches across the stage. The dancers make kaleidoscopic thingies with their upraised fingers, hands, legs, behinds, and finally whole bodies. Yet the newer work was less effective than the older. In *Imago* we saw the dancers who were producing the fantastic shadows being thrown on the cyclorama behind, and were amused. (The same thing renders charming the animals we make out of hand shadows.) In *Crucible*, by contrast, the bodies making these effects were supposed to be invisible, so that as a perverse result all I could think of was the dancer behind the ramp, and the severed body parts we saw seemed very much attached to the unseen people.

To be sure, another reason *Crucible* seemed weak may be that the Terrace Theater was simply too small for it. When viewers sit this close, the mirrored lower half of the Rorschach image looks decidedly less real than the upper half, and the tendency is to ignore the mirror image visually. Despite

the lighting that turned these body parts into zebras, statues, and what appeared to be the Kenya flag, what this piece gave us was a row of dancers playing an annoying peek-a-boo with their body parts, rather than the series of stunning stage effects that was surely intended.

The theater too played a role in my reaction to *Blank on Blank* (1987). The costumes were stark white for all performers, with hats; the dancers stare steadily at the audience, one of them talks and has a temper tantrum that goes unheard under the more than usually harsh score of natural sounds (water, wind). The whole thing is done against a huge photograph of Wall Street turned in mirror image on itself. Clearly this was Social Protest (or at least Nikolais's idea of it)—but against what? Noise? New York? Yuppie malaise? Many other pieces we're seeing nowadays address similar themes, such as those of the Washington choreographer Daniel West, recently seen in the same hall. Indeed, Anna Sokoloff was doing them years ago. *Persons and Structures* (1984), with its two stacked guinea-pig cages or aquarium cubes filled by various combinations of dancers who stare out from their confinement, seemed to be addressing some of the Themes of the Modern World as well: isolation, voyeurism, passivity, or limitation. Once again, the effect seemed thin, as if, instead of being directly plugged into a *Zeitgeist*, Nikolais nowadays gets his inspiration in a mediated fashion, from other choreographers. It resembled as well Paul Taylor's *Polaris*, a dance that used a larger, skeleton cube to more inventive effect.

Another of the 1980s pieces, *Contact* (1985), was also stamped by borrowings—this time apparently from Pilobolus. The impressively muscular, meditative duet for Alberto del Saz and James Murphy (the latter the reigning dancer in the company, as well as the rehearsal director, and a marvelous presence) seemed to owe much to the gymnastic/contact improvisation "look" of Pilobolus, and the women-being-walked-by-men movements of the last section seemed a quote from the Pills' joyful *Molly's Not Dead*. Yet this, at least, is not an alien aesthetic: both Pilobolus and Nikolais share an interest in stage effects as well as a tendency to abandon the upright torso, so that the quotes seemed at least appropriate to their context.

Not that the more contemporary works were without their striking moments. However, those bits of the 1980s pieces that stuck in the mind seemed to suggest much darker truths than the sunnier and less complicated world evoked by the earlier ones. The most striking single scene from this group of later works was the duet from *Graph* (1984) for two women, Sheila Lehner and Sara Hood (both as supple as the contortionist in the wonderful

Cirque du Soleil, playing concurrently on the Mall in front of the National Gallery). Each is wheeled in by Bunraku-style black-clad attendants, splayed on a huge sheet of vertical, cross-hatched Plexiglas. Never breaking their mesmerized stares at the audience, the two women twist themselves into inhuman, almost grotesque postures like people in silent agony, then return to their crucified positions and are wheeled off. And this excruciating, yet powerful piece—somewhat suggestive, as was *Persons and Structures*, of cages, control and more hypnotic ugliness—was echoed by the solo (Lehner again) in *Contact*, the best part of the piece. (Some idea of the postures can be gotten from Rodin's sculpture in the Hirshhorn Museum called *Isis, Messenger of the Gods*, or from the awkward bathers of Degas pastels.)

These slow twistings in transfigured time for one or two people hit a nerve that the more overtly stagy parts of the 1980s pieces do not—as if Nikolais now sees something darker and more individual in the human soul than he had before. Yet these two programs suggest that he has as a correlate also lost the ability to choreograph effectively for groups—since such choreography was marked in the earlier works by what seems now-vanished innocence. What, otherwise, to make of the crazed chess game of the opening section of *Graph*, without any visible point or even pattern save that given by the graph paper matrix on the stage floor? What of the rushings-in of the white-clad people in *Blank on Blank*, or the business going on outside of the cubes in *Persons and Structures*?

Clearly the Nikolais of the 1980s is a more sober sort on many other fronts as well. The dancers wear more standard clothes, the stage is not infrequently lit in normal degrees of brightness, and when the group of dancers pairs off, it is always male-female. This last is even true in *Crucible*, which begins by demanding that the viewer perceive a hand as a kind of Nessie's head, and a foot as the neck of a strange bird. Yet nothing comes of treating the dancers like men and women rather than as intergalactic visitors, and the viewer's response may be to long nostalgically for the tubes and day-glo sheaths of bygone years that admitted from the beginning that beasties were more interesting—or at least more amusing—than people.

Not to say that the earlier works are without their failures too. The last section of *Suite from Kaleidoscope*, for example, with its buck-toothed grotesques, seemed ridiculous without being cute, and all I wanted to do with the swaying tubes of Stripe toothpaste populating the first section of *Imago* was to squeeze them—and not from the bottom, either. Yet these were faults in another direction entirely than that which seems to characterize the more contemporary works—whimsicality gone silly, rather than the empty lack of

structure that haunts these 1980s works, seemingly caught between a disinterest in the surface and an involvement in the heart that is almost too deep for effective expression.

It may be that Nikolais is groping toward a breakthrough to some other sort of work entirely than that which made his reputation. If so, it was unfortunate that both programs closed from a stunner from 1953, *Tensile Involvement*, a dance for the web of an electrocuted spider, or a geometric Maypole whose ribbons stretch across the stage. The dancers fold themselves among the lines of force, enter into them (making boxes around themselves—the audience applauds), escape them, and dissolve them. This was smashing, exhilarating. Was it a sop to the past from someone who stands before new things, or a marvelous relic from a golden age now irrevocably gone?

Washington DanceView 1988

Spring Triumphant

IT SEEMED A HAPPY COINCIDENCE THAT the Washington season of the Martha Graham Dance Company (March 29-April 2), the first in eight years at the Kennedy Center, coincided almost perfectly with the arrival of spring and the emergence of the cherry blossoms. For the company we saw presented works in which the forces of light were triumphant, where spring sprang eternal, and where pain, suffering, and hopelessness, when present at all, were reduced to the status of unequal competitors in the contest for dominion over the human soul.

To a certain extent, this pervasive sunniness was the result of the particular pieces Graham brought with her. It was also the result of the way dancers are performing her pieces nowadays. And finally, these two seemed linked, perhaps as cause and effect. One of the two recent pieces on the program, *Temptations of the Moon*, consists almost entirely of the innocent frolickings of boys and girls under the influences of that silvery goddess that drives people mad, the moon. For once in Graham, the half-nudity of the men seemed designed merely to show them as creatures of nature rather than as power-mad macho pin-ups, and the circle they make and unmake with the girls (who are nearly shapeless under drapery), folding sideways over each

other in two directions, seemed like the ring dances of virgins, male and female, on a meadow.

The moon, danced at the Saturday afternoon performance by Terese Capucilli, flirts with each of the boys in turn. Yet when some of them attempt to carry her off, she is defended by her male partner, the Velvet Night (Donlin Foreman)—whose part consists of support and presence, as indeed perhaps the sky merely supports the sharp-pronged moon. By the end, the boys had become satyrs and the girls nymphs and things seemed to be heading for a rather harmless orgy, when all at once they loudly counted to seven in a chorus and began stomping in a ring. The curtain fell.

The other recent piece, last year's *Night Chant*, seemed at first glance anything but innocent. Yet its very cartoon nature suggested that when the Graham of our 1980s and her 90s attempts to draw on the spring of darkness from which she once drank such drafts, she conjures up only shadows. Thus the viewer is convinced that they are not so terrifying after all, that spring does in fact reign triumphant. For this piece seems the Saturnalia of a priestess and her male worshipers (there are just as many female devotees, but these fade into the woodwork) that ends in a male-on-male sacrifice. And the whole thing seems done in honor of a sun or moon-like tambourine that the woman (Denise Valel in Tuesday's performance) hangs above her head on the beautiful Noguchi cactus-skeleton that forms her shrine. At times she raises her hands to it as if invoking its powers, and at the end, takes it down.

Yet this is ritual without myth, the motions of a witches' Sabbath with none of its spookiness. On my program I wrote a question for my own consideration: "What makes bad Graham?" I think it is just what we saw in this piece: movements straining for power and achieving only gesture. The men slap their legs to denote power and virility (how much better this worked in *Night Journey*!), carry in the girls upside down (granted, the silhouettes this produced were amusing), and even, at one point, form Pilobolus-like dyads with the girls' crotches held over their heads. The priestess makes swooping gestures with her arms, and her henchman (Peter London) stamps the sacrifice to death with great ferocity.

The Halston costumes of this piece are another feature too we have come to associate with bad Graham: just slightly too colorful, slightly too sleek. (The program credits the costumes here to both Graham and Halston, but the viewer is not fooled.) Furthermore, this piece was choked with props—something we are usually spared in Graham. From the long wiggly poles (bamboo?) with which the men put a hex on their victim before killing him, to the flowery head-bands they removed from the women and carried off

above their own heads, the stage was awash with things as empty and extraneous as the motions of the dancers who propelled them.

I suppose that someone whose introduction to Graham consisted of pieces like these (coupled with, perhaps, *Judith* or *Phaedra*) could perceive her as initiating a theater of self-conscious camp, as Almodóvar makes a cinema of camp. But seen against her older, greater works, they are clearly only bad.

In this context, *Circe* (1963) seemed a harbinger of things to come. Circe (Thea Nerissa Barnes at the Saturday matinée) writhed and ground her hips like a burlesque queen. She was aided and abetted by four lascivious laddies, Snake (Peter London), Lion (Young Ha Yoo—the victim of *Chant*), Deer (Christopher Dolder) and Goat (Mark Borneman). Only London seemed able to give a concrete sense of his animal, undulating and curving his way across the stage, but Goat at least got to rub Circle's scarlet cape against his genitals a number of times before offering it to Ulysses (Julian Littlefield), whom his Helmsman (Kenneth Topping) tries in vain to keep in their Noguchi boat, stage left.

For Ulysses, true to the story, wants to join in the fun, and the Helmsman restrains him only fleetingly. But no fear: Circe, it turns out, makes house calls—joining them in the boat, around which the animal-men dance. At the end, however, even Ulysses has had enough, and the curtain falls on the two men navigating their boat rather more rapidly than at the beginning, in a beautiful abstract motion where the arms themselves almost seem to become the sails. The evil here is so slimy it seems like fun, like a Hollywood *série noire* flick with Barbara Stanwyck, or a good smarmy Douglas Sirk. And it certainly doesn't seem to pose a threat to us. Instead, these are only "villains whom you love to hate"—who really, we know, wouldn't hurt a fly.

Diversion of Angels (1948), by contrast, acknowledges that pain exists: real pain, not this comic book kind. The contractions in the solar plexus of the red girl (Takako Asakawa) who stands on one foot with the other up near her ear and becomes wrenchingly concave on cue, are drastic. Yet the other dancers leaped and cavorted with such pleasant abandon that she seemed the grump who had wandered in from another work (say, *Cave of the Heart*, that terrifying piece where evil triumphs utterly). I had the feeling that the other dancers didn't understand that their youthful joys were supposed to come off as bittersweet. Instead, they seemed airborne sylphs, light and gay.

Some of this is inherent in the piece, given that it is in fact much more airy than many of her works. In addition, the dancers' lightness, their almost balletistic flitting, made the dance itself seem even more than it had to like an

insect's wing, insubstantial gauze of motion strung between the armatures of veins formed by the stationary poses. That is, the yellow girl's leaps into her four-limbs-back jump and the red girl's arms swings seemed mere filler between the still striking static images of the work: the red girl's contractions in pose, the white girl's standing-with-her-hip-stuck-out posture (one of those classic Graham poses), or the male-female couple who sit like mirror images of the Sistine Chapel Adam in a beautiful silhouette against the cyclorama. Perhaps more substance and weight by the dancers would have prevented this sort of binary separation between stillness and motion in these programs.

Nor did *Deep Song* (1937) provide the profundity I was looking for. It was Graham's response to the Spanish Civil War, a kind of *Guernica* on the suffering of Spanish women, distilled into the body of its single dancer. Joyce Herring sits *Lamentation*-like on a white bench, clad in a huge skirt in black and white vertical stripes. Her arms reach heavenward, she touches her temple with the back of her hand in a gesture of suffering, her legs open in anguish (legs that have given birth to those who died?). Eventually she is off the bench, her legs curving through the air in beautiful Graham parabolas of drapery. She makes the bench her cross, carrying it on end on her bowed back, and lies beneath it as if folded into a coffin.

This is a great piece. So why did it leave me so unmoved? Can it be that we have seen so many of its gestures integrated into other Graham works that it seems self-evident to us now? Are we too removed from the historical context that produced it? Or are we simply longing—as I, at any rate, admit I was—for the impossible, namely, for Graham herself to dance this work again with the intensity and conviction that viewers of my generation know only from films?

We will never have Graham do so again, and perhaps it is wrong to look for an incarnation of her among her current dancers. Yet there is at least one among these who seems to have some of Graham's lashing intensity—Capucilli, who showed what she was capable of in Tuesday's *Errand into the Maze* (1947). This dance is one of Graham's myth recountings with the elements rearranged for her own purposes. We have a creature with horns (Kenneth Topping), which presumably makes him the Minotaur, and the string, which presumably makes the woman Ariadne. Yet in this version there is no Theseus. The woman herself enters the maze, her arms curved downwards from her shoulders like an inverted candelabrum, her feet taking mincing steps that twist her over the rope strung out across the floor.

The whipping jerks of Capucilli's head on a count of three to Menotti's eerily symbiotic score while she stands with her arms crossed over her tensed thighs, one arm and one leg reaching out and then being pulled back into the security of her frontal pose, seemed a bit out of control on Tuesday night, not tightly enough coiled to snap back to center. Despite this, however, she seemed more than any other single performer on the two programs to give some sense of the true heart of darkness that Graham once showed us so consistently and so unflinchingly.

Certainly it was not the Minotaur that was her problem. Topping was neither menacing nor fear-inspiring, so that I had time to wonder if the steps had been altered at the end of his first encounter with the heroine. Surely he didn't used to fall on the floor at this point? In doing so, he almost seemed vanquished already, and the brief interlude by the woman that precedes the second encounter seemed almost a celebration of victory—as it turns out, premature. In a curious way, though, the relatively low-level threat of the Minotaur made the woman's fear seem all the more self-induced. And since the program notes suggest that the Minotaur is allegorical anyway (he is referred to only as a "creature of fear,") this may be precisely the right effect. Yet I can't help thinking that Graham intended a more overpowering male threat—this is, after all, her most successful dramatic portrayal of what we now call testosterone poisoning: man as beast.

All of this left me eager to see what such a group of generally so light-hearted and somehow innocent dancers—Capucilli excepted—would do with *Appalachian Spring* (1944), undeniably one of Graham's richest works in its nuanced treatment of real human beings rather than mythical Forces, male and female, who must somehow cope with each other rather than merely conflict. This dance is unique among Graham's works in that all the possibilities along the scale of light and dark are present, parceled out to a number of characters, rather than being reduced to a Manichean conflict of their extremes. The most sinister of the lot is the preacher, who jumps heavenward yet points to hell, describing the fire and brimstone that await all those who do not do his bidding. Certainly he has sucked the life from his four clone-women, who follow him adoringly, hold him up when he is weary, and support his hat during the Big Sermon. Yet Steve Rooks turned him into yet another cartoon villain—scary on the surface but harmless underneath.

At the other end of the scale is the young wife (Christine Dakin), who adores her husband, leaving her house to visit him in the fields and skipping across the stage in giddy legs-up leaps. Yet she too knows some pain: she wants a child. And she feels weak, perhaps alone; she needs her husband for

support against the preacher, who seems to accept their union only grudgingly.

Her husband is the most sympathetic portrait of a man in all of Graham's theater. Donlin Foreman danced the role beautifully, nobly. In love with the wide open spaces, with the house he must have built himself, and with his wife (perhaps in that order), he is respectful of the preacher without being intimidated by him. He strides across his land, gazes at the horizon, and makes great virile movements of ploughing and clearing. The worst we can say of him is that he isn't as much in love with his wife as she with him. Or at least, not in the same way. A man, after all, needs a vocation, while (so the theory once went) a woman only needs a man.

Which leaves the Pioneer Woman as the most complex character in the piece, the one who links together the church of the hereafter that the revivalist preaches and the domestic shrine of the here and now tended by the young couple. Yet Maxine Sherman danced too prettily, too blandly for us to sense the contradictions that surely must be present in the Pioneer Woman's situation. She must have lost a husband. Perhaps the "baby" (arms held in a cradle shape) which is passed back and forth between her and the bride is hers; perhaps it is imaginary, or dead. And although she too gives allegiance to the revivalist, she does not seem to believe all he says. This character is at the center of the two worlds of church and home of this piece—entering both and at home in neither.

There was one other love duet between non-mythical people on the two programs: the "Conversation of Lovers," Part II of *Acts of Light* (1981). Yet this too seemed on the near side of the fence that separates the earlier, far-away, Graham from the later. In contrast to the duets in *Appalachian Spring*, there was no love or warmth in this succession of overstated, too forceful poses, so that the whole thing seemed like an argument in slow motion, two people screaming at each other with the volume turned down. And the third part of this piece, the "Ritual to the Sun," is Graham's shamelessly narcissistic elevation of a Graham class to the level of timeless ritual. Still, this may be a better solution to her quest for the mythical than most of those she is coming up with nowadays. The dancers seem to love it, and why not? It valorizes their lives. It even seems contemporary, having about it a tinge of postmodern self-reflexivity. Yet it also shares the defect of many of the other works of our postmodern age; namely, that it cannot be noble, or moving. And nobility is precisely the effect that Graham is aiming at here—as she has for over sixty years. Now, however, this is apparently beyond her grasp.

What, then is the difference between Graham Then and Graham Now? Usually, this is summarized as a loss of inspiration. Yet perhaps, in a more forgiving mood, we can see what has happened to Graham in a different light entirely. Certainly there is no point, in 1989, in re-enacting the weary tug-of-war between those who are happy to see a great artist producing works of any sort at ninetysomething (which includes me), and those who greet the prospect of looking at yet another of them with a sinking heart (which also includes me). I think we can explain the difference between the old Graham and new in more positive terms, namely as a victory of light over dark. For what she makes nowadays are works that are merely pleasant (as her works never used to be), or like comic strips in their evil and in their blatant eroticism, as if this were the only way she could make a villain any more, or evoke lust.

Still, if my explanation for this development is plausible (less kind critics may simply speak of loss of inspiration), it becomes difficult to tell if her dancers' lightness and tendency to bland quickness, as well as their tendency to make the pleasant more pleasant and the evil positively silly, is cause or effect in this process. Perhaps they deserve one another, Graham and her current dancers—or at least mutually reinforce one another. And if this means that spring has finally triumphed over winter in Graham's once-cavernous heart, we, her fans, can only be happy for her, and wish her well. The audience that rose to its feet on Tuesday night at the sight of her dressed in a glittering silver tent clearly did. And so did I.

Washington DanceView 1989

Thoroughly Modernist Merce

ALTHOUGH MERCE CUNNINGHAM was on the Kennedy Center Honors list four years ago, the appearance this spring at the Center's Eisenhower Theater (May 2-7) was a first for Washington's foremost center of culture. In fact, it's only recently that he's been appearing regularly in "uptown" halls in New York. The astonishing thing was just how much at home in the gilded and velvet opulence of the Kennedy Center Merce's works seem—to what an extent they are to the manner/manor (or at least to the Center) born. For this called into question the received wisdom which understands Merce as the bridge between modern and postmodern dance. The Kennedy Center

concerts made it clear, in fact, that Merce's closest kin are not to be sought in the realm of dance at all, but instead among the modernist writers and artists of the turbulent teens and twenties of our century, a period of which he seems the last living relic.

Merce, of course, has always emphasized the philosophical aspects of what he does—which makes it easy to see his works as related to the efforts of artists, writers, and composers. Yet the temptation is still strong to see him in purely terpsichorean terms, bracketed by modern dance on one end and by Judson on the other: rebel angel of the Graham band on one hand, prophet of postmodernism on the other. To be sure, we can see with no problem how he diverges from modern dance (especially after the Graham season in the Opera House a few weeks previously): his works lack the presupposition of audience perception of visual structure that marks modern dance, even Graham's later pieces.

Yet after this week at the Kennedy Center, neither did it seem right to conceive of Merce in the terms of the dance world's 1960s postmoderns, who (among other things) were interested in somehow opening up dance to daily motions, everyday spaces, and less direct control by the choreographer.

For Merce does not make what by any stretch of the imagination could be considered populist dance. Instead, it is rigorously elitist and hermetic, like all modernist art. Although he may talk a rhetoric of artistic modesty implied by the elements of chance, dissonance, and audience subjectivity that he incorporates into his works, he ends up with Art and the Artist on a pedestal higher than anyone had ever imagined possible before. And this is a paradox, one seen before only during the period of high modernism, in writers like T.S. Eliot (whose word for artistic modesty was "impersonality"), Joyce, and Gertrude Stein, and in artists like Braque and Picasso.

What this paradox means (a paradox that Merce's work shares with all the products of the modernist 1920s) is that when you're in the mood for this kind of rigor and purity, his works seem like food for the gods. In fact, when you're not in the mood, they still seem like food for the gods. The only problem is, we're not gods, and require other fare. (Some of the Washington critics turned themselves inside out to deny this duality, beating the drum instead for Merce as—of all things—accessible, and implicitly denying as Philistine the reactions people have been having to modernist art for decades, namely puzzlement.)

My first exposure to Merce was in his studio at Westbeth, in the early 1980s, at one of his evening-length pieces pasted together from snippets of

other dances. I remember being conscious of the people around me on the bleachers, of the walls of the studio, of the windows looking out onto lower Manhattan, and of the dancers, who didn't disappear into the wings (there were none) but breathed hard on the sidelines. John Cage sat a few rows down, but there was no music. Merce danced, with his knobby feet feeling away at the wooden floor like suckers. The lights were kept high, and perhaps for this reason, I was conscious of everything going on around me. The dance seemed unable to compete with its surroundings, or to be merely one more piece of visual noise in an already noisy environment.

Jump to the Eisenhower Theater, May 2, 1989, in all its sleek mahogany-paneled purity. The hall floats, out of space and time; the darkness is absolute. In the four corners of the hall, the up-to-the-minute technology of speakers as big as refrigerators fills the darkness with the buzzes, whines, and clicks of David Tudor's *Rainforest*, which gives the title to the opening work (1968), so that the audience feels enveloped in these sounds and can almost feel the dampness oozing up from the floorboards. Then the curtain rises, and dancers are revealed on the fully lit stage, curling and uncurling their hands by their sides like the nodes of ferns. They move sideways, with square-legged skitters: insects, perhaps. The music changes to a tractor's growls; one thinks of the latest news from Brazil, where the Amazon is being bulldozed away, minute by minute. A man butts a couple with his head, as if an animal. Other dancers are added one at a time, and sparingly, as if all were creatures flitting from place to place. A girl swings on a boy—a monkey? And of course there are those famous silver pillows of Andy Warhol, lying sodden on the floor, save when a dancer's leg kicks one of them out of the way.

And then it is over, and the viewer goes out to the lobby to think, or perhaps talk, things over. What made *Rainforest* a coherent piece? Warhol's set, for one thing. For another, the title, which imposed a certain set of associations on the music (which in turn was perhaps following its own title in choice of sounds), and in a secondary manner on the movements. The fact that the curtain had been raised and lowered. But perhaps most of all, the fact that it was being presented here at the John F. Kennedy Memorial Center for the Performing Arts, where we had come with the proper attitude of respectful attention, and where we knew that it was good manners to pay attention to what was going on on the stage. Like virtually all Merce's works, it lacks any visible over-plan that allows the audience to "think along" with the choreographer, denies us any sense of beginning, middle, and end. Instead, we are condemned to accept what the choreographer dishes out:

love it or leave it. So why is it more worthy of attention that (say) seventeen minutes of watching traffic on Virginia Avenue outside? It cohered largely because of the lack of distractions such as those that plagued me at Westbeth, as well as because of a more than usually suggestive score.

Watching the second piece on Tuesday's program, in fact, *Five Stone Wind* (1989), I thought of the way we watch clouds form into patterns and then pull apart, or the way printed words on a page sometimes seem to form patterns in the white between them. Here the pattern is largely to be found in the recurring theme of turns that take place in varying configurations. Merce himself dances at the beginning and the end, his fussy, fluttery hands and feet held together in the middle by a purple leotard which blurs into the purple backdrop. The movement looks familiar too—almost balletic. There are even lifts, and a pose of one boy and two girls that looks like a barefoot version of the tableau from *Les Sylphides*, then a version of arabesques in attitude, then a moment where the girl puts her foot on her partner's shoulder like Farrell's famous drop-dead pose from *Slaughter on Tenth Avenue*. A woman sways from side to side as if in water or one of the hanged people from Balanchine's strange *Gaspard de la Nuit*. Two dancers smile at one another in a fast pas de deux while a slow pas de deux is going on behind them. Another girl repeats her signature side-to-side scuttling run across the stage.

What makes it cohere? Perhaps, for this piece, all these hints of classical, and neoclassical ballet. Indeed, many of the pieces have some overall characteristic of this sort. In any given piece, Merce always seems to have been thinking in a single general direction. But this is not enough to hold it together, as opposed to merely giving it a taste. What holds it together is not the content but the frame: the darkness, the societal importance of the Kennedy Center and all the feelings this inspires in us, perhaps the acoustic purity of this airtight cube of the hall, in which the tiniest switch on the sophisticated Japanese cathodes hooked to mikes is audible. The eponymous music, by Cage, Takehisa Kosugi and David Tudor, also contains sounds made by patting a series of clay pots to produce differing tones, and striking a section of bamboo. The piece coheres because of the very isolation of all these experiences from the world outside us—not because of an intrinsic connection with them. Even if we are unable to do more than accept passively each successive moment of what is going on on the stage, there is at least nothing else to distract us from paying attention. And pay attention we must.

How, I wondered at intermission, looking down at the river, could we ever have thought that Cunningham was telling us something about life? At

most, he was telling us something about art. Namely, that if an audience is willing to give its attention to a limited number of stimuli under exceptionally pure conditions, the resultant experience will be more intense than experiences of the other things which fill our lives to which we give only part of our attention. This is not dance making a philosophical point; least of all, as is sometimes suggested of Merce, that the world is not logical, does not follow dramatic forms, or is full of aleatory and unexplained happenings.

All life exists to end in a book, proclaimed Flaubert, that great proto-modernist. And the later modernists heard the call, producing works that dispensed with most of the things that, since the Renaissance, had been incorporated into art to allow the audience to follow its unfolding: plot in literature, representation in painting, melody in music. The artist of whom Cunningham reminded me most during Tuesday's program was that great literary modernist and enemy of plot, Gertrude Stein. For her pieces exhibit just the same sort of chaos wedded to order as Cunningham's, and in neither case is one sure where the line between these two is to be found. In both cases, moreover, the work itself relies heavily on external frames to produce its closure—the fact of print, in Stein's case, and a title that marks the beginning. The sensation of reading one Stein work is, with minor variations, virtually identical to the sensation of reading another, just as Cunningham's works too tend to merge into one great Work-in-Progress, held apart only by their slightly different "feels."

Yet it is clear as well that with Cunningham, as with Stein, we are not supposed to be distracted, or bored, change the channel or turn the page—as we would do if we had a similar experience outside of these framing circumstances. Instead, we are supposed to follow this work from beginning to end, and then applaud. And what this means is, we are supposed to deliver ourselves totally to the power of the artist—for ultimately the strongest unifying factor we have is the knowledge that a person has made this and is presenting it to us as a work of art.

Such demands on the audience: to follow where one is led merely because one has faith in the artist leading us! This is the first hallmark of modernism. It demands a high entrance fee, psychologically speaking. And yet, if we accede to these demands, what an experience! Successful works give us more than our money's worth in return. This is the second hallmark of modernism.

Thursday's program began with *Points in Space* (1989), which was as pure and unyielding a work of art as ever sat on a Plexiglas stand in a museum with white walls. It was beautiful. Victoria Finlayson, who has an

unbelievable solo near the beginning, is one of the century's great dancers. And she has a perfect partner in David Kulik. And a perfect choreographer in Merce.

This was noble dance. The people are men and women (rather than the usual Merce unisex bodies-in-motion) and pair off accordingly. Many of the progressions of steps follow the patterns for pairings and trios in the classical ballet (first together, then each separately, then together). There was what seems a quote from the "chariot" scene in *Apollo*, a hint of *Serenade* (where the "Poet" turns the girl by her leg), and a moment that had apparently strayed from *Tarantella*. Finlayson does a backbend, with her foot in a gorgeous arch. Kulick, who has been watching her, joins her for a kinder, gentler version of the pretzel-like *Agon* duet (here, he puts his arm through the hole formed by her arms in a backbend). The group comes back and does jumps in unison. The curtain falls.

In Balanchine, we know what is going to come next, or hear it in the music, and recognize deviations as being deviations. This means we are conscious of the given of the classical style that, despite everything, he remains true to. In Cunningham, we never know what to expect. And this means we are perennially conscious of the Artist, who is charting the course we see, but do not understand. Of the two artists, it is Balanchine who disappears to the greater extent behind his art, precisely because his pieces seem so complex and substantial on their own. Cunningham, by contrast, never ceases to be present.

If *Points in Space* is Cunningham's Balanchine piece, *Fabrications* (1987) is his *Tanztheater* piece. The women wear, for once, dresses, and of course are barefoot; the men wear pants. And thought the men-beating-up-on-women aspect of the *Tanztheater* of Pina Bausch, is missing, there are some of the same obsessively repetitive gestures. The music is German music hall 1930s for a while, then the bells of Mother Russia are heard from deep within the scratchy collage (by Emanuel de Melo Pimenta). The mood is Central European. The girls dance in a circle. Merce comes in, doing the same wavy movements as the other dancers, but more fluttery. A while later he comes in again, a flitting rage of arms. He leaves. The music changes to a solid chord. Merce is on with three couples. A girl runs across the stage; a boy catches her. The viewer thinks of *Esplanade*. A couple goes hand in hand. The boys are in a large circle, the girls in a tight knot in the middle. The lights dim.

By then I was flying, completely enthusiastic. I thought: who needs *Lilac Garden*? This has all that Tudor has, and more—hints of Bausch, the new

Flemish school, even Taylor. Yet even my high was a thought high, rather than a feeling high. Cunningham, like many modernist artists, provides a feast for the intellect: he reminds us of so many things, without delivering any of them. And for this reason, he teases the emotions. Merce doesn't effect catharsis—he doesn't want to, as if this were too vulgar. Instead, he merely refers to it, as if in quotes. By the time I hit the lobby, my exhilaration had faded.

Cargo X (1989) came the closest of any of the works shown during this week to having a structure comprehensible to the viewer. But because it ultimately did not fulfil this promise, its hint of doing so was almost a betrayal of the more rigorous of Merce's works. (One must have something of a Marines mentality to enjoy Cunningham, I thought. The harder going it is, the more one is supposed to like it.) This one involves a ladder that the dancers bedeck with flowers. They bring to it one of the girls, who seems dead. They tilt the ladder down over her, then do so once again later on, and finally take it down at the end. In the music (by Kosugi) there are fragments of Gregorian chant, guitars, and singing. Is this ladder the place where a political dissident met his death? Are the dancers helping out the stagehands with the decor for a new production of *Coppélia*? Of course not, we hasten to reassure ourselves. This is Merce. But then, what *is* going on? Isn't that girl who's flat on her back supposed to be dead? With most Merce pieces, of course, we can never ask such questions, and so they never bother us. Here they are both raised, and left without answer.

The other "coherent" piece presented during the week was *Pictures* (1984), where pairs and trios of dancers form a plastique- or Pilobolus-style tableau on which the lights go out, forming silhouettes against the white backdrop. The music (David Behrman) contains eerie shreds of Irish harps. Merce's presence makes one aware of the youth of the dancers. Is the stop-action a reminder of the transience and fragility of youth, the fact that beauty must fade if it cannot be frozen in the eternal forms of art?

Field and Figures (1989 again, a productive year) was a return to purer fare. The only coherence the work has is lent it by a revolving golden disc that catches the lights like a moon, once each revolution. (Again, this is a factor of staging, not of movement.) There is a central pas de trois (one woman, Finlayson, with two men) and a large number of other dancers, including Merce. The music (by Ivan Tcherepnin) is distorted fragments read from a text of Marcel Duchamp. At one point, the two men bring in Finlayson in a crucified posture, but by the time the curtain goes down in the middle of motion, the men are long gone—and in any case, the posture has

been abandoned. At times all this was beautiful, especially if we were willing to give ourselves up to the power of the Artist. At times it was frustrating, even maddening. Why *this* movement *here*? Are we near the end?

We can say many things about Merce and the sensations we have watching him. Yet the one thing we may not call the kind of work he produces is new. Only an hour before the Sunday performance, I was in the East Wing of the National Gallery, another of Washington's culture temples. There, an over-loud docent was explaining to a group of tourists the "meaning" of a Picasso newspaper cut-out: to show that art did not need to be made out of noble, permanent materials, she said. Yes, one of the people said, but wasn't it funny that the frame should be so traditional and massive, and gilded to boot? I pricked up my ears and wanted to add: and isn't it funny that this multi-million-dollar building of marble has been created to house a work made of torn newspaper?

Yet in a way, the answer is no. For of course Picasso intended us to give the torn newspaper the same attention we give a Titian—on the grounds that both are Art, and by Artists. The paradox of this Picasso piece is the paradox of Merce; the difference that Picasso was doing it back in 1914. The paradox is that an art that insists on respectful attention merely because it is art removes itself that much more irrevocably from the rest of the non-artistic world, no matter what it includes within itself as content. The logical conclusion of this is the much-quoted definition of art from the 1950s: art is whatever artist do—not, that is, a sort of content or even a sort of method. The second paradox both of the Picasso work, and of Merce (whose works are its brothers), is that precisely the works which dispense the most fully with guideposts to help the audience follow them actively, like plot or representation or visible structure, cry out most strongly for the proscenium stage, the museum pedestal, and the white space of the printed page. It is, in fact, only the museum that turns Duchamp's famous urinal into a work of art.

Merce's works, I thought in May, need to be performed in the classiest, most posh halls in the world, just the way Picasso's torn newspaper needed its frame of gold leaf and its building made of marble. (Balanchine, by contrast, would work in a barn, because the work itself is not in danger of merging into the chaos of the world if the frames that call forth our attention are removed.) An example from John Cage makes this point even more clearly. Consider Cage's much-cited *4'33"*, where the pianist sits in silence for four minutes and thirty-three seconds at an open grand piano. In order for this to work, we need the hall, the pianist, and the piano. (Think how cheated

we would feel to learn that the man sitting at the keyboard couldn't play at all!) And it requires the ascription of the result to Cage, the Artist behind it all. Hearing the sounds of coughing and rustling, the air conditioning system during this period of time under these circumstances is not the same as, say, suddenly becoming aware of the crickets outside on a summer night. This, after all, is Art.

Art makes the stone stony, said Victor Shklovsky, one of modernism's most agile polemicists. But people understood at the time that claims of this sort—endemic to modernism—were little more than wishful thinking, and assertions of the kind were ultimately abandoned. No one believes now that reading *Ulysses* or looking at works of high academic cubism has anything to do with the rest of life. Modernism cannot make us experience life outside the work. What it can do, however, is make works that require us to pay such close attention that the resultant experience seems more important than life. And this is both their value, and their danger.

Cunningham's works are modernist works, and are seductive in just this way. There is no danger of Merce's drawing us into a world of chaos and disorder (as "unenlightened" critics still claim). But neither can he liberate us to the feel of our real lives outside the theater (as "enlightened" critics tend to say)—for the point is precisely that these pass without the attention that his works demand as their due. The only thing Merce can seduce us into is the world of art, that world of things that takes place inside gilded frames in marble buildings—or on stage at the Kennedy Center. Merce is both god and devil. But so were all modernists both gods and devils. And Merce, above all, is a modernist.

Washington DanceView 1989

Talking Merce

PERHAPS I HAD FORGOTTEN THAT the haze of memory—or desire—is golden. If so, I was reminded anew by the conference on "Black Mountain College and Merce Cunningham in the Fifties" held in Troy, NY under the sponsorship of Russell Sage College and the Dance Critics Association. Nostalgia alternated with high-intellectual twaddle in the overheated lecture hall that was the venue of most events, and both gave way to momentary infusions of realism before shifting once more into the key of longing for a

time gone by, playing a song of love for one brief moment of youth when anything seemed possible.

The conference opened, fittingly enough, with a summary overview of Black Mountain College, offered by conference hostess and Russell Sage professor Jane Roberts. (Later, conference co-coordinator, New York University professor and self-proclaimed postmodernist Marcia Siegel asserted stoutly that there are, as we all should know, no such thing as "facts"—which made me wonder whether Black Mountain had existed.) Born in 1933 as the result of an academic spat (the founder was fired by his home college in Florida), the institution, whose rarely-awarded degrees remained unaccredited, started out in rented church buildings and never grew beyond the size of a few score students. It eked out a precarious existence for slightly over two decades in the hills above Asheville, NC, and had all but fallen apart when, in 1956, an end was finally and, it appears, mercifully put to its debt-plagued life.

Constantly roiled by faculty infighting and a chronic lack of resources (the library consisted of contributions from professors), it had gained even during its lifetime some national profile as a "progressive" college that welcomed expatriate Europeans such as Josef and Annie Albers and later harbored megapersonality and poet Charles Olson. In the phrase of Martin Duberman, who wrote one of the two definitive books on the college (the other was written by Mary Harris, who led a session the first day and whose erudition and deft modesty did much to keep things on an even keel), Black Mountain was "an exploration in community"—and clearly, in his view, one that ran into a dead end.

For those of a certain generation and mindset, the college needed no introduction, having long ago taken on the fetishistic quality associated with the vision of "Paris in the 1920s" or "Berlin in the 1930s." "Black Mountain" as a name means, in some circles, freedom, experimentation, and the New York aesthetic of the 1950s. The first "Happening" took place at Black Mountain, we are told, as did all sorts of wild and wonderful artistic experiments including summer performances of the music of John Cage and exhibition of some of the first geodesic domes of Buckminister Fuller. The fact that the locals apparently suspected the entire college of sins of Communism and free love only serves, in retrospect, to polish the college's lustrous image as a bastion of free thinking in an otherwise repressive era.

Not that everyone at this gathering was peddling a beautified version of the past. White-maned Nicola Cernovitch—currently lighting designer for Les Grands Ballets Canadiens and a longtime student at the

college—dismissed the scholarly papers as "worms feeding off the dead" and suggested that *Water Music*, a brief piece by longtime Merce collaborator Cage involving a piano and a series of noises that recent New York University Ph.D. William Fetterman had just analyzed, simply wasn't worth the energy.

Onetime Black Mountain student and Cunningham Company member Viola Farber pointed out that living conditions at Black Mountain had been nothing short of dire, with many meals consisting largely of okra and no heat in the winter (wonderful training for later living in New York, she suggested). Carolyn Brown, lead dancer with the Cunningham company in the 1950s and 1960s who spent some summer months at Black Mountain, ended her contribution to a panel discussion moderated by company archivist David Vaughan with a quote from a longtime Black Mountain faculty member, who asked of her fellow Black Mountaineers in a rhetorical summing-up (my paraphrase): If we are all so talented and artistic, so insightful and free, then why are we such petty, spiteful dreadful human beings?

The college's importance for the arts world, at any rate, would seem to lie not so much in what sent on during its academic sessions, but (as at Bennington) in the fact that it offered a summer haven to artists, including the then-struggling Cunningham. (Merce got no pay, as Brown pointed out, not even transportation expenses from New York, just room and board and a place to rehearse.) The articulate and reflective Brown evoked a physically beautiful Merce from the 1950s, a dancer then at the height of his powers, preparing a solo in the college's rustic dining hall/auditorium. She recalled wondering at the time what this world-class dancer was doing in such a provincial backwater instead of on the major stages of the world. (So much, I thought, for Black Mountain nostalgia.) The world, Brown suggested rather sadly, never saw the young Merce at his peak: those were the years where the company would rehearse for a year for a single concert that was sometimes canceled. The sense of melancholy, waste, and the struggle of genius was almost palpable.

Despite such recollections, the general tone of the conference was hagiographic. Dance Critics Association Fellow and graduate student Natelie Gerber expressed her sense of awe before the assembled luminaries and the phenomenon of Black Mountain. Those who had "been there" were treated with kid gloves, trivial events took on great importance, and all anecdotes were received with appreciative interest and laughter (to be sure, many were genuinely funny). Yet I thought it a reality check to realize that the hall was

largely filled with undergraduates who were dutifully checking off assignment sheets on each piece of dance discussed (date? title? does it tell a story?) and who wondered audibly, in the break, what was going to be on the quiz later. When Cernovitch asked in wild and somewhat discouraged abandon who among the students had read Joyce and D. H. Lawrence, only two women (who turned out not to be locals) were willing to admit to the crime, and only a few more acknowledged having heard of these two. The undergraduates seemed most interested, in fact, when they got to strip off their sweats and participate in the dance class led by dancer, choreographer, and critic Gus Solomons jr. in preparation for that evening's presentation of an early piece of Solomons structured by chance procedures.

Chance was another key word of the conference, with an emphasis on Cunningham's incorporation of methods of choreographic construction involving the I Ching and dice. Indeed, the blurb in the front of our booklet informed us that the conference would examine "the far-reaching implications of [Merce's] work with chance procedures in choreography." By the time I left, however, I had failed to see anything far-reaching at all about these much-mulled-over procedures, although I did understand much more about the process of petrification by scholarship happening before our eyes which had made them so famous. They ended up seeming nothing but technical tools for dance composition, of interest perhaps most of all to a class at conservatory, and not at all to a dance audience.

Yet the fact is that forests have fallen, drowned in oceans of ink, to mount defenses of outlandish theoretical claims for this "use" (I dislike the verb in this context and heard it continuously) of chance by both Merce and John Cage. The gist of the argument is that Merce and Cage were somehow, for the first time in human history, attempting to acknowledge contingency in a way that earlier, too-hermetic and too-structured artists and artworks did not. The point is a philosophical one: the universe is governed not by order but by disorder, so it's high time that we made art that reflects this truth rather than hiding our head in the sand with old paradigms.

The argument in fact was made decades earlier by Gertrude Stein, and it gives those who peddle it a delicious feeling of being the first to see the light of truth in an age of darkness—a feeling that, I think, is at the source of much of the awe that some of the scholars exuded before the grotty reality of Black Mountain College and the works of Cunningham and Cage.

Sara Rudner, a former dancer with Twyla Tharp and a choreographer in her own right, showed and, with the help of Deborah Jowitt, explicated a solo she had made involving chance-determined structures. Her piece turned

out to be one of the high points of the conference; it was followed by Solomons's dance class, and the evening offered the performance of his piece.

Rudner's dance was fascinating. As much at home with words as she is with motions, Rudner described in vivid terms her initial resistance to allowing a sequence of movements she had invented for herself be re-arranged based on a system of throwing coins (which she had herself chosen as her chance technique—think about that one). At first, she said, her body rebelled. Then she learned to love the discipline and ended by feeling that she had triumphed over adversity. Your humble correspondent (never able to keep his mouth shut) opined that this wasn't a "use" of chance per se, but only an incorporating of purposely frustrating constraints that could just has easily have come from, say, the decisions of a malevolent child (and hence not from chance at all). Could Rudner imagine being told how to move by a such a malevolent child? I asked. To which Rudner responded with what I thought the most quotable line of the conference: "I did just that for twenty years." (She then went on to say just how much she had learned from Tharp, the particular malevolent child to whom she was referring.)

The problem with talking of "using chance" is that chance (which Siegel insisted had to be distinguished from "indeterminacy," although I didn't see why) can be argued to be a fact of perception, not of the way things are. We say that it's chance that it rained today, or that the penny fell heads up. But what this really means is that we personally don't know what the causes were that produced this effect—not that no one could find out if enough time and energy were invested. In fact, it's nonsense to say we "use" chance; at most we simply become more aware of our ignorance than we were before. And true indeterminacy (i.e. cannot by anyone under any circumstances be determined, as opposed to: as-yet-undetermined or undetermined-by-me) exists, if I understand current science, only at the levels of quantum mechanics at one extreme and perhaps the macrostructure of the universe at the other. Drawing cards ain't it.

Ultimately, indeed, the strongest philosophical claim for the importance of this concept falls victim to its own success and so becomes trivial. Let us admit that chance in a stronger sense (that is: of true randomness) really is all around us. Then it's equally chance that we have the bodies we do, that we're born when we are, that a certain phrase comes out of us at a particular time. Any composition, therefore, "uses chance." Why, I wondered, is it more profound for Rudner to disrupt her initial (chance) phrase with the roadblocks she had after all chosen to put in her own way (such as the

re-arrangement of actions due to a penny's fall, or an ordering from the I Ching) than to let it simply flow, or re-arrange it to a way that seemed best to her at the moment (also, in the broader sense, an effect of chance, of mood or body type, and perhaps even of what she had for breakfast)?

Robbed of its philosophical glow in this way, the notion of "using" chance in dance construction becomes a matter of limited interest to anyone but the choreographer him- or herself. Indeed, Carolyn Brown made clear that Merce never broke his Olympian aloofness to the point of even discussing the concept with the dancers, much less an audience. Implicitly criticizing Natelie Garber's beatific vision of Cunningham works as expressing community, sharing, and openness to contingency, Brown told of Merce the taskmaster, obsessed with the perfection of his own pieces and tyrannical to the dancers, even if loved by them. According to Viola Farber, he didn't even apologize for slinging her about so hard in one performance that her head slammed against the stage and she saw stars. The dancers' job was merely to do what he wanted, as the audience's was merely to watch. So much, I thought, for the notion of a new dawn of freedom and openness to contingency in these works. Even a banana republic is free for the dictator who runs it.

All of this ended up corroborating my own view of Cunningham: a modernist artist par excellence, committed to the hermetic work that would somehow provide secular salvation, a work accessible only to those who had dedicated their whole beings and souls to its (1) creation or (2) presentation or (3) perception. Not a friend of accidents at all (precisely because, whatever their compositional techniques, virtually all Cunningham dances are set before the dancers see them, and certainly before they are performed), Cunningham was and is one of those obsessed artists that have haunted our post-Romantic imaginations for the last two centuries, people whose own conviction in their message serves to give a point to the more faded lives of other humans drawn to that person's vision.

As the conference went on, I thought of the aged Hemingway, his body a boozed-out wreck, married for the fourth time, inventing and creating a youth for himself in his rhapsodic hymn to his own youth entitled *A Moveable Feast* that he wrote in Cuba, his evocation of wonder years in Paris of the 1920s where genius consorted with genius, when love was still possible, and when the very poverty of those who later became world-famous focused their minds wonderfully on their art. I have always loved this book, although I know it is hogwash, or at least is more about its own creation than about any objective reality. It wasn't Nick Cernovitch's image of the can of

worms I left with as a controlling image for the conference, but rather one of moths drawn to a candle: the now-aging dancers, the scholars, the students (whether respectful or ignorant), and the critics, all of us sitting for the weekend in this stuffy room to mull over the phenomenon of what we call genius.

When the conference was over, I left the lecture hall and drove out toward Vermont into the brilliant fall sunshine, the hills aflame with reds and yellows so intense they hurt the eye. The air was crisp and cool. I stopped the car and let out a yell.

DanceView 1994

Open and Closed Forms

IN THE SECOND MOVEMENT OF Mark Morris's *Maelstrom*, performed by the San Francisco Ballet May 17-20 during its spring run at the Kennedy Center, a man falls to the stage and lies on his side, his back to the audience. The moment is reminiscent of a visually similar tableau in Balanchine's *Serenade*, where a girl falls to the floor and lies sprawling. Yet it was the difference rather than similarities between these two gestures, one in Morris, one in Balanchine, that set me thinking about Morris's aesthetic, musing as to why all of Morris's pieces leave me with the sense of "Yes, but—"

In *Serenade*, the girl's fall is part of a pattern of near-ruptures to an otherwise overwhelming unanimity of movement, a pattern established at the beginning of the ballet when all of the identically-clad girls drop their right arms, outstretched as if to shield off a great light shining from stage right, open their feet into first position, and curve their arms down to their sides. The effect is that of willingly assuming discipline, as if a stage full of novices were all taking the nun's veil at the same time.

Yet *Serenade* is at the same time riddled with moments where this discipline is questioned, the unanimity ruptured: by a girl who "comes in late" and assumes her position along with the others, her arm outstretched; and by the girl who falls (both of these are based on real events that took place during initial rehearsals). Further, the one who falls plays a role in the unsettling trio of the slow movement involving the man usually referred to as the "Poet" and the woman who shields his eyes, the "Angel of Death." Then there is the odd closing sequence where a loose-haired woman is carried

offstage into the light like a figurehead, her arms outstretched and her throat exposed as the music rises to a crescendo.

In *Maelstrom*, the man on the floor is part of a pattern too, only it is a different kind of pattern. The pattern is: if we've seen it once, we'll see it again. Sure enough, near the end of the piece the floor is covered with seven men, all lying in an identical pose. Yet at neither point does the movement suggest exhaustion, or death. It's just a movement, like the other recurring motives of the work—which is set, apparently for reasons of touring convenience, to the music of Beethoven's "Ghost" Trio (only three musicians). The other motives of this work function in the same way, namely as bits that show up later in different contexts. There's the stand-like-a-crane motif; there's the put-your-palm-out-like-a-traffic-cop motif; there's the stare-at-the-audience-and-shift-your-weight-from-leg-to-leg motif. This one is supposed to be funny, as if a rupturing of the "fourth wall" convention could still be worth a laugh.

Unlike Balanchine, in whose works people falling are always people falling, and people meeting are people meeting, Morris offers dehumanized carriers of movement who come on, do their thing to the music, and then go off. Indeed, one of the main motives of *Maelstrom* consisted precisely of the comings and goings. Dancers often enter a side of the stage only to be whisked off, exit in the same plane that they entered after their little bit, and remain so anonymous that I thought of the table-top soccer games where the players are in rods that you can pull in and out before spinning them to hit the ball. It was as if the stage were a hole poked in a much larger fabric, with equally interesting movements going on before and after the dancers' entrances and after their exits. We just happen to see this part, but we might have seen something else, and that would have been fine too. The effect was decentering: neither the stage nor the audience is on target, all of us perpetually somewhere in the hinterland of either perception or presentation.

Other critics have noted this decentered quality of Morris's pure dance works (those not set to texts). Many speak of it in terms of Morris's acknowledged rejection of the pas de deux as central to dance, whether this be male-female or same-sex. Morris' unit is the group, it is widely pointed out. Yet I think the lack of a pas de deux in his works is a symptom rather than the cause. I am more bothered by the homogeneity that his dances acquire as a result of the movements being stripped of their human meaning, as in the case of the man who falls and the fact that dancers are treated as mere carriers of motives, and so seem on the stage bland and anonymous. They come on, they do tasteful or amusing movements that build sequences,

then they go off. Now what? I always think. (I thought this after seeing Morris's much-acclaimed American Ballet Theatre commission of a few years ago, *Drink to Me Only With Thine Eyes*, and after his dances for the White Oak Dance Project, in town during the same week as San Francisco Ballet.)

Film theorists speak of a distinction between "open" and "closed" forms, meaning whether what we see on screen seems visually accidental, cut off by the frame as if by chance (open forms), or whether we see a series of arranged tableaux that render irrelevant the world outside. Closed forms are typical of formalist films, such as the German Expressionist *Cabinet of Dr. Caligari*. Open forms tend to be associated with the naturalism of a Jean Renoir, characterized by deep focus shots and outdoor settings, or with the self-referential playfulness of the early Godard, whose films acknowledge through their jump cuts, their addresses to the camera, and their use of old-time techniques that this is just a film.

Morris, I thought, is quintessentially the choreographer of open forms—clearly so when compared to Balanchine, whose closed forms took over the stage in the Opera House for the San Francisco program's closer, *Symphony in C*. In this work, we see pattern after pattern constructed for us right there on the stage. We can't look away for fear of missing a relevant fragment; on the other hand we know for a certainty that nothing is going on in the wings—this is, after all, a dance, and the dancers only come to life when they come into our view. The patterns always rise to smaller climaxes and then to larger; we are scaling mountains, not going over a series of hillocks.

In *Maelstrom*, I couldn't shake the conviction that the people speaking in these movement fragments were continuing to carry on their conversation away from my view—in the same way that the apologist for cinematic naturalism, André Bazin, insisted that the illusion of films by Renoir or William Wyler is that the world exists outside of the camera's frame. By the same token, we didn't learn anything by seeing the same motives come back a third or fourth time. If I had fallen asleep during the piece and been shaken back to awareness, the blackout wouldn't matter. The structure of *Maelstrom* isn't cumulative, it's one plus one plus one plus one, with some loopings-back.

Morris's pure dance pieces all have, for me, this one plus one plus one feel: they go on as long as their music, and then they are over. They do not, in an Aristotelian sense, have a beginning, middle, and end. This makes them agreeably open-ended, in the way that many contemporary works are

open-ended. We have the feeling that, like "film-school" films from the 1980s full of references to other films, this is deeply self-aware, and deeply cool. It is also exhausted choreography, dance at the end of its tether. Give me the stage and the music, and I can put movement to it, this aesthetic seems to say. I say, reverting to French for flair: *à quoi bon*, other than filling the evening or giving the dancers work?

This emphasis on the movement itself with the choreography being a kind of liquid poured into bottles of various sizes and shapes explains why Morris is so attracted to text (roughly half his works), which he treats in what for me is a stupifyingly Mickey-Mouse fashion. The most excruciating moment from his much-acclaimed version of *Dido and Aeneas* is the queen's mimed or American sign language-like version of her conclusion that "thus, on the fatal bank of Nile, waits the deceitful crocodile"—complete with wavy hand movements for the Nile and a hand coming up to snap at the other wrist as the crocodile's jaws close. Is this for real? I ask, and opine that Morris gets such high marks with literate sorts like critics for even being aware of the words going on behind his movement. (This jokey awareness of the words has been characteristic of Morris's works since the early Dance Theater Workshop days, whatever language those words were in. Hey, cool, critics seemed to say, he understands Italian! as a dancer mimed weeping to a phrase involving *piangere*.)

It's only at huge group works like *L'Allegro, il Penseroso, ed il Moderato* that my sense of "yes, but" with Morris vanishes before the onslaught of all this interesting movement for all these people for all this time. In *L'Allegro*, the choreography is still one plus one plus one, as if made by someone saying "hey, this would be neat to do now," and then later, "let's do it again." It has some of the same "howler" literalisms to words, though the *Allegro* sections aren't visibly different from the grumpy *Penseroso* ones. But the whole is greater than the sum of its parts simply because it's so wildly intelligent, and so wildly inventive, and so wildly fun to look at—and most of all, because it goes on for such a wildly long time. In works like this, Morris almost begins to intrude on Paul Taylor territory. We're reacting to the sheer exuberance of all these young people being so athletic, and to seeing such good dancers to such smart-as-a-whip choreography. So what if its basic unit is still the fragment?

In some ways, the contrast between Morris and Balanchine so neatly offered by the San Francisco program is the contrast between modernism and postmodernism. Modernism is quintessentially about closed forms, the primacy of the artwork that effects spiritual salvation, or substitutes for the

world. Postmodernism demands the same attention for its open-form works as modernism, but for none of the reasons offered by modernism: just because.

What of somebody like Cunningham (or rather, what of Cunningham, since nobody is really "like" him), whose works are sometimes carried out by completely anonymous dancetrons, neutralized and de-sexed by concealing costumes, interacting in fragments that may not even be as structured as those in Morris? Should I not be making my contrast here between Balanchine and Cunningham, rather than Balanchine and Morris? The fact is that we are similarly incapable in the cases of both Balanchine and Cunningham of imagining the dancers doing anything in the wings. In some odd way, the forms in Cunningham are as closed as in Balanchine: even if what we see seems aleatory and fragmentary, we know that it is only a dance, the dancers nothing but carriers of the movement. What we see in Morris, by contrast, is the ever-so-slight illusion that what we are looking at are people who dance, who happen to be moving for us in an open space we call a stage, but could just as well not be, or doing it elsewhere.

And this, I think, is why Morris's aesthetic with his own company tends toward the catholic and inclusive as far as body types go, and why he so happily appears near-nude in his current roly-poly state. The result is valorizing for the dancers, the pieces ultimately seeming like pages of a diary entitled *A Choreographer's (or Dancer's) Life*. Ultimately, I thought at the end of the San Francisco program, Morris's pure dance pieces have the feel of occasional pieces, or the opera ballets of the nineteenth century during which the Jockey Club talked, socialized, and ogled their mistresses. They are clever and worth looking at, but insubstantial, because they could so easily have been something else. And this is the same reason the text pieces (or the reaction-against pieces, like *The Hard Nut*) are so relentlessly determined by their aural structures that protrude from them like the external skeleton of a seahorse.

In some way, what Morris is doing is deeply old-fashioned, in that it is offering insubstantiality as a virtue (just try to imagine Cunningham doing this). I bet it would be fine by Morris if we revived the nineteenth-century practice of eating and drinking and wandering around in performances. The movement will still be going on as long as the music lasts, and you can come back when you feel like it. At the same time, of course, he's offering an aesthetic of the momentary, reflections of our reduced attention spans here

in the waning years of the second millennium. No wonder we like him so much.

DanceView, 1994

III

Billboards and More

Headpieces and Codpieces:
A Meditation on Costumes

HELGI TOMASSON'S NEW FULL LENGTH *Romeo and Juliet* for the San Francisco Ballet, to Prokofiev's familiar score, had its premiere in the War Memorial Opera House in San Francisco on March 8, 1994, and was presented at the Kennedy Center in Washington during the Ballet's spring season there. The one thing everyone could agree on was that it was beautiful to look at, with its pretty costumes and colorful scenery, both by the Danish designer Jens-Jacob Worsaae, who rendered a similar service for Tomasson's *Swan Lake* and *Sleeping Beauty*.

The operating pretense of the design—articulated in much of the publicity for the ballet—was to authenticity, or fidelity. To what, however, I couldn't figure out. "Renaissance Verona Comes to Life!" trumpeted the program. One character wore a leather sleeve "from a Renaissance painting, specifically from the Verona time period and from artists of that time." I liked the "Verona time period" bit; I just couldn't figure out when this might have been. The time when Verona existed? It still does. Romeo and Juliet were (duh) fictional (although visitors to Verona are still shown "Juliet's balcony"). Indeed, Shakespeare was quite a Willie-come-lately among those who penned versions of the tale. He took his plot from an English narrative poem of the mid-16th century by one Arthur Brook, but references to the feud of the Capulets and Montagues in literature appear as far back as Dante, with many intermediate steps in between.

To be sure, Worsaae concocted a beautiful "Verona," although he did so by borrowing from a generalized visual phrase-book of "Renaissance Italy" and presenting his world as a lexicon of its greatest hits. If periods of time had their politically correct defenders, like Edward Said, who has attacked the Occident's similarly imprecise and generalizing projection of the Middle

East in his book *Orientalism*, Worsaae would be guilty of "Renaissancism." Friar Lawrence, a simple monk, has a cell decorated with an over-life-sized version of the celebrated Giotto *Majestà* altarpiece that currently stands in Florence's Uffizi Gallery (in the ballet, it's superimposed over another Virgin and Child above it that reaches up to the flies—from the later Venetian Crivelli? after two performances I still couldn't say). Or is it a church instead? (A rose window was projected on the backdrop; when the scene switched to Juliet's bedroom, it didn't go away.) The Capulets have hung what looks like a frieze of Flemish tapestries across the top of their hall—strange, I thought, since the function of tapestries was to keep out the cold of the bottoms of stone palazzo walls, not decorate their tops. Pretty, it was; authentic it wasn't. For that matter, how could anything be authentically "Renaissance" when what we were seeing was a twentieth-century version of a nineteenth-century Romantic ballet, one where the men wore the glistening tights of the 1890s but none of the standard male codpieces (or even multi-colored crotches) of the Renaissance?

Certainly it wasn't true to Shakespeare. Just consider the balcony scene, here, as in most danced *Romeo* versions, the big romantic duet, a pas de deux between a man and a woman where they touch, embrace, and virtually reach orgasm. In Shakespeare, this scene is generated precisely by the fact that the two protagonists cannot reach each other, and so must articulate their love verbally at such great length. Not to mention the fact that in Shakespeare, Romeo and Juliet are scapegoats, the means by which their parents' anti-social feud is brought to an end. There's something illicit about their love. Here we're supposed to root for them.

But oh, those costumes. Even if they were so clearly not authentic to anything but a prop closet, they were certainly complex. Not to mention expensive. The posters and programs announced, under the ballet's title, that this *Romeo* was "made possible by the E.L. Wiegand Foundation"—and the press kit explained that this credit line was meant to acknowledge an initial grant of $336,877 that "specifically covers the construction of costumes and a number of head pieces for this lavish new production of a classic masterpiece." (What was the masterpiece here, I wondered? Shakespeare? Clearly not. Perhaps the composer, Prokofiev? Or was it the most enduring choreography to this score, from which Tomasson borrowed heavily, that of Lavrovsky in 1940?)

The idea that costumes, even implicitly, deserved to be right up there under the title before the name of the composer or the choreographer was interesting to many of us brought up in a modernist tradition. Indeed, it's a

notion that, in our post-Balanchine era, a number of people find positively strange—accustomed as we are to the "swimsuit" ballets and Balanchine's gradual stripping away of scenery and costumes from his own ballets, as well as to the spare "international style" that has been the world-wide result of his influence.

Yet the sheet of information in the press packet entitled "Romeo and Juliet Facts" consisted in large part of information apparently designed to warm the cockles of a taylor's or seamstress's heart. A quick perusal revealed that the fabric was purchased from Germany, France, Denmark, USA, Great Britain, and India; that the braid came from Japan and England; that the embroidery was done in Denmark and the beading in London; that some of the more complex of the approximately 140 costumes contained ten to twenty-four yards of cloth; that the fabric was bought in white but dyed, sometimes four different times ("very much of a Fine Art process")—and that "pearls have been dyed to Jen's specifications." Hand-dyed pearls? This is a ballet, or a fashion show?

I would have been even more flip about these facts had I not, just the afternoon of the premiere, wandered into a tiny and deserted shop on Grant Avenue in San Francisco's Chinatown. The old man keeping it, initially somewhat reticent about talking at all, became animated when I asked him about the cinnabar vases he had in stock, showed me how they were cut and how one in particular was more skillfully done than others (I hadn't noticed), and then, as if to fill up time while I was hesitating in the bargaining process, hauled out a string of jade beads that were, he explained, hand-dyed. Oh? I said naively. What difference does it make? So he showed me what difference it made, bringing out from another drawer a string of beads that, at first glance, seemed identical to that he was showing off. Careful perusal from a distance of several millimeters aided by the magnifying glass reveled that he wasn't making up the difference: the hand-dyed ones were indeed more intense, more deeply colored, and more lustrous.

Yet of course a ballet audience doesn't see the costumes from the distance of a few millimeters, nor with the leisure I enjoyed that afternoon as the sun faded on the strangely deserted avenue outside. Instead, if the audience is concentrating on the dancing at all (and it can be made to do so by good dancers), it gets what we might call a costume effect rather than costumes: a blur of colors and a little shine. The Ballet, I heard, had mounted fashion shows for donors using these costumes. I thought the more appropriate thing to do with them would be to set them up in glass cases in the lobby, the way the Washington Opera displays some of its costumes so

that people could look at them through their lorgnettes—maybe even letting the dancers wear a second-best set without the hand-dying or the lace made originally with thousands of pins (another fascinating fact from the press kit). I saw the production twice and can't even say who was wearing lace and who wasn't.

The sartorial fetishism of this production was so extreme it finally took on an almost religious aura. All that meticulous hand-work on costumes seen from so far away and in motion resembled actions done only for God—or the way the beautiful triglyphs and metopes of Phideas's Parthenon in Athens were invisible from the floor, lost in their great altitude up under the roof and the pervading gloom.

Another interpretation of what was going on here was sociological. I thought of what the great turn-of-the-century economist Thorstein Veblen, in his ground-breaking *Theory of the Leisure Class*, dubbed "conspicuous consumption." Veblen was making a parallel between the one-upping the Joneses characteristic of savage American capitalism (particularly that of the Midwest) and the Pacific Northwest Indian custom of the potlatch, an impress-the-neighbors party where valuables (including slaves) were actually destroyed to show the importance of those who could afford to do the destroying.

If we apply Veblen's analysis of ostentatious uselessness to this San Francisco production, it seems logical that so much effort was being expended for nothing. That's the point: the more complex the costumes for this production—precisely because the audience gets only a multi-colored blur and probably ought to be concentrating on the dancing anyway—the greater the company has shown itself to be. (Or do I mean, the E.L. Wiegand Foundation?)

Or just maybe, I thought daringly, walking back to my hotel, it indicated something else entirely. Perhaps it signaled the end of bourgeois Western theater with its tyranny of the proscenium stage and its pretense of the audience forming a fourth wall, an end that has been devoutly wished for by radicals and reformers of the modernist era from Brecht to Antonin Artaud, from Yvonne Rainer to the Living Theater. Suddenly it seemed possible that the E.L. Wiegand Foundation and the San Francisco Ballet had finally effected it.

How else to explain this degree of obsession at a level of precision of which the audience, in the nineteenth century the reference point of perception, must be almost completely unaware? Was it possible that, precisely by over-determining and pouring money into an aspect of the

production irrelevant to the audience, the designer, the company, indeed the E.L. Wiegand Foundation itself, was spitting in the eye of all these nice upper-middle-class folks sitting in the theater? It was saying, in effect, You are not the purpose of this exercise. Your presence in the theater is irrelevant. Your money is being poured down sinkholes, and you are being made to applaud the waste.

The irreverence of this production seemed to go farther. Do you bourgeois audience members want faithful re-creation of the past? it seemed to ask. Fine. We will give you faithful re-creation, hand-dyed pearls and all—but of what, that, ah that, is up to us. We will give you headpieces, but no codpieces. We will tantalize you with mentions of Shakespeare, but what we will give you is a loose re-telling of selected story elements that Shakespeare himself lifted from predecessors. We will give you a real altarpiece, but it will be Florentine and we will put it in a monk's cell; we will give you two different caps for two Juliets with different head sizes (also on the "facts" sheet), but we will strap her feet into shoes with padded ends that let her stand on toes! We will give you "realistic" fight scenes, but have everyone move with thighs open and their toes pointing outwards!

Was this travesty of authenticity, in other words, not subversion of bourgeois pretensions to stability at its most delicious, a Derridean deconstruction of the desire of the audience to see the "same" story it knew in decor that was "accurate" to an historical past? This whole production was, I thought, more properly seen between quotes, like a vast Cindy Sherman appropriating the look and details of its imaginary prototypes only to make the point that all images refer to other images, and finally only to themselves.

And yet somehow, I do not think this was the intention of Worsae, the San Francisco Ballet (or its fundraisers), or of the E. L. Wiegand Foundation—if, that is, artistic intention matters in our post-everything world, a world dominated by the marketplace, a world in which a piece that borrows heavily from the standard earlier versions of *Romeo* can be billed as having only "choreography by Helgi Tomasson." In such a world, one clearly defined by the postmodern givens of appropriation and pastiche, nothing is fixed and posture is the order of the day.

In such a world, even the earthquake-produced cracks that fissured across the ceiling of the neo-Classical style War Memorial Opera House seemed symbolic.

DanceView 1994

Clothes Make the Piece

COSTUMES: EVERYBODY KNOWS THEY'RE important, but something keeps us from acknowledging just how important they are. At best, good ones seem the icing on the choreographic cake. Bad ones can ruin the dance. Balanchine kept paring away until he got down to black and white "swimsuits," yet the audience always gasps in appreciation when the curtain rises on (say) the Montagues and the Capulets in full velvet and silk array.

If we focus too much on the costumes, however, it seems tantamount for many of us to an admission that the work itself was a failure. It's like saying that the audience left a Broadway show humming the scenery: what it means is that there were no tunes. Yet sometimes, even in the case of good dances by great choreographers, the costumes become the main statement, or at least render the movement comprehensible. Or so I thought so at a revival of Paul Taylor's *Cloven Kingdom* during the spring 1999 run of the Taylor company at the Kennedy Center in Washington.

The piece is Taylor at his most devilish, apparently a statement on the inner beast, or at least inner wierdo, trying to get out from inside each of us. The point seems Freudian: the more we try to keep the id inside, weighting it down under the bland, socially acceptable exteriors of clothing and good behavior, the more certainly it will gush out from between the cracks. The dancers in *Cloven Kingdom* enter in graceful swirls, the women alone or with their male partners. Yet their movement keeps being interrupted by what seems the inexorable need of the women to scoop their shoulders forward in monkey- or crab-like shrugs, and of the men to suddenly hold their hands out in front of them like limp doggy paws. What the men do when left to their own devices is fully as strange, including jumps on the balls of their feet and a form of grotesque gymnastics, all without breaking their impassive veneers.

The alternation between lyrical and grotesque movements comes so naturally from these people that they seem utterly unaware of any anomaly, as if a movie director had imagined a scene where snakes keep darting from the throats of the actors without their ever batting an eyelash, so fully have they learned to sublimate even their consciousness that anything is true but what others tell them. The music echoes this slippage. It's a mélange of Corelli, Henry Cowell, and Malloy Miller, combined by John Herbert McDowell: the pretty string music of Corelli is interrupted again and again by insistent drumming, or by alien sounds as if the radio were drifting between stations, caught between two worlds. The epigraph on the program keys us to the nature of the goings-on and puts is in the mood to draw

conclusions: "Man is a social animal," Spinoza is quoted as telling us. The dance exists to show us the price for this being so, or the degree to which it fails to tell the whole story.

Many congruent signals, therefore, converge to help us understand the dance. Yet, suddenly on this, the umpteenth time around on *Cloven Kingdom*, I thought that without the costumes, none of it would make very much sense. Specifically, the men's costumes. The last time I saw it, the credit for them read: "By After Six," as in the formalwear company, since what the men wear is nicely fitting white tie and tails. Nowadays there is no comparable credit: apparently it's thought inappropriate for garments that are not, after all, costumes but in fact real clothes. The women wear floor-length sleeveless sheaths in solid shiny colors that swirl nicely, but are definitely stage outfits, with little silver heel cups that look vaguely Grecian.

The women's headpieces (by John Rawlings) are arguably the wittiest aspect of this already witty piece: first it's the girl with the shining silver globe on top of her head like this year's most outlandish fashion statement, then comes the girl with the mirror box around her ears, then the tall one with the giant oval mirror held up over the head like a futuristic Nefertiti crown. The mirrors reflect the lights out to the audience in fragmented bits. And then the men, still in evening dress, come out wearing on their heads what looks like a combination of a fencer's mask, a Chinese burial shroud made of jade pieces, and a jockstrap. No one is in the least surprised at these things that grow on their heads and seem the symbols of more fundamental metamorphoses, nor apparently even conscious of them. It's all delicious fun.

Now, think away the headdresses. Think away, most importantly, the white tie and tails. What's left? For the first time I thought, not enough to make a comprehensible dance. The movement alone, even (let's be generous) with the music thrown in as a hint, would, I think, be almost incomprehensible: we'd see that there are alternations of type of movement, but we wouldn't know why. Dances of a half-civilized people trying to ape their betters? Rituals of a shipwrecked party cast up decades before from a luxury liner and now living in rags, trying to remember the shreds of their life before? Or just a new set of social dances from whatever follows Gen X (I assume Gen Y)? We wouldn't "get" it without the costumes that peg the work so strongly to a social statement, anchor it in time and make clear to us the meaning of this slippage from one world to another.

White tie really is at the center of it all. For white tie signals, as few outfits do, the acknowledgment of the Other that is at the basis of societal action: it's something we only affect for the most intensely regulated of social

occasions. Because its use is so rare nowadays, in addition, seeing a forest of men (well, four) all dressed in it evokes a world before modernity, the Edwardian twilight before the Great War swept all that away, or the Victorian world that now seems so lost to us. And this world, to us, means repression: we have never gotten away from Lytton Strachey's views of the "Eminent Victorians" as so many power-hungry hypocrites. No other social armor would allow us to see so clearly the odd movements as anything more than aberrations.

With this thought of the centrality of the costumes in my head, I sat the next night in the New York State Theater watching the New York City Ballet do Peter Martins's *Stabat Mater*, to Pergolesi. The first time I had seen it, I remember noting the attempt of the set and costumes to give a meaning to the movement I didn't think it had; this time they seemed quite at odds with one another (scenery and costumes by Alain Vaes). The three pairs of dancers are arranged on the fragments of classical ruins (a small version of the "Winged Victory" in the Louvre perches on the top) that apparently look out over the Bay of Naples: the men's costumes, velvet knee breeches and floppy shirts, suggested dress-up fisherfolk (think *Napoli*), the sienna and ochre scrim bore nineteenth-century-style evocations of bays and ruins. When the curtain opens, all are staring dreamily out stage left, with Darci Kistler plastered against a pillar as if turning into a caryatid, and all evoking goddesses in their filmy garments. Clearly they're not the fisher-girlfriends of the fisher-boys, but who else would be haunting ruins by the bay at night? If the boys work during the day, as their costumes suggest, they should be out partying now, or sleeping, not looking out across the water (?) like southern versions of the solitary watchers into the abyss of the German Romantic painter Caspar David Friedrich. The dances were pretty, but why Italian? Why in the ruins? Really, I decided, they could have been anywhere, in any dreamy pair-off situation.

The set and costumes of this piece, therefore, seemed a concept that the dance bore little relation to, a case of complete disconnect rather than the encroachment of costumes on dance that I'd felt in *Cloven Kingdom*. Granted, this ballet sorely needed some conceptual unification by sets and costumes. This concept was just the wrong one.

At intermission, enjoying the wonderful photo exhibit on all levels of the State Theater of pictures from the last fifty years, I found myself taken by an early shot of *The Four Temperaments*, or rather by the costume with what seemed a huge leaf on the head of the ballerino. Thank heavens, I thought for the thousandth time, that Balanchine ditched all that for the black

and white we now so take for granted. Or think of the way he cleaned up *Apollo*. We have only to look at period photos to be glad that now it's back to the Greeks, and that the final tableau is merely a starburst rather than the ascent of an over-detailed Mount Olympus (in some versions, a stairway, now no longer hidden by a mountain facade). Even *Prodigal Son*, which has retained more of its original "look" than most Balanchine ballets before 1950, has (thank heavens) simplified: the picture farther on of Jerry Robbins with his "do-rag" seemed almost comical. (The Siren costume has been largely retained.)

Less is more, it seems to those of us who subscribe to the Balanchinian emphasis on the dance itself: costumes are for wimps. Yet of course, practice clothes make a statement too. Balanchine tried, and stopped, doing *Les Sylphides* (*Chopiniana*) in practice clothes. The statement they were making didn't go with the piece, which apparently needed the suggestion of place and character produced by the reference to sylphs.

Balanchine's stripped-down costuming isn't authentic to the original conceptions of the pieces, as these photos reminded us, though to us it seems like removing layers of heavy encrustation to reveal the essence beneath. It's like the misinterpretation of Greece we're all so fond of as the civilization of eternal, bone-white statues promulgated by Winckelmann and others in the early Romantic age. The Parthenon was once vividly painted: you have only to look at the Philadelphia Museum of Art to see what that would have looked like. But that's not the "classical" world we wanted to see. So instead we've enshrined the incursions of time as the past itself, the weatherings-away to bare white stone as the vanished world rather than the marks of its vanishing.

That form of modernism that has remained strongest on our shores has insisted that the movement comes first and the excrescences (as modernists saw it) of costuming and sets should take a back seat. But of course the other strand of modernism, that exemplified by Massine's *Parade* and Oskar Schlemmer's legendary *Triadic Ballet*, was all about costumes, under which the dancers simply disappeared. This second strand, which until now has been represented in this country by such interesting but somehow second-tier artists as Alwin Nikolais, may (I thought after the NYCB program) be poised for a revival. After all, it's clearly a solution to what everyone acknowledges to be our waning movement inventiveness.

Nutcracker, the art form's most dependable cash cow in this country, is certainly "about" costumes in this sense, at least in the version you'll see if you live anywhere but in a good-sized city. Indeed, sometimes the most

honest choreographers nowadays seem those who simply move the costumes around, like Heigi Tomasson in his version of *Romeo and Juliet* for the San Francisco Ballet a few years ago, or the choreographers of virtually any of the contemporary full-length story ballets playing near you (*Dracula* was one of this last year's most popular themes).

It's paradoxical that I would have thought that movement may well have run its course as the heavy lifter as a result of watching a program by today's most inventive movement artist. But if costumes can take over one of even Taylor's pieces (and there are many others where the costumes seem indelibly part of the work: think of *Images*, with its Minoan snake goddess, or the body stockings with mirrored hands of *3 Epitaphs*), they can do so for anybody. Nor should we necessarily fear this development, if indeed it is upon us. We may simply be returning to something more like the nineteenth-century ballet's unabashed and unashamed lust for costume and spectacle, currently fed by the special-effects-driven musical shows on Broadway and by sixteen-car-crash-before-the-credits movies. In an attempt to compete with these, ballet may well bow to the inevitable and begin courting, this time with no attempt to keep things under wraps, the same audience.

Ballet can't give us car crashes, and it's unlikely that a helicopter will be landing onstage in a ballet theater. What it can give us is sumptuous clothing, all in 3-D, and beautifully moved. Expect to be seeing it more and more.

DanceView 1999

State of Darkness

ONE OF THE WORLD PREMIERES I saw at the American Dance Festival on the Duke University campus was of Molissa Fenley's version of *Rite of Spring* (June 20), called *State of Darkness*. Complex, beautiful, and brilliant, it was one of the most extraordinary performances, and pieces, that I have ever seen. Like all three of the works on her program, this was a solo, a true tour de force for a virtuoso dancer at the peak of her power, thirty-five minutes of continuous movement across the stage. Fenley's *Rite of Spring* was unbelievable in that it was so good. Yet in a sense, with such music (and with her downright presumptuousness in choreographing it as a solo), only the unbelievable would have been good enough.

The eye boggled at the fertility of the language that Fenley has developed for her body, dressed for this piece only in black tights and looking like the *Ur-mensch*, a strangely innocent Eve (or Adam: there is something androgynous about this dance) awakening to the dawn of the world. Sinuous twists of arms, wipes of a hand or hands across the front or side of the face, lunges with crooked hands, velvet kicks that stop instantly and return to the floor, even some Balinese arm curves and abdominal exercises like a belly dancer: these were some of the elements of the almost stupefyingly rich vocabulary that Fenley has generated. Fully as extraordinary is the complexity of the relations she developed between these motions of her body and the music.

The piece begins with Fenley in the middle of the stage in a spotlight with her arms down; the dance movement is the quivering of her abdomen. The first few moments seem slow motion, meditative and lyrical. By the time the sacrificial dance of the second part is reached, her arms are carving out chunks of the air and she is lunging, making giving gestures with her arms. For the music's hatching thuds, her arms slash again and again and then are caught in the cushion of control that surrounds each of her movements.

This was extraordinary, riveting. It was also slightly hypnotic. For the movements of Fenley's body are, like all physical gestures, charged with emotional associations. At one instant her arms plead with the air, the next moment they are scraping before her eyes as if wiping the skin from her bones, the subsequent moment they are offering all she has. To whom? To us, the audience. Yet there is something curiously lonely, almost solipsistic about these fragmentary bits of drama. For these flickers of emotional (as opposed to physical) content come, and then are gone. We must watch the physical movements intently in order to sense them on our emotional palate, yet even as we sense them they seem to be disappearing like the shapes into which clouds form themselves before pulling apart into thin air. Was this more evidence that Fenley has caught the taste the world must have had for Adam, alone at the dawn of time?

Washington DanceView 1988

In Utter Darkness

ONE THING I WORRY ABOUT increasingly is something that no critic over the age of twenty-five should really, for the sake of his or her own self-respect,

Sex, Art, and Audience

be caught worrying about. I mean whether what we see is really in the thing outside of ourselves, or whether it's only us. To be any kind of critic at all you must seem authoritative, at least with works from our own culture: the piece was good or bad, the dancers skilled or unskilled. (Mere description is the current politically correct solution with respect to dance from non-Western cultures.)

More and more often, however, I have to admit that I'm afflicted with the kind of searing doubt that used to be associated with existential crises. How reliable is my reaction? Is it me or is it them? When I saw Molissa Fenley's dance to Stravinsky's *Rite of Spring*, premiered at the 1988 American Dance Festival and entitled *State of Darkness*, I loved it. I was so enthusiastic, in fact, I went back the following night for the second performance, Fenley's only other presentation of it in Durham. And a few months ago, almost five years later, I saw the piece again in the Kennedy Center Terrace Theater's "Dance America" series. The first time I had been simply awestruck. Five years later, by contrast, it set me thinking.

This, then, is an essay about the unbearable subjectivity of seeing—and most particularly, seeing dance. We all know that the world is nothing but our perceptions. Still, most of us have realized that some of our perceptions are more permanent than others, and that we might as well call these reality. We see the ball from a different angle every time (or, to more philosophically scrupulous, we see shapes that sufficiently resemble each other that we group these together into a single bunch and refer to their commonality as "ball"), but the box is still there at its side every time, unless we or somebody else has moved it (both of these locutions are also things we've learned to say: if somehow we've moved without being conscious of it, we have to explain the situation another way). For our everyday lives, most of us go by the Newtonian notion that things do what they're doing until something changes them, even if what they're doing is only existing. And even nuclear physicists, who spend a lot of their time in a non-Newtonian universe, have to take the garbage out and hope the can will still be there.

So most of us are, in this sense, naive realists. I know I am. But after *State of Darkness*, Take Three, I was willing to say that I too live in a non-Newtonian universe for part of my life—that part that I spend in dance performances. In fact, I was willing to declare myself, for dance purposes, a disciple of Bishop Berkeley, who thought that things only existed insofar as they were perceived (so that the blue computer screen on which I'm writing this literally disappears and re-appears every time I blink), and retained the notion of a stable universe only by bringing in a kind God who

had it all in His mind when the rest of us went to sleep or turned away. I don't know who or what the equivalent for the dance world of Berkeley's God would be, so that leaves me back at the good bishop's first conclusion. Dance performances only exist insofar as they perceived. Which means, that they have a potential far greater than normal events for changing every time; we ultimately have no such thing as a stable given to refer our perceptions to.

Take *State of Darkness*. The first time through, I was riveted. I had been bused over from Duke University's grotty East Campus with the other participants in the ADF's Critics' Conference; we all sat in a bunch in the Reynolds Industries Theater. The first half of the program was interesting but hardly noteworthy: Molissa Fenley being ferile. Then came *State*. Stripped to the waist and looking like a female farmhand with no breasts, Fenley produced an endless stream of astonishingly beautiful and continuously inventive movement for thirty-five minutes. I don't know what it had to do with the original story for *Sacre*, if anything; it didn't have to have any relation. The action was married to the music. I couldn't look away. Nor, evidently, could anyone else. At the end, the hall simply erupted. We critics beamed at each other and clapped our jaded hands, screaming along with the rest. This was the reason that we went to dance concerts—what a high, to see that amazing thing, a real masterpiece, premiered before our eyes. We went back to the dorm on the superannuated school bus that was our transportation for our three steamy weeks at the Conference, all talking a mile a minute, then ran up to the computer room to produce our copy—the better to talk about it the next morning. I think all of us raved; I know I did. What beauty, what strength, what invention. What chutzpah, to have chosen this music for a single, half-naked body.

Even as the words flowed, however, I was aware that there was a price to be paid for this sort of lone daring on Fenley's part. For one, it required extraordinary physical prowess to dance this piece. Part of its amazing effect was in seeing her challenge herself to the utmost, then pull it off. It was dance on the edge. And precisely for this reason, it was even more than usually perishable. Could she do it the next time? Could she ever teach it to anyone else?

I spent the entire next day looking forward to going back. Unfortunately, the evening was a letdown because I could hardly see. I had the daft idea of wearing a pair of new contacts that did nothing but give me trouble; I watched the second time through a blur of tears and was conscious only of my blinking and my pain. Yet, at least I knew why the second experience

was such a disappointment, and perhaps thereby was saved what might have been the inevitable let-down, so frequent the second time around with art, at having my exhilaration replaced merely by mere admiration.

Thus it was the third time, some five years later in the Terrace Theater at the Kennedy Center, that I ran into the conceptual problems.

Not that the performance was bad. Probably it wasn't. I mean, that's what scared me—that it wasn't noticeably any different this time than the first. Still, it failed to jolt me. Somehow it was simply another solo dance performance. Was it because I knew what to expect? Yet I thought I knew the difference between a reaction of surprise and one of enthusiasm at the thing itself. Even so, I wouldn't have expected it to have evaporated so completely. Or was my subdued reaction the result of the marital problems I'd been having? Was it because of the conversation I'd been having, mere minutes before, with a fellow dance critic who was having employment problems? The fact that I wasn't on vacation anymore, as I was in Durham, but this time had to hurry into town in time to get there for the 7:30 Terrace Theater curtain time? Was it the fact that I was five years older? That Molissa Fenley was five years older? Or was it simply the melancholy thought that five long years had gone and here I was once again watching this half-nude woman with short hair dance the same solo and what did I have to show for the time? (Well, a baby daughter, two books, tenure. But perhaps not what I had expected.)

Maybe there were more directly dance-related reasons for my disappointment. Since this was the second different Fenley program I'd seen, could it be that I was less tolerant of the similarly less than wonderful first half than I had been of the first? Like the other, it was just Molissa Fenley spinning out movement. You'd have to be in love with this body to be enthralled, I thought—and I'm not. It made me wonder about Fenley's creativity, and her aesthetic, and the relation of this one work to the other things she did. If she's a one-ballet person, my reaction even to this one work would necessarily be more tempered.

Still, even if all of these things were working to diminish the nature of what I was about to see, there should by rights have been something left for *State*. I should have been able to put all of these things aside and concentrate on this one spectacular work. But the problem was, it wasn't spectacular. At least, not for me, not that night, not on that program or in the mood I was in. It may be that it's still a masterpiece, that Fenley still dances it just as well, and that for others in the hall that night it was just as big a revelation as it was for me five years ago in North Carolina. I sincerely hope so. The

applause was enthusiastic without being overwhelming—but what can I read from that? This was a more staid audience, an older one. And somehow, I thought, the piece was more spectacular in a bigger hall, which sharpened the contrast with this one vulnerable body.

I don't know why it left me cold. The point is that I'll never know. Indeed, who says I'll ever see *State of Darkness* again? It's not like *Pride and Prejudice*, that I can but back on the shelf if I'm stressed out and open again when I'm in a better mood. Nor is it like the Leonardo in Washington's National Gallery, that I sometimes stand in front of for a half an hour, sometimes turn away from in a few seconds with nothing. Most of us have some sense of the changeability of aesthetic response, and learn to take this in stride. It's like prayer—sometimes you get through, sometimes you don't. If the lines are busy, most of us don't despair, we just try again later.

The problem with dance is that we can't try again later, or at least cannot be sure we can do so. Dance shares this problem to some extent with all the performing arts, but the problem is exacerbated in the case of dance. We can't refer to the dance object, the way we can walk over and see if that really is a ball where we think it is; we have to wait for it to appear again, as a result of some promoter or the choreographer bringing it close enough to us to see. Three times in five years isn't a lot of appearances, but I might have had only one, and who can say if I'll ever have another? And woe betide us if we get in the habit of thinking of something like a video as the "object itself"—most of us know it's only the record of a single performance, and there are all sorts of problems with seeing it in a tiny square.

The identity of performance with object is especially clear in the case of a dance like *State* as I first saw it, a new dance for the choreographer's body, made for a single person. In such a case we don't even think of separating the dance from the dancer. Our only hope of objectivity is in comparing our reactions with other audience members'. Did they see what I saw? Was it me or the performance? Not even this gives always gives satisfaction—and what about those viewers who don't sit with the other critics, as I inevitably do?

It makes me think of those audience members new to Balanchine, who were seeing him for the first time in the recent Balanchine Celebration of the New York City Ballet. It's difficult to put ourselves in their place, but for them—we should remember—this *is* Balanchine, or at least, all the Balanchine they know. To be sure, in the attempt to get some perspective on what they're seeing they can read Arlene Croce on the subject (and go home thoroughly dispirited), or talk to other people who remember when Tanny did

this and Andre did that, or when Eddie did this, and when Suzanne Suzanne Suzanne did that and that and that.

I came into the story in the mid-1960s with New York City Ballet, so I can hold my own reasonably well in this game, but those who remember the 1940s and 1950s have me beat. And New Yorkers who went season in and season out, as I was unable to do, will have a much more complete picture than I do. Does this mean that only these people have the final say? While they were watching their hundredth *Concerto Barocco*, I was looking at performances in the three-country area around the Rhine. Doesn't that give me a perspective they might not have? Does my Durham experience mean that I'm the expert on *State of Darkness* and somebody there for the first time that night in the Terrace Theater should to keep his or her mouth shut, deny his or her own reactions?

It makes me rebellious. Makes me want to stick up for the people who are just coming in on things. I mean, maybe they're twelve years old too, like I was when I saw my first Balanchine at Saratoga, and can't very well be blamed for coming only now. We can't tell them they've missed the historical moment, can we? That's what every generation of oldsters always tells the young, and the young always rebel. I want to valorize their experience, say that it's worth something too, and not just by comparison with what I've seen—maybe precisely because it's the first time. Even that the dance experiences of those who have never seen Balanchine at all have to be taken seriously.

So many things can ruin a performance, it's a miracle we ever see anything good. For example I saw *Orpheus* for the first and, so far, only time at the Balanchine Celebration. I hated it. It seemed silly, neo-Grahamesque even unto the Isamu Noguchi sets. Sure, I could see the touches of Balanchine: the Poet and his muse, the phalanxes of predatory females. But I left thinking, how *could* he? And how could New York City Ballet use the Orpheus lyre as a T-shirt logo when the piece is so bad? What an embarrassment! At intermission, a more seasoned watcher I was talking to agreed that this performance had been a bust. But she had a reason I wouldn't have thought of. "It worked better at City Center," she said. "Something about the scale." And when I read Arlene Croce on the subject, I was interested to see that she ascribed the slowness of what I saw to the performers.

How to know? Is it us, the performance, the sets, the hall? We can go several times, of course, best of all several times over several years. If it's possible, that is; in the case of *State of Darkness*, it's not possible. At least,

I don't think it is; maybe if I became a Molissa Fenley groupie and planned my life around her concerts wherever they are, I could. But most of us have some givens in our own lives that prevents us following the stars. And those people who live at Lincoln Center give up having other experiences as a result that might enrich their reactions to what they do see. Does this mean that you don't react to something after only one seeing? What if repeated viewings leave you completely confused, as my third viewing of *State of Darkness* did? Or does it simply mean that as a critic, you don't write about something the first time, or the second, or the third? I bet Molissa Fenley would darn sight rather put my first piece about her in her press kit than this one.

Sometimes, the penny drops only after repeated viewings, as when we suddenly "get" a hitherto foreign ballet style, say Ashton, or the Danes. Sometimes, by contrast, repeated viewings only lead to a dulling of our reaction, as our gnawing sense of insufficiency grows stronger. (I remember loving Glen Tetley's *Daphnis and Chloe*, and simultaneously wanting never to see it again, suspecting that once was enough in this mesmerizing light-bath.) Anyhow, most of us are not such masochists that we are willing to sit through the dull time in hopes that suddenly, unexpectedly, we will come out of the tunnel into glorious day. I don't think that sitting through all of the works of Eliot Feld will fundamentally change my view of him as somebody with initial promise who now makes rather predictable, one-shot ballets. (It makes watching *West Side Story* painful, seeing him way back there at the beginning.) On the other hand, I remember to my discredit that the first time I read *Madame Bovary*, I was bored and didn't see what the fuss was all about.

In dance watching, it may be that more isn't necessarily more. More decades of seeing X certainly gives us the ability to quote names and dates and pick apart style. But that too can lead to an involution that isn't necessarily good. I often think dance groupies are unable to see the forest for the trees; they're discussing how X and Y did tonight in their new roles, and all I want to talk about is the piece. (Of course, they in turn probably think I'm up in an airplane with my generalizations and my theories.) T. S. Eliot considered a more philosophical version of this paradox in his *Four Quartets*: "In my end is my beginning." Age brings more knowledge, but does it necessarily bring wisdom? More isn't necessarily more.

Is *State* a masterwork or a so-so modern dance piece? I don't know. All I can do is spread out the fan of my reactions and say here, pick one—or rather, take them all. There is no object behind my perceptions, and it may

be that I'll never have another to add to the spectrum. A hundred viewings will only be a hundred viewings, and the last not necessarily preferable to the first. That's the way it always is. With dance, we're all in utter darkness.

DanceView 1993

An Experiment in Appalachia

OUR ROMANTIC CENTURY, THE SECOND, or even third, such century, and counting—sometimes called modernist—takes for granted the all-determining nature of the Artist's vision in his or her creation. Works that don't take their form from the vision of one particular person aren't Art, or if they are, are only so by extension, or in a second-rate sort of way. Even that quintessential merchandising manipulator Madonna, in the simultaneously diverting and appalling documentary *Truth or Dare*, evokes her "freedom of self-expression" to fend off a threat to close her show in Toronto. It's instructive hearing the Material Girl, goddess of the postmodern, talking pure Romantic dogma: Art is about self-expression, and it is above the law. (This evidently still carries clout: the Canadian cops backed off.)

Thus we're interested when an Artist puts his or her sacrosanct ego on ice, working together with someone, taking cues from the outside. For a while in the 1970s the *Yellow River* concerto from China, written by a committee, was the rage on concert stages. The news that some of Merce's dances were structured by chance or the I Ching (actually the structuring principle seems to have been a set of parameters accepted as a given, rather than real chance) was taken as evidence that he was making a new kind of work.

Thus, the collaboration between choreographers and Paul Taylor dancers Mary Cochran and Thomas Patrick, joined by Andrew Lebeau, and the Broyhill Chamber Ensemble at the eleventh Appalachian Summer Festival in Boone, North Carolina (July 9) was interesting from the start. The festival's Artistic Director and Ensemble co-director Gil Morgenstern pointed out, in a brief introduction from the stage apron, that most choreography is made not only to a single work of music, but to a single performance of a work of music, typically recorded. Usually the choreographers are unaware that they are reacting not only to (say) Brahms's music but to particular performers' notion of Brahms.

The point of departure in commissioning this work, Morgenstern explained, was wondering how much the particular musical performance could influence the choreography produced, and how much choreography could, potentially, influence the musicians' performance. The pieces we were about to see, he acknowledged, posed these questions without pretending to have answered them.

The program's opener, *Three is Public*, was a piece that had been presented by choreographer Mary Cochran in New York, re-worked for the occasion. The re-working involved punching a hole in the motions on the stage, a hole filled by the pianist Shirley Irek and violinist Morgenstern, who played Stravinsky's *Suite Italienne*. In best *Dances at a Gathering* style, the dancers listen to the music and acknowledge the performers' presence. For some sections, they listen, like the dancers at the beginning of Balanchine's *Stravinsky Violin Concerto* or Robbins's *Mother Goose*. (In the original, these were simply not choreographed.) The result was pleasing: real warmth between performers and dancers, who disport themselves using Taylor vocabulary to the palimpsest music, Stravinsky's take on the *Pulcinella* music ascribed to Pergolesi.

The more ambitious piece and the real commission followed, entitled *Come Like Shadows, So Depart* The title is from Shakespeare: it's what the witches say to the apparitions they've conjured up, the ones that show all of Macduff's descendants who will be kings. Nothing, in other words, to do with another passage I wanted initially to believe it came from, namely Puck's curtain speech at the end of *A Midsummer Night's Dream*, beginning "If we shadows have offended." This, at least would make some kind of sense. The music to this piece, after all, is the same sort of tripping Mendelssohn as the famous incidental music to this play, the *Piano Trio in c minor*. The backdrop is a woodland glade (suggesting *Les Sylphides* or *Giselle*, Act II), and much of the action of the first movement consists of Cochran and Patrick rushing in and out without seeing each other, as if in a silent movie or the production of *A Midsummer Night's Dream* that John Houseman's Acting Company put on a few years back.

Cochran wears a scarf. According to her program notes, it's "symbolic of a psychological treasure and a bond between the two." (Oh, those program notes, poisoned candy like all "explain-it-all-to-you" trots.) It lends an air of melodrama, like the affectation of a unusually histrionic pseudo-Bernhardt. It's dropped, picked up by Patrick (sporting a becoming beard and vaguely *Belle Epoque* duds: vest, boiled shirt, tie), made to disappear for a movement, and then dropped from the flies at the end of the piece.

Lebeau, dressed in what seem tennis whites, opens the second movement by squatting downstage (this part choreographed by Patrick), interacts with the couple in no identifiable way, and then disappears. The movement is broad, gracious, Tayloresque; the idiom the choreographers are using is so appealing it's hard to fault it for being derivative. It feels like Tudor's *Lilac Garden* or a piece by the Pilobolus founders called *The Garden of Villandry* (a French château) about intertwining male-female relationships in high society.

A dance that sports a backdrop of trees, has the dancers costumed in clothing associated with a specific time that moreover changed from movement to movement (signifying what? a different day? trysts in the woods over time, like a Neil Simon play?), and that seems to key into fairly stereotypical boy-gets-girl scenarios cries out to have us make story-sense of it at some level. The tradition it's following is that of nineteenth-century narrative ballet. The plot may be stupid, but at least we're supposed to understand it. Here, I didn't.

Who, for example, is the boy in white? I say boy because all males in dance are known as boys, but he's not visibly younger than the man in the couple (unless that's what Patrick's beard is supposed to be for—dancers *never* wear beards, save in character). The program (sigh) suggests that he is "the worldly manifestation of the two, the son dealing with the memories of his parents' imperfect union." (Some people liked these program notes. The woman sitting next to me, for example, was overheard to say how grateful she was for them, which to me is worse news than she realized.) And what about that scarf snaking to the ground at the end? Why end with this? It's not as if the thing played the role of any kind of macguffin (Hitchcock's word for the central object around which a film turns, like the uranium in bottles in *Notorious*). Or that it was the center of a tragedy, like the handkerchief in *Othello*. Yes, the program notes had a lengthy opinion about its meaning.

Also I wondered, what were these musicians doing in the forest? I knew what they were doing onstage in the Stravinsky; they were playing music on a stage and the dancers were dancing around them. Did the dancers know there were people playing instruments? Yes: at one point Cochran turns her head toward them, acknowledging them. Perhaps they are practicing in the woods, as we did at summer music camp, or like the rustics in *A Midsummer Night's Dream*?

Morgenstern described this piece as an experiment. The backdrop, with its sylvan associations (which tended to emphasize and ask us to make sense

out of the otherwise so evanescent "plot" elements of the dance) was his choice. Winningly, the choreographers acknowledged that they had been glad to have a backdrop, any backdrop, because they would never be able to afford one in New York. And it turns out that much of the influence of dancers on musicians was verbal; all of the artists did a great deal of discussing in the early stages of work. The dancers did not, that is, influence the musicians by their movements, but only (if at all) through intellectualizations, conceptions.

Was this a true collaboration? Did the particular interpretation influence the choreography? Difficult to say. I didn't hear the flickery melodrama in the first movement that the choreographers gave us, but perhaps it was there for them. (Or is the influence rather through Taylor's *The Rehearsal*?) What was fun was to take seriously Morgenstern's suggestion that this was an experiment. (There was a discussion for audience feedback afterward, much of it predictably inane.) I sat mentally re-arranging the work's elements, for example eliminating the backdrop and costumes to ask what the effect would be. Would this alone press the right buttons in an audience so it didn't ask for the plot consistency the piece didn't ultimately provide? How to clarify the relationships? Did the piece need to move in the direction of greater clarification, or could it instead reverse its tracks and become more abstract?

Morgenstern asked us to think about the fact that the musicians weren't in the pit. I thought their being on the stage posed difficulties. Shouldn't they have been costumed, like the band in MacMillan's *Elite Syncopations*? During the discussion, it became clear that the artists themselves were flying by the seats of their pants on these issues. When asked what the musicians were doing in the scene, several suggested the dancers were the musicians' dream—or the reverse, they quickly added. One suggested bird costumes for the musicians. I liked the idea, silly though it was intended to be, because it at least addressed the question of how literal to make the musicians' presence.

Nicest of all was the freedom this performance gave audience members to be mentally "interactive," trying to sort out what elements had worked and what had not, and how they had worked with or against each other. This, perhaps, was the best collaboration. And, as Morgenstern suggested, this is what festivals—as opposed to high-pressure, big-bucks in-town presentation venues—both allow and do best.

DanceView 1995

In Praise of "Interesting"

I LOVE LISTENING TO PEOPLE talk during intermissions. It's almost voyeuristic—or at least, écouteuristic. Besides, you get to feel smug, since what other people say sounds more fatuous than what you'd come up with yourself, even if it undoubtedly isn't.

Recently I was much taken by an analysis I overheard at one of the programs of the Pacific Northwest Ballet in Washington (Kennedy Center Opera House, week of October 15). A young man was explaining just what a stroke of genius this particular program, the first of two by the Northwesties, was. Or rather, the programming of this particular program. "What's neat about it is that it all culminates in the last piece," he explained to his companion. "First there's *Agon*, which is very strict, then there's *Quaternary*, which is very classical, then *Jardi Tancat*, which is modern. Finally there's *Symmetries*, which is all of them at once! It builds up to the last one!"

Most amusing was the portrayal of Balanchine's stand-your-hair-on-end masterpiece *Agon* as merely a warm-up to Mark Dendy's silly *Symmetries*, and of Kent Stowell's delicate but son-of-*Dances at a Gathering* (two-) piano ballet *Quaternary* as a sort of filling-in-the-holes of what's missing. Not to mention the Martha/Limon/Ailey homage *Jardi Tancat* (Closed Garden) being the spice the cook had somehow inadvertently left out of the other dishes. In this piece, three pairs of barefoot people inside an enclosure of rough sticks emote and roll on the floor to heart-rending chansons in Catalan.

According to this guy, it all culminated in *Symmetries*. Not that I failed to see his point. In the everything-but-the-kitchen-sink sense, the last piece on the program *did* include something from all those preceding it. A little neo-classicism (men interlocking flexed-bicep arms again and again: with a stretch, something that probably came from *Prodigal Son*), a little classicism, even if in affectionate mockery (tutus and a take on the snowflake ballet from *Nutcracker*), a little modern sprinkled liberally throughout, a lot of silliness (a fox hunt, complete with a red coat and a dancer in a fox mask and tail), and some more *Nutcracker* digs in the form of a family photograph of various fractured fairy-tale-type characters.

Certainly it wasn't great choreography. But at least it was interesting, which is a word I try to get my students *not* to use when describing their reactions to artworks. After all, you have to do *something* to jazz up all those monotonous John Adams chord repetitions. It was like a setting of one of

Frank Stella's black paintings to music, throwing in all of the bits and snatches of associations that ran through the composer's head while contemplating the blankness. Or like Robbins's *Concert*, where the audience members play out their fantasies while a pianist drifts through Chopin. Dendy really despises this music, I thought. And at the same time, he loves it for what it lets him do. Namely, whatever he feels like doing at any particular moment. Of course, it didn't add up to any more than its parts. But so what? At least it was interesting, which is more than I can say for any other piece on the program.

Agon wasn't interesting. It was more than interesting: it was riveting, it was excoriating, it was dynamite in swimsuits. *Quaternary* was pretty, but it wasn't interesting either, with all that steeped-in-longing coupling of young people. *Symmetries* was. Interesting, that is, since it was an imaginative attempt to respond to choreographic blankness. Not to literal silence, in which a choreographer like Merce seems to find oceans of inspiration, but to banal ear-candy like Adams. Of course the movement is going to be flip, probably somewhat snide, silly, with much sound and not a little fury. Because there's little pattern to the music, you can do anything. Foxhunt anyone?

There was an interesting ballet at the end of the first San Francisco Ballet program the week before as well: Val Caniparoli's *Lambarena*, set to a music collage of Bach and African and employing a comparably mixed movement vocabulary. What was interesting here was the same thing that was interesting about Twyla Tharp's early works, namely the movement style. Twyla's people in the 1970s looked all melted, as if they'd got too close to the heat source, with their rubbery upper bodies and their Charleston-on-speed legs. As jitterbugging, maybe it wasn't so interesting. But as stage dance, it was something new. As only a moderate enthusiast of Tharp, in fact, I'd say that this movement was ultimately her major achievement; the pieces she made with it seemed to me like so many virtually interchangeable bottles to hold more of the same liquid. (I know I'm swimming against the critical stream on this one: now that she's fifty and has written her autobiography, she's an institution.)

The movement of *Lambarena* was interesting as ballet. Interesting, that is, because it wasn't really ballet. It was ballet with a heavy overlay of movements inspired by traditional African movements. There were lots of curving arm-lyres, cantilevering hips, and separately-motile body parts. I'd never seen motion like this before, and I thought it was interesting to look at.

Not that the choreography was otherwise any great shakes. Nor that what we saw was anything but ballet dancers trying out new steps, having nothing at all to do with authentic (or "authentic") African dance. Of course it was uptown slumming, Western appropriation. In fact, the critic for *The Washington Post* took Caniparoli to task for just this kind of politically incorrect incorporation of non-Western movements, that we're presumably supposed to worship from the outside when danced by indigenous types and keep our hands off. But why should we as long as we know we're being "ethnic" rather than ethnic? The result may be nothing but a flavor of our theatrical dance, but at least it's a new flavor.

This San Francisco program started, like the Pacific Northwest Ballet concert, with another oh-my-God type masterpiece, not coincidentally also by Balanchine: his *Stravinsky Violin Concerto*. (One thing about those late Balanchine titles, you never have to wonder what the music is.) Of course it overshadowed everything else on the program, including the tasteful house choreography by Helgi Tomasson. Thus the evening offered great, pretty, and interesting, in that order, with a *Corsaire* pas de deux thrown in, for Tina LeBlanc and Roman Rykin. Of the three, interesting is by no means the least worthy, and deserves more respect than it usually gets.

After all, I'm not sure how much sense it makes to hold all ballets up to the standard of the true masterpieces, especially for a dance company that puts on some pieces that have stood the test of time along with lots of new ones. It's like saying that all the literary magazines published this year in the U.S. don't contain one poem of the level of *The Waste Land*. It's true, but it doesn't really imply anything. Masterpieces are what are left when time has done its work on the less-than-masterpieces. Surely it's not the case that no works but masterpieces should be performed. That would be like saying that if a woman doesn't look like this year's beauty ideal, she might as well be dead. Perfect isn't even necessarily even good, and an interesting face is sometimes more lovable than a classically flawless one. With great works, there's nothing to change, nothing to hang on to. You just have to hold on for the ride and hope you don't fall off. The sensation of watching interesting works is different, in some ways more comforting. They're not so intimidating as truly great ones. You're not made afraid by the speed you're going at, and you have a pretty good idea of what makes the old crate run. They're more homey, more on our level. With interesting works you can almost feel part of the process.

I like interesting. Not as a substitute for great, but as an adjunct to it. Which is good, because interesting is just about as good as it gets in new pieces nowadays. But that's another story.

DanceView, 1997

Waiting for the Millennium

FROM MAY 18-21 THE WHITE OAK Dance Project brought its peculiar brand of low-key, high-quality contemporary modern dance to the Washington area. It felt good. It was good. There was excitement in the air. The beautifully renovated Warner Theater's tiny lobby created a crush of people on the sidewalk waiting to get in, tickets were being scalped, the crowd was dressed to the teeth, and everyone seemed to be buzzing with anticipation.

The two programs presented during the run's opening three days clearly pleased the audience, which applauded enthusiastically after solos by Mikhail Baryshnikov, the group's most famous dancer. I left exhilarated and pleased, but a bit sad and at the same time musing (as I do more and more) on the state of dance in America today.

What an odd phenomenon we had just seen, I thought, the oddest thing about it being that companies like White Oak are so rare in today's American dance world. How perfectly ordinary it ought to be! It's the equivalent of a good "little" literary magazine: a few stories from interesting writers, a handful of poems, and an essay or two, all by different people. There need not be masterpieces (indeed the format of a little magazine militates against any one piece dominating the others), and works by the best-known writers tend to be re-workings of things done with more flamboyance elsewhere. But in a good magazine, practically every piece has something—a clear idea, a nice touch, or an evident reason for being. For those who liked the White Oak Dance Project, let me recommend the *Yale Review*, the *Antioch Review*, the *Southwest Review*, the *Virginia Quarterly Review*—all of them first-rate, all of them worth subscribing to, and none of them so overwhelming in importance that if you miss an issue (or a year) your life will be any different.

But if there are lots of quality literary magazines (with circulations of a few thousand, most of them—a drop in the bucket compared to *People*, or even *Car and Driver*), there's only one White Oak Dance Project. And it takes a star (sorry, I don't mean *a* star, I mean *the* star) to pull it off and

make it financially feasible. That's what was so sad about it all: how low-key, if consistently satisfying, the works presented were, and how high-key the hype and the expectations necessary to get them put on and attended. Why should it take someone of Baryshnikov's ballet stature to get off the ground what should be so self-evident as a chamber company for nice, newish modern dance choreography?

Both programs opened with what for me, at any rate, was a surprise, Hanya Holm's *Jocose*, made over a period of several years around the time of the modern dance pioneer's ninetieth birthday. It was much better than Martha Graham's productions from a comparable age, and much better too than that brittle attempt at humor of Holm's approximate contemporary Agnes de Mille, *Three Virgins and a Devil.*

The title had me worried (an unfunny way of saying the piece was meant to be funny), as did many of the initial entrances for the women, all long skirts and arching bare feet. They reminded me of student dance concerts I used to go to at Bryn Mawr College, which reeked earnestly of what I later understood was, in turn, the spirit of Bennington in the 1930s—and the Indian Clubs that Keith Sabado waves at the end of both the first two movement, to no visible purpose, emphasized modern dance's links with early twentieth-century women's gymnastics. Still, it was a lot of fun. A light-hearted take on the relations between the sexes, the piece is cast for two men and three women who pair off, disappear behind vertical screens, shimmy-dance, give each other same-sex support, flutter their hands or bang their fists in the air in time to the quivers of Ravel's jazzy *Sonata for Violin and Piano* (nicely played by Diane Duraffourg and Michael Boriskin), and generally go about the quirky business of making contact with that greatest Other of all, the opposite sex.

Joachim Schloemer's *Blue Heron*, which closed the first program and was in some ways the most intriguing piece of the run, seemed made in the same spirit, namely the spirit of a little of this and a little of that. There is some camp surrealism (three women in long white veils, with their arms up like the nymphs in *Afternoon of a Faun*, enter and exit at odd times), some narcissistic silliness (Rob Besserer plays with his foot while sitting on the floor), a little unexplained gender-bending (tiny Baryshnikov is constantly flinging himself on statuesque Besserer, who seems vaguely discomfited by having a man attached to his side), and a running undercurrent of fun-to-look-at constructions and gestures that ties it all together. The extremely listenable violin music was the *Suite in Olden Style* of the Russian composer Kurt Schnittke, played by Laurence Shapiro and Michael Boriskin.

The final piece(s) of the second program was/were Mark Morris's *Mosaic* and *Untitled* (they unroll as one, although identified as two in the program), which had in common with the Schloemer the fact that Baryshnikov was treated as merely another member of the company. Set to two of Henry Cowell's moody string quartets, the Morris pieces are constantly inventive and frequently amusing (one whole movement had as its primary movement unit a bent-elbow arms-up "oomph" gesture that is repeated to the music's momentarily lilting strains), and offered an agreeable way to pass the end of an evening.

Ditto the penultimate piece in both programs, in one case Merce Cunningham's less-than-usually-deadpan *Signals* (1970), in the other a likable *Quartet for IV (and sometimes one, two, or three. . .)* by Kevin O'Day, a former dancer for Twyla Tharp and fledgling choreographer whose product was fully at the artistic level of anything shown during the run. The movement for the O'Day was endless pairings and groupings and solos in a quartet of two men and two women. It was diverting, although a day later I found myself unable to describe any single gesture or sequence, as if it had been a modern dance version of Chinese food. And I remember Cunningham's piece the way I frequently remember his pieces, namely by the props—in this case, chairs on the side that various dancers sit in while they're waiting their turn, and the wooden baton that is manipulated in various original ways with the utmost seriousness before being abandoned again.

Cunningly placed second on each program were the solos for Baryshnikov (at which point audience expectations were aroused and not yet frustrated), who of course was the reason why the tickets were being scalped, the crowd abuzz, and the seats around me full. (Both programs had a similar structure: Baryshnikov absent for the first and third pieces, the second piece a solo, the last piece an ensemble.) Both were witty, intelligent, made-for-his-body pieces, in one case by Jerome Robbins (*A Suite of Dances*), in the other by Twyla Tharp (*Pergolesi*), the latter adapted from the awful duo program with Baryshnikov and Tharp that toured last year. Both are pieces for which the rhetorical question-with-a-sting "What's not to like?" was certainly invented. They were perfect for Baryshnikov: offhand, charming, punctuated by bursts of energy that damp down in a second, intimate, and knowing. The Robbins begins, in good *Dances at a Gathering* style, with the dancer contemplating the on-stage musician, here Wendy Sutter, playing from Bach unaccompanied 'cello suites. *Pergolesi* contains the entrance of a now-invisible partner, Tharp having been removed, as well as a string of

references to the great ballets (those Baryshnikov doesn't dance in any more, that is), including *Swan Lake*, *Giselle*, and the Nijinsky *Afternoon of a Faun*.

Baryshnikov does these solos beautifully. Why wouldn't he? No one doubts his taste or his wit, and after all they were made for him. To be sure, no one learns a thing from them either, least of all Baryshnikov. They're styles that he perfected decades ago, and the references to now-absent pyrotechnics wear thin. Back then, in the flush of his voracious terpsichorean development, it was breath-taking to see him plunge into more substantial works in the styles of Robbins and Tharp. Now he's not plunging, but merely treading water for dear life, so the effect is more subdued. Plus it's strange. Here was an audience paying top dollar to see a name dancer, even if it's one who will never again do the things they associate with his name. What do they get? Tasteful, witty, jokey, self-referential shuffling. In one of the two pieces (Robbins's), Baryshnikov pulls up on the back of his shirt; in the other, he adjusts his left sleeve. Both pieces were like that all through: way cool.

So what *was* not to like? Well, the fact that the entire enterprise was utterly devoid of any sense of urgency. I don't just mean the fact that many of the dancers were past their peaks, or the fact that behind Baryshnikov doing modern dance as well as trained modern dancers is the ghost of Baryshnikov doing ballet like nobody else did ballet. I mean the fact that the choreography, while frequently amusing and interesting, tends to be either minor works by major figures, or promising works by minor ones. I mean the fact that a repertory company for modern dance, since it is not the expression of one person's sensibility as modern dance companies have traditionally been, must necessarily seem less focused.

I think of a phrase from Gore Vidal in *Fellini Roma* that was used to advertise the film: Rome, says Vidal (interviewed eating dinner at an outdoor restaurant in a piazza), is a good place to wait for the end of the world. So is being in the audience at the White Oak Dance Project. Perhaps at this moment, another great choreographer is slouching or hoofing toward Bethlehem, New York, or Paris, to be born. In the meantime, we will go to White Oak and we will teach ourselves to say, It is enough.

DanceView 1994

Tweedledum and Tweedledee

IN AN ESSAY IN HIS BOOK *On Seeing*, the English art critic and novelist John
Berger writes disparagingly about domesticated animals. On one hand, he
acknowledges that their lives are easier than those of wild animals—that they
are more agreeable and better looking, bred so as to be compatible with
humans. On the other hand, he finds them sad, evidence not of the
development of society but of its decadence. For, pampered, petted, and
protected, their nature as kept creatures denies them, in his view, precisely
that precarious existence of tooth and claw that would at least would
constitute life on their own terms. By attempting to tame and institutionalize
the wild in the form of domestic animals, we alter it, render it safe, ultimately
demeaning the creatures themselves that lead such privileged lives.
Domesticated animals, Berger almost suggests, would be better off
non-existent—or dead.

Berger, as his argument with its critique of the specialization of the
industrial world makes clear, is a Marxist. And where would Tweedledum
Marx be without Freud, his Tweedledee? I thought of Berger, and of both
Marx and Freud during a week in May when I was alternating programs of
two of the world's finest dance troupes, the San Francisco Ballet and White
Oak Dance Project. I thought of them first at Donald McKayle's rather retro
Kennedy Center commission work *Gumbo Ya-Ya* for San Francisco Ballet,
and the next night in the middle of Joachim Schloemer's *Blue Heron* for
White Oak.

In *Civilization and its Discontents*, the still-controversial Viennese
master proposed that society was both powered and ultimately undermined
by ingrained sexual repression that was at once its greatest fault and greatest
achievement. Worst of all, there's nothing we can do about this. There are
things that are wrong with the enterprise of our society, Freud thought, but
they're so fundamental to it that we can't correct them without abandoning
the enterprise itself. And how to abandon an enterprise as complex as
Western society? Or the current dance scene, that is fully as riddled by
discontents as anything Freud could have dreamed up?

Watching Rob Besserer play with his feet in Schloemer's genial piece for
White Oak, clapping his hands together as if to make his leg jump up off the
stage he was sitting on, I realized that all the movement on the program that
included works by Merce Cunningham and Jerome Robbins, was much more
interesting than virtually anything you can see among "normal" people in the
world outside the theater. The best justification for this movement being on

the stage before us was that it offered an alternative to and departure from
the too-lockstep, too-predictable set of norms that regulate standard street
behavior among the productive middle class in West of the late twentieth
century.

I had seen people flutter their hands across their chests from left to right,
lie face down on the stage with one leg bent up, manipulate other people over
a wooden bar, play with their arms and legs, and generally break the mold
of the shoulders-up, chest out, confident stance or sitting posture that marks
the ordinary nine-to-five world outside. We all know that the motions
allowed to mainstream men and women (especially men) are woefully
circumscribed. It's all sit down, stand up, walk forward, turn around. It's
only in bed that we're allowed to be supine, and we're practically never
allowed on the floor, unless we have back problems. How boring real life is!
Hence the necessity for making, or at least looking at, choreography that
exploits some of the other just as real possibilities of the human body. It's
like suddenly varying your diet, after years of fried chicken and hamburgers,
to include *vichyssoise, pâté de fois gras*, and tongue.

Freud would say, such modernist pieces are evidence of the discontents
of our movement scene: on one hand, they are interesting, because made to
be so. On the other hand, the fact that we need to make or see them—the fact
that our ordinary life does not, by and large, offer the opportunity for
anything comparable—shows how much this development has cost us. It's
a zero sum game: the more interesting our past-times are, the more boring
reality has to be for us to have created these vents into a more diverting
world.

And then suddenly, Freud's twin Marx coming to the fore, the Warner
Theater seemed like the gleaming metal jungles of our spas and weight rooms
where we go to isolate and exercise the muscles that our everyday life would
allow to atrophy. Given the sedentary nature of our post-industrial world, it's
the only way to keep our bodies fit. Certainly the weight room produces more
pumped-up people than the less specialized exercises of an earlier agrarian
era. Indeed, it was only in the late nineteenth century with strongmen like
Eugene Sandow that people discovered that they could make their muscles
grow by manipulating metal weights of increasing size. But Sandow was
small by current standards, and he had few immediate followers. There could
have been no Arnold Schwarzenegger in 1894, no *Flex* magazine. That, in
a sense, is progress—specialized progress, that is, and hence also evidence
of general decline. We need gyms, and so admire people like
Schwarzenegger, because our general state of physicality has become so

debased, our lives consisting of sitting in office chairs and scarfing high-fat fast food to make it to our next meeting on time.

"Make it new," urged the Imagist Manifesto of Ezra Pound and F.S. Flint. The phrase was the battle-cry of an entire generation of now-classic modernists. What this imperative does is make art quintessentially the alternative to daily life, its very being defined as an adversarial alternative to the quotidian. It sends choreography in a breathless quest of the new movement, the untried gesture, the striking moment. All modernisms, whether of dance or art, are rebellions against the non-artistic world, which is perceived as inimical to the free expression of the modernist—that is to say, post-Romantic—artist. This is the reason the modernists, like the Romantics before them, rejected the bourgeoisie, that middle class devoted to making money and babies whose norms were so at variance with those of the alienated, individualistic artist.

The modernist impulse also rejected codified art forms, which are almost more threatening than the easily laid-aside norms of the nonartistic world. The biggest threats to early twentieth century modernism seemed the visual tradition of the Beaux Arts, and the three-volume nineteenth-century novel. (Nowadays we realize that societal indifference to art is the greatest threat.) Thus the modernists, for what I take to be the same reason that Schloemer has Rob Besserer play with his foot, were interested in the art of schizophrenics, children, and those taken to be outside the pale of Western society, then called "primitives."

The problem with modernist art is that the more developed and the more interesting it becomes in contrast to real life, the more it removes itself from that life. Either we can rejoice at this divergence—like the Symbolists and late nineteenth-century aesthetes, such as Mallarmé, Huysmans, or Oscar Wilde—or we can fight it by popularizing and hence commodifying art. The former is what one of the first critics of modernism, Edmund Wilson, thought the natural end of the movement—its immurement in the ivory tower of Axel's castle, an image drawn from the Symbolists (Axel was the eponymous main character in a poem by Villiers de l'Isle-Adam.). The latter is the development of modernism into postmodernism, as understood by the theoretician Fredric Jameson: art defined by and in some sense synonymous with the marketplace, individual inspiration turned into a publicly available commodity that exists only to be sold. Think of Andy Warhol as both an exemplar and critic of this movement, or leaf through any issue of *Vogue, Vanity Fair, GQ*, or the new *New Yorker* for tongue-in-cheek critiques-as-examples.

It's a paradox. The more interesting modernist art becomes, the more self-enclosed, and the more irrelevant. It achieves its end of offering a more interesting alternative to the real world, but leaves us feeling that the more noble cause would have been to try and change that world, rather than escape it. But how to change the world? Soviet agitprop is not the answer. In the West, art becomes like a poodle with painted nails, ripe for Berger's impulse of saying, If it can't survive in the wild, it shouldn't be protected.

In some sense, Donald McKayle's rather silly *Gumbo Ya-Ya* was an honorable attempt to circumvent this paradox. *Ya-Ya* offered a strangely old-fashioned mix of costumes, movement, and decor (costumes and scenery by A. Christina Giannini) that harked back to the glory days of Fokine and the Ballets Russes. The movement wasn't particularly interesting in itself, unlike that presented at White Oak; instead it was an amalgam of jazz dancing and balletistic leaps. The unit of interest was geographical, namely the stage itself, not anything temporal, such as the movement.

With its great pulsing tree dripping vines, its Pocohantas-meets-Motown costumes for the jungle movements and its glittery Flash Gordon-meets-the-aerobic-age leotards for the final, city act (danced against a grid of black and gold rectangles that telegraphed "Manhattan"), *Gumbo Ya-Ya* comes closer to a late-Romantic *Gesamtkunstwerk* than anything I have seen in a long time. It was its own world, but that world was the world of the stage. It showed no less evidently than the Schloemer that the real world came in a poor second to art, but at least it acknowledged this with its whole heart. It said: The stage is the only thing that maters; the artifice of the theater is itself a valid experience. Indeed, it is a more valid one. (This is the mentality that has people standing in line for hours for tickets to *Miss Saigon*—where you actually see a convincing-looking helicopter land on the stage! Yet who is standing in line to see the real helicopters land at the New York heliport?)

Is there no way out of this impasse, this constant attempt of the stage to flee the mundane world, this weary search of modernist art for ever-new sensations that are, all of them, alternatives to reality? Yes, in what we call a classic style. And it is with some brief meditations on what this constitutes—and the impossibility of achieving this simply as an answer to our discontents—that I close. In a classic ballet style—I think of Helgi Tomasson's Lavrovsky-influenced *Romeo and Juliet* that played to good effect later in the San Francisco run—the movement vocabulary is codified; it's there because as a language, it's more beautiful than normal movement. In other words, the choreographer doesn't have to find new units of motion, because they are already given. The movement itself is the interest unit, in

the way that the individual gesture is so in the Schloemer, or the whole stage in *Gumbo Ya-Ya*. In a classic style, the questions posed for the choreographer are different than in a modernist one. Not, How can I fill the stage, or How can I keep them amused with gestures, but: What can I say in this already-established language of movement that I have to work with? If we ask that this "make it new," we are making the wrong demand.

A classic dance style is not subject to the same discontents as those which plague a modernist one; here old is not bad. Instead, it is preservation of the old that is the greatest good. The bad news is, it is subject to other sorts of problems, namely the fact that this preservation of the old, at least for a novelty-mad sensibility such as that of critics, seems boring.

DanceView 1994

Between the Movements

ART IMITATES LIFE. OR IS THE OTHER way around? Sometimes they just intermesh and for a few delicious moments, there's no way to pull apart the strands.

Something like this was, I think, the moral of the closing piece on the White Oak Dance Project's Washington performances at the Warner Theater (May 20-23), a piece by Neil Greenberg entitled, in best self-referential postmodern fashion, *Tchaikovsky Dance.*

The piece begins with a large muscular man, body-doodling. A slide thrown on the back wall identifies him, laconically, as "Jamie." Clearly, we are meant to care who the dancer is in real life. The string quartet that provided the evening's music breaks into the frenzied climax of a quartet movement and then is silent while Jamie continues to doodle. He leaves.

Another dancer comes out. She doodles too. The text identifies her as "Manou: Short for Emmanuèle." There is the same frenzied music going nowhere. Then another dancer. By now the words behind the dancers have become more chatty: "His parents used to tell people he was an actor rather than a dancer. They were afraid people would assume he is gay. (He is.)" At this the audience laughs.

By now several dancers are on stage together. They exit, they re-enter. The running commentary behind them becomes more time-specific: Dancer X used to wonder what's wrong with men. Audience laughter. Pause: Now she's in a new romantic relationship.

Mikhail Baryshnikov suddenly appears, along with another dancer. The text explains that "Misha was in Europe and came in at this point in the dance." The audience laughs again. (Compare this to *Serenade*, which fitted in real rehearsal events without identifying them as such: in *Serenade* the girl who falls or the one who comes in late seem fraught with unspecified meaning. Here it's just fact.) Meanwhile the music is stopping and starting, climaxing into silence that is ignored by the dancers, who continue what seems a regularized version of improvisation (groups of them do the same apparently desultory movement in unison). Every once in a while the words throw us a tidbit: "A thinks she is packaged as a normal American girl . . . she doesn't see herself that way; B was dealing with an illness in her family when the dance was being made." And so on.

The text is inviting us to see what is on the stage as a diary of process, rather than as a finished product, and as the product of many individuals who have names, problems, and family situations. And yet, at the same time, the program identifies a single choreographer, and the piece is dated with a specific year, 1998.

This is the paradox of the postmodern, I thought. If only they could take the last, logical step, and not sign it! Not signing it is not the same as refusing to sign it. Even the refusal can be a great Romantic gesture, and in our post-Romantic age it may be the only way to make a successful gesture at all. (Sartre will always be known as the author who refused the Nobel Prize.) Refusing to sign it, that is, would still be signing it, like Rauschenberg erasing a Motherwell drawing and exhibiting the fainter picture as his own. Or the artists in the 1980s who were big on making works that couldn't be sold—Robert Smithson's monumental "earthworks" come to mind—or that "subverted" the myth of originality—such as Sherrie Levine's re-printing of Walker Evans' photographs, which she then signed as the artist. But even these appropriations were "by" Smithson, or Levine.

"A solo for Misha to Tchaikovsky," the words suddenly say. Another joke: Greenberg knows this is who we've come to see. Then Misha is alone on the stage, doing beautiful, regal movements that for several horrible moments we think are meant to be funny. Is this in quotes or isn't it? The audience readies itself to titter, then settles down, fascinated, almost afraid to hope that this might be for real. Baryshnikov does his beautiful solo and we clap, perhaps a bit puzzled: have we been had or not? Then there is more text about Jamie, once the youngest, now the oldest in the company (except Misha, the text says). It adds: "He doesn't see himself dancing much longer."

"Finale," the text abruptly announces, and tongue firmly back in cheek, all dancers come together in a knowingly too-pat ending. They end in a big flourish; the music climaxes. This time the stage stays empty, and dark. I kept waiting for them to re-appear, but no, this really is the end. More quotes around the end. And yet how else to end a piece save in the traditional way?

In spite of these moments of uncertainty, I find I am won over—also despite my lack of patience toward wannabe choreographers with nothing to say who make audience members suffer through the detritus of their uninteresting lives. For suddenly, at least in the context of this one particular evening, the piece seems to me profound. To be sure, the text was little better than arch. Nor was calling attention to the intrinsically personal source of (impersonal) art particularly original (Keats was saying this almost two centuries ago). In a sense, it was a postmodern backstage drama, a 1990s *Stage Door*, that 1930s film with a heartbreakingly young Katharine Hepburn, Ginger Rogers, and pre-Lucy Lucille Ball.

What stuck with me was the more overlooked fact that artworks are made and consumed in bits and pieces in the usually messier continuum of our lives. We construct them by transcending and ignoring other things—and consume them in the same way.

For, I realized, there had been a distinctly downer thread in these texts: illness, impending career end, lack of acceptance, the pains of romantic attachment. The artwork here wasn't just what we saw on stage, it was somehow also the relation of the artwork to the lives that powered it, a larger whole transcending the stage.

This is Virginia Woolf's point in her final novel *Between the Acts*. She expressed it by interspersing the various acts of a village pageant with the fragments of human interaction on the part of the spectators—and, in the final tableau of the increasingly-contemporary historical portrayal, by Miss Latrobe, the pageant's author, who simply has the cast members turn mirrors on the audience. The world of the spectators is the culmination of this history leading up to the present. Much is made in the Woolf of the way the outdoor stage interacts with the bucolic surroundings: Miss Latrobe has set her pageant in the meadow for a reason, even if she is not personally responsible for the lowing of the cows.

My own reaction was surely just as much determined by context, and as much a part of a larger flow, as that of the audience members in Woolf's novel. I was primed to see Woolf in the evening because of having gone only two days before to see the rather flat movie of *Mrs Dalloway* now gasping its last in the $2 re-run house in Georgetown. I still couldn't knock from my

head the rather annoying sound of Vanessa Redgrave enthusing about the "paaahty"she was preparing to give that evening, and the film seemed, indeed, about very little else than a rather dotty socialite whose paaaahty preparations kept being interrupted on the screen by flashbacks to her youth (in the book, it's clear as a result of the stream-of-consciousness narration that they're *her* flashbacks. She's haunted by them. On screen, they merely become the film's flashbacks).

What else fed into my response? Certainly I had been put in a mood to think in terms of the relation of art (or at least artifice) to life by that afternoon's show by the Navy's stunt airplane team, the Blue Angels. I'd look away from the three, or five, planes flying in perfect formation high up in the sky and have my view snagged by a pair or trio of birds, of almost the same apparent size, soaring down the Severn River, unconscious of these multi-million-dollar objects that were getting such effects from the crowd by mimicking their motion. Too, I'd gone into this program full of the article on Baryshnikov in that morning's *Washington Post*, all about the physical aches and pains that make up the life of a fifty-year-old dancer, oxymoron as this is: the countless hours of physical therapy, the knee operations, the fact that Barysnhikov can no longer dance *Pergolesi*, a piece I saw him do merely two years ago in this very theater.

This context made the program's headliner, *HeartBeat:mb* ("project conception and sound score" by Christopher Janney, "choreographic direction" by Sara Rudner, and improvisation by Baryshnikov to the miked sound of his own heart) seem profound as well. Yet once again, there was nothing special about the movement itself. Even the intermeshing of conceptual artist, choreographic "director" and improvising performer seemed to chip its bit away at the notion of the self-contained artwork.

At first, the thud-thud of the heartbeat, which Misha invokes by twiddling a dial on a bank of machines stage right (the curtains are up in best Brechtian style to reveal the back wall and the consoles offstage left) seems nothing but a gag. He doesn't quite know what to do, it seems (how many times has he now "improvised" to this? Surely he has some opening moves, like a chess player): he checks his pulse in his neck, his arm, then plays with the mike taped to his chest. The audience laughs. He runs in a circle, slowly, then faster, then skips a bit—this is getting boring, I think—then throws in some other moves. Some give momentary hints of the dancer he once was; most are like listening to Suzanne Farrell talk about her cats, only interesting because she's her. I'm in danger of losing interest. I sigh, re-arrange, wonder if I can decently tell the large man to my right that he has sinus problems

which make his in-out of breathing a real imposition on the people around him (yet how can I criticize too-loud breathing during a dance that mikes a heartbeat?).

There's a voice-over, someone who sounds like a doctor droning on in clinical terms about the heart. Misha is still doing his stuff. Then the string quartet picks up its instruments, and we hear the slow movement from Samuel Barber's quartet, what most listeners know in string orchestra form as the *Adagio for Strings*. Suddenly I was hooked. Who cares about movement? I thought. This is a man falling apart before our eyes (Baryshnikov's exposed upper body looked so bony I thought of Auschwitz survivors, and was surprised to see, in the last piece with his torso covered up, how substantial his arms and legs still look). This is a dance about mortality, about the body and spirit Barber somehow expressing the inchoate longings of the "heart" that the clinical fact of the real, organic heart makes possible: you've got to have a pulse to do anything at all, whether it's dancing, longing, or playing the violin. By the end, Baryshnikov was running in the same circle he started with. I found myself abruptly close to tears.

Indeed, the whole program seemed more an indicator of its context than discrete pieces, seemed fragments of a continuum. Again I thought of Woolf, this time her story "Kew Gardens," where four couples wander by the unseen drama of a snail pulling its way up and over a leaf, each human pair interacting in a fragmentary way before once again disappearing into the faceless crowd of people. To a certain degree, even the program's format seemed calculated to produce this effect. Paul Taylor's *Profiles* (one of his ugly, Column B pieces) followed *HeartBeat:mb*; both were preceded by a "Music Interlude" that made me think of the whole evening as a sort of vaudeville show: a little of this, a little of that. No coherence, then we all go home.

In the "Interlude," Margaret Jones and David Bursack stood before the curtain and played a Mozart duo for violin and viola. They played well, I thought, although what interested me most was the dance with their shadows produced by the spotlights on the curtain behind them. It reminded me of Margot Fonteyn's celebrated dance with her shadow in Ashton's *Undine*. I've only seen this on film: the Fonteyn I remember from life was an old dancer, then putting on one more *La Sylphide* at the National Ballet of Washington, showcased with an even creakier Rudolf Nureyev in *Marguerite and Armand,* and dancing an insubstantial *Merry Widow* for the Australian Ballet. Now she's long dead, and with her, part of my youth. The shades of mortality seemed once more to close around me.

Of course, being postmodern, this dance with shadows was cooler, far more hip than *Undine*: the motions were more circumscribed, and produced by the swayings of people playing instruments—not to mention being unchoreographed.

Best of all, at least for my interest in things ancillary to the ostensible show, in the middle of the "Interlude" there was a great commotion in the street, perfectly audible through the painfully thin doors to my right giving directly onto the sidewalk. The musicians continued to play; I enjoyed the trio with the street for as long as it lasted. If this was not an intrusion of "life" into art (or was it "art"?), I had never heard one. At the same time, both an announcement and several placards in the lobby told patrons to turn off their beepers. Usually I am overjoyed at announcements like this, finding alarm watches one of the great plagues of modern civilization (I make my students disarm them when they walk through the door of my classroom). But here, I thought, the more the merrier.

For reasons only partly of its own devising, therefore, the evening transpired under the signs of mutability, of impermanence, of mortality—and of context. It reassured us that our lives are fully as interesting and valuable as the things we invent to give them meaning. Of course, this is a frequent point in postmodern circles, with boring dances full of people narrating what happened to them that morning at the bus stop. Here, it all fell together, perhaps because I actually sensed the life outside the artwork.

Woolf, I think, would have understood. Much of my reaction was the result of what had been going on in my own private world. *Jacob's Room* makes the same point, as does her essay-story "The Mark on the Wall." What if I hadn't read the newspaper article on Baryshnikov's physical problems? What if I hadn't gone to see that movie last week? What if there had been no disturbance in the street? Would the pieces have held up as works? Like Miss Latrobe's pageant, they would have worked if circumstances conspired to let them work; if not, then not. Usually I worry about the source of my experience: this time I was content merely to have it.

I wasn't quite sure what to make of the program's opener, *Y* (or is that *Why?*). It was set to the Debussy string quartet, and made me think of a remark ascribed to Balanchine (himself not so long dead) about New York City Ballet: if you didn't like what was going on onstage, you could always just listen to the music. I wanted to just listen to the music, but the quartet wasn't played in a lush enough style to merit focused listening, and the pit's dull acoustics deadened it further. The problem was that the movement, ascribed to Kraig Patterson, added nothing to the music. (I often think the

same about Mark Morris's non-witty pieces, and usually too the empty abstractions of European "greats," say John Neumeier, whose *B Minor Mass* is so insubstantial as to be embarrassing.) Or was Patterson making a statement, telling us that subsequent reactions to an original, in this case the music, always fall short? Was it simply insubstantial? Or a work about The Insubstantiality Our Age Condemns Us To?

The question is a Pandora's box, indicating once again that an ascription of artistic intention is all in judging a work, and utterly irrelevant to the experience itself. If the evening was satisfying merely because of the things I had been reading and seeing or because of an accident of programming, or a noise in the street, then we have to conclude that the works themselves weren't great, and maybe not even good. There has to be a difference between things that merely happen by chance, as the swirl of events around this evening's performance seemed to do, and things intentionally contrived so as to happen by chance, as we so frequently get in the anti-music of John Cage—the 4'33" of the pianist's silence in the piece of the same name, or the radios tuned to local stations.

Yet this brings us again to the paradox of rebelling, in a post-Romantic context, against the givens of Romanticism. If chaos and disorder really are the point, then artists in our post-Romantic age should, it seems, have the courage of their convictions: they need to give up their own claim to artisthood. That means, don't sign the work, don't present it as a work. But then why should we go to the theater at all? Why fight traffic? Why not sit on the front porch and watch the people walk by?

Art will never go away, even if we are suffering through an age of anti-art, art that refuses to do any of things artworks do, and then demands the same adulation as if it had. We will never cease to be hungry for the contact with others through the body of the work that is the center of the artistic experience. And that is why my experience in the Warner Theater was so troubling. I'd had feelings, but the experience was a lot like eating the stone soup of the fable, where the hostess provided the stone and the guests all brought "minor" items like potatoes, ham bones, and vegetables "just to give it a little seasoning." I'd sensed people whose lives as dancers mirrored in more concentrated, more tragic microcosm that degeneration of the body leading to death that we call life, and which is the human condition. But did this come from me, from the world as a whole, or from the dance? Try although I might, I can't make the answer to this questions a matter of indifference.

DanceView 1998

The Problem with Improv

THE PRINTED PROGRAM FOR THE WINTER concert of "Improvisations Unlimited" (University of Maryland Studio EE, Nov. 30-Dec 3) starts with a quote from Daniel Nagrin, who explains that "watching improvisation in concert is quite different than watching choreographed dances." Given this suggestion that what we were about to see would be a new experience indeed, I found myself reflecting in more than usually abstract terms on the nature of improvisation and more structured choreography. The first half of the program was composed of improvisation and the second half of pre-set choreography, so the opportunity to try my own hand at the comparison seemed too good to miss. Yet the conclusion this program brought me to was the opposite of Nagrin's. I left convinced that watching improvisation is in fact the same as watching choreographed dances—it's only the content of the works that is different. And it seemed to me that most of this difference consisted in limitations, rather than liberations.

The improvised part of a concert by this group is nowadays called "The Process," to emphasize the temporal, coming-to-be element of what one sees. (The program quote from Nagrin goes on to underline this aspect too: "unlike choreography, [improvisation] is 'real' time.") The company's director, Meriam Rosen, chooses a specific number of dancers, sometimes the particular configuration she wants (a trio, a duet), and gives the dancers a phrase to work from, or a prop. Then they improvise. The verbal cues frequently sound like quotes from Gertrude Stein: more elusive than allusive, and open to a good deal of dancer interpretation. The particular night that I was there, one of the cues was "slanted enclosure with rough interior," and another had to do with disposable contact lenses. (I thought of a fragment from Stein's *Tender Buttons*: "Elephant beaten with candy and little pops and chews.")

The dancers, two men and four women, are clad in unisex shirts and pants, and dance in non-gender specific terms. Rosen refers to them in this way as well, never specifying male or female, but only "people" (as in "I need four people, please"). Sometimes they make noises, or tell a story: one by Stephanie Ginger Butler about buying panty hose was particularly amusing. "Guest artist" Jim Brown makes noises on what seemed to be a pot.

Near intermission, the group did two versions of an excerpt from a piece whose directions were supplied by (absent) choreographer Jeff Duncan: first one person dances with a prop, then two others do a dance based on the movements from this first one, then all three dance together. At the

performance I saw (Dec. 3), John W. Dixon did a dance with an electric cable and Heather Oldfield did one with two sticks of wood. Rosen suggested that the piece had something to do with ritual, which in any case came through rather successfully in the way the dancers treated their props.

After a performance of the charming Kei Takei *Paperdance*, where dancers clad in Japanese costumes draw faces on pieces of paper to a strict beat and end by showing them to the audience, Brown improvised a solo. He started by dropping a white tablecloth and a piece of black mesh on opposite sides of the floor. By the end of the piece (which contained repeated phrases: "Why are you following me?," "Okay buddy boy") the mesh was wrapped around his head and he was wearing the tablecloth over it like a photographic negative of a Muslim woman shrouded in black, or a laboratory mutant with an enormous squashy head.

And this brings me back to the Nagrin quote. Was watching this dance different than watching a choreographed dance? Did the aspect of "real time" make a difference to the viewer? Was it, that is, at all perceptible? How was Brown's solo, for example, different from the piece by Wendy Woodson on the second half, called *Edgewise*? This was a duet for two men (Dixon and Michael French) in coats and ties who interact using phrases torn from conversations, which they say simultaneously before falling silent again: "Sorry, I thought we'd decided . . ." ; "What's the big idea?" The movement between these fragments of social interaction—set to spooky music by Kevin Volans—tends to be slow-motion. And the dancers hold their facial grimaces long after they have stopped speaking, so that they look like Diane Arbus grotesques, or something from a recent Woody Allen movie.

For each of these two pieces contained fragments of talk ripped from context as well as obsessive behavior, and clearly both have something to do with alienation or inability to communicate—with another person, or the world in general. Were they really different animals, as Nagrin seems to suggest? To be sure, some things from the choreographed dance could not have been included in the improvised one, even if this had had two people in it. I mean the fact that the words the people used were the same, and the fact that they started and stopped the interim sections together. Yet this fact suggests that the difference between the pieces was merely that of a sort of content rather than a difference in the way we see the result, dictated by the limitations placed on several people making things up as they go along.

In a solo, after all, one person makes all the decisions, and so can spin out a longer, more involved structure without fear of someone breaking it off with another idea. Thus there should be no differences a viewer can detect

between an improvised solo and a choreographed one. Certainly there is no evident difference between the way Dixon manipulated his cable and the way Kei Takei uses props as imagined ritual objects in parts of her ongoing (choreographed) opus *Light*. Someone seeing a video of Brown's solo without explanatory notes would not, I think, be able to tell that it was improvised rather than choreographed. For the point is precisely that it *was* choreographed—it just wasn't polished, or refined. It seemed comparable to the first rehearsal of a piece that would never be done again. (Or will Brown do a work with these props, and repeat some of these gestures?) And this is not a difference that is visible to the viewer—unless in the sense that a rehearsal will probably be marred by glitches. But is this a positive quality?

I made a list of the effects that seem impossible, or very difficult to achieve, in group improvisation works: movements with a developed pattern of any complexity, long phrases, regular simultaneous movements. For example *Paperdance*, with its precision movements on a beat, seems the antithesis of improvisation. And the degree of co-ordination demanded by Rosen's own contribution to the program, *Looking Back*, would clearly have been impossible in an improvised work as well. (I imagine, in fact, that the search for more complex structures is what has impelled this group into choreographed pieces in recent years.) The piece is set to a rendition of the Schumann *Kinderszenen* on tape with voice-overs from three of the dancers echoing the stories they tell during the piece. The credits read "Choreography/ Meriam Rosen, based on thematic material created by Stephanie Ginger Butler, Darryl S. Thomas, and Heather Walker"—from which I gather that these three people told stories at rehearsals that were incorporated into the tape.

Which is not to say that the group improvisation works failed, only that their pleasures were of an identifiable sort: fragmentary, and "bitty." In those that worked, the effect on the viewer was like a little series of low-level electric shocks rather than the greater jolt that a choreographed piece with more room for concentrated development can deliver. For example, I liked a passage where the dancers shook their feet a lot, and one where they crowded in on each other (this last was the "contact lens" dance). Sometimes an image works, sometimes it doesn't. But it really doesn't matter, for by this time we're on to the next one. There was something almost monotonous about these series of little self-contained dead ends, which may be partly because there is no way to develop middle-level relations of any interest. The people are never differentiated as men and women, and what you see can never be any more than the sum of its parts. What you see is what you get;

there's not any other sort of overall point. These improvised pieces are all about the same length (three or four minutes), and contain about the same amount of material. The dancers seem to sense together when they are ready to stop, and Rosen says, rather extraneously, "rest."

So much for the limitations placed on improvisation. What about its liberating qualities? Well, clearly it gives the dancers more freedom to do their own choreography than is usual in many companies. The new aspect is that all of them are doing it, not the mere fact of a dancer choreographing his or her own movement. After all, this is what modern and postmodern dancers have been doing since Isadora Duncan, even if they perform the same movement a second (or third, or fourth) time. Nagrin's distinction in essence between steps made up before the viewer and steps made up in the studio and then done before the viewer seems specious. How would (say) Brown's solo be different if he decided that this was a pretty good dance and was going to repeat it, even clean it up a little? It could only get better by his cutting out some of the boring parts and perhaps inserting others. Certainly some of the group dances of earlier in the program could have benefitted by this kind of editing.

There is something refreshingly democratic about group works such as these: choreography by a collective of dancers. This was one of the aspects that made improvisation interesting to dancers in the first place, as a kind of logical outgrowth of some of the dances at Judson for "any body," although of course many of the Judson dances were very carefully made, and the choreographers were drawing on a European tradition of improvisation. But I think this first flush of thinking that everybody has something to say has faded with time. Even Pilobolus, which only used improvisation as a means to an end and never as the end in itself, does works by single people, and nowadays is moving toward works with stories, or at least evocative situations.

Inevitably some of the choreographer/dancers are more interesting than the others, so that the viewer wishes for more of their work and less of the others'. Yet if these are too interesting, the danger is that so many cooks will spoil a broth that one of them alone could have brought to a pleasing boil.

The reason frequently given for a preference for live music performances over records seems relevant here. Fans of live music point out that nothing compares with experiencing the high points of a performance as they are made; low points are simply forgiven. Recordings, by contrast, seem somehow flat, artificially perfect. Yet this comparison between live performances of music and recorded ones is not the right analogy with

improvisation and choreographed dance. A better one would be watching the composer at work or listening to the singer sight-read a new score versus reading a finished score or hearing the piece in final performance. Come time for the concert, after all, the singer has already learned the music.

It may be that the point is precisely that the difference between performer and "creator" is a quantitative one rather than a qualitative one. But isn't it precisely in dance where this point needs to be made least, because it is so obvious? Choreographers have almost always been dancers first, or even foremost, and everyone knows that even works of what is sometimes called "imperial culture" such as those of Balanchine are inspired by the particular dancers he has to work with, and build on the possibilities of their particular bodies.

I wonder, in fact, if there is not just a little arrogance behind the pretensions of improvisation. Every one of us, at some time, brainstorms, and does first drafts—but what chutzpah it takes to ask others to suffer along. I admit that I may merely be jealous. How convenient it would be if, instead of organizing and honing, I could merely say the first thing that came into my head in an essay such as this—if I could just free-associate my way to a point, leaving my meanderings, my bloopers, my less than perfect first-time expression! Improvisation seems to assume that watching The Artist (or here, Artists) at work is interesting in itself.

I can imagine that dancers like doing improv, and it is clear that an audience containing many dancers (such as this one at Maryland seemed to) enjoys looking at them.As far as that goes, however, we all like the valorization that comes from seeing ourselves reflected in art. Yet precisely for that reason it's not always a pleasure we can expect others to share. After all, my students at the Naval Academy love the movie *Top Gun*, about a young, good-looking Navy pilot who gets the girl, and read the Tom Clancy books about Annapolis. Similarly, dancers like dances about dancing—as shown by the reception given *Acts of Light*, Martha Graham's sanctimonious hymn to the floor exercise. In a way, improvisation seems like the logical expression of our post-Warhol "everybody famous for fifteen minutes" world. It's like offering talk shows as the medium of the future that will replace the polished reasoning of an essay, or watching somebody shoot baskets without keeping score.

Having said this, however, I hasten to reiterate that some of the individual moments in the section of "Process" on this program were lovely. But this was because the individual dancers are good choreographers as well (Oldfield, Dixon, and Butler stick in my mind). I don't think they would be

giving up anything really worthwhile if they started making repeatable dances that contained yet more of these interesting movements and less of the boring ones.

Certainly the last piece on the program, Jerry Pearson's *Zen Exercises for Limbs and Pins* owes little if anything to the improvisational esthetic, and is a good piece to boot. Yet it seemed particularly at home in this context. I decided that this was because it was the kind of work that an improv company *would* do when it turned to doing "choreography." For it was built on a skeleton of almost military unison—that, I realized, had been present to some degree or other in all the choreographed works—as if this were the logical flip side of moment-to-moment improvisation. You want structure? it seemed to say. I'll give you structure.

The piece was danced by five dancers wielding pairs of what seemed homemade Indian clubs of plastic bottles and wooden sticks. At the beginning of the piece they kneel in a line, tapping their sticks and clapping their bottles in unison. Ultimately they stand and move about, swinging the bottles in unison (the light sparkles off the plastic: pretty), then walk themselves back into their row, passing the bottles between taps, not breaking the beat. Then once again they are on their feet, throwing the clubs to each other (they are not as good as the jugglers at the stellar Cirque du Soleil that I saw in the fall: sometimes they drop them). They do jumps to count-offs (I suppose the precise nature of the jump is the improvisatory aspect of this dance; Rosen tells us that all of these choreographed works contained such improvised elements), then end the piece by throwing all of the bottles on the floor in a gesture of freedom from this military lock-step that has provided the logic to their movements.

What was interesting was the way all these people kept up such perfect unison, not missing the beat. In short, the pleasure was no more and no less than the pleasure to be gained watching (I hate to say) a Nazi, or Chinese, display of thousands of stalwart youths swinging scarves and brandishing hoops in perfect unison. This, at any rate, was the pleasure of *Paperdance*, where the faces were drawn in strict rhythm, and the simultaneous fragments of conversation in *Edgewise*–and it seemed behind the repeating fragments of stories in *Looking Back.*

Yet most of life operates somewhere between these two extremes of make-it-up-as-you-go-along and strict unison, or with a combination of both, and is composed of men and women (rather than "people"). I left grateful for the fascinating program this company had put on. For by giving me a taste

of two extremes, it defined the area in the middle, where most of the dance that really appeals to me is to be found.

Blurring Boundaries

ONE OF THE BEST PARTS ABOUT WATCHING Basil Twist's *Symphonie Fantastique* in New York's HERE performance space (where I was ensconced on July 10) was coming up with the list of reminds-you-of. Here's a partial one; I'm sure a parlor game could be invented to ferret out others. Loïe Fuller. Cleo the goldfish in Disney's *Pinocchio*. Doris Humphrey's *Soaring*. An Esther Williams synchronized swimming spectacular. Chinese sports demonstrations with lots of girls twirling lots of scarlet ribbons. Television. Viking Eggling's early abstract film *Symphonie Diagonale*. Jellyfish. *Fantasia.*

But that wouldn't explain to your neighbor back home what the piece *was*. For that, we might well appeal to the program, which notes that the piece is "a production of HERE's Dream Music Puppetry Program," and that it was partially funded by The Jim Henson Foundation for Puppetry. Aha, you say. That's the rubric: puppetry. But, you might object, there are no humanized figures to be seen! Well, abstract puppetry. More specifically, abstract puppetry in a black-backed aquarium that was large enough so that, when framed by black cloth in front of a black box theater, the effect was very similar to watching a smallish television set in your family room.

Aquarium means water. Were we conscious of the water? Yes, insofar as some of the "choreographed" effects included bubbles released at strategic times. But it's difficult to choreograph for bubbles. The only way they go is up. Most of the movement, therefore, was for pieces of colored cloth that were drawn through the water. Or perhaps I should say, that moved across the screen, since I think that was the sense we were supposed to have. After all, the sticks were usually invisible, and the puppeteers (Basil Twist, Sam Hack, Chris Hymas, and Jessica Chandlee Smith) came out only at the end, wearing soaking evening-length black gloves that had hidden their hands from the audience.

Some of the fishies were little. I say fishies because the tufts of cloth Twist and his cohorts set dancing were usually triangular, with the "head"

gathered to a point. Sometimes two were attached to one stick, and so by definition "swam" in chorus; the more usual pattern, however was two or more crossing from opposite sides, swooping across the screen like birds confined to an aviary. Occasionally the fishies took a rest and a beam of light did a little dancing. At one point a great "sun" rose. Sometimes a big jellyfish came out, a great parachute-like pulsation (*cf. Soaring*) that quivered and quaked.

The structure to all this was provided by Berlioz's delirious work that supplied the work's title (the precise wording for the relation between the two in the program was "*Symphonie Fantastique*, created and performed by Basil Twist, music by Hector Berlioz"). I say structure, but what I really mean was that the sections of the piece began and ended with the music, with a "curtain" coming down inside the aquarium at the end of each movement/act.

Berlioz's piece practically marked the birth of Romanticism in music when it appeared in 1830. Like much music of the nineteenth century, it's music telling a story, and a rather lurid story at that. I've always enjoyed the first sentence in the story's English translation: "A young poet has poisoned himself with opium." He's obsessed with a lady, whose theme comes up repeatedly as the piece's musical *idée fixe*. He has drug nightmares: he sees her at a ball; there's an interlude in the country; he imagines an overheated gallows scene, and then finally a witches' sabbath, complete with the *Dies Irae* in the music. It's all deliciously overwrought, as if banishing forever in its story and music shades of pastels: only intense colors for us, it seems to say, the colors of Poe's "Masque of the Red Death," blacks, purples, scarlets.

This, then, was the music playing while the Trained Guppy Show was on the TV before us. Unlike Berlioz's poet, these guppies had definitely said "no" to drugs; there was no visible correlation at all between the music's program and their movements. Nor was there any effort to achieve the intensity that Berlioz was aiming at. The music, instead, was used only as a producer of rhythm; the treatment of this rhythm was decidedly Mickey-Mouse. When the music tiptoed, the fishies twitched. When it became bombastic, they swooped and glided. At one arch moment in the music, they even came to the front of the aquarium and "looked out." The audience tittered.

In some ways, however, Twist's abstract puppetry *was* true to the spirit of Romanticism—at least, to the late Romanticism of the Symbolists that had long since found fatiguing the heart-on-sleeve subjectivism of the early

nineteenth-century pathfinders. Walter Pater, after all, had insisted that "all art aspires to the condition of music," music in his view being free of the abstractions of figuration and plot. In something of the same spirit, Twist got rid of clunky people-figures we associate with marionettes (think of the puppet show to "The Lonely Goatherd" in *The Sound of Music*) and replaced them with the imprecise shapes of animated pieces of cloth. Even Twist's switch to abstraction was, arguably, Romantic: it wasn't by accident that Symbolism begat twentieth-century abstract art, where shapes with largely subjective meaning to the artist could be used to express states of mind and philosophical concepts (*cf.* Kandinsky).

What Twist was doing was also Romantic in its insistence on blurring boundaries between the arts (the Romantics were the formalist experimenters of their day, with intimate marriages of words and music in *Lieder*) and within the arts (painting's reversal of the neoclassical hierarchy that placed landscape and still-life at the bottom of the heap with allegorical history painting at the top: think Barbizon School, or Impressionism). The Romantics were fascinated too by the blurring of senses, called synaesthesia (heard colors, seen music), that Baudelaire first evoked in his poem "*Correspondances.*" Twist's attempt to push puppetry toward other arts—dance, abstract film—and to intertwine it with music was akin to these.

The problem was, it just wasn't very good. Line head on exiting: "Kid's gotta be making a joke. Pulling a bunch of *schmottes* through the water and having people pay!" The twirls and twists quickly became boring, because somewhat predictable; the fishies cloyed, and the whole thing seemed insubstantial against the unwisely-chosen backdrop of the so-rich musical story unfolding—and being so roundly ignored—behind it.

Faced with all this warmed-over Romanticism, I found myself feeling very neoclassical in reaction. I thought of Lessing's seminal mid-eighteenth-century aesthetic treatise *Laocoön*, named after the figure group in the Vatican of the Trojan priest who warned his people against the Greeks' stratagem of the horse, attacked, along with his two sons, by huge sea-serpents sent by the pro-Greek gods. The statue group shows father and sons entwined in the snakes' horrible coils; their bodies show pain softened, Lessing believed, by beauty that made it tolerable: their mouths aren't open in screams.

The thrust of Lessing's essay is to insist that the arts are separate, and that they are so for a reason. Epic poetry such as Homer's, because it unfolds in time, can (in Lessing's view) legitimately show such extremes of

emotion, because it puts them in a context that shows them to be, precisely, extreme. Sculpture, by contrast, should aim for the mean. (The concept of the mean, Aristotlean in origin or at least development, was a staple of neoclassical aesthetics). Because it works in a frozen moment, that frozen moment should not be the rule rather than the exception, as the *Laocoön* group would be if the mouths were open, because it would be unrepresentative, not to mention less than beautiful.

Particular arguments aside, the thrust of Lessing's consideration is to keep the arts firmly in their boxes: cross-over isn't good, because it muddies the waters. The Romantics liked their water muddy, and blurred boundaries to beat the band. Lessing freely acknowledged that it was possible to do this, but pointed out that it creates monsters. That is, it offends against taste, which of course the neoclassicists thought abhorrent, and was precisely the point for the Romantics: the Romantics liked monsters. (A great deal of contemporary art seems to me to be about showing that such fusions are possible. Of course they're possible. Are they advisable?)

Seated at HERE, I was convinced that Lessing was right. It may be a great theoretical step forward to make puppets that didn't look like people. But, at least in Twist's hands, it led only to a quaint anthropomorphism of the abstractions in a Disneyesque vein. Aristotle too seemed valorized, with his insistence in the *Poetics* that plot was the most important element in a play. Once we dispense with plot in puppetry and throw ourselves on the structure of the music, the limitations of manipulating bits of cloth become clear.

Was the problem with Twist, or with his attempt? Perhaps the solution is more experimentation in this vein, not less. Clearly most people saw no problem at all: performances of his piece, have been selling out, and the run has been extended.

DanceView 1998

Billboards and More

IT'S RARE WHEN A DANCE COMPANY gets to be the center of a media flurry any more—even if it's only in the *Style* section of the newspaper. So we would be grumps to begrudge the Joffrey its coup with *Billboards*, an evening-filler of undistinguished choreography accompanying the music of

rock personality Prince that premiered in Iowa in January and made its East-Coast premiere during the company's appearances at the Kennedy Center in Washington, D.C. (June 1-6).

Sellout crowds, people shouting "yes!," audiences stomping and clapping rhythmically at the end—it all had the feel of a bygone era, the height of the "dance boom" of the 1970s. To be sure, it's not quite the same crowd that wouldn't let the newly-arrived Baryshnikov off the stage after his phenomenal first appearance in this same hall. The audience for *Billboards* is even less a real dance audience than that one was, for one thing, and the reasons its members were keyed up are even less related to the dance *per se*. But it has something of the same feel. And the way it feels is good. Since feeling good is, after all, the message of *Billboards*, things are as they should be.

I don't mean this ironically, or at least not completely so. Years ago, Edwin Denby acknowledged openly something that many serious dance watchers admit only secretly, that a legitimate component of dance performances is the pleasure we get from watching a group of uniformly young, uniformly healthy-looking young men and women bound about. Nowadays we might be even more honest, and call it a low-level erotic charge. It makes us feel good, whatever the boys and girls on the stage doing, as long as things maintain a certain energy level. It's the charge of rock concerts too: the sound is loud, the adrenalin is up, the star is adored, the pressure of the crowd is exhilarating. So we might say that this Joffrey-style marriage of ballet and rock was a haddabe. Indeed, the Joffrey has been the matchmaker for this sort of coupling since the 1960s, when Robert Joffrey made *Astarte*— and Gerald Arpino kept the faith alive in the 1970s.

But this isn't the 1960s any more. The emphasis nowadays isn't on being hip, it's on being Somebody. The music for *Astarte*, after all, wasn't ballyhooed as being by a rock star, and that person's name didn't appear four times onstage in billboard-sized combinations with the individual choreographers, as Prince's name was here. (This produced what I thought of as a found poem, served to us one line at a time over the two hours of the performance, perhaps a bit repetitive: "DEANPRINCE MOULTONPRINCE SAPPINGTONPRINCE PUCCIPRINCE.") Four segments, in other words, four choreographers, as Norman Bates might have put it to Marian Crane in *Psycho* ("twelve rooms, twelve vacancies").

Not that you could tell that the choreographers were different, and the mile-high parading of each choreographer's name seemed a futile attempt to assure the dance fans in the audience (rather than the rock fans) that this

program played by the same rules we have come to take for granted in our post-classical age. Namely, it assumed dance to be an expression of the individual. It's what we might call, borrowing a film-critical term, the *auteur* theory of dance. We've been hooked on this *auteur* theory since the early twentieth century, when—as a result of the "make it new" strictures of modernism—it seemed that each dancer had to invent his or her own vocabulary. This way of going about things has its own set of discontents, some of which we are witnessing today (such as: What happens when the person who invented the vocabulary dies?). It has also determined the way we look at dance. We copyright it, see it as a Work by X; our assumption is that choreography is individualized, and part of an individual's self-expression.

Yet it's an assumption increasingly difficult to take seriously, now that the giants are dead and even on our major stages we are firmly into the age of "school-of" pieces, and you can't tell the choreographer of one from the next since they all look like worshipful spin-offs of the Master. The more provincial the choreographer (a quality not measured by distance from Manhattan), the more the pieces blur. Every regional company has its X-type and Y-type pieces. And who, save the pop culture experts, can tell apart the dances from one Broadway show and another, one dance video and the next? Still, we haven't given up seeing dances as "authored," when in fact we should probably be seeing them as much in collective terms as we do Hollywood films that, despite their myriad of nominally separate directors, seem stamped out with cookie cutters—or perhaps, merely products of the *Zeitgeist*, that prolific author of most of our contemporary entertainments.

There were, to be sure, marginal differences between the four sections of *Billboards*. There's the most to be said about Laura Dean's opener, so I'll come back to that. The other three sections were by Charles Moulton, Margot Sappington, and Peter Pucci. (Pucci contributed to the repertory program I saw on June 1 a pseudo-Native American piece entitled *Moon of the Falling Leaves* that pleased me simply because it was a perfect example of what I have elsewhere called "faux" ritual in contemporary dance.) The sections remained separate in memory afterward largely because of the costumes, which after all were by people other than the choreographers (Dean's came from a "concept" by her)—or maybe because of the fact that they were set to different songs. The dancers did different things in each segment, but they were all expressions of the same sensibility, all painted with the same spectrum of choreographic colors, speeches in the same vernacular. Moulton's section was a kind of orgy for grotesques that

reminded me of an updated version of the troll party in *A Folk Tale* in its current Royal Danish Ballet production (sets and costumes by the Queen of Denmark, thank you very much).

A kind of mistress of the revels with a heart-topped wand leaps out and calls several orange-or-red-wigged boy-toys to sporadic life. These make desultory efforts at coupling with the grotesque females (jolting their hips in congruent motions), but, seemingly rebuffed, give up quickly and go on to other things.

The next song was *Purple Rain*. It's the most downer treatment of music in the program, although one thoroughly in keeping with the general spirit of things. A sad-faced Pierette trapped in a spotlight pouts at the audience, gets upset, and strips off her silken pajamas to reveal gold lamé that looks bonded to her skin; she ends up in a pile on the floor.

It's emoting rather than emotion, or perhaps emotion twice removed, once by the white pajamas and whiteface, another by the spotlight, the lamé, and the look at the audience the way women look at a mirror while they're putting on lipstick. The whole thing is done as if in double quotes, sophisticated and knowingly empty, with the feel of a drag or Vegas strip show. The French social theorist Jean Baudrillard, with his theory of simulacra become reality, would have approved.

Sappington's section is the Brechtian one: banks of visible lights, open flies, posters for, what else, the Joffrey Ballet, boys lounging on chairs in tank tops and girls in Frederick's of Hollywood sheer nighties with bikinis underneath, sashaying around. (To my eyes, it looked like a combination of Robbins's *Mother Goose* and *Afternoon of a Faun* with Kenneth MacMillan's *Elite Syncopations*.) By the time Pucci's section rolled around with its pointedly gender-various pairings, my eyes had glazed, numbed by the relentless high energy and all the boys and girls preening, all of them with zonked-out eyes. Ultimately, however, they weren't preening for each other, but for the audience. It was a show about showing, an exhibition of exhibitionism (in a way, the whole evening was the legitimate child of the Broadway musical *A Chorus Line*, its backdrop an implied bank of mirrors.)

Whatever their particulars, the sections tasted of the movement gravy that covered them all, made of a dollop of jazz dancing (high kicks, active pelvis, mobile upper bodies, back-and-forth arm swings) and more than a soupçon of drag-queen style vogueing (the preening, mannequin-like posing, the constant blank-faced stares at the audience), with its base whipped up from the common vocabulary of post-Fosse Broadway and television dancing today. It's the movement lingua franca of our consumer age; every gypsy can

do it, and every aerobics class wants to. The point, therefore, was who was doing it, and where. The audience gets to feel simultaneously naughty and valorized; the action itself is an event, and the merchandising is the message. (The sections even looked largely the same, being lit by Howell Binkley with arching klieg lights or banks of footlights that rose to the flies or spotlights cutting through the dry ice, in imitation of rock concerts. The lighting here seemed merely affectation—compare it to its stunning first cousin by Jennifer Tipton for Tharp's *In the Upper Room*.) All, that is, were cuts from the same visual track, separated by intermissions and strolls by the Potomac River, visuals for audience members who had come for the music, a kind of live visual accompaniment to their favorite songs, dance MTV.

It's a novel way to treat a dance company. Not that I necessarily disapprove. The National Symphony plays movie soundtracks every summer at Wolf Trap, and I don't see any reason why they shouldn't as long as it fills the lawn.

It was easier, as a critic, to react to the Dean opener, simply because she best fits the bill of a choreographer with an identifiable style that can't be confused with anybody else's. Trouble was, it wasn't evident here, nor on the other two of her pieces that were part of the company's repertory evening, *Structure* and *Light Field*. It's beside the point to say that Dean has sold out. She has, of course. The question is whether what she is doing here is more or less interesting than work she did for her own company and for ballet companies trying to approximate her own movement patterns. The bad news is, it's less interesting; ballet movement doesn't seem to be liberating for her as it was, for a while, for Twyla Tharp. The genesis of Dean's trademark spinning of her earlier years was, after all, the Sufi (Islamic) mystics who believed that they were getting in touch with God by their turning. When her company would lock into the spins, inevitably set to the mesmerizing arpeggios of Glass or Reich, the motion seemed almost religious too.

The Dean pieces shown on these two Joffrey programs were, by contrast, deeply shallow and relentlessly secular. They're a series of ballet high points (lifts, jumps) strung end on end whose effect is to show how beautiful the people involved are. The mood is always up, and so, usually, are the people. Unlike the spinning, lifts and jumps are actions that project out, rather than in. Of course, they're nice to watch, in a Pepsi commercial kind of way. Even the costumes help set the mood of "look at me, I'm beautiful": gold lamé in *Structure*, glittery white in her *Billboards* segment—entitled, after one of the songs, *Sometimes It Snows in April*.

Thinking again of Denby, I say: there's nothing wrong with youthful beauty. It's at least related to the same kind of gorgeous youth thing that Paul Taylor does so well. Only instead of Taylor's misty European dream, it's all good clean American boys and girls jumping and cavorting. Indeed, if what she's done weren't so exploitative, I'd almost be willing to say that Dean is taking on our myth of distance from the aesthetic object. What she's given us is the dance equivalent of a porn movie. The people are pretty, they're hot, and we wish we were them. The dance strings its climaxes ever more tightly and we all come together.

As far as that goes, all of the pieces take themselves on to a certain degree. That, after all, is the nature of our current hipness: it's knowing. We'd kill for our fifteen minutes of fame, and then tell Geraldo about the murder while the clock is ticking away. Madonna, after all, is both poking fun at fame and being famous, both ruthless in her pursuit of power and mocking of it. Drag queens are both making fun of the airs and graces of great divas and trying desperately to acquire them. This program, with its glitz and lights and youth and heavily artificial naughtiness, was both fixated on The Gaze and an exposé of it. (For this reason it bears comparison with Robbins's *Faun*, another dance about dancer narcissism.) Indeed, all our sex gods and goddesses of the last decades have had the same air of tongue-in-cheek that this whole program had. Was Marilyn the exploited or the exploiter? Isn't Liz her own caricature? Did we really even need Warhol to point out the cardboard quality of our icons? That's precisely why we love them.

An enterprising Ph.D. candidate could certainly show that this program exemplified Michel Foucault's claim that the artist (author), and by extension art, is dead. It was so shallow it was profound, the argument might go, a claim that is at the essence of most contemporary analyses of postmodernism. It's a program, we might say, about its own media-ness, an event about its own hype: and this is simply where we are, historically speaking. It reminds me of a show I saw at the Hirshhorn Museum of the sketches and bureaucratic documentation of Christo's mega-event *Running Fence*. The art (or "art") wasn't the fence, or even a simulacrum of it: it was the exhibition of the paperwork from the litigation to make possible the installation and then removal of his great wasteful atrocity of canvas and stainless steel that cut across California farm land and disappeared into the Pacific Ocean.

Whether we approve of *Billboards* or disapprove, we can at least agree that it wasn't very good art if we apply the same "masterpiece" standards

that we can apply to, say, Balanchine or Ashton. Yet this may be beside the point. Should we/can we apply these standards? I leave that to the academics and pop culture theoreticians. Another set of questions entirely is, Was it a good idea of the Joffrey to mount this? A bad one? These questions may be no more fruitful. Clearly if it sells tickets, it's a good idea, at least at this point in the frightening degeneration of dance's economic base. It's especially good for the Joffrey, a financially strapped company in search of a home (and perhaps an artistic center as well). Besides, this kind of program feels right on the Joffrey, which has always tried to keep polished its youthful image. Clearly too the concept got people in the theater who weren't usually there: I don't think that part of the audience that yelled and screamed was a dance audience.

This was good on several fronts. These people weren't asking whether the choreography fulfilled the criteria of the self-sufficient modernist work. It moved and that was enough. Given our current dearth of fresh talent, this kind of low demand threshold is positive. Furthermore, the rock fans in the audience were used to paying inordinate amounts of money for high-tech entertainment, and so weren't the kind of people to leave the theater saying, "we paid money for *this*?"

But there is a down side too to pulling in such a wide non-dance audience. First, it's bound to be less effective the more often it's done. It's like Beverly Sills putting out a record of Christmas songs, or Dame Kiri singing Gershwin, or Pavarotti singing whatever will sell: each performer has to be solidly set on a high-culture pedestal first, or there's no meaning to the gesture of reaching down from it. The more they reach down from it, moreover, the less interesting the gesture is. The Joffrey has to be associated with "ballet"—that somehow foreign, imperial art form—in order for it to make headlines that they're putting on sexy dances to Prince. It helps too that the whole thing is at the Kennedy Center, that symbol of the Washington and national arts establishment. In other words it's slumming, which only makes sense if it's only temporary. Only the first time around can it grab headlines. Needless to say, it's only relative slumming: it only attracts into the middlebrow, not down to the lowbrow, leaving untouched the people who don't know where the Kennedy Center is, or how to use Ticketron.

If the next three years bring three similar suites of dances by other rock stars, I predict precipitous audience drop-off. It's a one-shot deal, a dead end. I think of Schoenberg's pun on the German word for "dead end," a *Sackgasse*—literally, a street that ends in a bag. Reacting to the charge that his own twelve-tone system, in contrast to Stravinsky's chosen early path,

was a *Sackgasse*, he replied: there is no *sackere Gasse als Sacre*—no deader a dead end than *Rite of Spring*. There is no *sackere Gasse* than *Billboards*.

Furthermore, there's another disadvantage. Because the audience isn't asking itself whether the dancing is substantial on its own, shows like this aren't bringing in people who will be able to distinguish between one choreographer and another, or appreciate dancing for its own sake. Such a program blunts the purely choreographic sensibilities of an audience. That's its pernicious aspect: it's like spending your capital, or eating your seed corn. Of course, straits may be so dire that nobody cares. Already it seemed silly to place so much emphasis on the choreographers, and I would predict that if this type of experiment is repeated, they would have to become anonymous, or at least be relegated to the small type, like the directors of MTV segments.

What I felt most strongly during *Billboards* was a sense of pathos, a feeling that I really was watching the end of an era, rather than the dawning of a new one. The big question on all stages now that Balanchine is dead and has even had his first posthumous retrospective is, Where is dance going to go? Balanchine taught us to see dance as something primordially linked with music, with incidental or absent sets and costumes. (I'm talking about the modernist ballets here, not the Romantic ones). He stripped away all the elements but two, the dance and the dancers, and they came in that order. Because he was a genius, he realized that he had to make up in these areas for what he had taken away in others.

Now we're in an era where people continue to make dances like this, with the other elements still missing, or incidental—but they haven't got anything to make up for them. The dance and the dancers just aren't interesting enough to bear all the weight that's still being put on them, and nobody has yet re-integrated them successfully into larger structures that can help with the load. And they're not linked to the music, although they play simultaneously with it. (Cunningham, who de-coupled music from movement, simply did overtly what has become fact in many theaters today already.)

I think again and again at concerts that choreographers X or Y would be better off renting out to provide the movement equivalent of chatter music at a social function. Each can fill the time, but what we see hovers on the threshold of boredom: the works don't hold up as the great objects of our undivided attention we modernists have been taught to think of dance as being. I even think this sometimes at less-than-great Balanchine pieces, which shows how much it worries me.

Maybe the time has come to simply give up this presupposition that dance is meant to be an end in itself, to let all these minor *artistes* who can move dancers around for twenty minutes between intermissions go back to being minor rather than trying to pass themselves off as "choreographers"—free them of the pretense of being the producers of Art. Dance, I think, needs a new structure. Is it going to be found in movies? The musical? Some variation on the evening-length ballet? I don't know. By parading the very vacuity of our collective invention in these waning days of postmodernism, the act of commodification itself become saleable commodity, the Joffrey may have brought us closer to the day when we simply give up this paradigm and move on to other ones. Perhaps we will go back to a situation like that of the nineteenth century, when ballet and dance had their secure if second-rate niche as minor arts in the context of something larger. And if this happens, who can say that we won't remember *Billboards* as a seminal work in this development, and in retrospect be grateful to it?

New Dance Review 1995

IV

Looking Out

Critical Imperatives in World Dance

"WORLD DANCE": THE TERM ITSELF is new, its adoption for general use the sign of an alteration in sensibility that merits consideration. For in this term are hidden presuppositions and assumptions which, if they are not exactly false, should at least be brought to light so that they can be considered on their own merits. And it may very well be that their merit is not quite as great as it had initially seemed.

"World Dance" as a term to refer to non-Western dance replaces, for the culturally sensitized, the semi-pejorative "ethnic dance" that is still common currency in some circles. The labeling of anything non-Western as "ethnic" is a value judgement, underlining the primacy of one particular cultural matrix. It implies that there is, on the one hand, standard dance; outside of this, on the other, there is merely "ethnic." Indeed, the insistence that the standards of white people of Northern European stock not be used as a measure of value for all artistic products is heard and seen nowadays in virtually all American professional organizations and journals, from the meetings of the Modern Language Association, to *College Art*, the magazine of the American College Art Association, to the Dance Critics Association Conference. This itself is part of a yet larger cultural agon. Universities debate the inclusion or exclusion of literary works by non-white, non-straight non-males into the canon. Museum directors clash with ethnographers on the most suitable way to display the art objects of Africa and Oceania—should the formal qualities of the works be emphasized by showing them on pedestals in a museum with white walls? Or are they comprehensible only in the larger and more specific context of the society which produced them?

The Dance Critics Association Conference on "Looking Out," held in conjunction with the 1990 Los Angeles Festival devoted to the indigenous arts of Pacific Rim peoples, is not an isolated blip on a screen. It is part of

a much larger wave, as much following a trend today as making one. So too is Peter Sellars as much a trend-follower as a trend-setter in deciding to devote the Festival to the arts of Pacific Rim cultures—which means, largely non-Western ones. Sellars, and by extension, the "Looking Out" conference, are yet further examples of the alteration of sensibility that American sociologists have expressed as the abandonment of the paradigm of the "melting pot" for our society and the adoption of one sometimes called that of the "beef stew": lots of chunks, rather than one smooth consistency in the mixture.

This cultural trend is earth-shaking in its implications for America. I do not think it is too much to compare it to the displacement of the Ptolemaic earth-centered paradigm of the universe by the Galilean insistence that the earth moved around the sun. Like the earth and man upon it, Caucasians of Western European origin are no longer the center of the universe. Instead we must acknowledge that there are other planets of equal value, all of which (it may be) circle round a single source of artistic inspiration. We have, it seems, been taught for too long that women deforming their feet in strange hard-tipped shoes in order to stand (of all things) on their toes and dancers of both sexes opening feet and hips in ways that God never intended them to do is, in the words of Keats's urn, all ye know on earth, and all ye need to know. It is time (and here I am stating a personal conviction as well as summarizing an overall trend) to acknowledge the fact that there is indeed more in heaven and on earth than was dreamt of in our philosophy of dance—as anyone attending one of the many performances of the Festival in a dance form strange to him or her will attest.

Looking Out: the theme of the conference (which is to say, looking outward); acknowledging our own limitations and contingency. This is clearly a good thing, a humble thing, indeed one might almost say a Godly thing, helping to free us as it does of the sin of pride. And yet for all of the virtuous, even self-congratulatory feelings this openness to other cultures than our own may produce, it is not easy to know how to put this openness into practice. Indeed, there are problems with the result even if we are able to do so.

We may take for granted the point of the ethnographers: that all art forms spring from a particular culture. (In her essay "An Ethnographer Looks at Ballet as a Form of Ethnic Dance," Joann Kealiinohomoku outlines the cultural givens undergirding the classical ballet—as if it were a surprise to hear that it possesses such. *Of course* the classical ballet presupposes cultural givens; *of course* the only reason we do not see this is that we take

them for granted.) The difference between the products of Western culture and those of non-Western cultures is not that *theirs* are specific to their cultures while *ours* are somehow universally comprehensible, transcending specificity. Yet the fact remains that there is a fundamental difference, for the perceiver, between a work whose cultural underpinnings he or she can take for granted and a work where these are totally strange. And it is in the latter situation that we find ourselves when we sit at programs of "world dance."

As an example of this fundamental difference between works of our own culture and works of other cultures, I offer an experience I had some months ago at a performance of a Japanese kabuki troop led by the celebrated actor Ennosuke, which (as a result) was billed as "Ennosuke's Kabuki", and presented at the Metropolitan Opera and the Kennedy Center. The peculiarity of this performance was the fact that in the hallway beforehand viewers were exhorted to rent, for $5, a headset that was advertised as "absolutely essential" to the understanding of the performance. Mine came with the press kit, or I might not have rented it. (I am one of those people who refuses to look at an art exhibition with a recorded curator talking in my ear.) The voice provided information about nearly every conceivable aspect of the performance: the term used to refer to the female impersonator actors, the plot developments, the meaning of the drum roll in the music—in short, all of the "footnotes" that the editor of a text from a long-ago era or a strange culture must provide to make that text accessible to a reader.

Because I could make this voice go away simply by pulling the plug out of my ear, I was able to switch at will from performance-with-footnotes to performance-without-footnotes. The difference between these two radically different phenomena was as follows: with the auditory footnotes, I understood what I saw, but was unable to see the performance as the end in itself that art from a culture I understand seems to be. Without the auditory footnotes, on the other hand, the performance on the stage took on, to a much greater extent, the visual character of a performance in ballet or modern dance, but was utterly incomprehensible, perceived the way someone ignorant of the rules of baseball would watch a Dodgers game. And yet these footnotes were not even at the base of the page, where I could look at them at my leisure—but instead (so to say) interspersed through the text, simultaneous with it, so that it was impossible to see the performance as an individual event. Instead, it became the example of a type that was being explained to me over the head-set. The voice-over was both destructive, that is, and absolutely necessary.

If I were Japanese, I might be able to take for granted all of the things that the voice filled me in on—just as I now go to a performance of *Giselle* knowing the plot, expecting a position of turn-out from the dancers, accepting the mad scene as an essential feature of the work's Romanticism, and not finding inherently foreign the notion that the dead might well be conceived of as existing in spirit form, flitting through the woods. Without such information, I do not, we may say, understand *Giselle.* Without comparable information for dance from other traditions, partisans of world dance would insist, I cannot hope to understand (in this case) the kabuki. And their conclusion from this is that we as audience members must educate ourselves, must learn what are the givens and what the variables in the products of other cultures, just as we learn more gradually, and almost by osmosis, similar things for our own cultures. (That the givens of classical ballet and modern dance are in fact learned is clear to me from teaching dance works from films and performances to midshipmen, who take for granted neither tights, toe shoes, turn-out, nor tutus.)

In fact, I agree with what would certainly be the reaction of world dance partisans to such situations as that in which I found myself at the kabuki. We cannot fully appreciate the products of another culture until we have internalized a vast list of cultural givens that serves as the hidden part of the iceberg supporting the tip—the tip being the program that is presented to us from eight in the evening until ten-thirty. Yet now we come to the heart of the problem, which has both its practical and theoretical sides. First of all, to the practical: it is, let me state flatly, utterly beyond the bounds of possibility to ask the average viewer to educate him- or herself before such a performance in an unfamiliar form to the point where he or she will understand *this* performance (in the sense of, knowing what to look for in it). Even assuming that we critics learn enough about the form to process a few general pointers regarding what to look for, most of us can't do enough advance articles to impart this information to others—and if we could, how could we guarantee that the audience would have read them? Require them to pass a test before they enter the theater?

Some critics say, the answer is adequate program notes—something that has been criminally lacking in most commercially-produced world dance concerts. But here again practicality kicks us in the leg: the fact of the matter is that people don't usually get to the theater in time to read program notes, me included, or are talking with their neighbors or having people climb over them. And this is what certainly impelled the promoters of "Ennosuke's Kabuki" to the concert headset—an experiment that I must proclaim a

resounding failure. It's too distracting, and it makes the performance into a teaching tool for the generic, rather than something to be perceived—at least consciously—as a specific performance.

The practical problems facing those who would have us understand world dance, therefore, are daunting. But the theoretical problem is worse. For even if we somehow acquire, as critics or as audience members, a minimal fluency in the givens of those few major non-Western art forms that we may expect to see more than once in a lifetime, the most we can get from this stumbling acquaintance is a relationship with the works of these other cultures which approaches, perhaps asymptotically, that relationship we already have with those of our own. We can get to know more quantitatively, but we do not hope to know qualitatively more.

Understanding art consists of knowing what to look for. Art is not created in a realm separate from the world; instead artworks include some of the givens of a particular world and add to them elements that are not part of that world. Experience teaches us to situate the dividing line between that proportion of the quotidian, which every artwork contains, and that which is added individually by the artist. We appreciate the artistic side of an object or event only in contrast to that which it accepts and incorporates without change from the world. This process, of course, admits of stages, and we can understand more or less at any given time—which is to say, see more or less of what makes the artwork in question art. (For a fuller development of my ideas on this subject, see my *Essay in Post-Romantic Literary Theory: Art, Artifact, and the Innocent Eye*.)

What this means is that we can become more familiar with non-Western cultures and their dances—and curiosity may well impel us to do so. But the paradoxical fact we must confront at the end of this process (a paradox which Proust articulated many decades ago in his *Remembrance of Things Past*) is that by bringing the outside inside, we render it banal—by domesticating the exotic, that is to say, we are left not with an accessible exotic, but only with the domestic. By attaining visual fluency in the dance forms of other cultures we may keep ourselves intellectually busy for decades. Yet the result can at best be merely more of what we started with in the beginning: a near-native fluency in a certain number of languages, not a fundamentally other sort of comprehension. And what this suggests is that there is no moral compulsion to engage on such a process. If we are curious, let us do so by all means. I am curious, and I imagine that most members of the critical community are curious too. But we must divest ourselves immediately of our feeling of somehow being morally sensitized in our

actions in a way that others are not, as if we were more tolerant, or more open, than those who would really rather watch boring ballet and moldy modern dance.

Frequently, scholars and critics who have climbed on the "world dance" bandwagon exude an air of the sanctimonious. For that matter, even the term bothers me: for if "world dance" is dance from Out There, what are we here at home? Other-worldly? Indeed, it may not merely be provocation to say that the greater openness to the world on which partisans of world dance pride themselves is in fact nothing but sordid appropriation, intellectual colonization under another name. What the most vocal partisans of the necessity to understand world dance propose is nothing but the systematic intellectual digestion of new foods, sought out precisely because they are necessary to titillate our now-jaded Western palate. Indeed, some of the more honest of the proponents of world dance have explicitly, if only privately, linked the growing Western interest in non-Western dance to a fading of vitality on the domestic avant-garde scene. Critics and promoters are suddenly interested in the rest of the world, that is, because the scene at home is becoming uninteresting.

Yet we should remind ourselves that all this dance existed for a good long time before we decided we were interested in it. We need not congratulate ourselves for finally getting around to looking at it, and we are ill-advised to castigate others who do not currently feel the need to do so.

We may relativize our current openness to other cultures even farther by pointing out that it is, in its turn, only the latest turn of the post-Romantic screw, the expression of a sensibility that defines our modernity. Part of the definition of Western modernity (which, for literary history, begins perhaps with *Madame Bovary*; for dance history perhaps with Isadora and Miss Ruth) is our disgust with ourselves, our conviction that we are not the best of all civilizations but probably the worst. And the flip side of this malaise with Western civilization (which we can see in writers, artists, and thinkers stretching from Rousseau through the Romantics and Freud up to our day) is the belief that Out There, people are different.

Modernist art almost takes this as a defining notion. Yet it was not the modernists who articulated it first; this honor goes to the Romantics, who crystallized and somehow deepened a comparatively trivial contrast between the classical and modern ages that was common currency in eighteenth century European thought. The Romantic form of this notion with which we are most familiar is Rousseau's conception of the noble savage—the idea that more elemental people with less "civilization" were somehow kinder,

gentler, or at least more in touch with their feelings than the decadent Europeans. (For Marie Antoinette and her serving women who played at milkmaids at Versailles, the noble savage was as close as the peasant's cow field.) We see this malaise with city/Europe/Caucasianness in Shelley and Wordsworth, in Schiller (*On Naive and Sentimental Poetry*), in Delacroix (all those charging steeds and Moors that so contrasted to the sedate Europe they were marketed to), in Alfred de Musset's autobiographical novel *Confessions of a Child of the Century*—Musset thought this malaise the "sickness of the century," the nineteenth century that is. A generation later it was something like this belief in a simpler, more elementary or direct world Out There that drove Gauguin to Tahiti, that sent Bartók and Kodaly into the villages of Hungary to record folk songs, that set the German Expressionists making sculptures mimicing African ritual objects, that produced the cubism of Braque and Picasso and the fascination with the Chinese ideogram of Ezra Pound and Sergei Eisenstein.

It was also a diluted version of this that found its way into the American Indian-influenced *Primitive Mysteries* of Martha Graham, the dreamy mysticism of Miss Ruth's "Oriental" solos and the works that Erick Hawkins still offers today—and of course, in third-generational form, into the highly sophisticated cross-cultural works of artists like Meredith Monk and Kei Takei, with dozens of other artists drawing on "exotic" sources as the inspiration for particular works. Yet the early modernists were more honest about their appropriations than we now tend to be. Back then, they could acknowledge that they frankly sought The Exotic—which is to say, the Other that was meant to stay Other, even when it was displayed on the stages and museums of the appropriating culture. The Romantics and the modernists were frankly pillagers—bringing back fragments of other worlds "out there" and setting them up in museums, putting them on their canvases or in their books as exotic backgrounds, translating them into the "ethnic" divertissements of Moorish or Spanish or Chinese dances in full-length ballets, or as ends in themselves in the style of St. Denis. Nowadays we pat ourselves on the back by saying that we no longer pillage: instead we try to comprehend, to understand other cultures on their own terms. The exotic is out, explanation is in.

One example of this is seen in the fact that African art was initially displayed in the West in ethnographic museums. For a time, it was considered evidence of cultural sensitivity to accord it the status of our own art objects—at which point it moved to Plexiglas stands under spotlights before white walls. Now the trend is to bring it back into the ethnographic

museum: to insist that it is part of a larger context, that it is not merely an object of disinterested contemplation. Yet under these circumstances such objects tend to fade into the light of common day, becoming just as comprehensible, and banal, as our own lava lamps and stainless-steel toasters.

It is still interest in a world outside we take to be alluringly Other that drives our interest in world dance, as it is in things like African sculpture: they are something different. (We are the children of our parents the modernists, after all.) Yet nowadays we do not frequently acknowledge that this is so. And the result is that world dance is now caught somewhere between the second and third of the stages outlined with respect to African art objects: in many places it has not yet reached the status of the second, while those really in the forefront of sensibility are already on to the third. In some places it is progress to get it on the stage of the major culture palace; in others it is progress to get it off these stages and into the classroom.

Although we are fueled by our desire for the transgression of borders into a fascinating Other world that we inherited from the Romantics and modernists, we lack the honesty nowadays to acknowledge that this is so. The problems this produces are the same in the case of world dance as in the display of African masks: do we take out of context, and risk incomprehension? Or do we fill in the context—assuming we can find a way to do so without totally destroying the performance as performance—and bring ourselves closer to the same boredom with this art form that sent us in the first place from the forms we understand? These are the problems of the in-between time in which we currently find ourselves with respect to world dance.

Address to Dance Critics Association Conference 1990

Angel's Gate

THE DAY WAS THE FIRST OF SEPTEMBER; the scene was Angel's Gate, in San Pedro south of Los Angeles, high on a bluff with a view of the sky-blue expanse of the Pacific. And looking out at the few lonely boats sailing past the palm trees of Point Fermin Park, I thought that no more breathtaking place could possibly have been found to open the 1990 Los Angeles Festival, several years in the planning and devoted to the arts of Pacific Rim cultures. Nor was the site the only spectacular aspect of the happenings: the special

"artists' ceremony" up by the huge Korean temple bell was attended by dancers of many counties of origin in a brilliant variety of costumes and colors. Maori tribesmen from New Zealand were placed next to what they referred to in their remarks as their "younger cousins" from the islands of Wallis and Futuna, who were dressed in beautifully painted bark cloth and who rubbed shoulders with Australian aborigines decorated largely with body art, Korean Shamans in immaculate white robes and high black hats, and Ikooc dancers from Mexico in scarlet headbands and loincloths. Native Americans on whose sacred land we sat brought welcome and blessings, obviously touched that they had even been asked their permission; each group brought welcome, prayers, and in most cases dances.

Yet for all of the color and pageantry, the beautiful site and the moving prayers of these divergent peoples, something was strange about these opening ceremonies that set my brain whirring with questions. I thought of the fact that as soon as the dances were over, many of the most interestingly "native"-looking of the dancers pulled on jeans and jogging shoes. I thought of the T-shirts silk-screened with a Gauguin painting that the booth representing Tahiti had on sale down below as souvenirs from its territory. I thought of the fact that despite our delicious feeling as spectators of having left behind the hustle-bustle of our alienating industrial society by retreating to this holy spot on the Pacific, none of these ceremonies would have been audible without the bank of microphones (that were continually going on the blink and bringing everything to a grinding halt)—and could not have happened at all without the airplanes that had brought the participants to L.A. to begin with.

Nor did my sense of paradox weaken during the entire opening weekend of the Festival, continually fed as it was by contrasts and contradictions. For example: one morning the aboriginal group taught a class outside on the campus of Cal State U, L.A., where the Dance Critics Association was meeting to debate just such questions as those that bothered me. A television crew dangled state-of-the-art microphones over their heads and circled them with cameras, while members of the DCA tried out trilling like birds and throwing imaginary spears.

The theme of the Critics Conference was "Looking Out." But, I wondered that morning while the eerily beautiful sound of the didjeridoo breathed underneath, are we really touching the Other when we bring in already half-assimilated groups like this with their Anglophone spokesmen, their easy adaptability to our ways (based perhaps on an understandable desire for Western amenities), their air of being foreign-but-not-too-foreign

that is both interesting and comforting at the same time? Or are we simply engaging in the cultural tourism of the nineteenth century that saw the exoticism of Africa and the Orient as an antidote to their own societal malaise?

The sheer variety of things subsumed by this notion of "Pacific Rim Arts" was staggering. There appeared to be little in common between, say, a participatory or ritual dance whose purpose is to ensure a successful harvest and the highly stylized, highly self-conscious art forms of the Bedhaya or Wayang Wong from the Javanese court of Yogyakarta, of which I attended performances on subsequent evenings. Perhaps all are movement, but if this was the only criterion for inclusion, where was the San Francisco Ballet, equally Pacific Rim movement? Really, of course, the only thing that united all of the groups that performed that morning at Angel's Gate and subsequently during the Festival was a single negative characteristic: the fact that none of them was Western. And yet the polyglot character of the happenings seemed itself precisely the Western aspect of the entire goings-on, mirroring our belief that within our structure, people have the right to do their own thing—so that a similarly diverse festival in a traditional culture is almost a contradiction in terms.

In a beautiful outdoor setting with a view of the San Gabriel Mountains, the performances by the group of Javanese dancers and musicians led by Artistic Director R. M. Soedarsono challenged the first-time viewer to further question his or her presuppositions regarding non-Western dance and its accessibility to us. Program notes filled in the viewer on the complexities of the plot and some of the givens of the form, but I still wondered how to judge what I saw, whether it was appropriate to do so, and what I was missing altogether. How much more acute the problem must have been, I thought, for the people beside me who were chatting rather than reading their program notes! Or did they already know that the asymmetrical form in which the nine women of the Bedhaya enter must be resolved into three rows of three before the drama portion of the dance can start? That the nine dancers are associated with the nine orifices of the body? Could it be that it didn't matter, any more than one really has to know anything about the rules of baseball in order to visually ingest, at some level, the proceedings at Yankee stadium?

I caught myself in the act of what I would have to call mis-seeing at numerous times during the Festival. A mournful dance put on by the Ikooc dancers in the courtyard of the atmospheric Spanish church of Nostra Seniora La Reina de Los Angeles in old downtown L.A. seemed, at first

glance, to be about a slaughter of natives by white intruders: a man with his brown legs painted white and wearing a mask with Latin-looking features moved around the circle of spectators, miming at slitting their throats with a wooden sword. A chat afterward with a press spokesman, however, produced the information that this man represented a force of evil, a snake (to be sure, there was a snake's head tied to his back), and that the throat-slittings were not—as I had conjectured—the remembrance of a particularly gruesome encounter with colonizers, but an abstract portrayal of natural disasters. Or was I wrong even to ask; was it enough just to look?

The same problem hovered around the performance by Peter Schumann's Bread and Puppet Theater at UCLA. Here an obviously affluent audience in an equally affluent setting was asked to consider the problem of the homeless, in a piece called *Metropolitan Indian Report* put on by an all-white cast of obviously healthy-looking college student types. Certainly if the challenge of this festival was that of dealing with the Other, the homeless represent an Other within our own society. Yet it is hardly likely that the audience would have been as pleased if a group of the homeless themselves had themselves appeared on the stage.

No, I thought, all of us need this distancing from the Other of stylization (such as the huge *papier-mâché* heads that the actors wore) or of limitation of temporal contact (here, to little more than an hour). The Festival events as a whole only lasted two weeks, and when we got tired of looking at the Indians we could go to the Koreans. In the last analysis, I wondered, was this Festival ultimately more about the Other, or about ourselves?

© Dance Magazine 1991

Ritual Resurgent

TRY THE FOLLOWING EXPERIMENT. Close your eyes. Then have a friend hand you any kind of object. Now treat it as a ritual object for five minutes. What would you do with it?

Not spit on it. Not break it into bits—or if so, this would be done very, very slowly. Perhaps you would hold it in the air, as if venerating it. Perhaps you could do the same motion with it over and over. Perhaps you would put it down and resolutely, very resolutely, walk away from it. What is certain is that you would not treat it in any way that seems too close to the object's

"real" function: if the object is an eggbeater, the last thing you are likely to do is whip up an omelet with it.

This experiment is precisely what the dancers do on the stage in *Ceremonies*, a piece by Jeff Duncan presented (in partial performance) during a recent season by the Washington-area group Improvisations Unlimited. The evening I was there one dancer was asked to treat an electric cable in this ritualistic fashion; another had to cope with two sticks of wood. The first, John Dixon, remained frozen for a few moments in the bent-over position in which he caught the cable thrown to him by the group's director, Meriam Rosen, touched (I wanted to say) by the hand of God. Later on, he used a loop on the floor as a kind of magnet for his foot, as if some part of his body just had to stay inside the magic circle. And when her turn came, Heather Oldfield made a Cross of Lorraine with her sticks, then seemed to be playing them like a rudimentary violin or making fire from them, then used them as crutches.

Duncan's choreography called for each dancer to do a solo with his or her object and then be joined by two other dancers. When these joined Oldfield, she guarded her sticks jealously, as if their priestess, and the three of them ended with a rush across the stage, propelling the sticks in a state of intoxication. Dixon, in contrast, shared his prop with the others and allowed the cable twining around the three of them to evoke, perhaps inevitably, the Laocoön group with the serpent.

Rosen explained that this was supposed to be ritualistic. But even if she had not done so, the movement itself screamed out ritual, ritual. Just as we know that whipping up an omelet does not count as "ritualistic" use of an eggbeater, I think it is clear that we know ritual when we see it on the dance stage. And the fact is that more and more of the works seen on today's stages do contain elements of ritual.

This is by no means true of all works; many of the pieces we see are clearly bereft of any element of ritual. Yet this in itself helps to convince us (should we need convincing) that ritual movement is movement of a certain kind; it helps us to see as well that ritual movement is part of the vocabulary of only one of the two major streams of contemporary American dance. For let us consider that most of Balanchine's neoclassical works (as opposed to what we may call the Romantic ones, like *La Sonnambula* or *La Valse*) seem almost anti-ritualistic, for instance *Agon*, *The Four Temperaments*, or *Divertimento No. 15*. There is something too clear, we would say, something too pure, too "up-front" about these Balanchine works to qualify as ritual. By "up-front," I do not mean that we get all there is to see in such pieces at

the first viewing. What we do get by repeatedly seeing a Balanchine work of this sort is more surface, not more depth. It seems to be only in those of his pieces that plunder another world or culture for dramatic effect—*Union Jack* or *Bugaku* or the revelers in *Prodigal Son*—that we can begin to think of Balanchine in terms of ritual at all. And these are the exceptions in the current Balanchine repertory.

Many people have noted that there is something implicitly ritualistic about the classical ballet technique, yet this can be sensed by the audience only if the technique is foregrounded, as in Harald Lander's *Etudes*. Classical (which is to say impersonal) dance is not congenial to ritual. A classical style is shared, taken for granted: if it is ritual, it is so ingrained as to be invisible. Motion we sense as ritual, by contrast, is tenebrous, opaque, mysterious. For this reason it is no accident that the ritualistic moments in Balanchine appear in the works produced by his Romantic rather than his classical side, and why they are practically non-existent in the Ashton most of us know, perhaps the more completely classical of the two great twentieth century masters. (It is no accident that viewers raised on Balanchine frequently find Ashton a bit bloodless, if at the same time exquisite.)

The same quality of being too "up-front" to qualify as ritual characterizes much contemporary modern dance as well—by which we usually mean the dance of Judson and its heirs, inspired by Cunningham's dances of bodies in space. No to the mysterious, Yvonne Rainer's famous manifesto might have read, what you see is what you get. It is clear that at least for this reason Balanchine and Judson are kin. In the terms of Arlene Croce's celebrated dichotomy between the "Mercists" and the "mysterians," we can at least say that neither Balanchine nor those who performed at Judson are "mysterians." (Does that make Balanchine a Mercist? Perhaps.) The source of ritual in American dance is therefore not its Balanchinian, neoclassical stream, but rather the other principal stream, what we still call modern dance. The first necessity of the modern dancer was to find his, or more frequently her, own movement style, to write a dictionary for a new body language. And this necessity to begin from zero is what led the modernists so unerringly to ritualistic situations.

How to invent a new language? Steal from foreign languages, which by definition will seem new to the monolinguals back home. Think of the goddesses and temple dancers of Ruth St. Denis or indeed of the whole strain of exoticism on which Denishawn was based. Modernist art has always been attracted to the exotic: Picasso was, Bartók was, Graham was. This is not a flight from modernity; it *is* modernity.

One of the greatest of the ritual works of this heroic period of early modern dance is Graham's *Primitive Mysteries* (1931), performed in revival by the company in recent seasons and captured in an older incarnation in the 1964 film of Yuriko and the Graham company at Connecticut College. In this piece, inspired by American Southwest Indian dances, a white-clad woman flanked by two attendant women and a line-up of somehow subordinate women enter and exit three times in silence. During the sections framed by these entrances and exits, they assume positions concerning which the most concrete thing we can say is only that they are somehow devotional. How this is so, however, varies from gesture to gesture, and the roles played by the three main dancers vary so widely that they cannot be identified with any single known religion. There are hints of crucifixion, adoration, a *pietà*, and veneration. But who is venerating whom or what? And what does it all mean? All we know is that something is going on, that the dancers seem set on doing that something, and that we can only sit with our eyes glued to the stage until it is over.

Almost everybody who sees this dance wants to speak of it in terms of ritual. I think this is because it has two qualities that define the type of movement we perceive as ritualistic. First of all, it is intensely earnest (or was; the recent revival was considerably softer than the 1964 film). Whatever it is these dancers are doing, they are dead set on doing it: they stop and start together, enter and exit in elongated gliding steps that bespeak great purpose, and are valorized in their purposefulness by the Louis Horst music, which starts only when they are set in their pattern and ready to move. Reiteration, repetition, collective movement are the hallmarks of ritual.

The second quality that seems to be necessary for the sense of ritual that this dance exudes is related to the first: we cannot follow what is going on. The dance is given to us as it unrolls, but we cannot for a minute predict it. We do not, as we might say, know what the dancers are doing. This implies that they are doing something—other, of course, than dancing. They are engaged in purposeful, structured activity with a dramatic content, only we do not know what that content is. And this is what makes their actions seem mysterious. It is also in contrast to dances whose dramatic content we do know about, like Tudor's *Lilac Garden*, as well as to those dances that reproduce rule-governed activity either in order to make fun of it (as, say, Eliot Feld's send-up of football games and flag-waving, *Halftime*) or to glorify it (Gerald Arpino's hymn to sweat and beefcake, *Olympics*).

Seen as a collection of particular actions, as movement meant to be looked at (rather than done) must seem, rituals are by definition mysterious,

because the only justification for the actions is that they constitute the ritual. Why the flowers and bridesmaids in a wedding? Why the caps and gowns in a graduation? Why the candles on the cake at a birthday party? The answer has to be, That's just the way things are. No more do my first-year students at the U.S. Naval Academy know why they have to eat their meals using right-angle motions (called "eating a square meal") or jog down the hallways of Bancroft Hall, their common dormitory (the motion is called "chopping," the hallways are p[for "passage"]-ways); it's tradition and it's part of being a plebe.

What this means is that the rituals we see most clearly to be rituals are the ones we do not see as functional, which usually means those that we do not take part in ourselves. This is why our choreographers are impelled to turn to other cultures, especially to the religions of other cultures, when they want the viewer to sense "ritual" in something on the stage. With echoes of another culture, the quality of purposeful but mysterious action can be easily evoked. Nor does it matter, for the purposes of a dance, whether what we see really is ritual or whether it just looks as if it is. The effect produced on the audience is the same.

But why should all these moderns want us to see ritual?

Well, because ritual movement is one possible content for an individual work (this ought to pose a paradox); moreover it is an attractive one at that, precisely as a kind of temporary escape from the modernist work's individuality. The urge toward the collective and non-individual is the logical flip side of modernism's individualistic basis. Given our current emphasis on groups and group-membership, we are beginning to see that it is a constituent part of modernism as well. Think of Ezra Pound's fascism, T. S. Eliot's monarchism, and the myths of W. B. Yeats and James Joyce.

In dance, the same impulse toward the collective is expressed by inventing rituals—or rather, since this is impossible, by inventing something that looks like ritual. Laura Dean's work, to take one contemporary example, evokes dervishes and religious incantation. The closing portion of Twyla Tharp's *The Catherine Wheel* looked obsessive in the same way, as did her more recent piece *In the Upper Room*. And Kei Takei's ongoing epic *Light* is perhaps the most massive accretion ever made of imagined and imaginary rituals. I caught *Pilgrimage*, one of its more recent sections, on the Washington Monument grounds a few years ago. What we saw were men and women with staves going somewhere (we knew not, of course, where), relentless and untiring among the trees. In earlier parts of the work it is stones, or pieces of wood, that Takei's dancers use no less obsessively.

Takei's work is meant to be seen with a knowledge of the contemporary Western dance context; it is not meant for an audience of Japanese cave dwellers. An example of ritual "as if" which effects its cultural amalgam from the other direction is the recent piece called *Unetsu (The Egg Stands Out of Curiosity)* by Ushio Amagatsu for the Japanese Butoh group Sankai Juku, presented in Washington and New York in recent seasons. The entire piece took place around a large rectangular pool of water that suggested lustral baths or the holy pool in the Temple of Karnak. The five male dancers (covered, as in all of the group's pieces, with white rice powder and evoking priests or eunuchs) gonged bells hanging nearby, cried out in unison, waded in the water, and finally fell over sideways in it. The fourth section opened with Amagatsu lying on a couch positioned stage left, whose surface was a glowing bed of light. His actions consisted of caressing a white egg and of undulating his long scarlet fingernails, one of the few touches of color on the stage. He finished the piece nearly buried in one of the trickles of sand that had been falling behind the water throughout most of the piece.

This was not the ritual of a real world. At most it was the world of the choreographer's imagination, loosely "based on" (or some such formulation) extant rites. So, too, for the recent work-in-progress of Arthur Mitchell and Billy Wilson for Dance Theatre of Harlem, *Phoenix Rising (Part I: The Birth)*, a free reworking of vaguely African themes. In this piece, we were offered troll-men rather like the revelers in *Prodigal Son* who lie on the ground, roll about, and stamp in unison until the Priestesses come in, covered in grass and leggings such as those that disguise the bodies of masked dancers in West African rites. The Chief Priestess (Cassandra Phifer, in the performance I saw) comes out waving a fluorescent plastic hose that produces a low whoo-whoo noise as it is spun, a child's toy available at every Toys R Us. I thought it was all pretty silly, even although the integration of the cast-offs of Western civilization into African rituals is an honorable tradition. (This tendency was played for comic effect in the film *The Gods Must Be Crazy*, about the ritualistic career of a Coca-Cola bottle among the Bushmen.) This too was clearly ritual "as if."

The return of ritual to our stage in forms such as these is a kind of second generation resurgence of Miss Ruth's original impulse to appropriate the exotic for her own dances. Today we may look down on her "Indian" or "Javanese" pieces. Yet Miss Ruth understood the fundamental modernist truth that somebody else's tradition looks individual when you put it on a stage back home. And this is what the more sophisticated contemporary modernists have realized as well.

However, these sophisticated versions of "faux" ritual are not the only form in which ritual is to be seen in increased quantities on our stages. The other form in which we are seeing more and more ritual is in the rising swell of what we now call "world dance." Even although such dance does not have to be ritualistic in nature, it frequently looks as if it is, because most of the audience does not understand what it is seeing. This, I suggest, is the source of much of the audience's interest: the movements, if not understood, are (as a direct result) at least mysterious, and the dancers are doing them earnestly.

The fact is that a piece from another culture (one that is really Other) can give us another kind of thrill entirely than the one we get from looking at (say) a Kei Takei piece. It may, we tell ourselves, really be ritual that we are seeing, at least for the world from which it has come. We are fascinated by the fact that this movement somehow seems to refer beyond itself in a way that movement we understand does not; it escapes the stage and indicate the entire (coherent, nonalienated) society from which it has been torn. This, we tell ourselves, is not our own Western art-to-be-perceived, but an integral part of a more unified world. Yet no matter how respectfully we speak of the ritual significance of such works of "world dance," they enter our world under the rubric of "art" and hence are treated the way Western art has been treated for the last two centuries: as something to be perceived and nothing more. We go out and see this dance on a stage, applaud at the end, and then leave to go back home to our houses filled with Matisse prints, African masks, and a myriad of gleaming gadgets.

Nor is such interest in the world outside at all new. We post-Romantic Westerners have always been fascinated by the authentic, whole, and unspoiled which, by definition, is always to be found elsewhere. The paradox is that our interest in "world dance" is the latest, and completely logical, turn of the modernist screw. No longer satisfied with invented rituals, we turn to ones we perceive as real for a contemporary version of the titillation sought by nineteenth-century explorers, who thrived on the real peril of exposure to the dangerous world outside. The hunger that we now collectively feel for world dance is the same hunger that Miss Ruth must have felt before her famous Egyptian Deities cigarette poster, way back at the beginning of modern dance.

Now, of course, affluence and the jet airline has upped the ante: what we want now is the imported rather than the domestic version of Otherness. Yet in turning to world dance we are not turning our back on our modernism, past or present: we are expressing it. All of which helps to explain why

ritual, in one form or another, is enjoying such a resurgence on our stages.

Ballet Review, 1992

Hulahula

LAST NOVEMBER, I STOPPED OFF IN Honolulu on my way to Hong Kong, staying with a friend who teaches at the University of Hawaii ("The U. H.," in local lingo). She showed me an envelope spit out by her insurance company's computer in, I believe, Chicago. "Professor Virginia Hench," it said, "University of Hawaii, Hulahula HI." I liked the Hulahula part, as she had. A prankster? A machine losing power, like HAL in *2001: A Space Odyssey* running out of steam? A clerical mistake?

From that point on, I thought of the city I was staying in as "Hulahula HI!" It seemed particularly appropriate the evening we attended the Invitational Hula Competition in the town's civic auditorium. I certainly wanted to say "hi!" to all those lovely hula performers. The entrance spaces were full of groups of women in identical flouncy-bottomed and -bosomed ankle-length dresses in colors we see on the Mainland (for so the rest of the U.S. is referred to in Hulahula, HI) only in get-ups for bridesmaids. Everyone was decked out in leis (including me, getting into the spirit), men and women alike. Where else in America can men walk around wearing flowers? Craftspeople in the lobby were selling gorgeous creations of seeds and feathers, at suitably gorgeous prices.

We took our places rising in tiers from the dance floor in the middle of the basketball arena. Groups of giggling adolescent girls balancing hot dogs sat all around us, waiting to cheer for their own hula teachers or friends. The cement stairs and the flimsy plastic chair backs gave it all the agreeably exciting air of a sports event. I felt the disadvantages of being a neophyte among all these people for whom going to hula class was as natural as attending cheerleading practice.

At least, I told myself, I knew that hula wasn't girls in grass skirts swinging their hips for Navy guys. I'd trekked down to the Smithsonian Folklife Festival the year there were Hawaiian dances, and had a few of my illusions dispelled. There, no ukeleles. No svelte dancers, either male or female. Only chunky ones, and everybody wearing leaves. There were stamping dances for the men that got everybody's blood hopping, and

interesting but hardly "pretty" dances for the women that made me want to see more.

Now I was seeing more. I also got a crash course from my friend and learned a thing or two. First, that there were two categories in this competition, because there are two types of hula: classical and modern. The modern is what the ladies in the vaguely New England *ca.* 1860 dresses in the lobby did. Anything with heels and a frilly dress, and that involves a song past 1930, is modern hula. The movement vocabulary is similar to that used in classical hula, but pieces are made new, by individuals. All pieces are done to songs, and the gestures usually bear some relation to the words, although not the same relation all the time.

The next night, I saw some modern hula in, of all places, the cocktail lounge of the Waikiki Hilton Hotel, with the wonderful modern singing group "Olomana." (My friend apologized for taking me to a hotel lounge. "But really," she said, "it's the best stuff going.") The arms of the single female dancer were liquid, her hips swinging, the hands carving gestures even I could understand in those songs that were in English (rain, butterflies, or the sun). Some of the gestures, woven into a back and forth swaying and turning line, were less literal, and just seemed agreeable. Considering the fact that the dancer was limited to a back-and-forth glide in a six-foot line, the variations she managed to evoke were considerable, and she never lost the forward impetus of the movement.

At the competition the night before, however, we had arrived at the beginning of the classical hula portion; by the time the modern rolled around we were ravenous for something more substantial than hot dogs, and left. The dance we saw was largely unisex groups: lines of men, or women, all doing the same gestures. The result is impressive, if a bit like the Rockettes. Some of the men's dances were visibly different from the women's—done by boys wearing only loin clothes, with leaves around ankles, heads, waists, and wrists and stamping or doing bellicose or overtly athletic movements. Sometimes, however, there seemed no gender differentiation, with similar movements for the girls and for the boys. Sometimes the boys were fully clothed; sometimes the girls wore grass skirts and looked like the chunky Polynesians I had seen in Washington; sometimes they were slimmer and did movements I could imagine seeing off a ship in Hulahula harbor.

Classical hula, my friend explained, exists at all today thanks to the penultimate sovereign of Hawai'i, King David Kalakaua, who decided to rescue an all-but-vanished art form from the ravages of modernization and the missionaries. King Kalakaua is thus thought of as the patron of the hula,

hence it is after him that the largest hula festival, in Hilo on the "big island" of Hawai'i is named: the yearly Merrie Monarch Festival. Indeed, it is the Merrie Monarch Festival that was responsible for the great revival of hula in the present generation. In Hawai'i, people—men and women—take hula the way we on the Mainland go to play golf—or so it seemed. I saw a number of stores selling "Hula Supplies," rather on the pattern of sailing stores in Annapolis.

What King Kalakaua was rescuing from oblivion by royal fiat were dances largely religious in origin, akin to the dances of other Polynesian peoples (originally, the Hawaiians are thought to have come from the south, from the Marquesas Islands, followed by an influx of Tahitians, whose language is similar to the Hawaiian). At the time, the 1880s, the surviving hula dances were collated, stitched together, and codified. By that point, the near-nudity of the original Hawaiians had been missionarized (hence the flouncy dresses that I had thought New Englandish, which are the standard dress-up wear of women in Hawai'i even today: the missionaries were from New England, and downtown Honolulu is marked with New England architecture built by the missionaries from gray ballast stones of ships). Thus it is part of "classic" hula to allow pants and shirts for the men, and near-total cover-up for the women, freezing even the "costumes" as they were at the moment of codification, as if the dances were insects caught in amber, or the recently exhumed Ice Age hunter preserved in the glacier. There are (so to speak) no symphonies in this reconstituted hula, only "*Lieder*," or *mele*—all pieces are about five minutes long, and danced to chants that involve a big two-part figure-8 gourd and voice accompaniment.

Classical hula is a fixed canon, as opposed to modern hula. It has a finite repertory of dances, which are learned verbatim and passed down from teacher to student. Groups of people do them, or soloists; there are even dances that involve a single dancer sitting for the entirety of the *mele*, which are considered particularly difficult. You go to your teacher with your hula sisters or brothers and learn the same movements as a generation ago, or two, or three. Invention isn't forbidden, only that makes it modern hula, not classical.

I was intrigued. Talk about creating a canon! Kalakaua had had the remaining hula masters give him the equivalent of the Dead Sea Scrolls—fragmentary bits with lots of things missing; he had accepted the state of preservation in which he found them, accepted clothing for men and women, had them pieced together into performable wholes, and created a text

that now could not be altered. Or rather, it could, but that was doing something else.

This was intrinsically multi-cultural classical dance, I thought, as Hawai'i is an intrinsically multi-cultural society. (Whites are the tiny minority, and virtually everybody is mixed something, and proud of both the something, and the mixture.) Nothing "authentic" about it—and yet, it had been made to seem so. I mused on the moving finger of time that had lighted by chance at this one particular point in evolution (or devolution) of the hula and valorized this moment above all others.

I was fascinated. Not disapproving—I was, after all, a visitor—but interested. Never before had I seen so clear an example of willful freezing the march of time in its tracks at so arbitrary a point. How horrified and touched the hula masters of, say, 1750 would undoubtedly be to see these poor bits and fragments, so religiously learnt and handed down, protected from incursion or change. For the fragments themselves are little but incursion and change, more holes than parchment. Not that historical beggars can afford to be choosers: preservation of whatever shreds of the past remained by the time the *haoles* (white foreigners) were done with Hawaiian culture was a positive thing. Preservation of anything Hawaiian is an absolute good, as far as I am concerned, especially given the rampant exploitation of the islands by the plantation owners and now, perhaps, the hoteliers.

But I was interested to see this reverential treatment of something that itself was so aleatory and fragmentary, the way the bits and pieces chosen from so many other contenders that compose the Christian Bible are pored over, or the seemingly patternless observations of the Qur'an. Think of our interest in, say, the grave baubles of King Tut: a minor, teen-aged pharaoh, whose paltry trove is of interest only because his alone escaped the grave robbers and so has come to stand for pharaonic glory. Anything can become a classic, I thought. If all the rest of writing in English disappeared and only this article survived, I bet people would analyze the sentence structures and words as if it had been graven in stone on Mount Sinai, or dictated to Mohammed by the Angel Gabriel.

I mean no blasphemy here, I hasten to say (keeping Salman Rushdie in mind). God is great. Hula is beautiful, and I haven't seen enough of it even to seem authoritative. But I thought that evening, and the next, sipping my drink with the lounge lizards and watching this entrancing dancer in her modern hula, that history is odd. Sometimes swallowing things up, it can sometimes be stopped in its tracks, made to freeze its frame and these replicated in something of the same form over and over again. And this is

what we call a canon, or a classical style. There's nothing absolute about it, of course, only the need of us poor fragile humans to rescue some fragments from the waves of time. Never had the justification for preserving a "classic" style seemed so transparent, so illusory—or so justifiable. Hulahula! I thought. Hulahula, HI!

DanceView 1995

A Conversation in Conakry

SHORTLY BEFORE CHRISTMAS A COUPLE of years ago I sat in the garden belonging to the American cultural attachée in Conakry, capital of the Republic of Guinea—a verdant extravaganza on the edge of the Atlantic Ocean, which splashed in the somewhat fetid heat on the rocks below. I had been invited to Ms. Bedichek's house that afternoon to talk with a group of Guinea's intellectual elite, including those largely responsible for what is perhaps the best-known cultural export of this medium-sized West African nation, Les Ballets Africains de la République de Guinée.

Les Ballets Africains is one of the most well-traveled of Africa's large-scale dance ensembles, and also the oldest, having been founded in Paris in 1952 as Les Ballets Africains de Fodeba Keita. In 1959, a year after Guinean independence, it was moved to Conakry as a "gift" to the new country, and changed its name accordingly. In December when I was there, the troupe—under the leadership of Italo Zambo (Director), Haimdou Bangoura (Technical Director), and Kemoko Sanoh (choreographer)—had just returned from a run in London. Some months earlier they had taken part in the Black Arts Festival in Atlanta. Indeed, they were hardly strangers to the United States, having made ten tours here between the time of their transplantation to Guinea and their appearance at the 1984 Olympic Arts Festival.

What we talked about that afternoon while the sun set gradually behind us were the critical reactions to the troupe during their London run and, more generally, the reactions of Western viewers as a whole to dance troupes from non-Western nations. (That it was possible to generalize about Western viewers as a whole my hosts had no doubts.) For although the London writers had praised the dancers' style and energy, the Guineans found that Westerners were almost uniformly obsessed with a question that for them

had no interest whatever: the question of "authenticity," the relation of the dances to what would have been presented in the villages. Indeed, as the sky grew more and more flamingo-colored, I found myself referring to this term as "the A-word"—attempting as I talked to bridge the gap between Western perceptions of what they are doing and their own.

For many viewers in the West (including the English critics who were our point of departure that day), it seems that dance troupes such as Les Ballets Africains offer a degree of verve, panache, and raw energy that few of our own indigenous choreographers—save, perhaps, Paul Taylor at his most athletic—can produce. The drumming that provides the inevitable accompaniment, moreover, gets our enervated *fin-de-siècle* blood pumping in a way that not many contemporary dance scores can hope to do. Yet "serious" critics remain ambivalent, and the audience that goes to such a spectacle is rarely the same as that which goes to a showcase of the latest Western choreographer, or that hits a first night of a major ballet company. Most viewers in the West, that is, accepting more or less tacitly our so-fundamental split between "high" and "low" culture, just don't take "ethnic" dance seriously—especially not shows that seem as slick as these.

Indeed, most of us come away from a performance of a troupe like this one feeling somewhat guilty: we have had a good time, but at the same time we suspect that we have been had. It was almost unrelentingly glitzy, we think, was all pounding and smiles, was indeed hardly to be distinguished from a Vegas show, or the Academy Awards. It certainly didn't correspond to our notion of "art": after all, it didn't seem to be the expression of any one creative (not to say agonized) individual, and was too anonymous to bear the stamp of any one person's psyche.

Yet, we quickly remind ourselves, it was African. And even the least culturally sensitive among us is willing to acknowledge that there exists in the world another kind of art than our own, one more integrated with its society—which we tend to situate in the agrarian Third World, or in pockets of traditional culture within our own. If what we saw was not a product of the first sort, we reason, it must be the second. If it is not the self-conscious, individualistic expression of the post-Romantic West, it must be tribal. And just as the highest accolade for our own individualistic sort of art is "original," the highest accolade for the other sort of product is "authentic." Hence our vague dissatisfaction with what is presented by the touring National Dance Companies of Countries X, Y, and Z: what we see seems too homogenized, not to mention too pasteurized, to be "authentic."

What is the context of this step, we wonder? Do they really wear these costumes in the original version? Can it be that steps from more than one people are being mixed? Perhaps fragments of these dances may have once been performed in the villages, we concede, but now they seem to have been hopelessly corrupted. If we consider ourselves politically sensitive, moreover, we go farther. We begin to think that these people have betrayed their own heritage by putting these steps on a stage to be looked at, and by peopling that stage with these relentlessly photogenic, muscular boys and by girls with bared (or sometimes, in deference to Western mores, scantily covered) breasts. Or was all this the fault of their Western producer?

What for us is a criticism seemed not to faze my hosts that afternoon. In fact, they were happy to admit that yes indeed, the choreography of the Ballets Africains was hopelessly polyglot, made of a step here from the Baga, a sequence there from the Malinke, and the whole thing done (say) to a Soussou accompaniment. Of course the result would not be literally what was seen in the villages. How could it be? After all, the company was of the whole Republic of Guinea, not of any one particular tribe. Thus it was the attempts of the more culturally sensitive of the Western critics to impose, in the name of authenticity, a standard of cultural purity that my hosts found so infuriating. Why should they not mix steps? they demanded.

Their goal, after all, was to define a national style, to forge (in this case) "Guinea" from the patchwork of sometimes competing tribes and peoples. Furthermore, as they pointed out, we in the West don't hold our own choreographers to a standard of "authenticity." Western choreographers are not only free to steal, mix, and adapt, they are almost required to do so. We don't criticize *Oklahoma* for inauthenticity with respect to cowboy dances; why do we make this demand of "authenticity" for others when we have long ago given it up for ourselves?

I thought that this was the best question I heard during my entire visit. It is, I finally decided, because we want these still largely traditional societies to play the role of the cultural "Other" that we have carved out for them in the world, to play the role of the collective so that they may serve as a counter-weight to our own overweening individualism. The fact that such shows are patterned on Western mixes of anthropology and Hollywood, perhaps most specifically showing the influence of Katherine Dunham, makes us queasy. Nor are we Westerners interested in the attempt—so important for those more directly involved—to create national styles. After all, we have nations ourselves, and don't currently think of them as sources for artistic inspiration. What we want from Africa is something

different—which means, tribes, and "authentic" dances. In denying to these people the possibility of a polyglot, even Broadwayized transformation of their heritage into a self-conscious stage show—or what amounts to the same thing, relegating it to a lower aesthetic level—we are (I decided) denying them the right, so jealously guarded for ourselves, to act and create consciously, to be the masters of their situation.

But of course the sun has long since set by the time such thoughts occurred to me, and we were already on to the peanuts and beer.

<div align="right">*DanceView 1993*</div>

Cross-Culturalism Revisited

ONE OF THE CAUTIONARY PHRASES of the anti-AIDS campaign enjoins us to remember that we sleep not only with another person, but with all that person's previous partners. In the same way, I thought during the performance of Welcome Msomi's *UMabatha*, sub-titled *The Zulu Macbeth* (offered at Lincoln Center and then taken on tour, where I caught it at Washington D.C.'s Lisner Auditorium September 17), we see not only the show we're seeing, but all the previous shows we've seen, not to mention the shows that provide the context for this one. This *UMabatha* was a revival of a twenty-year-old original, a piece that, coming from apartheid-ruled South Africa, was greeted the first time around as a revelation. A revelation, that is, of the validity of non-Boer culture, much as Chinua Achebe's ground-breaking novel *Things Fall Apart* was a response to the colonial portrayal of "native"cultures as nothing but despicable and undeveloped. How would it fare now? What, in more general terms, were the implications of showing, to a Western audience, an "Africanized" version of a Western classic? Was this a daring gesture or a cop-out? Avant-garde or dated?

Certainly it was a lot of fun to watch. There were pounding drummers, high-stepping girls, warriors playing at battle with shields and lances, and songs galore, ranging from stirring to plaintive. There was even some dialogue, summarized, after a fashion, on two minuscule surtitle screens above the stage. Certainly there was a sufficient amount of the old-fashioned spectacle of the people kind, as opposed to the new-fangled techno-spectacle of, say, helicopters landing on the stage or of revolving sets, to justify dance

critics offering their two cents worth. But what *was* it? Western? Zulu? Both? Neither?

Definitory of the last decade or so in dance-critical and -presentational circles has been a marked upswing of interest in dance from Outside. Outside our own Western world, that is: dance that offered an alternative to what by the 1980s was clearly the all-but exhausted impetus of modernism and its brash but ultimately not-destined-for-longevity offspring, postmodernism. After the modernist impulse to "make it new" that inspired Balanchine to such effleurescence from the 1920s to the 1980s and that produced Graham's seminal works of the 1930s to the 1960s, after the subsequent postmodernism of the Judson Group and performance art, what then? What, in short, is post-postmodernism? This has been the big question in all the Western arts, American dance included, for the last fifteen years.

To many people, acknowledging the waning of a the modernist impulse, the answer seemed to lie outside of our cultural boundaries entirely. The hottest Western dance forms, many critics and not a few promoters felt, weren't Western at all. The result has been stages booked with Kuchipudi, Kabuki, and Kathak. Audiences, meanwhile, attempted to cope with unfamiliar dance idioms using usually sketchy program notes, ill-attended pre-performance lectures, and even voice-over translations on headphones.

Yet although such interest in the Other may have been an expression of post-postmodernism, it was, at the same time, modernism as usual. By our standards, of course, the early modernist interest in the world outside was woefully under-researched at best and positively predatory at worst. (We need only think of the read that Picasso and the cubists gave to the African masks they were so inspired by in the Parisian Musée de l'Homme: they thought the masks showed primal passion and frank sensuality, just the ticket to combat the enervation of that *fin*-of-their-*siècle* world against which they were reacting.) By the time the Outside had become chic again in the late 1980s and early 1990s, the end of our particular *siècle*, influenced by the self-aware and breast-beating ethnography of Claude Lévi-Strauss and Clifford Geertz, we had begun to demand that this Outside be offered on its own terms, that it not merely be appropriated for out own purposes. (Ultimately, as I suggest in my book *Caging the Lion: Cross-Cultural Fictions*, this is impossible: for if we're doing the offering, it must by definition be for our own purposes.)

By now, what we may call the Scylla and Charybdis of presenting dance from Outside have gradually become clear. On one hand, there are the pitfalls for the Western viewer of insisting that we take other dance traditions

on their own terms: boredom and incomprehension. On the other hand, there is the danger of making the Outside too like things we take for granted, allowing self-contained traditions to function merely as flavorings for thoroughly familiar concoctions based more on Vegas and Broadway paradigms than those of Vietnam or Bali. In this case we are not opening up to the outside, but only delineating more firmly the walls of our own cultural prison. Of course, the fact that Broadway spectaculars make scads more money than the real thing (as the recent examples of the vaguely Irish-flavored extravaganzas *Riverdance* and *Lord of the Dance* have shown) has meant more people see the Broadwayized versions of things, much to the distress of serious critics and dance-goers. Most national folk dance troupes are Broadwayized to a certain degree, Mazowse, for example, from Poland, or the Ballets Africains of the Republic of Guinea. The more production values, schematically speaking, the less dance; the more the audience is wowed, the less it is enlightened. Substance and accessibility seem incompatible commodities.

Yet this kind of slick spectacle full of production values didn't begin to solve the problems of the post-postmodernists. The idea was to escape the notion of "ethnic" dance altogether, reaching to what was sometimes called "world dance." We were supposed to pay the same kind of attention to this dance from outside that we would devote to *Swan Lake*, not to mention paying the same money as well.

It never happened. Perhaps it can't happen: by avoiding Charybdis, we merely fall into the trap of Scylla. Accessibility or authenticity: the two cannot, it seems, be reconciled. Art truly from outside just doesn't fit within the givens of our society, or our expectations; a Vegas show does nothing but keep us amused for an hour or two without nourishing us spiritually.

This was the background with which I entered *UMabatha*. Imagine my surprise to find myself, so it seemed at any rate, finally watching, in flesh and blood before me, the solution to this knotty problem! Unlike the story behind dance dramas from Asia, this plot was familiar to Western audiences. This was hardly surprising, as it was in fact a Western one. Thus it was not so bothersome as it might have been that most of Shakespeare had ended up here on the theater version of the cutting room floor, or that the surtitles flashed only summaries of what *was* said. Indeed, I felt charmed by the fact that I "got" without benefit even of surtitles that I was watching the dagger soliloquy (body language clearly written into the words), or the "out damned spot" scene (ditto). Drumming and reasonably interesting jumping around provided spectacle on the filler level of the happy peasants in *Giselle*. The

mre appropriate comparison, however, was to Kurosawa's classic *Macbeth* film, *Throne of Blood*, where the dialogue is similarly reduced to a few phrases and the viewer is treated to the spectacle of black and white samurai warriors galloping about in the mist, their back-flags fluttering in the winds.

The dance elements, as well as the costuming and vivid acting—even if we didn't know what they were saying, it was fun watching them do it—filled in the gap produced by our ignorance of the precise words, as well as the gap between the Zulu script and Shakespeare. Nor was it bothersome that the dancing, as I reflected later, could not have stood up under the relentless scrutiny of a concert audience: it was neither sufficiently interesting nor sufficiently well danced. (This highlights another problem with bringing dance from "outside" to Western stages: in many traditions, they are not performed by trained dancers at all, somewhat akin to European folk dances or the Virginia reel. Exceptions are, of course, Indian dance forms, or the Indonesian Bedhaya from the court of Yogyakarta.) As part of a larger whole, however, it was perfect.

Yet even this seemed a solution, of sorts. I have this same reaction time and time again in "world dance" concerts, or even many postmodern ones. What I see is mildly interesting, but hardly riveting. So many concerts of all sorts seem like the vain attempt to make decorative arts play the role of the major ones. Why not admit implicitly from the get-go that we're looking at decoration?

In addition, this frank filling in with local elements of a plot from the West rendered moot the question of authenticity. We assumed these funeral dances and coronation dances had something to do with the Zulu, but not for an instant did we think they were necessarily identical with what would have been performed back home.

It was certainly better than, say, the Ballets Africains, because it wasn't so slick. (This in turn was a result of the fact that the dance wasn't trying to hog center stage, at least not all evening.) It was also better than an "authentic" presentation of something for hours on end because it was properly dosed to Western attention spans. In short, I thought excitedly on leaving the theater, *UMubatha* seemed the way to go, a viable template for the presentation of somewhat-authentic dance traditions from outside.

Or did it merely show, as an exception that proved the rule, that the problem was truly insolvable? After all, how many Western plots are there floating around that non-Western dance forms would be willing to fill in with "native" spectacle? How many countries are there like South Africa where high Western culture rubs shoulders with more than vestigial local ones?

How much willingness on the part of the locals to fit their wares into these structures that will be accessible to Westerners?

Yet this at least seemed clear: the first step toward integrating dance from Outside into the Western mainstream would be abandoning the presupposition that it will function like a Romantic artwork, as the object of our complete and undivided attention. And this may end up with a greater functional "authenticity" than a greater fidelity to the letter of the performance. After all, many of the hours-long dance dramas on familiar Hindu themes that mark the forms of South-East Asia aren't meant to be Paid Attention To, merely lived with. You can go to sleep, or eat, or leave the room.

I'm not suggesting that the audience for *UMabatha* should have been roving about, only that dance played an appropriate role in the spectacle. Viz, part of a larger whole. This, it seems to me, may be the only way to do an end run around the brow-furrowing modernist concentration on the work. This was fine for Balanchine, who had the wherewithal to keep us interested. But in the absence of a Balanchine, the time may have come to move on.

DanceView 1997

V

Spirit and Letter

A Conference in Copenhagen

LETTER AND SPIRIT BATTLED it out for a morning and afternoon at the Symposium on "Tradition/Reconstruction" in the University of Copenhagen's spectacularly ugly Amager building, a symposium held on April Fool's day in the context of the sumptuous Bournonville II Festival. The question running beneath all of the presentations was (in my formulation), To what extent is it possible to produce in 1992 a production of Bournonville that would pass muster with The Master himself, postulated as having risen from the dead to oversee the goings-on? Some speakers thought it more possible, some less; the word that was bandied about as object of both veneration and scorn was "authentic." No one asked why this question should be so central, or why it was worth considering at all.

The morning began with remarks by the elegantly muttonchopped Erik Aschengreen, ubiquitous at this Festival, who asked for audience sympathy for the fact that he had to come to this rabbit-warren-like building every day: Aschengreen, a critic for the newspaper *Berlingske Tidende*, is also a professor at the University. (The fact that he also acted as a sort of aide-de-camp at the April 3 reception with the Queen, after a performance for which she had designed the sets and costumes, prompted some visitors to wonder just how objective he could be in his criticism, and set some critics murmuring about conflicts of interest.) Aschengreen also pointed out the coatroom behind the auditorium, itself a dance studio, and invited audience members to take a movement break from all the talk if they felt so inclined.

After this lighthearted beginning, the heaviest session began, initially with two speakers advertised cumulatively as "Introduction." Aschengreen turned the microphone over to Dinna Bjorn, formerly of the Royal Danish Ballet and now the Artistic Director of the Norwegian Ballet; she was followed by critic and New York University professor Marcia Siegel, who

offered some remarks of her own, beginning with the assertion that "history is dance's guilty secret." What was billed as the "panel discussion" that constituted the remainder of the symposium's pre-coffee break fare turned out to be a series of polished and sometimes hard-edged position papers, delivered with relentless speed one after the next. The speakers defined a spectrum with regard to the question of achieving authenticity stretching from "very possible, and here's how to do it," to "not possible, but a good idea."

Given the context of this panel in the festival, it was understandable that no one adopted the inflammatory position of "not a good idea in any case, whether or not it's possible." Those firing their shots along this spectrum included, first of all, the dance notation expert Ann Hutchinson Guest and the scholar Knud Arne Jürgensen (who had collaborated with Guest in the production of a book of Bournonville notation that was presented at the conference); these represented what I wanted to call the formalist view of dance reconstruction, that view which holds that it is always theoretically (if not always practically) possible to achieve authenticity in the presentation of historical dance works. The remaining speakers took up positions mixed with more pragmatism, doubt, or simple theoretical unconcern: these included the Royal Danish Ballet dancer and producer Flemming Ryberg, RDB director Frank Andersen, critic Ebbe Mörk from the newspaper *Politiken*, and choreographer Elsa Marianne von Rosen, partly responsible for the recent RDB re-production of Bournonville's *Lay of Thrym*, presented at the festival only in excerpt.

Perhaps it was the bullet-like speed of the presentation schedule, perhaps it was the vehemence with which some of the speakers defended their positions; at any rate I drifted to coffee afterward with no sense that the people on the podium saw any room for compromise. The scholars seemed to be wagging their fingers at the choreographers, but what went unsaid was that the choreographers and company director would in any case have the last word on the stage. It was to the credit of the organizers of the symposium that they allowed the ideological rifts on the subject of reconstruction to be displayed so nakedly.

The battle lines between formalist and pragmatic, letter and spirit, were established by the opening sallies of Bjorn and Siegel. Bjorn remarked on the personal aspect of transmission, noting that dance roles are passed down from dancer to dancer, each of whom has his or her own physical strengths or quirks which color the result; she noted too that she herself danced Bournonville differently at different stages of her life, so that the

Bournonville she might pass on would vary even within the span of her own years.

Siegel seemed at her best on a podium, where the audience could appreciate the workings of her not inconsiderable intelligence, and where her own inability to respond to opinions different from her own save defensively was not so evident as it became elsewhere during the festival. Following her opening epigram (which I think was meant to point to the uneasy role played by the past in dance), she went on to muse on the perceptual split between dancers and audience with respect to reconstruction. Audiences, she suggested, can afford to ignore history. Dancers, on the other hand, cannot afford to ignore it, but do not like it: dancers do not like repertory because it makes them feel old-fashioned, feeling they are creating something only when they do new work.

Siegel went on to point out—in my view quite correctly—that the text of the dance work cannot in a theoretical sense be separated from performance; in this way, dance is different from art forms like literature and music, whose primary product is notation—what we call a score, or a novel, only secondarily (or at least subsequently) passing into performance. Yet this was not Siegel's bottom line; her intention was to show the merits on both sides of the letter/spirit gap, not to take up one side at the expense of the other. Making a conceptual jump, she immediately went on to ask, Why repertory? In other words, if (as she suggested it must be) the word "authentic" needs to be written between quotes, then what point is there at all in even attempting to resurrect the past in the form of repertory, or a festival such as this one?

Siegel's interest was clearly not so much in how to do this, but in the more abstract question of what its point was—something that a number of the audience members with whom I talked over lunch seemed to feel was out of place, like telling the hostess that she shouldn't be giving the party at all. The point of resurrecting the past, Siegel suggested, was that living in the present was simply "too narrow." Nor, she insisted, should we shy away from strangeness in works from the past; the stranger a piece, she suggested, the more it tells us about that past.

The virtue of Siegel's presentation was that it attempted to look at, and justify, something that many audience members took for granted, namely the festival itself. Yet it seemed not only the limitations of time that caused her to break off with a question mark. For if text is only performance, how can we even speak of a past that would give us works strange to us? If we can do so, then it seems we have left plenty of room for the theoretical position of

the scholars and the annotators, who would tell us that "authentic" need not be written between quotes, and that there is in fact such a thing as greater or less accuracy in reconstruction.

Precisely this was the message of Ann Hutchinson Guest, who pulled no punches in stating her position. Guest is best known to critics as the expert responsible for the 1989 production of Nijinsky's *Afternoon of a Faun*; indeed Guest made the claim that prior to 1989, what people knew as *Faun* was at best "variations on a theme" or a piece "freely adapted" from Nijinsky. Her version, according to her, was correct; others were not. A score existed in notation invented by Nijinsky, which had remained unreadable until that time; finally we were able, in her words, to "break the code." In passing, she compared such notation sources to musical scores by Beethoven or Mozart, and pointed out that dance notation can tell us (for example) that the legs were not extended so high in Bournonville's day as they are in ours.

This is the strict formalist position, despite Guest's acknowledgment that notation leaves some questions unanswered: how to get the arms from point A in one diagram to point B in the next, for example. At times, we simply have to guess, but even this can be done with greater or less knowledge of the stylistic givens of the source. Guest was articulate, polished, and sure of herself. I thought the theoretical weakness of her position lay in the very strength of the example she had chosen. There may be a sense in which the notation for *Faun* is like the scores of Mozart or Beethoven. But for how many works do we possess such scores in the hand of the choreographer, roughly contemporaneous with the works themselves?

Choreographic works are by and large made directly on the bodies of living dancers, and passed down by them. Such notation as exists is almost invariably an *ex post facto* version by a subsequent viewer. As Frank Andersen winningly noted when his turn came, two reconstructors working from the same notation can come up with vastly different products; and Siegel has pointed out that even the act of notating by a person other than the choreographer is a subjective act, an interpretation rather than merely a recording. Everyone, for that matter, knows that choreographers change their own minds: what is the "authentic" that we are aiming at? Which version? Which performance of which version? Which annotation of which performance? Guest came off in the context of this discussion as something of a dogmatist, a doctrinaire letter-of-the-law interpreter who thinks that authenticity is not only achievable but in fact the highest goal that dance company directors can aspire to.

In this she was joined by her co-author and collaborator Knud Arne Jürgensen, who challenged Frank Andersen's use of Bournonville's libretti, and pointedly asked why more account had not been taken of his own work in the production of the ballets we were to see this week. The challenge to Andersen was direct (and in most people's eyes utterly graceless), though it went unanswered for lack of time, Ashengreen once again taking the microphone to introduce the late-comer von Rosen and leaving Andersen blushing and, it seemed, tongue-tied.

In his own remarks preceding Jürgensen's challenge, Andersen had defended a position set somewhere between the two theoretical extremes, heavily leavened by pragmatism and given weight by the fact that he was, in any case, the only one who would be presenting Bournonville under the auspices of the Royal Danish Ballet. (At times speakers seemed to lose sight of the fact that whatever the theoretical disagreements, only one version would be seen in Copenhagen. I heard some audience members say afterward: let whoever put on his/her own production!—a remark which I thought disingenuous, if not silly. These so-divergent positions needed somehow to be reconciled for pragmatic reasons, if for no other.) Anderson acknowledged the personal nature of reconstruction, insisting that it depended on the person doing it, which determined the result. In fact, he observed that he preferred to speak of a "restaging" rather than a "reconstruction."

At the same time, however, he offered his work with Bournonville's libretti as evidence that he was not a complete anti-formalist, and did in some sense believe that it was not only possible but desirable to get back to the original sources. To what extent this apparent desire to please all camps was the result of Andersen's finely developed sense of social style and what extent it was the result of conviction remained unclear. Certainly he distinguished himself throughout the week as a master socializer.

Jürgensen, who had come back from Milan where he is writing a book on Verdi's ballets, fired his most damaging shot against Andersen in pointing out that the libretti (in fact, as he pointed out, poetically-written program notes intended for audience use in later mental re-creations of the ballet experience) were not literal descriptions of the action, and that it was mistaken to treat them as such, as he accused Andersen of doing. Among Jüergensen's specific objections to current RDB stagings were that the female trolls should not dance in the second act of *A Folk Tale*, and that Birthe in the same ballet was for Bournonville a tragic figure rather than a comic one.

In his turn, Ebbe Mörk seemed to agree that current productions, both by the RDB and other companies, left something to be desired. For example, he objected to the fact that in Peter Schaufuss's production of *Napoli*, the escaping couple steal Golfo's jewels. This, he said, clearly contravened Bournonville's notions of fairness and the correct behavior expected of guests. He objected in addition to the lifts in current productions of *La Ventana*, too high to be true Bournonville. At the same time, however, Mörk insisted that the only thing the audience is waiting for is an artistic experience—a remark that went unexplained and un-elaborated-on, but which seemed to suggest some sympathy on his part for the anti-formalistic strand of thought evident in the morning's proceedings.

In his remarks, Flemming Ryberg made clear the self-referential nature of the day's undertakings: it was the first Bournonville festival in 1979, he said, that had prompted the Danes themselves to ask what the Bournonville style was. Before then, he said, "we didn't even know we had one." The point seemed to be that questions of style, and by extension of preservation of that style—in short, of "authenticity"—only become problems in the eye of someone for whom they are such. The very search for authenticity (this time written without quotes) presupposes the impossibility of every achieving it, or at least its *a priori* alienation—just the way Schiller realized that the only people who yearn for an Edenic state of "naive" art are "sentimental" ones, irrevocably fallen from the naive state themselves. On a less philosophical level, Ryberg's remarks made clear the centrality of the foreign critics to the enterprise of this Festival: in a sense it really was put on for us.

The entire discussion of this symposium, I thought—insofar as it was based on philosophical disagreements rather than merely differences of perspective—has centuries-old antecedents, and could be heard as the contemporary version of a standard post-Romantic problem. It is a version of that strand of thought developed by the German Romantic thinker Schleiermacher, taken up again by the contemporary philosopher Hans-Georg Gadamer and promulgated in America with regard to literary texts by E.D. Hirsch, Jr. Usually known as the "hermeneutic" school, these thinkers ask whether it is possible at all to have direct contact with texts from the past; the first texts about which such questions were asked were those of the Bible, where the question was of no little import. If in fact the Bible was the word of God (or even if it isn't), how can we make contact with it, given that it has been translated, re-edited, and filtered by the act of transmission? All hermeneutic thinkers acknowledge that the passage of time distances us from earlier texts; the question is whether mere scholarship can bring them

back. Perhaps our distance from earlier texts is one not only of information, but of sensibility, brought on by the passage of time itself.

In an article entitled "Idealists, Materialist, and the Thirty-Two Fouettés" (included in Copeland and Cohen's *What is Dance?*), Jack Anderson applies this position to dance, arguing that with the rise in importance of notation, dance is becoming less "idealist" (transmitted by word of mouth and infinitely malleable) and more "materialist" (based on specific steps, and in my terms, more formalistic). I agree that modernist dance is more materialist (in Anderson's sense) than nineteenth-century dance, but I do not think that the reason this is so is that notation is becoming more ubiquitous. Few people today besides scholars use notation; it has not turned out to be the preservation medium of choice. And video entails problems of its own.

As I sipped my coffee during the break, I thought that there was one position in the morning's going-on I had not heard. Namely, the position that although fidelity to the letter is, under certain circumstances, possible, it might on occasion actually contravene the spirit of the work, whereby this latter is not to be taken as identical with the choreographer's original "intention." Authenticity, even if in some sense possible, might not always be the best goal to aim for. Jürgensen's position on the female trolls, for example, was that in Bournonville's time the audience would have been shocked to see grotesque women dance, so that it was a violation of authenticity for us to see them do so now. The proper response, it seemed to me, is precisely that in our time we are not shocked, and so it is quite permissible to put them on stage. Indeed, if a completely "authentic" version were offered, we might be offended at the fact that the women were made to sit this one out, and so it may in fact be truer to the "spirit" of Bournonville to diverge a bit on the letter.

This seemed applicable to the question that set the American critics abuzz later after *Far From Denmark*: what to do about the black-faced dancers? One answer might be to acknowledge that something which on the stage might be identical now to a century ago might now produce vastly different effects, at least when performed far from Denmark: fidelity to letter might actually produce a violation of spirit.

Scholars court naivete in believing that achieving authenticity is as simple as burrowing about in sources; company directors court naivete in seeming to believe that what their teacher taught them is necessarily right; philosophers court naivete when they lose sight of the exigencies of putting

on a show; audiences court naivete in being utterly unconcerned with any of the above.

A compromise among the morning's series of dogmatic position papers might look like this: Siegel was right that the interests of dancers diverge from those of audience members, and both of these in turn from the interests of scholars. Authenticity for one may be pedantry for another, or utterly without interest for a third. In trying to make theoretical distinctions, we should be very clear about the group for whom we are making them. Yet if evidence regarding original performance practices exists (it doesn't always, although that is what scholars spend their time looking for), we are justified in being interested in it. And if we accept that such evidence exists, we need to accept as well that we can get more or less of such evidence—it is this that justifies the scholar's life.

What we do with such evidence, however, is another question that lies outside the sphere of scholars: it is the responsibility of the ballet's producers, who must be conscious of things like audience and box office in addition to questions of whether what they are producing today could be transported back to 1868 (or whenever) without exciting comment. Authenticity, in other words, even if possible to some degree, is not an end in itself. A performance the shade of Auguste Bournonville would be able to approve might not have the same effect on a contemporary audience as it would have had on an audience of the time. (I think of Borges's celebrated short story about the man who re-writes, word for word, Cervantes's *Don Quixote*—whereby the point is precisely that the second time around it is no longer the same book, given that *Don Quixote* already exists and is part of our cultural heritage.) Yet on the other hand, it may well be something that company directors will want to dabble in, more or less seriously, as one of their several concerns.

The after-coffee fare of the Symposium was vastly different. It consisted of a series of devastatingly charming reminiscences to Tobi Tobias by Niels Bjørn Larsen, once a lead dancer of the RDB , intermittently company director, and now character dancer, of the early days when he entered the school as a child. Larsen had the audience in his pocket with his recollections of having to piss in the toilet of the royal box as an initiation rite when he first arrived, of telling the new boys—as he had been told in his turn—that they had to mix their face powder with water. He corroborated that the famous Bournonville Monday classes had in fact been done on Monday, the Tuesday on Tuesday, and so on; he was perhaps at his most informative in his insistence that his "entrance examination" had consisted of determining

that he was suffering from no major diseases. Our current emphasis on tracking seemed inhuman and somewhat obsessive by contrast.

What Larsen presented was the vision of someone who had spent all his life at his craft and was still in love with it. Speaking of being invited to do Madge (in *La Sylphide*) with Peter Schaufuss in Florence, he bubbled over with glee at the thought that at his age, people still wanted to see him on the stage. Keeping in mind someone like Larsen, the plea of Lise Le Cour at the Mayor's reception to keep the school in the same building with the theater so that the children could grow up with the theater in their veins seemed all the more poignant.

The audience was in Larsen's pocket by the end of his interview, and when Tobias (somewhat shamelessly) asked him to mime "I have an idea: let's go to lunch—I love you" everyone clearly reciprocated the sentiment. After lunch, most of the audience returned—save those who had gone back to town to see the video of *The Lay of Thrym*—to hear Ole Nørling, professor at the University, give an "Introduction, musical and cultural, to *A Folk Tale*." The subject here was more technical, Nørling's English not quite up to the stupendously fluent level of most of the Danish participants, and the lecture was filled with music examples on a sound system that seemed very nearly dead. The points raised, however, were well worth considering, touching as they did on the relationship of Bournonville to the general cultural climate of his era.

At 3:00 the events were declared over and people began to scamper for their coats and the taxi ride back to the center of town.

DanceView 1992

Bournonville in His Surround

SEEING BOURNONVILLE IN COPENHAGEN, everyone at the Bournonville II festival seemed to feel, is not the same as seeing Bournonville elsewhere—say, New York or Washington. Of course, some of this feeling was undoubtedly due to the fact that in Copenhagen, we critics—in our own cities merely marginal players—were treated like royalty, waddling from groaning board to groaning board, with guided tours and receptions in between.

Yet some of the feeling that it was different seeing Bournonville in his home city may have been due to artistically relevant reasons. In Copenhagen, the visitor gets a sense, however slight, of the larger historical picture of which Bournonville and his ballets were a part. And this sense of context can only serve to make more profound our understanding, and hence appreciation of, the ballets.

Of course, Bournonville's world—in the sense of his milieu, his time period—is no more. Yet surely, it seemed, there was some continuity between then and now in this charming and pleasantly provincial northern haven, set far from the upheavals of Mittel- and Osteuropa. Something about the scale of the place seemed just right for the charming, low-key ballets we saw night after night: for Bournonville ballets tend not to be populated by Petersburg- or Paris-style moping princes or fairy princesses but instead by honest working people or bourgeois who want to get married and live in houses with the Danish equivalent of white picket fences. (The notable exception, *La Sylphide*, seems to prove the rule, having been lifted from Paris by Bournonville, no more or less light-fingered with choreographic ideas than anybody else at his time.) Even the Royal Theatre, although done in the same overwrought gilt of other Third-Empire-era theaters across Europe, is of a smaller, somehow more humane size than most others—and the theater that Bournonville knew for most of his productive life, now destroyed, was even smaller.

We visitors found ourselves in a world where the bicycles were lined up on the street ready for stealing, being locked only with a rear wheel block and not attached to anything—and somehow were, miraculously, not stolen; a world where one could leave one's coat in the unguarded cloakroom of a museum or the theater and expect to find it there when one came back for it. It really seemed a world apart. Denmark is part of the EEC, but I heard all sorts of murmurings from the locals on whether or not it would not after all choose to withdraw. The locals seemed both flattered and puzzled by the interest of all these foreigners in Bournonville, as if they could not believe that we would have come so far for someone they regard as something between an albatross and an old shoe. What, us interesting? they seemed to say.

These ballets seemed right at home in a city with an amusement park in the middle of its downtown, regrettably closed in pre-season slumber during the festival. Closed as well was the famed Tivoli pantomime theater, where *commedia dell'arte* shows are still performed. It seemed logical too that, aside from Bournonville, the city seems proudest of Hans Christian

Andersen. There is, of course, the famous statue of the Little Mermaid from Andersen's story that I jogged by in the afternoons, invariably finding it surrounded by Japanese or American tourists, that has been taken as Copenhagen's answer to the Eiffel Tower or the Statue of Liberty. People frequently ask why it isn't larger, expecting something on the scale of those more gargantuan symbols.

This pride in a creator of fairy tales goes so far as to inspire the city's tourist booklet to make an outrageous comparison of Andersen to Mozart: both, it insisted, are read or performed somewhere all over the world. By contrast, the country's greatest philosopher, Søren Kirkegaard—a far less sunny disposition—merits only a mention in the blurb for the city museum, where he is represented by what seems a temporary exhibit including his spectacles and a few papers. Perusal of festival material takes the connection between writer and choreographer one step farther: Andersen, it turns out, was Bournonville's good friend; Bournonville himself harbored literary pretensions that found expression in his scenarios and libretti.

In fact, the connection between Bournonville and Andersen may serve as a point of departure for answering the larger question, How does Bournonville fit into his time? This question lay behind the lovely book entitled *Bournonvilleana*, edited by Marianne Hallar and Alette Scavenius, that was produced in conjunction with the festival. Indeed, several of the essays address directly the question of Bournonville's relation to folk sources, notably those by Bengt Holbek and Erik Kjersgaard dealing, respectively, with "Bournonville's Sources: Legends and Fairy Tales" and the cholera epidemic in the midst of which Bournonville wrote *A Folk Tale*, where water shows both its infective and potentially healing properties.

Interest in folk and fairy tales, manifested in Germany by the brothers Grimm, was itself an expression of the Romantic *Zeitgeist* on which Bournonville rang such high-bourgeois changes. The Grimms, acting under the influence of the theories of national character of Herder, collected those grisly tales known to most of us in the expurgated, Disneyized versions; Andersen's are created, un-"authentic" tales. (The Grimms were understood as collecting folk tales from the *Volk*, but most modern commentators agree that they were in fact collected from the bourgeoisie of Bremen, with French influences thrown in). And it is precisely the contrast between Andersen's gentler, "art" versions of folk tales and the more earthy ones collected by the brothers Grimm that sets us on the track of a perception of Bournonville: not a first generation Romantic like the Grimms but a second- (or perhaps more accurately third-) generation one, who mined Romantic sources for

inspiration, transforming them into sanitized, sweeter versions that would be acceptable to his audience, composed of the aristocracy and the haute bourgeoisie.

This very point, in fact, was made by the scholar Ole Nørlyng, speaking at the April 1 Symposium the University on the music for *A Folk Tale*. Nørlyng's point of departure was the fact that Bournonville asked two distinct composers, Niels Gade and the sunnier J.P.E. Hartmann, to write the music for his ballet. This, Nørlyung suggested, was because while Hartmann could be trusted to do the first and third acts (which take place among humans), Bournonville needed music more threatening, more Dionysian, for the second act, at which point he turned to Gade.

Unfortunately, this distinction between Apollonian and Dionysian that Nørlyng found in the two acts was not audible to many in the audience at the Symposium. Many of the visiting Americans, especially those reared on the works of Balanchine set to far knottier scores, felt the musical diet during the Festival week was thin indeed, and were not in the mood to make distinctions between one nineteenth century Danish composer and another—as if we had been asked to follow a learned dissertation on the influences operative on Minkus: after Tchaikovsky, it just doesn't seem worth making the effort. Yet despite the fact that most audience members seemed to hear no great difference between the two composers, the overall point Nørlyng was making was clearly worth considering. It was that although, as he put it, Bournonville "knew about the split of the divided self," the choreographer both evoked earlier folk material and blunted its sting, encasing the potentially threatening second act of *A Folk Tale* in the sandwich of its first and third acts. The demonic, as Nørlyng put it, "had to be turned into something educative." Genuine folk material tends to be more depressing, and less productive of morals, than this: Bournonville subjected it, in Nørlyng's opinion, to the "shaping demanded by his era." Indeed, Bournonville (or at least his "sunny" composer Hartmann) returned the borrowing and shaping of folk sources with interest: the wedding waltz from Act III of *A Folk Tale* has, he told us, become standard fare at Danish weddings, one of those cases of life imitating art that is dear to the hearts of all critics.

Nørlyng insisted that we need to be aware both of Bournonville's attraction to the danger intrinsic in Romanticism, and his withdrawal from it, the result of having to fit in in a late Romantic era, in the high-bourgeois form of ballet in the Royal Theatre. Teresina comes back from the Blue Grotto (*Napoli*); the switch of children is rectified and the human restored to

humans (*A Folk Tale*). The sensuality and wealth conjured up by the candles in *Abdallah* disappear in a flash, leaving the eponymous hero with his lone bride—and once again, with a mother-in-law. Reality is momentarily contravened; the forbidden seems possible—but in the end, all is set right and the world returns to its safer, tamer boundaries. No suicides, no deaths: even in the unrepresentative *La Sylphide* the order is restored, where Gurn and Effie go off to be married while the weak-willed James (who, we feel, deserves to die for his fickleness) writhes on the stage.

This view of Bournonville was borne out both by the concentrated viewings of his surviving ballets over the course of the week, and by visits to the accompanying art exhibitions set up in various venues all around town. For another way of taming the dangerous and unknown is by exoticizing it. Virtually all of Bournonville's ballets seem to rely on an exoticized setting as one source of their interest, a fact which in turn tells us something about his society's perceptions of its own boundaries. The obsession with the sunny south of Italy which defines *Napoli* was well documented in an exhibit on the Danish view of Italy on display at the Decorative Arts Museum in the Bredgade. This offered, in a single room, Italian paintings of Danish Romantics (happy peasants in Naples, for example, and ruins with herds of sheep), some examples of furniture and lamps made in the Pompeiian style, and ballet photographs showing the reliance of the original flats for Act II of the ballet on paintings of Capri's Blue Grotto by Danish artists.

The obsession by the north with Italy was not, of course, a Danish invention, nor even a Romantic one. We take things one step back when we recall Goethe's celebrated song of Mignon in *Wilhelm Meister's Lehrjahre*; Mignon longs to go to Italy "where the lemon trees bloom." Yet interest in things Southern was by the time of Goethe in full neo-Classical bloom through the writings of Winckelmann, and had indeed been one expression of the Northern imagination for centuries: one has only to think of the Classical ruins or re-creations of Claude Le Lorrain and Poussin, on view in the Royal Museum of Fine Arts in a special exhibit of paintings from the National Gallery, London, or of the handful of lesser-known French classicists of the seventeenth century who now seem to us precursors of such Romantics as Caspar David Friedrich.

By Bournonville's time, this interest in things southern was a commonplace. The Danish rooms of the Royal Museum of Fine Arts are full of paintings from early in the nineteenth century, all painted by Danes in Italy, that play variations on the themes of happy peasants and melancholy ruins in the sunny south—the same paintings one sees in the less headlined

museums of Switzerland, Germany, and the U.S. (One particularly winning painting in the Royal Museum shows a group of Danish artists from early in the nineteenth century lounging, smoking, and talking in a sun-filled room in Rome: they obviously meet to reminisce about home, yet none is on his way back.) North has always been obsessed by South—at least up through Gauguin—as a space of lazy lotus-eating, a world of happy peasants in touch with their agrarian roots, a source of festivals that spring naturally from the soil. Perhaps we have now lost this sensibility in the economic split of the late industrial age that equates the South with poverty and mosquitoes, the North with Swedish Modern and Coca-Cola.

The notion of the Exotic presupposes that the place perceived as exotic is both desirable and quite unattainable. *Napoli* is not alone in partaking of this sort of North/South exoticism: so too the remaining fragment of *Flower Festival at Genzano* (performed at the final program of "Bournonvilleana"); there is also the Argentina of *Far From Denmark* with its black slaves and swishing mantillas; there is the picturesque Flanders of *Kermesse in Bruges*; there is the marketplace of Basra in *Abdallah* with its echoes of the *1001 Nights*.

One variation on this fascination with the south is also expressed as a fascination with the mysteries of Catholicism: I do not think it chance that *Napoli* was produced in a Protestant country—one whose windswept Lutheranism is evident in a short story by another Dane, Karen Blixen, who contrasted it to French "joie de vivre" in "Babette's Feast." For in *Napoli*, it is the magical power of the monk's amulet that wards off evil as effectively as garlic a vampire; this is both powerful and silly, evidence of the child-like quality of the characters, as well as the agent for the necessary happy end. Nor, I believe, is it too much to see a slight mocking of popery in the final scene of *Kermesse*, set in Catholic Flanders, where the priests and their henchmen trying to burn the heroes to death for blasphemy all begin to kick up their heels at the sound of the magic instrument. Catholicism, with its powers and amulets, is both attractive and reductionist, part of a Southerly world "out there" where life is more simple—and hence perfect for the ballet stage back home.

Another major exposition in town, entitled "Sculptor and Choreographer," was at Thorvaldsen's Museum, dedicated to the relationship between Bournonville and the work of the Danish neoclassical sculptor. The exposition was a series of rooms documenting Bournonville's choreographic fascination with a series of exotic Other places, some of which were also of interest to Thorvaldsen: Spain, Italy, Greece, and the mythic

Nordic past of *The Lay of Thyrm*. Yet the museum itself, and indeed the friendship of Bournonville with Thorvaldsen that the festival literature played up, seemed more interesting as cultural evidence than for purely artistic reasons. Thorvaldsen, unlike Bournonville, will never leave Denmark: not because what he was doing was too local, but because it was too universal. Thorvaldsen was the man who brought neoclassical sculpture to Denmark, as others brought it to other countries, usually to better effect. Thorvaldsen, we might say, was the Danish Canova. Canova is still seen in Western museums, if not precisely highlighted (his "Perseus" was moved a few years ago from the top of the stairs at the Metropolitan Museum to a less central place overlooking the balcony), but he is something of a curiosity for postmodernist (or at least postcubist) museum-goers.

Nor need we look as high as Canova for equivalents to Thorvaldsen. Thorvaldsen's American counterpart was the now all but forgotten Hiram Powers, whose once-celebrated *Greek Slave* diverts an occasional footsore tourist in one of the back rooms of the National Museum of American Art, in Washington, D.C. Indeed, one needed only to go the New Carlsberg Glypothek right there in Copenhagen to find deserted hallways of virtuoso nineteenth-century marble-working in the neoclassical vein that astonish us most of all by making us realize just how utterly uninterested we now are in this particular technical feat.

Neoclassical architecture has fared better, for occasionally, one of these early nineteenth-century classicists managed to leave his mark on a city in a way that cannot be overlooked: Leo von Klenze, for example, is responsible for the majestic Königsplatz in Munich, as well as for the two museums that flank it. In America we had Jefferson and his followers (in subsequent generations they built the neoclassical city of Washington, D.C.), drawing on Greek or Italian sources. (The other main architectural vein of the Romantic era was of course the neo-Gothic, which is visible in Europe in various Parliament buildings and fantasy castles, and in America on college campuses.)

By mid-century this sort of architectural classicism had been codified into the international Beaux-Arts style, which began with Athenian columns and added enough curlicues that eventually the ship was all but sunk: it was through rebellion against this that what we call "modern architecture," deriving from Louis Sullivan and then the Bauhaus, perhaps via Wagner's architecturally spare Bayreuther Festspielhaus, was born. And now, of course, the neo-neo-classicizing of postmodern architecture, such as James Stirling's Stuttgart Staatsgallerie, quote once again from the Greeks,

although this time tongue-in-cheek, and with liberal dabs of the bright colors once enlivening the originals.

Despite the attempts of the exhibit at Thorvaldsen's Museum to suggest a direct connection between work of the sculptor and the choreographer, it is difficult to see any evidence in Bournonville of the spirit fundamental to Thorvaldesen—none of the frigid, heroically perfect physiques that Thorvaldsen marketed as sublime. For although Bournonville's ballets offer a kind of artificial perfection of their own, they are set in a more mundane world than these heroic nudes of Thorvaldsen, even if a world given a perceptible taste by being colored with exoticism. The connection of Bournonville with Thorwaldsen, finally, seems strongest not so much in direct stylistic borrowings as in a more abstract link-up: namely the way both men situate their culture through a fascination with what it is not.

With a few honorable exceptions, it seems fair to say that Danish culture is provincial—or at least that it has not, by and large, reached the world at large: caught as it seems to be between the Germanic cultural sphere and the Scandinavian, on the edge of the continent of Europe, largely inward looking for most of the nineteenth century. (Denmark too had its revolution in 1848, however, as the result of the same winds that swept across most of the rest of the continent.) Yet there is good provincial and bad provincial: Thorvaldsen seems merely the latter; Bournonville the former. Indeed, the extraordinary preservation of Bournonville's output was possible only to the extent that the society in which he grew and flourished *was* provincial: the fewer the outside influences, the purer a style will stay. We in 1992 are experiencing what may be the last gasp of that purity, already caught in the agonizing self-reflections made clear by the University's Symposium.

One example of the "apartness" of the Danish view was seen in the gulf that opened between the Danes and the American critics conscious of the exigencies of multi-cultural reporting over the subject of racial (i.e. black) stereotypes of *Far From Denmark*. Erik Aschengreen had tried unsuccessfully to quash this as a subject of conversation in the initial lecture/demonstration in the Court Theatre, observing that Bournonville was not a racist. At the Symposium, Niels Bjørn Larsen shook his head over the fact that foreigners had evidently "misunderstood" Bournonville's assigning non-balletic character dance to natty-haired black-faced dancers as racism.

On one level, the Danes are right: this particular exoticism, this particular evocation of childlike silliness, is no different than the stereotyping of Spaniards, Chinamen, or Neapolitan Catholics that dot the other ballets. Bournonville, we can certainly say, wasn't trying to make fun of black

people because he didn't know any black people. However the Americans were equally correct in saying that the Royal Danish Ballet would not be well-advised to bring *Far from Denmark* to the United States; even if the ballet is old, the performances and presentation of the material are new. A black viewer would be quite right in being insulted, just as the Nigerian novelist Chinua Achebe was right to take umbrage at the treatment of blacks by Joseph Conrad in *Heart of Darkness* (in a now-celebrated essay entitled "A View of Africa: Conrad's *Heart of Darkness*"). The black characters in this ballet dance in a non-graceful manner, as the black characters in Conrad talk in pidgin; the black maid clearly admires her mistress's looks not only because of her individual features, but simply because she is white.

Danish intellectuals and artists seem to work overtime trying to avoid insularity on the high-cultural scene: the Louisiana Museum on the coast showed us both the Edward Hopper retrospective which has been on view in the States and a far more extensive show of Robert Mapplethorpe photographs than has yet been shown on our shores. Yet this desire not to be thought (or to be) old-fashioned was precisely the reason, I thought, why a number of the Danish critics at the Festival found the enthusiasm of the hoard of American critics for Bournonville's ballets somewhat outmoded. Each of the groups thought the other provincial in its own way. Again and again we heard the plaintive observation, from the company members and directors, that the RDB did other choreographers than Bournonville, and heard their fear that they would be forced to do nothing but this "old-fashioned" choreographer. The choreographers the Danes are eager to do (and think themselves up-to-the-minute for doing) are the same ones Americans tired of long ago: Tetley, Neumeier, van Danzig, and so on. Who is the more up to date, us or them?

Are we guilty of patronizing them in wanting them to bring only the internationally exportable Bournonville ballets to our shores, as they will be doing this summer? There seemed a parallel to be drawn here with the way Western societies want traditional societies to remain traditional—so that their products can be exported in unadulterated form to our Third World arts festivals, and can feed our museums. Perhaps as a result, there was distinct ambivalence to be felt from company members regarding this choreographer that so charmed the visitors. Of course, if we are just discovering Bournonville, those for whom he is old stuff are right to be tolerant of our enthusiasm: they've been doing him for a long while, after all. Why is he only now so terrific?

As Flemming Ryberg pointed out at the University's symposium, the Danes learned they had this thing called the "Bournonville style" at the first Bournonville Festival in 1979; this is what set them wondering about questions of "authenticity" which hitherto had not troubled them. In a quixotic mood, I wondered: can it be that our interest in Bournonville in 1992 is as much a factor of the slowing of our own domestic scene as of anything else? What would have happened to Bournonville without the influence of the festivals? What has happened to him as a result of them? I could ask these questions, but I could not answer them.

DanceView 1992

Toward a Theory of Dance History

THE 1992 SUMMER SHOW OF PAINTINGS and engravings by the Italian Renaissance artist Andrea Mantegna at New York's Metropolitan Museum of Art set me thinking about history in the arts, perhaps most immediately in the visual arts. Because I was fitting in my museum visit before a matinée of New York City Ballet, which was dancing works by Balanchine (a dead white male choreographer), my thoughts turned as well to history in dance. It seemed both that the relationship of dance to history was more problematic than in other arts, and that this fact ought to cause us more worry than it does.

In the case of dance, I thought once again as I walked dreamily down the grand entrance staircase, we are without a precise definition of our object of study. Art has paintings and sculptures; literature has written texts; music has at least scores. All have the corpus of individual artists, schools, and movements. But dance lacks a text, in the sense of an object that can be referred to, and is different even from the other performing arts in that it is not usually performed from an existing score, as is a symphony or a play. Our need for a coherent theory for dance history is, moreover, a pressing one. What will come after Balanchine? What will pull us out of the doldrums that have followed the celebrated "dance boom"? Questions like these are pressing. Yet even asking them implies that we have a conception, articulated or not, coherent or not, of dance history, for this determines what we are looking for in the future. Is dance a sort of language, a liquid that can be put into bottles of any size? Does dance consist of works? Or, alternately, does

it consist of the personalities of forceful individuals somehow expressed in dances? We have to know what the units of our conception of history are in order to know where to look for future developments.

The fact is that we don't know what those basic units of dance history are. The artist's corpus? Dramatic situations? Sometimes it's one, sometimes another. Balanchine's densely step-oriented ballets have encouraged us to think that dance history does consist of works, that is, patterns of steps, classified and organized around the centers of individual choreographers. The copyrighting of those works and of the Graham technique that has followed the deaths of these two masters has encouraged us in this way of thinking. But certainly nobody before Balanchine, or perhaps Fokine, would have agreed. And why should Balanchine have been able to change this work when others are not allowed to? Shouldn't he have given it a new title? All of the versions of what we call a single work are in fact cut out of a continuum, a particular band of colors that meld into other colors at their sides.

No more helpful for dance history are the neat divisions of individual artists and their schools that we learn in an undergraduate course in literature or painting. Although there is conjecture about some of Balanchine's early or lost ballets, in most cases we know what pieces he did and which he didn't do. But in fact the distinction may be less evident than this absolutist labeling suggests. Are there even such things as schools in ballet? Sometimes we joke and speak of the "School of Balanchine," as I was impelled to do after seeing works by Richard Tanner and Peter Martins. We do it, but we're not sure exactly what it means.

Of course, we can say what the basis for the family resemblance is, just the way we can see Mantegna's influence on other sculpturally-inspired northern Italian painters. Typically, all School-of-Balanchine works are titled after their music and lack plot, scenery, and developed dramatic interplay between the dancers. At the same time they bear an obviously careful relationship to the music, preserve many of the givens of male-female interaction inherited from Petipa and the Russians, evince a hierarchical ranking of dancers; and, of course, are based on classical ballet technique.

We feel free to speak of "school of" works with those that are set on his company or include students from the School of American Ballet, use the same blue cyclorama, the swimsuit and leotard costumes, even literally the same orchestra. Yet when Balanchine became an international commodity in the sixties and seventies, the world's dance stages were filled with works that, in an only slightly more attenuated sense, also looked like Balanchine: bare stage, steps set to music, men partnering women, lead couples dancing

in front of solists and corps, and so on. The Mantegna show included engravings by other artists, Rembrandt among them, that mimicked Mantegna's trademark sculpturalism or even echoed whole groupings from his works, just as any quartet of one man and three women nowadays tends to evoke *Apollo*. Perhaps "Balanchine ballet" is more appropriately seen as a way of doing things, a conception, rather than as a body of works associated with one person's personal involvement, which means that "school of" works may be a huge and all but unmanageable category.

What, on the other hand, of the lamentable *Agon* I saw in Budapest in the early eighties, credited to Balanchine but hardly recognizable as being like any performance I'd seen at the New York State Theater? Was this Balanchine? By contrast, many of Martins's little pieces, perhaps *Les Gentilhommes*, seemed better Balanchine. The question is similar to the following ones: Is it Bournonville that is being put on the stage in Copenhagen today, or Petipa in St. Petersburg? In the first case the distancing is geographic; in the last two cases it is temporal.

Frequently we skirt the issue of what the unit of our conception is to be in dance history by contenting ourselves with the physical fragments the passage of the dance across a stage has left us. Even when all that is left is a title and some costume sketches, we can point to these and make of this disappearance a fact to be passed on to our students. But is it really history of dance that we are promulgating here, any more than the display of Kierkegaard's spectacles in Copenhagen's City Museum constitutes the history of philosophy?

In addition, we're unsure about what kinds of data even count as historical. A colleague and I were talking one day about arts coverage in New York, and about the passing of Burt Supree, Cultural Editor of the *Village Voice*. One reason so many people felt fondly toward Burt, she said, was that when so many New York newspapers with arts coverage died in the 1980s and 1990s, it was only the *Voice* that gave coverage to downtown companies. This fact, too, seemed to me to be related to history, and to its relation to dance. While many critics are unsure of just why we write, others of us comfort ourselves that we are doing it for posterity, so that scholars can read what we have written and use it as a record of the arts of our time.

But what if a dance concert is not written about? What, that is, if it somehow fails to enter into the written record of happenings? Does it not thereby escape from history? After all, the meaning of the term "prehistoric" means simply, before written history. At most, someone who was there could turn subjective memory into data by writing it down. If not, isn't it as if it

had never been, a version of the tree in the forest that falls soundlessly if no one is around to hear it? I don't think anyone knows the answers to these questions.

Maybe by dance history we simply mean that which isn't being put on right this minute, what we watched last night or last year rather than tonight, or what somebody watched a century ago. By that definition dance history ends up being the same as the sum total of all dancing. It's a comfortable way to define the object, similar to the way the term "film history" is sometimes used as a synonym for all the films that have ever been made. But films, unless their celluloid has been destroyed, still exist in a vault somewhere. Dances by and large simply disappear from memory, or more problematically are transformed by it. Our last-ditch attempt is simply to go back to the time-line way of conceiving dance history: we order cardinally what we know, and call it done.

Yet, although it seems that dance is more fluid, more transient, and less amenable to codification in history than other arts, including painting, it was, paradoxically enough, the Mantegna show that reminded me that this is so. The show made it clear how imprecise and constantly changing artistic history is, even in the case of such seemingly solid objects as paintings and engravings. And if this is true of painting, think how much more it is true of dance.

Before this show, I knew Mantegna primarily as the painter of the jewel-like but strangely cropped *Judith and Holofernes* in the National Gallery in Washington, and of the amazing *St. Sebastian* in the Louvre. Stopping before an attractive bas-relief in the New York exhibition, I felt silly for not realizing that Mantegna was a sculptor, too; I felt better after reading the text and finding out that the experts aren't sure that he was. The so-circumspect text attached to the painting began with the acknowledgment, "Tradition has it that Mantegna was a sculptor as well as a painter." Not only, the text went on, was there no evidence that this particular work was from Mantegna, but also there wasn't any certainty that Mantegna was ever involved in the medium at all.

The same willingness to acknowledge the gray areas, the patches of uncertainty, continued throughout the other textual commentary at this show. The curators discussed at great length, over a whole string of wall labels, whether one series were pre-work sketches for paintings by Mantegna himself, or after-the-fact copies by students. Ultimately, they were in favor of the latter, finding the drawings in question somewhat too passionless and static for works by Mantegna. (This reasoning doesn't always hold true;

sometimes works by disciples, even the experts are forced to admit, are better than those by the master.)

The labels were also refreshingly candid about the state of preservation of the paintings (a subject on which the Met, by contrast with many other museums, is always forthcoming). A certain painting was "badly abraded," a criticism frequently leveled at Mantegna's *Adoration of the Magi,* acquired some years ago by the Getty Museum. Another had been "heavily retouched, especially in the facial area." Similarly, the labels mentioned, somewhat disparagingly, the darkened varnish on paintings not belonging to the museum. The original effect of one such painting, it remarked sourly, was surely quite different from that which the painting produced in its current state.

In another case, the curators summarized the universal critical uncertainty regarding just how much involvement there was by Mantegna in the picture in question, an issue that dogs gallery directors continually. In my museum-going lifetime alone I've seen the ascription of one small painting in the National Gallery change three times: once Vermeer, then demoted for a while to Unknown Artist, now re-elevated slightly to "School of Vermeer."

The obsession with crediting works to one particular painter, insofar as this is possible, frequently seems more the result of market forces than anything else. If you can prove that what you have is "a Mantegna" or "a Picasso," its value goes up. This is the result of our Romantic theory of the arts. The artists of the medieval era were uninterested in stamping their own particular works as theirs. Certainly, a contemporary interest in the masks and ritual objects of so-called primitive peoples has suggested to Westerners a way to produce carvings that does not rely on the assumption that works are primordially the expression of one individual's sensibility, and hence most properly identified as works by X.

Here it's not the work that is the unit in focus, but the corpus, a conceptualizing device that we may, with time, come to find equally unsatisfactory in dance. A lot of times it doesn't simplify our world; it complicates it. How to explain Balanchine's Romantic facet, evinced in *La Sonnambula,* given the fact of his neoclassical one, shown in any of numerous Stravinsky ballets, and the one from which came the legendarily bad *PAMTGG*? Surely it is only a fetishistic interest in the biography of the artist that makes it necessary to lump all these together, rather than staying with more comprehensible stylistic units that cut across many choreographers. The widespread post-Romantic usage of the artist as the unifying unit presupposes some degree of coherence among his or her works

for it to gain our loyalty. Otherwise it becomes merely a fact, and not a very useful one. Surely it is of no use at all to know that the same person who made *Gaspard de la Nuit* made *Symphony in C*. The two works are simply too diverse. Frequently in the visual arts many people were working in one style, and the smallest unit of conceptualization becomes this style, so to speak the common language, not the less-than-individual speakers whom we can no longer distinguish one from anoter. Many paintings, for example, are identified simply as "Flemish school," or "French school."

In the visual arts, therefore, the task of redefining the territory goes on all the time, with conjectures hardening into patches of certainty, until another set of data, or another expert's opinion, renders them liquid again. Sometimes the solidity is more seeming than real, or indeed positively illusory, as when we know nothing at all about the painter who made a certain work and are obliged to call him only the Master of the So-and-So, where the So-and-So is the painting we're looking at.

But at least, in the case of paintings, we have the physical objects and can now use X-rays to separate layers of prior painting. With dance, this uncertainty defines the very field, and we cannot even separate the layers. Prior to the twentieth century, a ballet master could put on his own version of something seen elsewhere and no one would cry "Foul!" Who knows how much Filippo Taglioni is in Bournonville's famous Paris-inspired *La Sylphide*? Even today, we place a high premium on local versions of classics. Helgi Tomasson does "his" *Swan Lake* for San Francisco Ballet, for example, although we can see that it is inspired by Nureyev's "brooding Prince" Russian version that is still seen elsewhere, and that it uses virtually the entirety of the traditional (i.e. Petipa) pas de deux for the prince and Odette, and the dances for the potential brides. The choreography for this piece is, however, credited simply to Tomasson. Presentation fuses layers of history, leaving only the scholars to try to disentangle them outside the theater.

To a certain extent, this is true in the visual arts as well: the art historian may note the Italian influences in certain Dürer works, for example, or explain the Utrecht Caravaggists through their study in Italy. The casual museum-goer doesn't care, seeing only all the painted objects that exist in simultaneous time and space. Similarly, most museum-goers remain oblivious to questions of preservation or the relation of this painting to other paintings elsewhere in the world; this is the province of the scholar.

Yet, in painting, the subject of scholarly scrutiny is at least the same object the tourists glance at before turning away. Not so for dance, or at least

not usually. For dance historians, the mutable performance is useful only insofar as it produces immutable spin-offs, like notation, or notes, or videos, or programs and costumes, or critical descriptions of what happened.

To critics, on the other hand, are given the somewhat thankless tasks of remembering what the piece looked like the last time around, saying what it reminds them of, and generally placing it within its context. To be sure, the distinction between the critic and the historian isn't absolute; usually the critic just relies on the history that he or she has been a part of. However criticism of many works is better if it draws on a larger temporal spread than merely a couple of decades, which is why the better critics are usually also historians at the same time. Yet how to apply dance history, however we understand it, to the present? Another way of putting this is, How is dance history related to dance criticism? No one knows, although everyone has an opinion.

Painting has critics and historians, too, whose relative functions are roughly comparable to those in dance. The difference is that in painting we have, at least, the physical object with its backing of canvas or wood, and perhaps traces of earlier versions underneath. We can write wall labels calling viewer attention to alterations or abrasions. In dance, the ability of scholars even to disentangle the strands of authorship is limited. It is easiest when we can make the distinction back at the inception of the piece, such as the Ivanov/white, Petipa/nonwhite act division in *Swan Lake*. It becomes more difficult in the subsequent interpolations. A sport of Kirov-watchers in the eighties, when the troupe began to tour widely in the West, was determining how much was Petipa in the full-length ballets being offered and how much was more recent interpolations. In other contexts, where we can assume a greater respect for the past than may have been usual in Russia, a big question is, What is the overlay of repairs and what is original? At the Bournonville II Festival in Copenhagen, the big question was, What was Bournonville and what Hans Beck?

It's even possible that measures applied at one time to preserve the work have taken it farther from where it started than it otherwise would have gone, like the varnish applied to paintings to preserve them that has darkened and rendered them all but invisible. In other cases the paints have simply oxidized and can no longer be stripped off. In dance, the question of how to "restore" the work is more than technical. It involves appealing to written records, if such exist, or to documents of the choreographers, and so on. Yet even when we have done this, we don't know how to interpret the data or what conclusions to draw. In any case, the problem with dance history applied to

the current stage is found in the question, Does more authentic mean better? Even if it's possible to get back the work as performed in, say, 1852, is there any point in doing so?

The ongoing fight over the restoration of the ceiling of the Sistine Chapel shows that this issue is real even in the visual arts. Some scholars asserted that Michelangelo knew that his frescoes would age, and so we should leave this patina as part of the work. Even if he didn't know, isn't leaving the grime a healthy acknowledgment of the passage of time? Everyone now knows that Greek temples were once garishly painted, yet those who revived an interest in classicism for the modern world, such as Winckelmann, liked precisely these white skeletons, a taste almost universally shared even today.

In dance, which is still all but exclusively transmitted body-on-body, the confusion of transmission with the thing being transmitted seems complete, in theory as well as in fact. We can read documents, but what do they tell us? We can clean paintings, but we cannot clean dances. All we can do is put on other versions with the same title. Titles are, however, not the answer to our quest for permanence in dance history, in that they are not the determining factor in what makes a ballet the "same" ballet. Titles have changed on Balanchine ballets and they have remained the same; some ballets with the same title are not considered the same.

Even in the visual arts, at least up to the Romantic era when people began signing things, authorship was highly uncertain. To be sure, some paintings are mentioned in ancient catalogues or letters, but then only cursorily. One text in the Mantegna show suggested that the work in question might well be that referred to as merely the *Portrait of a Woman* in a document of some centuries ago. Or again, it might not be. There are always surprises. One lovely painting now ascribed to Mantegna was, according to its tag, "unknown before 1986, when it appeared at auction."

As this show reminded me, the history of the visual arts is comfortingly gray, rather than black-and-white; it is patchy, interrupted, and beset by uncertainty. The realization somehow made me feel better at NYCB later that day. For here we had pieces by a choreographer no longer around to superintend his work, which could be obscured by the dance equivalent of varnish, namely new dancers from different traditions who give a different coloring to the choreography, or dancers from the same tradition allowing their personal quirks to overshadow the work, or a tempo a shade slow here, a step slightly different there. The ballet master or mistress tries to catch what he or she can remember, but this too is subject to attention lapses and the vagaries of memory. Besides, we all get older, and our tastes change.

Who says the way person X will put on Balanchine ten years from now will be the same as when the master was alive? Is this necessarily bad?

Such thoughts hooked on to an ongoing conversation I had been having with myself since the previous May, when I sat in the Zellerbach Auditorium of the University of California at riot-wracked Berkeley, to see a concert by the Merce Cunningham Company. What rang in my ears there was the comment before the curtain by a colleague: "Merce won't be remembered for his repertory," he said, "but instead for his ideas." Certainly, similar things are said about Gertrude Stein, one of my fetish authors. Without deciding whether this is true in Cunningham's case, the idea made me see the program with a fresh eye, realizing that the most original contributions of an artist may not necessarily be his or her particular works, but instead a way of doing things.

Indeed, we all know that it's not the technique in modernist, and more clearly postmodern, art that's the point, but the ideas behind them. That's why, in fact, the standard saw about "my five-year-old could do this" is both so true and so beside the point. Of course, technically speaking, most five-year-olds could do much postmodern art. The question is, rather, could they think of it in the first place? Conceptual art, overtly about the idea behind the work rather than about its execution, makes clear that we are more interested today in the idea. Virtually all visual art beyond cubism is conceptual art to one degree or another, no longer intended to impress the bourgeoisie by its technique, i.e. its degree of verisimilitude to a common, recognizable world. Instead, it is meant only to express the sensibility of the artist, and to take up the place in the museum the artist had hoped to achieve for it.

Back in New York, watching "School of Balanchine" pieces and thinking of the uncertain ascriptions of the paintings I had seen, I wondered, What was Balanchine about Balanchine? What was copyrightable? How much of this would be around five centuries from now? Would we be able to distinguish Balanchine from "school of"? Would there be fights among scholars about whether a certain minor work was by Balanchine or by an epigone? Would there be enough left to fight about?

Unsurprisingly, those "school of" pieces I saw seemed uninspired by contrast with the still-vibrant performances of first-rate works by the master that were on the same program. Particularly instructive was comparing those movements of Peter Martins's *Mozart Serenade*, danced as part of the afternoon workshop performance at the School of American Ballet, with Balanchine's *Divertimento No. 15* on that night's performance across the plaza, and both with Richard Tanner's *Prague Symphony* the night before.

Neither of these "school of" pieces had the wit, the density of Balanchine's. Wherein did this difference lie?

To some degree, I could point to steps. To a large degree, however, the difference was just as nebulous as that which differentiated, for the curator of the Met Mantegna show, a pre-painting drawing by the master from a student's copy after the fact: something like "life," or "force." But are these ballets any worse than bad Balanchine? Perhaps the determinative factor is a lack of momentary inspiration, not whether the works are by one person or another.

The "great man" paradigm seems particularly ill-adapted to use for viewing a more collective enterprise like dance, in the same way that it seems alien to films produced under the auspices of the Hollywood studio system. Not even the most dedicated *auteur* critic can see any difference among most of the virtually identical car-chase-and-blow-'em-away pictures put out by Tinseltown to feed the taste for vicarious violence of our television-numbed multitudes, even if they are directed by several scores of different individuals. Each film or dance is the result of so many people working together that it doesn't make sense to list it just under the name of one, be that person the choreographer or the director. When one creative intelligence was supervising everything—steps, costumes, interpretation, lighting, decor—perhaps it was appropriate. That may be why the *auteur* theory works in the case of Hitchcock as well as of Balanchine and Graham, who seem examples of the closest the later twentieth century has come to Wagner, with his idea of the *Gesamtkunstwerk*.

Legally, at any rate, our society has decided that the units of dance history in the case of Balanchine and Graham are the tangible ones of the step, the work, and the name, represented by ©. Nowadays in order to teach Graham Technique or a Balanchine piece you have to be licensed, and you pay money for the privilege. It's mind-blowing enough to think about pieces in dance being copyrighted. Does this mean that no combinations of one man and three women, which for a contemporary viewer will seem to reek of *Apollo*, will ever be permitted in any other work? The notion that a technique can be copyrighted is even more problematic. Why not copyright the notion of doing dances after music, which after all was brought to its current level of universal popularity by Balanchine, or dancing in a rhythm of contraction and release, which is Graham's idea?

If the intention is to keep imitators away from the choreography of these two people, it won't work. People have been imitating them for years. Alvin Ailey stole from Martha (*Feast of Ashes*, among many other pieces), as does

Erick Hawkins, although he'd be loath to admit it. And if Martins isn't a disciple of Balanchine, usually working "in the manner of," what else to call him? Artists will always steal from one another, and the distinction between what's personal and what's collective in a piece will always be fluid.

In fact it seems that what most of us are really interested in is the creative intelligence that we see in a performance, intelligence that can come from one of a number of sources. We say that it's the good new work we're looking for, but it isn't really; it's the charge we get from a performance that we're looking for, a charge that can be dulled by a bad choreographer, a bad ballet master, a bad performer, or a good performer's bad night. Despite all our attempts to convince ourselves that dance history is important, for most of us it all still comes down to an experience in the darkened theater.

What will move dance history forward? What is to come after Balanchine? Will we have decades of "school of" pieces? In order to answer this question, we have to know what has moved dance history forward in the past. And this is precisely what we do not know.

Certainly, it's possible that we'll have season after season of people chewing over the same discoveries that Balanchine made. Epigones, in dance as well as in painting, philosophy, or literature, can be had for the asking. If it really is works that are the smallest unit in dance (and it has to be if copyright makes any sense), we condemn ourselves, at least theoretically, to centuries of "school of" pieces, for there is a near-infinity of works of music to which we can put permutations of steps. One thinks of the story of the monkeys with the typewriters. Given enough time, they will produce all of the extant works of literature in the world, along with mountains of gibberish and near-gibberish, including works that are identical to, say, *A Tale of Two Cities* in all particulars save the last comma or an uncapitalized first letter of the book. A consideration of this will convince us, I think, that it's not steps, not works that we ultimately want.

Some of us, although perhaps fewer and fewer, are still satisfied with current versions of old stories, or with new stories that involve costumes and movement and fill the evening. But not those of us who ask questions like: Whither NYCB after Balanchine? Whither dance in the nineties? We don't know, and that is so for the good reason that somebody has to come along who, rather than thinking in terms of the tangibles of works and steps, which are amenable to listing, codifying, historicizing, and copyrighting, instead understands the fundamental questions that Balanchine was asking of his medium, and thereupon simply asks other questions at that same level of generality. This is always the way that something really new happens in the

arts. Or, as an alternative, it's possible that someone could arise who asks the same question in a slightly different way, just as Webern was as twelve-tone as Schoenberg, and yet completely different. In any case, the work cannot be the bottom line, and this means that we cannot say where things will go. We audience members, historians, and critics, see only the effect of the question a choreographer asks; it is already an act of choreographic originality to know what this question is.

These unseen questions, to which the works and steps are answers, are the real basal unit of dance history. Indeed, comparable unseen questions are the real basal unit of all histories in the arts. They are not the same as biographies or the names of individual artists, although they are questions individual artists ask. Yet, because of the apparent solidity of paintings and novels, we have been able to avoid seeing this in the case of non-dance arts. Indeed, we have tried to conceive of dance history in their terms. Finally, however, we are unable to go on doing so. History in all of the arts rests on questions posed and answered, but it is in dance that this becomes clearest.

With respect to the future, this means that we have absolutely no idea what will come next: do not know and cannot know. A new question is a new question; we can only wait to see what happens.

Ballet Review 1993

Les Ballets Suédois

EVERYONE IN THE DANCE WORLD knows something about Diaghilev's Ballets Russes, that avatar of "The New" that set Paris on fire in the 1920s and formed the link between Petipa and Balanchine through the works of Fokine. But try dropping the phrase "De Maré's Ballets Suédois" at an artsy cocktail party: the result, at least until recently, is likely to have been merely blank stares.

A one-day symposium devoted to the Ballets Suédois on October 14 in the New York Fashion Institute of Technology's Katie Murphy Auditorium did its part toward changing the blank stares into knowing nods. The occasion was an exhibit of costume and set designs, backdrops, posters, and memorabilia of "The Swedish Ballet 1920-1925" organized by Stockholm's Theater Museum, Eric Naslund, Director, on view at FIT's Museum across the plaza. Attentive looking and listening at both exhibition and symposium

suggested that the appropriate response to someone evoking the name of the Ballets Suédois might well lie between these two extremes, perhaps an acknowledging smile rather than either dismissal or unbounded enthusiasm.

Like so much in the symposium's setting of New York, the story of the Swedish Ballet was fundamentally about money. Rolf de Maré, founder, impressario and Mycenas of the Ballets Suédois, was raised in the lap of turn-of-the-century luxury. Grandson to one of the greatest Swedish fortunes (a fortune made in logging in the frozen wastes of the Swedish north), de Maré passed his pampered childhood in a high-bourgeois palace in central Stockholm. Involved with the arts from an early age, de Maré hit upon the idea of bankrolling a group of dancers from the Royal Theatre in Stockholm who would perform in Paris, crucible of the avant-garde. The company, which he dubbed the Ballets Suédois, had more in common with Diaghilev's than merely the pattern of its name. To start with a little biography, De Maré, like Diaghilev, was the lover of his principal dancer, Jean Borlin (the name sometimes written with the *Umlaut* over the 'o' and sometimes without).

This liason, according to Naslund, was the source of the consistently negative publicity given the Ballets in their native Sweden, both in the 1920s and in more recent years. The museum's sponsorship of the North American exhibition (drawn from its holdings and first seen in Stockholm) is an attempt to redress this imbalance. Amazingly, Borlin was also the company's sole choreographer, creating every one of the 25 major works the company did during its five-year lifetime, along with a handful of minor works and divertissements. After the demise of the company in 1925, Borlin, who drank heavily, continued to choreograph, although apparently to little effect. He died in New York in 1930, and was interred in Paris's Père Lachaise cemetery. De Maré became a world traveler and early dance ethnographer, taking many films of non-Western dances in locations as far-flung Africa and Indonesia. His express wish to be buried at Borlin's side was ignored, and instead he was interred in Stockholm, with his father.

A number of the company's works appear to have been made as conscious spin-offs of Ballets Russes repertory, including Borlin's *Jeux*, Games, which like Nijinsky's was set to Debussy's music and involved a triangle of a man and two women. Other works drew on Swedish themes, including *The Foolish Virgins*, set to Swedish folk tunes, and *La Nuit de Saint-Jean*, A Midsummer Night's Revels. Set and costume designer for the latter was Nils Dardel, the talented Swedish painter who was part of the original group of Stockholm artists drawn to de Maré. Dardel's most striking

backdrop was perhaps that for *Maison de Fous*, The Insane Asylum, on which the huge elongated arms and foreshortened chin-angle face of a demented man appear to be forcing their way out onto the scene from the crack between backdrop and stage.

However, those of Borlin's works for the Ballets Suédois which hold the most secure place in our collective dance consciousness struck out in a direction not taken by Diaghilev, one influenced by Dadaism and American popular culture. The exhibition at FIT (subsequently to be seen at the McNay Art Museum in San Antonio and the Fine Arts Museums of San Francisco) includes, most spectacularly, Ferdinand Léger's set and costumes for *La Création du Monde*, The Creation of the World, inspired by Black and jazz themes and set to music by Darius Milhaud. *Within the Quota*, widely performed during the company's U.S. tour of 1923, was based on a scenario about a Swedish immigrant to America. It was suggested by the American painter and 1920s man-about-the-Riviera Gerald Murphy, who designed sets and costumes, with music by Cole Porter. (The backdrop was a huge newspaper front page whose screaming headlines were "UNKNOWN BANKER BUYS ATLANTIC," and the hyphen-filled "EX-WIFE'S HEART-BALM LOVE-TANGLE.")

The company's final work, *Relâche*, claims perhaps the strongest hold on the dance-historical imagination. Set on a stage filled with industrial-strength lights, the work is remembered as a collaborative effort of "uptown" Dada: impudent and daring to be sure, but remaining within the parameters of a performance at one of the capital's flossiest theater, the Ballets' "home" Théâtre des Champs Elyssées. The title of the work means "Theater Closed," or "No Performance Tonight"; as if to take pity on the audience for such negativity, the intermission was taken up with René Clair's famous avant-garde film entitled *Entr'acte*, Intermission: its title was an early example of the same truth-in-packaging that has since produced Bloomingdale's "Big Brown Bag" or the T-shirt for pregnant women with a down-pointing arrow and the word "Baby."

The repetitive music to the piece was by Erik Satie, the most famous of the composers who worked with de Maré. Only a general conception of the movement survives, involving a man who smokes, various "audience members" who move from the audience to the stage, men in evening clothes who strip to polka-dotted long-johns, and numerous drop curtains painted with Dadaist provocations (including "Do you prefer the ballet or the opera?" and "poor imbeciles"). After *Relâche*, de Maré is remembered as saying, he simply had to disband the company; any new work would have

been a step backward. Speakers at the symposium suggested more prosaic reasons for the company's demise: Borlin's alcoholism, the staggering amount of money de Maré had poured into the project, and a general sense of artistic exhaustion in both choreographer and dancers.

Lynn Garafola, speaking on "Rivals for the New" at the symposium (and reprising her essay in the elegant catalogue entitled *Paris Modern: The Swedish Ballets 1920-1925*, edited by Nancy Van Norman Baer, curator of The Fine Arts Museums of San Francisco), pointed out that many of the effects produced by the ballet would not qualify as dance in our current movement-oriented climate, with the admittedly spectacular costumes rendering even ordinary movement by the dancers difficult. (Carina Ari, the company's featured dancer, for example, left after a few years, claiming an insufficient outlet for her artistry.) The air of aping the Ballets Russes, the necessity continually to up the ante in the attempt to "make it new," and the fact that Borlin was perhaps a more enthusiastic than talented choreographer may have contributed as well to the short life of the company.

The symposium as a whole suggested, perhaps unfairly, that the Swedish Ballet was a dance phenomenon almost more interesting in retrospect than it would have been in performance at the time—reduced as it was to still photographs, surviving sets, designs, costumes, some pieces of its music, and a few minutes of film. We not only re-discover the past: we make it. I thought of a conference I went to several years ago on North Carolina's Black Mountain College. Seen through the blurred filter of time, the improvisations of Cage, Rauschenberg, and the works of the then-unknown Cunningham seemed to have been prescient and weighty, chaos become proto-Happenings. At the time, however, dancers who had participated made clear, conditions at the college had been grim and the works largely incomprehensible.

Garafola argued that the Ballets were an artistic dead end, not real artistic competition for the more mainstream Ballets Russes at all, but a minor tributary that simply dried up. Speakers on the designs, music, and film that remain from Borlin's works (respectively, Judi Freeman speaking on Ferdinand Léger, Dale Harris on "Satie and Les Six," and RoseLee Goldberg and Virginia Brooks on Clair's *Entr'acte*) conceded the point or implied it, by reserving their enthusiasm for aspects of the works other than the choreography. George Dorris's informative talk on Borlin was largely biographical, perhaps because we have so little information about the dances themselves.

Indeed, the most touching moments of the day's presentations came in a film by Gerd Andersson on the Ballets Suédois made for Swedish television, entitled *A Great Adventure* and hastily (but flawlessly) sub-titled in English for the occasion. Andersson focused on the somewhat caustic widow of painter Nils Dardel, an apparently dyed-hair, bitter woman (Dardel too was homosexual) who interacts for the camera with the charming Margareta Johansson, a sweet-tempered old lady still living in Paris whose recollections of her time with the Ballets as a young girl make one melancholy over lost time, the past, the ageing process, and the persistence of memory. Andersson shows the two women recollecting, from their so-divergent perspectives, Borlin, de Maré, and life with the Ballets. Johansson is taken to the apartment of Carina Ari (now a dormitory for Swedish dancers in Paris) and exclaims over how little it has changed. Except, she adds, that Carina—who was like "an older sister" to her—is no longer there. Then she is helped across the busy Paris street, hunched over and leaning on her cane.

Both the symposium and the exposition reiterated, almost despite themselves, the fundamental paradox of dance history: remembering dance is like excavating a burial mound. What remains will always be secondary: jewelry, tooth fillings, burial objects, accompanying keepsakes, or masks. The humans at the center of these toms, meanwhile, have left at most a few bones, or more likely are turned to dust.

Reprinted courtesy of Dance International; appeared 1996

Art and Archeology

RECONSTRUCTION IS ARCHEOLOGY, I thought after the presentation by the Royal Swedish Ballet of their all-Borlin evening (June 8-11, Kennedy Center Opera House). In the same way that the palace at Knossos has been re-made after the taste of its excavator, four the "lost" Borlin dances for the short-lived Ballets Suédois (1920-25) have been reconstructed and are being presented in the U.S., a year after their Stockholm premieres. Three of them, *Within the Quota*, *Dervishes*, and *Skating Rink*, are the product of the Anglo-American reconstruction team of Millicent Hodson and Kenneth Archer, also responsible for the Joffrey's reconstruction of Nijinsky's *Rite*

of Spring of a few seasons ago. The fourth work on the program, *El Greco*, has been mounted with fewer claims to authenticity by Ivo Cramér.

The credits for Hodgson and Archer's reconstructions read "Choreography and Set Design"; "Original Choreography" is credited to Borlin. The program notes by the team radiate confidence that what they have presented is close to what an audience in the 1920s would have seen. Patching together photographs, memoirs, reviews, interviews with former dancers, and at least in the case of *Skating Rink*, a quasi-scenario from the poem on which the dance was based, Hodson and Archer explain that they worked to "form quite an authentic hypothesis of what each production was intended to be." They then "intervene and complete the creative work of the choreography and the design."

Maybe they're right. I'm sure they're careful scholars, and I'm willing to believe that what we see on the stage is as plausible a fill-in as any other would have been. Barring the discovery of some hitherto-unknown cache of material, we'll have to take or leave the result. There's no getting behind appearances to get at the "reality," now lost to us forever.

The result they've given us is not without interest. Blocky, limited movement styles carry the day in *Skating Rink*, where the people seem to enter and become part of set and costume designer Ferdinand Léger's turbo-mechanical world. Many of the pieces have the same period taste of another reconstruction-of-the-new, Massine's *Parade*, with which many American viewers are familiar, bodies subordinated to decor. *Skating Rink* makes one think as well of Ashton's *Les Patineurs*, another work that has skating movement as its premise (here roller, there ice), and *Within the Quota* has something of the silent-movie taste of Paul Taylor's take on *Rite of Spring*, *The Rehearsal*. But these are, I think, coincidental similarities, not to be confused with influences or homages. There are others: the working-class verismo of *Skating Rink* had the same whiff of the Parisian gutter as the stylized-violent *Le Rendez-vous* of the young Roland Petit, presented here a number of years ago by the Paris Opera Ballet.

The least interesting of these four reconstructions seemed *El Greco*, all posing and *tableaux vivants* of celebrated paintings. For this, Cramér made a much weaker claim to authenticity than Hodgson and Archer had done for their own efforts, pointing out in his notes that only a few photos of the original remained. The credits too were more modest, noting the source of what we were to see in a "Mimodrama by Jean Borlin, freely interpreted" by Cramér. What we saw was dreary, and it was difficult to believe that the original would have been much less so. Perhaps the piece, or rather its

vanished prototype, would have made more sense in a world where bored bourgeois in country houses mounted elaborate charades with costumes for holiday entertainment, a world, and time now gone with the wind of the radioactive particles emanating from a billion television sets.

Within the Quota too seemed dated beyond retrieval, despite its music by Cole Porter and its witty newspaper backdrop by expatriate American Gerald Murphy. I liked sitting close enough to see that below the headlines, the text of the huge "newspaper" was gibberish in an invented language too full of consonants. In this piece, a newly-arrived Swedish immigrant meets a series of stereotypes of the time who come on, do their thing, and go off. They include a Mary Pickford type, a blackface dancer (tastefully done in a bow to current sensibilities without the blackface), a bowlegged trigger-happy cowboy, a Jazz Age flapper, and a woman with a tiara and pearls. I initially took the lot of them for actors, that is dancers playing actors playing characters, because they spend all their time hogging the movie camera that is being constantly cranked by a man in a cloth cap and huge glasses. Certainly some of them are based on entertainment types: the Mary Pickford send-up, the Tom Mix-like cowboy, even the dancer. But the program identifies the woman with the pearls as "The Heiress" (which means, a real one, not a camping Gloria Swanson actress), the cowboy as "The Cowboy," and a multi-part character, among others, as "The Sheriff." I had to conclude that they're dancers playing real people who like the idea of being on camera when the opportunity presents itself, at which point the whole thing seemed like an early riff on our national obsession with getting our 15 minutes of Warholean fame. I suspect, however, that I'm trying to find something interesting where there isn't anything: I imagine it's really only the attempt of Borlin (or the Europeanized Murphy) to get a little mileage out of throwing a few easily-recognized national stereotypes at furriners, the cameraman being only one. (The troupe brought this on tour in America in 1923; I would be curious to find out how it was received.)

Which left *Dervishes*, an early take on the Sufi worship through spinning that Laura Dean subsequently developed to such a monotonous fever pitch. It reeked a bit of the "exotic lite" dances of Ruth St. Denis and Ted Shawn, but after *Within the Quota*, it set me thinking. Thinking, namely, that not only were the reconstructions we saw archeology, but that all art is archeology, or at least travelogue: it presents a mediated view of something to the folks back home, a something they will never see, or should never see. *Within the Quota* would, I imagine, seem dull for an audience that was already familiar with the American types European outsiders would find

delicious in their own right, even in 1923. (Program notes credit Murphy with initiating the French craze for Black American dancers and musicians, of whom the most famous was Josephine Baker; the French thought jazz the pure expression of uncivilized libido.)

In the same way, *Dervishes* was clearly a Western outsider's once-over-lightly view of Sufi (Islamic mystical) worship. It had a plot, of sorts: something was going on with a group identified in the notes as soldiers, who join the twirlers, removing first their belts and then, in a final gesture, their shirts, which they fling on the dervishes. (A statement of some sort was clearly being made with the bare torsos, since the dancers hurried to cover up again for the curtain calls). The choreographic point, however, was simply how neat twirling men in skirts look to people unused to this. Certainly it had nothing to do with "authenticity," any more perhaps than the reconstructions themselves. Think how offended and contemptuous an adherent of this order would be to see this uninformed view of what isn't stage movement at all, but worship! (Real dervishes appear on Western concert stages today: a conundrum by itself.) Think too how silly a specialist in El Greco would find people moving through the postures of recreation of well-known paintings! Think how puzzling the real working-class people who sought a bit of pleasure at the skating rink would find the stylized view of their hang-out!

All art is somebody's once-over-lightly of something seen from outside, presented to the folks back home who haven't seen the original. Sometimes the outside is only in the artist's brain, and sometimes not. What's interesting to the artwork's audience is not what's interesting to the people who created, or lived, the original. If you know the thing the art is a riff on, the mediated, altered version seems strange, unfaithful, inauthentic.

All art is therefore flawed as a representation of reality: the fact of representation means it can't *be* reality. Usually, as in reconstructions, there's not even anything to compare it with, the original being so hidden or transient that it can't be brought back. In Gertrude Stein's famous phrase, there is no "there" there. She was talking about Oakland, California, but her perception applies equally well to the work of Hodson and Archer, and to the now-vanished originals by Borlin whose shadows passed across the stage.

DanceView 1999

Dance Ink Photographs

IN THE AFTERWORD TO THE SUMPTUOUS, decadent, and way mannered collection accurately entitled *Dance Ink Photographs* (after Patsy Tarr's now-defunkt magazine in which they originally appeared), Nancy Dalva tells us: "the dancers in these pictures were free to show themselves as they wanted to be seen." And: Tarr set about "matching dancers and photographers in commissioned shoots intended for publication. . . . [The result is] not so much as reporting as a revealing." Of what? I wondered, leafing through these stylish creations so abstracted from the fact of performance and the motion of dance that they might as well have been images of ants, of falling leaves, or a random group of in-shape twenty-something people. Surely not revealing, say, of whether the dancers were *good* dancers, the works they made *good* works.

The photograph by K.C. Bailey of Margie Gillis on the page facing this Afterword, for example, is a black flower of swirling cloth, like a splotch from one of Robert Motherwell's *Elegies for the Spanish Republic*, from which protrudes one white forearm and a neck (the head is shrouded in black by the flailing stuff). The bottom of the dark splotch allows the viewer to intuit the direction of swirl of the body underneath, into which the arm is swinging; the result is like Loïe Fuller got up as one of *Macbeth*'s witches, conjuring up a spell. It's a wonderful photograph, and something only a camera can deliver. The black and white has increased the contrast between the stygian black and the sepulchral white of the arm: in reality the dress may have been red, the arm pink. Not to mention that split second where the cloth covers the face, that instant where the limbs are in perfect whirling alignment. It's Cartier-Bresson's perfect moment, that one shot culled from what were undoubtedly scores of also-rans.

Or take Marcia Lippman's purposely grainy shots of the Isadoresque Lori Belilove and Company, strewing flowers in their Grecian garb in the empty basin of a mosaic swimming pool (?) that evokes classical flooring, just sufficiently rotted and decayed to mime Pompeii or Hadrian's villa, which transported me for a brief instant to a Keatsian world of beauty doomed to die. Or Guzman's portrait of a shirtless Ethan Stiefel, his torso slumped over his Harley-Davidson belt buckle, his ringed hand holding a smoldering cigarette whose smoke, exiting from his mouth and veiling his eyes, obscures his features and makes him seem like a rotten angel, doomed to the hell whose vapors pour from his lips.

Or again, K.C. Bailey's image of Arthur Aviles' naked muscular body caught from the back in a crab-like heels-up leap, silhouetted against the surrealistically large onion domes of a Russian church, the next building over from the rooftop where the picture was taken. This is quite simply one of the best male nude photographs I have ever seen, a landscape of protuberances: the dancer's round, gleaming head (seen largely from the back) echoing his tensed, globular buttocks, his sun-lit testicles seeming like ripe plums beneath them; the almost anatomical curves and valleys of his ripped back both echoing and serving as counterpoint to the round domes and curving white window-outlines of the architecture behind, punctuated by the relentless right-angles of its bricks.

Run, jump, leap—do not walk (no one in this book does)—to acquire this book, if only for photographs like these. Or for the handful of shots by Annie Liebowitz, our reigning queen of the stylish. Liebowitz takes the famous and make them look as if they deserve to be so. Her picture of the sumptuously beautiful Darci Kistler, all dress and flowing hair, reclining in the evening-clothed lap of her husband Peter Martins, seems to summarize everything we want to believe about ballet. Her picture of an elfin figure dressed in Chaplinesque derby and oversized tails dancing delightedly down a leaf-strewn path, when identified by the caption as being Twyla Tharp, seems to capture the essence of that so-quick, so-hyper dancer. And the portrait of Mark Morris as a Romantic poet for the nineties, facing into the wind on a boat, his arms outstretched, his unruly locks blown back across his face by the wind, his shirt blown open to reveal his hairy, un-pretty body, seems like a distillation of the Love-me-as-I-am aesthetic of our time.

But it is precisely Liebowitz's photographs that make clear the problematic nature of many of the photographs in this book. For in order for us to smile knowingly, or grin in appreciation, as we invariably do at her images, we have to know who these people are. By nature, they are portraits of the already-famous, like Arnold Newman's equally stylish pictures of celebrities of a generation ago: Stravinsky reflected in the mirror surface of his piano, Louise Nevelson looking like an upscale gypsy against the reiterated knobs of some of her newel-post constructions. We have to know who Twyla Tharp is to have this sprightly photo be amusing; Mark Morris with his shirt off has to be preceded by his reputation and his works. We have to know that Darci Kistler is the last remaining Balanchine ballerina. We have to remember Peter Martins when he was Apollo, have to have heard all the delicious gossip about wife-beating, have to have some sense of the events at New York City Ballet since Martins took over the helm. All that

serves as background to these two impossibly gorgeous people washed clean of earthly endeavor in the mask of ultimate chic: evening clothes.

So what of it? We all like to look at famous people, and if the photographs can be stylish, so much the better. Guilty pleasures aren't less fun for being things we know we should be ashamed of. Probably they're more so.

The problem is that this book has nothing to do with dance, and everything to do with its trappings. It operates from a kind of *People* magazine aesthetic re-tooled for the Upper West Side. When you go to see Mark Morris's works, you'd better not be sitting there thinking how famous he is, or you won't be able to concentrate. Yet if you don't know how famous he is when you look at the photograph (famous in the dance world, of course: these people aren't movie stars), it makes no sense at all. If, in a dance, he shows off his roly-polyness without a shirt, it had better be relevant to the work of art (the good news: it usually is). It can't be an end in itself, as it is in the picture, where we laugh tolerantly and say, "what a character."

Many of the book's opening shots (it's organized, somewhat unnecessarily and rather archly, into "Acts" and an "Intermission"; the back cover lists "The Cast") serve the same gossip aesthetic: specifically that important sub-set of gossip I call the prurient interest aesthetic, specifically as applied to bodies. Being creatures with bodies, we are fascinated by other people's. These photographs give us bodies in abundance: very close up, posed beautifully in that never-never-land of stillness in motion where virtually all contemporary dance photography lives. They're not all great photographs, but they are all photographs of great bodies. It doesn't really matter whether the particular well-muscled, zero-body-fat armature suspended in midair is Ethan Stiefel, or an also-ran from a regional company in the Midwest. It doesn't matter whether this incredibly desirable (okay, my personal view) woman with the achingly beautiful breasts posed on a trapeze is Judy Flex (photos by Mark Hanauer) or an undergraduate from Florida State. We're still fascinated, or turned on, in a lurid way by this relentless up-closeness of sheer attractive physicality.

Or rather, and this is the horrible thing, it *does* matter who these people are. If this particular attractive specimen of humanity is not an international star, but a bad dancer from Nowheresville, the shot suddenly loses its intensity. The body not only has to be beautiful, it has to belong to a Somebody, rather than a Nobody. That ups the ante. And why shouldn't it? After all, people read *People* to hear what Madonna or Kevin Costner think about, say, raising golden retrievers. What their neighbor thinks is irrelevant.

It's so much more interesting to watch a genuine celebrity pick his ear than to watch a bag lady in the subway do the same thing.

In one shot, we get a man laughing: it *matters* that the man is Paul Taylor. We get a relentless closeup of a man's Butohed-up face with the main event the folds in his lips: it *matters* that it's a photograph of Ralph Lemon. We get adorable pictures of a fashionable, sprightly old lady wearing a fake nose, and can only chuckle if we know that *it's Alexandra Danilova.*

"Didn't I meet you in the Hamptons?" this book asks us as a pick-up line, knowing that it didn't. Which is why we might just shell out thirty-five bucks to look at these pictures of people who, figuratively speaking, were at the week-end that everyone is still talking about six months after the fact. The photographs in this book flatter, feed off of, glamorize, and ultimately have nothing to do with dance.

DanceView 1998

Writing Dancing

IF SALLY BANES DIDN'T EXIST, it might be necessary to invent her—as the prototype of the engaged dance scholar, someone who refuses to stay within the cloistered halls of academia, instead scouring the world for movement events to which her resolutely decentered sensibility vibrates. The essays of twenty-odd years collected in her *Writing Dancing* crackle with intelligence, humor, interest, and rationality, standing as examples of just how good dance scholarship can be that combines meticulous research with an eye for the fresh and new.

If you know anything about Sally Banes from her earlier work (most notably her first book, *Terpsichore in Sneakers*), you know that she's not going to be caught reviewing *Swan Lake*—or if she is, she will have found an influence of (say) Native American bird dances on Ivanov. Her radar picks up, among other things, non-traditional influences on high culture artifacts—such as black dance influences on Balanchine (considered in the book's essay 6). She loves dances that pop up in unexpected places, as documented by her series of articles on breakdancing in the early 1980s. Refusing to acknowledge boundaries between high and low culture, Banes passes through middlebrow on the way: one essay (21) considers the "drunk dances" in Fred Astaire's films. She is interested as well in early European

experimentalism, such as the Ballets Suédois (7) or the works of Kasyan Goleizovsky (9).

Banes is brainy as well as hip. She's also a one-woman refutation of the argument Roger Kimball has advanced against "tenured radicals" in the university. Unlike many, Banes is not sentimental about the marginalized. She isn't saying that Balanchine was exploiting black dancing, or that he should have been more up front about his borrowings. And she doesn't object to non-mainstream dance making it to prime time, as breakdancing did. At the same time, she is aware that a price is paid for commercialization; in the case of breakdance, it became homogenized as adolescents gave way to more muscular adults and everybody was learning it from television.

Banes has the distance of the historian on such developments. She doesn't resent Hollywood's appropriation of an indigenous art form in *Flashdance*; that's just the way things go in our postmodern age. Indeed, according to thinkers like Fredric Jameson, commodification is what makes our age postmodern.

Such appropriation is the paradox that Claude Lévi-Strauss outlined with respect to the "primitive" cultures of the ethnographer: the fact of the study alters the society. The lone ethnographer is necessarily the precursor of the Cook's Tour, since we Westerners are constantly on the lookout for the new, the unspoiled, and the unmapped. Banes seems ruefully aware that she is too. Indeed, one of the more meaty pieces in *Writing Dancing*, called "Criticism as Ethnography," looks at just this comparison between the critic and the ethnographer.

Banes's conclusion is that the ethnographer is essentially different from the critic, despite some similarity of contemporary criticism (such as hers) to the ethnographic paradigm. The critic works within his/her own culture, and at the same time preserves a distance to the perceived object of the performance. The ethnographer goes outside, and works at breaking down—or at least calling into question—the distinction.

Yet I thought *Writing Dancing* ultimately in this sense more ethnographic than critical. Banes is going outside her world, and mapping it. Her world is scholarship, and what she maps is the messy world of art production, by definition only the raw material of the article or the university course. The scholar is always in search of new worlds to conquer: to order, to explain, to compartmentalize, all of which Banes does with a deft hand. See, for example, a wonderfully efficient summary article for a Munich journal on all of the various "isms" of post-Sixties dance (36). Why live it,

I wondered, when you can save all that time and have somebody explain it to you after it's over?

This is the colonialism of scholarship. Banes does it well, and with the same tinge of self-reference that marks Lévi-Strauss's *Tristes Tropiques*. At several points, Banes refers to Susan Sontag's seminal 1960s book *Against Interpretation*, with its famous suggestion that interpretation was the "revenge of the critic on art." Banes must be aware of the same danger for her own enterprise, which (although she clearly loves what she writes about) is the revenge of scholarship on the lived world.

Banes reminds me of the Stanford scholar Marjorie Perloff, who provides the same services for literary postmodernism that Banes does for dance. It all makes so much sense when you read about it—when, that is, you read about Cunningham or Molissa Fenley in Banes, or John O'Hara in Perloff. Trouble is, it makes too much sense. Banes can show us what the intellectual progenitors of all the "make it new" dances of the last thirty years have been. She can list works and dates and can take on more normative critics (like Monroe Beardsley, in a fine piece with Noël Carroll, 2) with an intellectual scalpel. But the deadening experience of watching a Karole Armitage dance, with the body language (and usually the music) turned up so loud it hurts, is quite different from reading about it in Banes's rational *ex post facto* historical explanation. It's more enjoyable to read Banes on minimalism and postminimalism than it is to sit through the performances. In the same way, it's more fun to read Perloff on some loopy postmodern writer than it is to read the meandering work she's analyzing.

Banes points out that post-1960s dance, like post-1960s art, was informed by theory, which is why it's frequently so much more satisfying on the page. The title of this collection is apt. In the literary theory of the 1960s, observer merged with observed. So too here: this is not writing about dancing. The external object has largely disappeared, ingested into the body of scholarship. For Banes, we might say (paraphrasing Flaubert), all dance exists to end up in a book.

How can things that try so hard to escape all the boundaries end up so firmly within them? This is the paradox of all modernism (indeed of post-Romanticism). It is also the paradox of scholarship such as Banes's.

Body Peircing

THE RECENT RUN OF AMERICAN BALLET THEATRE at the Kennedy Center (week of April 7) made me nostalgic for the 1970s. For the 1970s, that is, of my graduate school years, when semiotics was all the rage, and when all it took to raise a good discussion among the bohemian set was to drop the buzz-phrase "sign-systems," or evoke the holy names of Ferdinand de Saussure and Charles S. Peirce (rhymes with "verse"). For what jumped off the stage at both the program of shorts and the week-end's full-length, *Coppélia*, was the fact that piece after piece constructed its own sign-system of movements all vaguely like a certain type of movement in the world, yet sufficiently differentiated from one another to form vocabularies capable of expressing many diverse things.

The run began with Frederick Ashton's *Les Patineurs*, and was followed, on the Wednesday night program, by Agnes de Mille's *Fall River Legend* and by *Theme and Variations* of The Great One (oh, all right: of George Balanchine). In the Ashton, we might say, the title tells if not all, then at least a good deal. The ballet is a kind of game, and the game is: how can Sir Fred come up with enough diverse ballet motions, all of which mimic, to some degree, the characteristic glides of ice skating, and put them together in enough different combinations, that the audience is simultaneously charmed and interested? If there are too many, we lose a sense of "family" in the motions; if they are too repetitive, we are only bored. If he can establish the tone, he's then allowed some motions that don't have much to do with skating at all, but which aren't egregious enough to dilute the effect appreciably.

In lesser hands, this game would make a pretty good school choreography assignment. It works much the same way we can see Taylor posing problems for himself: how to make a dance without using the arms (*Counterswarm*)? How to make a dance in which grown men dance at half-size (*Snow White*— recommended for very little else)? *Spindrift* seems to be Taylor at his most linguistic, with the guy who's been washed up on land communicating by means of elementary blocks of body speech that are then strung together into phrases and what finally seem whole sentences.

And Ashton's solution? First, of course, we have glides and slides in place of steps: the surface of the stage is smooth enough to permit this. Then there is the crossover joining of the hands for couples. A file of girls all on tippy-toes stands in for neophytes going very carefully (you don't walk on the tips of skates on the ice). When the Boy in Blue (danced with pazzazz by

Angel Corella in the performance I saw) comes out, to do his bravura stunts, they're the usual balletic turns and leaps, all nonsense in the context of skating. Still, he does alternate slips on and off, so somehow we buy his jumps, not to mention the concept of leaving the floor with pointed toe "really" encased in a skating boot, as being enough like the rest of the skating motions as to seem part of the same family of signs. It's not a double axle he's doing, but it's at least a jump and a twist. In another context, these same motions would be part of a different sign system, and usually are; proving Saussure's point here, however, they took on their meaning from the other signs around them. And then Sir Fred hammers home the point by having one of the going-gingerly girls fall and go boom on her bum, as of course she would almost never do on the stage. Even the Boy in Blue "dusts off" the snow.

The set by William Chappell, all glowing lights and gazebo, did its part to telegraph "skating" to the audience, as did the costumes (hats and muffs up there on that sweltering stage!). Finally it begins to snow, or rather, "snow"—we "read" those pieces of white paper falling from the proscenium as snow because that is what fits in with the setting and the motions. We can imagine an entirely different ballet in which, say, flakes of some sort fall at every point on leotard-clad dancers dancing to John Cage: perhaps yellow ones, purple ones, white ones. Under such circumstances we might not see snow, but only a curtain of small objects to be navigated, much like Andy Warhol's mylar balloons that the dancers in Cunningham's *Rainforest* kick aside as they move across the stage.

In *Fall River Legend*, it was the quivering of hands to indicate gossip that caught my eye: in another dance, this might be "read" as fear, or palsy. Here it means talk, because that's what we expect the townspeople to do under the circumstances: anyway, they're standing still in groups. They can't *all* be afraid of something. In dance, before Judson at least, people didn't really talk: the flapping of lips becomes the flapping of another body part, and we "read" it as verbal communication in a world in which there is no verbal communication. In Graham's later *Seraphic Dialogue*, the saints talk to Joan of Arc by flapping their hands, but it's not clear what the hand-quivering-behind the head motion of the older woman from *Appalachian Spring* means; lacking a surrounding situation or vocabulary, it simply seems a dead end. Indeed, Martha seems to have been on de Mille's mind for a great deal of *Fall River*. In both, there is a preacher with simpering cohorts, although de Mille's lack the intensity of the clone-women who support the fire-and-brimstone preacher in *Appalachian Spring*.

It's something of the same problem that faced the Russian and German silent movie pioneers: how to show sound? As answer, they give us an exhalation of steam from a pipe whistle, a close-up of a calling mouth. We see that one character has said something awful by the cringing response of the "auditor" in the film-world (the "diegesis"). Or rather, we see a reaction which could only have been produced had the first person "said" something awful.

By the time *Coppélia* rolled around, I was waiting for all the jerky arm-movements that denote "dolls," playing on a single difference between dolls and people, namely non-articulated joints. This one difference used as a synecdoche short-hand (part standing for whole) is so clear in Saint-Léon's choreography that square legs and whirligig arms here become part of the lexicon of mime gestures, joining the usual circle-the-face-and-kiss-the-fingertips gesture for "she's sooooo beautiful" and the point-to-the-ring-finger-make-an-X-with-your-arms gesture for "I will NOT marry you." To "tell" her friends that her imagined rival is only a doll, Swanilda points to the doll, makes the jerky-arms gesture, and laughs in dumb-show: the gesture "stands for" the whole gesture of laughter, which includes sound. (The ring is of course the metonym—an associated element standing for another one—for marriage: how Peirce would have loved this, symbolic object taking on all the semiotic weight of the situation when the only thing that can be shown is the object.)

All the dolls speak this same movement language, from Coppélia herself to the Chinese, Scottish, and Wizard dolls Swanilda pushes over and sets in motion. A twirling motion behind the back indicates winding up with a key (think how puzzling this would be if it did not cause a quiescent being to spring into motion). Doll-movement has to be sufficiently like human to be recognizable, sufficiently unlike it to "read" as drawing on a separate movement vocabulary. Needless to say, no real person would ever be fooled by mannequins moving with such jerky movements as these, but if they're good enough to be believable to the "real" characters, they don't seem different enough to the audience. The vocabulary is for us, not for the characters in the diegesis.

Coppélia, I should note as an admonition to the too-light performers I saw (Yan Chen was better than the foppish, almost fey Parrish Maynard) is not only a fun ballet, it's a great one as well. Based on one of E.T.A. Hoffmann's spooky short stories, *"Der Sandmann,"* about a traveling salesmen whose eyeglasses have functional eyes in them, it's a version of the Pygmalion and Galatea myth, a meditation on the *Unheimlichkeit*

(creepiness) of almost-human creatures like mannequins and robots, and a commentary on the Frankenstein story, our own human desire to play God by creating life. The moment when Coppélius, "stealing" (as he believes) the life from the organs of his captive Franz, transfers the force to his doll (actually Swanilda in doll disguise), is potentially one of the most touching moments in ballet, perhaps largely because of Delibes's magical stardust-and-suspense chords. Here it just seemed dumb.

All of this altered my perception of the *Theme and Variations* that closed the program of shorts. The performance was perfectly all right, although and Stiefel, the leads, lacked the majesty necessary to making this work truly transcendent. At the time, I was glad I had not been required to sit through a performance by the peppy Corella, cast on opening night, who, according to reports, danced the sublime Petipan Balanchinisms as if they were circus turns. In the context of all the other dance languages with which these programs had been peppered, the turnout that is at the basis of the classical ballet once again took on the meaning it sometimes loses of fearlessly opening up the lower body to the viewer; the upright but not stiff carriage of the upper body oozed royalty; the extension of a hand became a sign of aristocracy. The vocabulary itself, in other words, was once again expressive, making clear its own status as a sign-system: a step in the classical ballet is like a step in the real world, but not identical to it. A leap is not a leap in the world, but its second cousin—but because that's all there is on the stage, we "read" it as taking the place of the more mundane movement.

Not that all ballet movements are visibly connected to street movement: indeed, so far are they removed that it was a gesture of great rejection for Martha, drawing on the German modern dance tradition, to put her dancers on the floor, or for Paul Taylor, drawing on his avant-garde beginnings, to incorporate walking and running into a mainstream work like *Esplanade*. And what does a fish dive correspond to in the ordinary world, save perhaps circus acrobatics? It's not a one-to-one line-up: we accept the fish dive because we accept the supporting of the woman by the man (which does have equivalents in the real world, metaphorical as well as real); it clearly goes several steps beyond this even in the language of ballet. Because we accept the baseline of movement vocabulary, we can process motions that "read" as superlatives of it.

Systems of signs, each movement taking on its meaning from the things around it that are part of the same system, odd when perceived outside of it. How amusing it is to see fifteen-year-old bunheads at intermission with their

turnout in heels glides over to the candy stand! Some of the signs in dance, to be sure, have "iconic" significance, direct relation to the world outside of them; others work only in context. It all made me nostalgic for the old days before gender and race took over as the only acceptable topics of conversation. Saussure, anyone?

DanceView 1998

Marie Antoinette and the Joffrey Ballet

IT IS 1973. TWYLA THARP'S *DEUCE COUPE*, set on the Joffrey Ballet, explodes on the dance scene: popular culture has finally made it uptown. The Beach Boys pulse through the theater, the dancers are all quivery speed and rubber legs, a group of spray-can-wielding subway car painters create the backdrop of graffiti. The gap between museum culture and popular culture has, it seems, finally been bridged. To some delighted viewers, indeed, it may have seemed that a new age was dawning, seemed that, in the image of German 68ers, the "cobwebs of a thousand years," or a couple of hundred anyway, had finally been swept away.

Deuce Coupe wasn't Tharp's first dance inspired by and paying homage to popular styles or American culture in general, but it was her first hit for a ballet company. *Push Comes to Shove*, for American Ballet Theatre and Mikhail Baryshnikov, soon followed, as did many more. Meanwhile the Joffrey Ballet continued its search for the fountain of relevance down the endless byways paved with the excruciating ballets of Gerald Arpino, programming relieved by revivals of early twentieth-century works. Yet *Deuce Coupe* remained a watershed.

Before Twyla, it seemed, the two main "schools" in American dance were Martha's Greek agonies and Balanchine's sleek neoclassicism. Now we can see the influences of Broadway and African-American (as well as African) dance on Balanchine. At the time, his permutations of Petipa-era technique seemed ascribable to the more imprecise influences of "American energy" or the wide open skies of the New World, whatever influences he picked up from the world around him having been transmuted into ore so pure it seemed almost *sui generis*.

Flash forward to the 1990s. Dances that spoof or pay homage to popular culture are so ubiquitous that their eyebrow-raising potential is nil. Even an

Olympian like Paul Taylor makes *Funny Papers*, to comic book themes, or *Sea of Grass* that opens with a dancer in bell-bottoms puffing on a joint. The Joffrey, in search of its lost youth, not to mention financial solvency, hits a financial jackpot with *Billboards*, a rock-and-jazz-inspired triptych by a trio of showmen whose drawing card was that it is set to music by the artist now known as TAFKAP (The Artist Formerly Known etc.).

Downtown, countless small companies perform pieces that skewer, somewhat predictably, the nefarious effects of television on our collective psyche, the impersonal nature of the corporate world, or the existential nature of youthful existence. Performance art, threaded on a death-by-free-association narrative of the performer's life, thoughts, and preoccupations, seems intrinsically wedded to popular culture. Inevitably pieces are centered on one person, who regales us with the minutiae his/her life while (pick one) snapping his/her fingers, running about the stage grasping after invisible flies, sticking holes in his/her body, or (as I experienced one evening of wretched memory) sitting at a table over which is suspended a plucked chicken that drips occasional drops of blood onto the guttering candle beneath. Of course, the culture that is referenced may not be so much popular as merely quotidian (the distinction is a fine one), and somewhat predictable. Performance artists tend to be one kind of person: much more likely than the average, for example, to be urban, marginalized, full of unrealized dreams, living in cold-water walk-ups, gay, and coping with the problems of youth. A sixty-five-year-old American Legionnaire from Topeka—now *that* might make for an interesting performance piece.

Yet the fact that we have lost the sense of revelation we once had in seeing popular culture on the stage means that we can for that reason hope to begin putting it into perspective. Dance in America, back then (it *seems* so long ago, somehow, well before our time of post-post-dance-boom woe), was undergoing a change the visual arts had undergone a decade earlier, when Robert Rauschenberg incorporated newspapers into his collages, Andy Warhol painted Brillo pad boxes, and Jasper Johns re-created through brushstrokes laden with loving irony that most banal of all middle-American icons, the flag.

Literature was undergoing something of the same transformation at about the same time as dance. Thomas Pynchon, in *V*, *The Crying of Lot 49*, and then his masterpiece, that most monumental of 1970s novels, *Gravity's Rainbow*, was incorporating turns of phrase from real speech and graphic descriptions of death, destruction, and defecation that had hitherto not found their way to the page. In his incorporation of popular culture he was, in a

sense, taking one step farther Nabokov's acid-etched descriptions of the string of fading motels where Humbert Humbert departs in futile flight with his step-daughter Lolita, that rotten-on-the-inside land of milk and honey contemplated with such desperate awe by the author's string of emigré Russian aristocrats. Pynchon had as his progenitors the Beat poets of the 1950s as well, filling their poems with references to sexuality and quotidian objects up to and including the kitchen sink. Kindred sensibilities were Kerouac's drifting malaise, James Dean's apparent "cool," and Salinger's rejection of "phoniness."

In the world of cultural reporting, there was change as well, in the form of the "New Journalism," exemplified by Tom Wolfe's breathless romps full of colloquialisms that seemed to have swept away once and for all, in an exuberant tidal wave of manic word-smithing and crushing don't-even-think-of questioning-me irony, the banalities of who-when-what-where reporting.

Finally, in the 1980s, popular culture breached what may have been the last and most daunting barricade: academe. Under British Marxist influence, Cultural Studies was born as the latest, but surely not last, in the now dizzying succession of lit-crit "isms" that fret and strut for their fifteen minutes, get their practitioners tenure, and then exit, as if pursued by a bear. Or rather, fade away, hibernating in the cracks of English Departments in small colleges where decades later their defenders are stumbled on by unsuspecting freshmen, like Japanese soldiers unaware that the war is over who emerge suddenly from the jungle, preaching the homilies of their more hirsute youth. It is difficult to believe that bell-bottoms and long straight hair were once the cat's meow in fashion. But they were. Similarly, proposing during the 1970s that we consider something *sous râture* was enough to send chills down the spines of lit-crit types, with-it *rive-gauchiste* adherents of Derrida and de Man. And for an earlier generation it was the invocation of "complexity"and "ambiguity" that made the heart beat fonder.

Cult Stud types, as they like to call themselves, write about every possible manifestation of popular culture: Tinker-toys, TV, and take-out food, with their all-time favorite subjects apparently being Barbie (the doll) and Madonna (the singer). (I recently overheard a mother in the National Gallery in Washington, responding to the question of her young son who had just read the label of the Gallery's Giotto and leaned up to ask her for clarification: "Not *that* Madonna, honey.") For the Cult Stud people, everyone and everything is an "icon," as all objects of study for an earlier lit crit era were "discourse" or "text." Cult Stud-ers inevitably lean, or positively tilt, to the left in the canon debates. They are, after all, studying

dolls rather than *A Doll's House*, comic book heroes rather than the Attic New Comedy.

Contemporary academic interest in popular culture takes off from the deconstructionist assertion that all written works are *écriture*, an endless murmuring stream in which all writing, no longer secondary to speech, presents a polyglot braiding of influences in which the feeble attempts at control by individual authors, who are now by definition dead (Foucault's most quoted dictum), barely ripple the surface. It tends to see groups rather than individuals, products of consumption rather than isolated New Critical art works. Anything done by individuals is, well, only individual. Anything done by large groups, by contrast, is a trend, something worth remarking. Cult Stud people tend to believe that bigger, or at least more numerous, really is better.

Movies too, one of the greatest caches of popular culture artifacts, went through their self-referential phase in the 1970s and 1980s, when film school graduates (Lucas, Scorsese, De Palma, Coppola) ruled the roost. Back then movies were dotted with references to other movies, movies from comic strips, movies of TV shows: popular culture about popular culture. This sensibility seems largely to have run its course. Now we have hip, where people do riffs: John Travolta's meandering monologue on the Big Mac in *Pulp Fiction* stands as a benchmark of the sensibility. Broadly speaking, Hollywood has ceased reflecting on popular culture, and gone back to merely being it.

It would seem, in sum, that save for the holdouts of the intellectual right in our country, forlornly grasping after "standards" or defending the place of Shakespeare in the canon, the world we live in has definitively destroyed the distinction between high and low culture, the latter now forevermore integrated into the former, high now free to speak the language of the streets and low a worthy object of consideration by tenured professors.

Even the way we dress now seems to reflect this late-millenarian hodge-podge that is so liberating to some, so threatening to others. A casual glance around the audience at the Kennedy Center in Washington on any given night at the opera or ballet will find as many blue jeans as dress-for-success suits, with some men in T-shirts and even a handful in black tie. Anything goes; the old divisions are down. I know what the rules are, our way of dressing—or living our lives—seems to say, but they are no longer even threatening enough to be worth rebelling against. Instead, we alternate abiding by them with not doing so: no sweat, one choice is as good as the other, as subjective

and ultimately meaningless as once the businessman's choice between one white shirt and another.

Or at least, this is the view from the castle, the perception of those in the ivory tower of stage dance or academe. What we tend to forget in our very hipness, concerning works including or influenced by popular culture, is that they themselves aren't popular at all. They're still expressions by the elite for the elite. A scholarly paper read to four people in a stifling hotel conference room is still a scholarly paper, whether its subject matter is Princess Di or the *Princesse de Clèves*. (A paper on Princess Di will probably draw more than four people nowadays, so aspiring Assistant Professors would be well advised to pick the more contemporary subject.) A performance piece where the performer bitches about the poor ventilation in her minuscule apartment and what a jerk her boyfriend is remains a piece in a black box for a few rows of supportive audience members, most of whom probably know the performer, and who aren't paying enough collectively in admission to put a dent in the hall rental. Whatever "popular" elements are included in those artworks that are apparently calculated to get Senator Jesse Helms's increasingly superannuated, dyed-haired goat, the result is not itself popular: it's still something that aspires to end up on a pedestal to be contemplated in silence, or be listened to respectfully by people sitting in the dark. And that means, for the tiny minority.

Despite appearances to the contrary, therefore, there has in fact been no bridging of the gap between high and low, popular and elitist art forms. What there has been is merely an inclusion of popular culture as subject matter. Popular culture may have been the flavor of the quarter-century in the high arts, but there has been no fusion between high- and lowbrow.

Indeed, like the now demonstrably-widening gap between rich and poor in America, the chasm between popular and elite culture has gotten bigger. And this widening has not worked to the benefit of the high arts. The market for serious literature has shrunk to minuscule proportions (ask any small publisher), virtually all dance companies in this post-dance-boom time lead hand to mouth existences (the downtown sorts always did), and new classical music, most of it roundly rejected by concert audiences, has retreated behind the walls of the university.

Perhaps it is for this reason that those still aboard the ship of the high arts are so eager to think of themselves as reaching out to the masses, as a choreographer in New York who incorporates movement from a non-Western culture diminishes her sense of isolation by telling herself, and us, that she is being influenced by "world dance" (she may have stolen some moves from

an all-night Indonesian dance drama based on the *Mahabharata*, but the fact is that she's putting it on in a black box, or if she's lucky, on a real stage, in a concert that lasts an hour and half beginning at 8 p.m. that charges admission and that she hopes will be reviewed in the *Village Voice*.) Reaching out to the world of Barbie dolls doesn't decrease the isolation of the academic world; if anything it probably increases it. At least the function of academia was clear so long as it stuck to its clearly separable subject matter: they were the people you went to if you needed to know about Shakespeare or Spencer, Thomas More or Thomas Aquinas.

Mondrian's *Broadway Boogie-Woogie*, as the critic Robert Hughes points out, seems like a riotously jazzy painting only if you consider it in the context of previous Mondrian grid-and-primary-color arrangements. To the world outside, it's still an arrangement of squares, hanging on a wall. Paul Taylor making a dance about comics only seems cute when we see it as a Paul Taylor dance about the comics. Charles Ives's earlier incorporation of patriotic tunes and hymns only makes sense as another way to write classical music.

The current scene may be described as the cultural equivalent of the Grand Canyon, the image exploited by filmmaker Lawrence Kasdan for his eponymous movie to emphasize the split between rich and poor. On one side of the divide, carloads of entertainment commodities made to flatter people weary from a day's work and fueled by the profit motive, created by specialists in What People Want; on the other side of this now-yawning gap the tiny island of individualized products still conceived of within the now-centuries-old Romantic nexis that allows us to see them as expressions of individual artists rather than as mere merchandise, made (or as we still say, "created") with the understanding that the artists' pay will at best be eternal glory rather than a Porsche and a mansion in Beverly Hills.

Fissuring in this way, our culture may only have come full circle to something approaching the pre-modern, which in some ways is synonymous with pre-Romantic, era. It is clear that when Marie Antoinette and her handmaidens, back at the end of the *ancien régime* when kings were still thought to have been put on their thrones by God Himself, played at being milkmaids at Versailles, high culture was slumming: referring to low or popular culture, not becoming it. Before the Revolution, we may say, high and low were utterly separate, with no one even thinking of this as a gap that needed bridging. The vast masses of the pre-industrial people, after all, weren't even in the running to appreciate, say, the plays of Molière or the music of Lully, which of course they couldn't have gone to hear if they had

wanted to. Change came slowly, even in countries where the *ancien régime* never had the power it did in centralized France. Beethoven, we know, was the first composer to make a living from performance of his works, rather than writing for the patronage of the courts. But even so, this was an expansion of support base no farther than into the now-public theaters and concert halls of the merchant class. German interest of the late eighteenth and early nineteenth century, say Herder's interest in folk poetry, or the Grimm Brothers' collections of folk tales, reflected an intellectual interest of the educated, not a true fusion of haves with have-nots.

It was in England and Scotland, those crucibles of the Industrial Revolution, and not coincidentally parts of a constitutional monarchy rather than an absolute one, that the arts of the rising bourgeoisie developed to the point where they offer, if only briefly, the vision of a world where great art could be synonymous with popular art: Dickens is frequently cited here as an example of an artist who, despite a sentimentality embarrassing to twentieth-century sensibilities, wrote truly great novels and made an enormous amount of money doing so, went on world-wide lecture tours that drew throngs, and was asked for opinions on as many subjects as only movie stars are asked to expostulate upon today.

And then, somehow, the great parting of the ways. The bourgeois arts (of course we are still not talking of works that drew the laboring class, by far still the majority in their respective societies) somehow disappeared with modernism, begat on the late Romanticism of Francophone Symbolism (Mallarmé and Maeterlinck) or English Aestheticism (Wilde and Beardsley). Edmund Wilson's prescient 1920 study of writers we would later call modernist, *Axel's Castle*, cites the almost-eponymous poem by Villiers de l'Isle-Adam (*Axel*) where the hero retreats to the ivory tower (the source of this image) and issues his famous pronouncement that "as for living, our servants can do that for us." Modernism, he believed, was the inheritor of Symbolist isolationism, a belated Romanticism rebelling against the ugliness of precisely that industrial capitalism that made wealth and literacy so widespread.

Now that our capitalism is post-industrial, the notion of another economic alternative has disappeared with the Evil Empire, and Coca-Cola disappears down the pampered throats of the world's clothed-and-fed from Bombay to Bangkok, from Yokohama to Yalta. The more successful our democracy is in producing general wealth and giving people what they want, it seems, the more our world will be dominated by products whose only purpose is to entice money from people's pockets. The uncomfortable truth

is that human beings, by and large, will only pay for things that make them comfortable. Coca-Cola may taste good, but nobody ever said that it had any nutritional value to go with all its empty calories.

On one hand the arts of the elite, on the other hand the arts of the masses. Which means, the arts made for the masses by the capitalists.

The realm between the two may not be completely barren, of course. Solid middlebrow entertainment is still produced, such as quality Hollywood movies (defined nowadays as those particular adrenaline pumpers that have a halfway human premise, or have been worked on by a competent writer). The current *L.A. Confidential* comes to mind. Perhaps its equivalent in literature are thrillers (for men) or the better-quality romances (for women), best-sellers rather than books in series with Fabio on the cover.

The arts of the elite, however, will never become popular culture, whatever they take as their subject matter. Should the elite, such as all those reading this must willy-nilly acknowledge themselves to be, retreat into their towers, letting the characters in soap operas do their living for them? Should intellectuals simply give way to the power of the marketplace, forgetting that the marketplace is in fact manipulated by sharks without consciences out to make obscene amounts of money so they can buy themselves another trophy wife? Is there not something paradoxical—no, horrible—about a Hollywood producer out for his next billion evoking the taste of The People as a justification for unleashing another improbable roller-coaster of gore and emotion to multiplexes everywhere?

We need not buy into the snobbish anti-populism of the Frankfurt School to feel queasy with the idea that capitalism, by giving people what they want, necessarily leads to people getting what they would be better off without. Vance Packard pointed out in the 1950s that the presuppositions of Adam-Smith-style theoretical capitalism were shot to hell by the fact of advertising: far from filling needs, companies were in the business of creating them.

What to do?, as one says in Indian English with a shrug of shoulders and an apparent cold in the nose, "whad do-do?" Perhaps, echoing the words of Rabelais, what you will. Just let's not kid ourselves that by analyzing bodice-rippers rather than Baudelaire or making dances where someone talks about the subway and the pipes that make popping noises in the night rather than practicing our pirouettes, we're somehow reaching the world outside.

"Be embraced, ye millions," wrote Schiller, and Beethoven set it to music for chorus. It's a hope that's dead in the water, at least for the likes of Schiller and Beethoven. Romanticism has run its course. Now we're back in

the world of Marie Antoinette and her milkmaid princesses. We've gone so far the old is new again. Deal and chill, children, deal and chill.

Dance Critics Association News 1997

Text and Transmission: A Summing-Up

DANCE IS DIFFERENT FROM ALL the other arts in that it lacks a text.

When a stage director decides to put on *Hamlet* or a play by Tom Stoppard, he or she simply distributes copies to the actors. When an orchestra conductor announces a Shostakovich symphony or a new piece by John Adams, the players get their parts, which are written down together in the score. If an art historian wishes to make a point about a painting by da Vinci or a collage by Robert Rauschenberg, he or she does so by going to the piece itself, or by studying a photograph. All the arts have their texts—objects which, fixed in one form or another, can be referred to, reproduced, brought to life, or otherwise given the borrowed life of attention to the product that is our homage to the creations of others.

But not dance.

In the spring of 1994, the San Francisco Ballet put on a new version of *Romeo and Juliet* that was credited to the troupe's artistic director, Helgi Tomasson. Where did Tomasson go to find the text to put on? Did he simply go to the dance section of the library and check out a score of the ballet? Scores of the Prokofiev music to which he set the work do exist, and with excisions and elisions, this music is what the audience heard. A press release listed exactly which sections were omitted. Where was the list of what was omitted or elided in the dance score? So too, Shakespeare's play exists in textual form, in several versions. But this was a ballet.

The program said "choreography by Helgi Tomasson." Did Tomasson simply start from scratch? Was this a completely new work? Was his text Shakespeare? Or was it Prokofiev, whose music is divided into programmatic scenes in which specific events audibly happen in a specific order? If so, what to make of the fact that many parts of the work looked suspiciously (or comfortingly) like the first full-length version of 1940, that of the Soviet choreographer Lavrovsky?

The oddness of ballet transmission can, perhaps, be made clear by considering how unpardonable we would think it if we went to the theater to

find a stage director putting on a version of hits from *Hamlet* with fill-ins made up for the occasion, signing the whole thing as his or her own with not the slightest mention of Shakespeare. (Even worse might be the same program that *was* ascribed to Shakespeare!) Yet this is exactly what happens many times a season in the halls of major dance companies.

That spring also brought the world premiere of another full-length ballet, Anthony Dowell's version of *The Sleeping Beauty* for London's Royal Ballet. In this case, the choreography was credited to Marius Petipa, who choreographed the original ballet in St. Petersburg nearly a hundred years ago. Footnotes added the information that specific scenes and sections were by Feodor Lopokov, as well as Kenneth MacMillan, Frederick Ashton, and Dowell with Ashton. This, at least, acknowledged textual sources—or what seemed to be text. Where did Dowell go to find this original choreography by Petipa and the somewhat later additions of Lopokov? Where did he go to get the English additions? What library? What file?

For those outside the dance world, it would certainly be unsatisfying to know the truth, which is surely that he just appealed to people who had danced earlier versions of *The Sleeping Beauty*, himself included. Before, say, the mid-twentieth century, it would seldom have occurred to anybody to keep a record of choreography for any reason but that of mere memory jogging. Dances were put on to be consumed in the presentation; they were revived with new steps, old bits that the dancers remembered, and the constant links of plot or premise. And this is still the way that story ballets, by and large, are put on today, even ones as recent as from 1940.

By the standards of the other arts, the strange thing about dance transmission before our own era (and well into it), is that it is like a version of the party game of "Telephone," where one person tells the next and this person the next. The point of "Telephone" is always to see just how divergent the last person's understanding is from the original message. It's a miracle that anything at all survives of the original conception. With all the middlemen and possibilities for error, we usually have less than a clear idea about what is original and what isn't, what was added when and what is from the first production.

Dance scholarship, a burgeoning industry in the late twentieth century, searches for notes, annotated scores, critical reactions, recollections of dancers—anything that helps us say what the original version of ballets, now largely lost or performed in mutilated versions, were. The Anglo-American pair of Kenneth Archer and Millicent Hodgson has, for example, come up with versions they claim to be authoritative of Nijinsky's original *Rite of*

Spring based largely on rehearsal notes. If it isn't what Paris audiences saw at the piece's celebrated premiere, it may be as close as we'll ever come to it. More survives of his *Afternoon of a Faun* (which is regularly identified in programs as being choreography by Nijinsky), yet recent scholarship has suggested that what we have been seeing diverges from the original in several important ways.

This scholarly patching together of recollections and notes with fill-ins of the rest has its detractors. Some critics and scholars think such reconstruction is positively pernicious; they say that largely invented versions based on speculation that claim the spot we assign in our imaginations to these seminal works are worse than nothing at all. We think we're getting *Rite of Spring* and are getting something else entirely. Moreover, it isn't just in the steps that we can go wrong in modern performances of long-dead works. Even when the steps of a work can be remembered, it may be that the way the work is currently performed misses its original point. Once again the audience will think that what they see is historical fact, when all it really is is a ballet of our own time and place—a mirror, in other words, rather than a window to another world; a new ballet rather than an old one. Some people think, as a result, that works shouldn't be revived. If there's not an unbroken line of transmission, we should treat them as dead.

Yet who says that original is necessarily best? *Swan Lake* was less than a resounding success at its first performances; what has come down to us is the revived version with (as most people accept) the "white" acts by Petipa's disciple and successor at the Maryinsky Theater in St. Petersburg, Lev Ivanov. Should these be stripped from the stage? We're used to the multiple layers of transmission. What, similarly of Balanchine's multiple versions of works? The New York City Ballet currently performs two versions of *Apollo*, one with the Prologue and one without.

Though we have difficulty telling the dancer from the dance, we do not have a similar difficulty telling the actor from his or her lines, or the violinist from the concerto being offered that evening. Alone of the arts, dance is a messy, all-too-human passing on of bits and remembered phrases, with continuity between one production and the next frequently only the title.

Which is why it is sometimes so unclear whom we should ascribe the result to. In San Francisco, the choreography to this particular *Swan Lake* was "by Helgi Tomasson," despite the fact that what the audience saw was heavily determined by Prokofiev and Lavrovsky. In the Royal's *Sleeping Beauty*, the troupe's director was more modest, claiming credit only for "production" and assigning choreography to Petipa.

The Royal's printed program meticulously ascribed various sections to specific people who had been involved in productions subsequent to the first. But these interjected sections, like those sections ascribed to the long-dead Petipa or Lopokov, were taught to the dancers by other dancers who remembered them (both Ashton and MacMillan now being dead as well). Productions to come will wreak their small changes, so that a printed program for this piece a hundred years from now may well have a list of credits longer than even the advertisers in it, and many people (dancers, directors) who changed a bit here or a step there will remain uncredited. We can never have a theoretically complete list of those people who have affected the thing we see, because it has passed through too many hands.

The fundamental textlessness of dance as an art is not to be confused with the willful putting aside of text in certain specific expression forms—jazz, for example, or its dance equivalent, contact improvisation. Forms like these do not lack a text, they reject it: they are overtly unrepeatable and made to be such. Nor do we go to hear jazz piece X; instead we go to hear specific people play. We do not ask for the "same" contact improvisation piece; instead we merely watch things unfolding before us. Yet we do speak of going to see *The Sleeping Beauty*. In what sense is this a fixed thing? What, in other words, does it mean to *say* we are going to see Ballet X?

With the full-length nineteenth-century story ballets, it usually means a ballet that tells a familiar story, or at least some version of it. (Versions of stories are as tenuously linked as versions of ballets.) We expect the two lovers to end up dead in *Romeo and Juliet* (although some choreographers have played with the idea of a happy end), and the princess to be awakened by a kiss in *Sleeping Beauty*. (In the Royal's version, the Prince didn't have to hack down the thorn hedge, and was so naive that the Lilac Fairy had to tell him to kiss Aurora to wake her up. Is this the "same" story?)

Going to see Ballet X may also mean a production that makes a link with previous productions through other factors. In the case of *Romeo and Juliet*, this is usually through the Prokofiev score, although Tudor did a one-act version under this title to music of Delius. In the case of *Sleeping Beauty*, it is usually through Tchaikovsky's music, although this may be manipulated and re-arranged with impunity. In some cases, it seems only the music that makes the work we see a version of others we have seen before. Mark Morris made a work called *The Hard Nut* (with a scenario based not on the Russian ballet, but on the E.T.A. Hoffmann short story on which the libretto for the original ballet was itself based). It is about a dysfunctional family set in

cartoon-inspired black and red 1950s settings—but does use the same Tchaikovsky music and is set at Christmas. Is this *Nutcracker*? Or something different? John Neumeier's ballet to the same music preserved the familiar title but eliminated Christmas altogether: the nutcracker the little girl usually receives as a present became a pair of toe shoes given at a birthday party; the Sugar Plum fairy is a ballet dancer, and the dream kingdom into which she leads her charge in Act II is a ballet studio. When the "tree-growing" music begins to swell from the orchestra pit, precisely nothing happens on stage. Is this a version of *Nutcracker* (despite the title)? Or another ballet?

The same question may be asked of this season's big success, Donald Byrd's *Harlem Nutcracker*, which uses Duke Ellington's arrangement of/take-off on the famous suite from the full-length ballet (many people think the title of this ballet *is The Nutcracker Suite*) for music. Act I has the traditional holiday party with a big punch bowl, but Clara is old, revisits a Harlem nightclub from her youth in Act II, and dies at the end.

No one can say for sure whether these are new ballets or versions of old—or rather, we can make a legitimate case for either alternative. Dance transmission is anything but clear-cut, and for some people (although it seems least of all the audience, that usually only wants a good time) this is a source of great frustration. Some people wonder why it is that dance should be content with this sort of approximation, that causes dance scholars of subsequent generations such sweat and travail. Wondering why something is so is the first sign of a resolve to change that situation. In the twentieth century, we've developed notation systems, and increasingly many works are "revived" (as the indicative verb tells us—literally: given new life) using scores in Laban notation, the most popular of those available. These are read something like a musical score, and notate the positions of the dancers' limbs and bodies at any given beat of the music.

Notation is problematic, however: three different notators producing a score for the same performance will produce three slightly different results. Each may be valid, in some sense, but each is an interpretation, not brute fact. It's a bit scary to think that history will take this one particular turning in the garden of forking paths as an absolute given, something that must be returned to again and again.

The most popular notation system in use today is, however, not the stick men and flag blocks of these schematic systems on paper, but video. So easy is video to use (in its most rudimentary form, you just push a button and aim the camera), it might seem that the technical innovation of video would have

eliminated the approximate nature of dance transmission with which the world has been saddled for centuries. From now on, some have argued, we will be able to transmit dances as they really were, preserved for future generations and in their pristine purity. In video—technically refined, easy to use, and relatively inexpensive—it seems that dance has finally found the medium of its text.

Or then again, perhaps not. Video, most clearly of all the notation systems, is a record not of a work, but of a specific performance of a work—determined by all of the infusions of sensibility, the slight alterations, and the personal interpretations of the particular dancers, lighting people, set designers, and company directors who put it on. Video preserves not the eternal dance, but its shape at one particular moment in time. And it may not make sense to try to preserve for eternity the way that the fragments within the kaleidoscope fell on that particular night in the theater or that afternoon's taping session in the studio.

Moreover the video camera, like the electron microscope, is far from being a neutral observer. As the theoreticians of quantum mechanics noted in the earlier decades of the century, we can by definition never know about the position of electrons in the atom because the instrument we have for looking at them, which bombards its object with a stream of electrons, blows away the very evidence it would allow us to look at. The subjectivity of vision: this is a notion that has filtered into late twentieth-century disciplines of all stripes, from anthropology to literary criticism. And into dance as well. The camera's eye alters what it sees, flattening it, looking selectively—so that confusing the product on a tiny box with the dance itself seems doubly dangerous.

Most choreographers do not like anything between themselves and dancers, and so will never be willing to create the text first. The nature of dance is movement, and choreographers are understandably reluctant to give up their contact with moving bodies. These bodies are like the clay into which a sculptor digs his or her hands; try telling that sculptor that it is necessary to make a sketch first. Furthermore choreographers frequently make the steps they do for particular bodies, and let themselves be guided by the possibilities of those bodies—a symbiosis of movement and performer far closer than that even of, say, a playwright who creates a part for a specific actress, or a composer who makes a score on commission to a particular performer. In the case of a written text, the words or notes remain the same: how to designate the similarity between two performances of the same motion?

All this would seem to render impossible any attempt to put on the "same" dance twice, as the pre-Socratic philosopher Thales noted that we can never step in the same river twice. Yet this is only half the picture—the picture with ballets based on stories, which is to say, most ballets prior to the twentieth century and many of our era. In non-narrative works, the steps are not merely the means by which the story is transmitted, but the very warp and woof of the work itself. The point of a "swimsuit" Balanchine ballet, or of a Graham re-telling of a Greek myth *is* precisely these movements, in this order, to these notes, and performed in these ways. What you see on the stage *is* the work, the way everything in a photograph is part of the art object. Nowadays, we are surrounded by dances whose transmission we take very seriously indeed. Take, for example, the fact that the technique of Martha Graham has been copyrighted. The technique, that is, not even the works! Or that companies who wish to put on versions of ballets by the century's greatest master, George Balanchine, must get permission to do so and be overseen by the Balanchine Trust. And the recent spate of articles by critics reacting to the way Balanchine is danced at the New York City Ballet today, fifteen years after the death of the Master, suggests that we are very concerned with fidelity to the original work, so long as the work is of a certain sort.

In modernist ballets, we need to see specific things on the stage for the work to be this work. Modernist dance was created by people as concerned with the surface of the dance object as painters or sculptors are with the texture and color of the object they produce. Story ballets, by contrast, are to a greater extent conceptual art—a kind of recipe that anyone can follow as he or she will, more or less closely. (It is interesting that contemporary plastic arts have re-invented this kind of conceptual artwork.)

To be sure, even we modernists allow the choreographers themselves to tinker with their works during their lifetimes: Balanchine changed costumes, titles, even whole sections of his ballets, as well as re-writing movements to fit the bodies of specific dancers. But we do not allow others to tinker similarly, either then or now. If Balanchine had three girls here doing pirouettes (unless he sometimes used six), we too want three girls doing pirouettes; Ariadne has to step over the rope in Graham's *Errand Into the Maze* in just this peculiar criss-crossing way, and not another way. The fact that these steps alter subtly from night to night, performer to performer, is why we place such importance in the choreographer being around to say: this variation is permissible, this one is not. When the choreographer is gone, the

range of permissible variations narrows, because we are afraid of making the call of too far or not too far ourselves.

Alterations wrought by time and diverse participants loom large in modernist works; in works of the nineteenth century they are to a greater degree taken for granted. Certainly we are left with a greater sense of deterioration and of helplessness before change than the similar erosion of story ballets, which can always be put on in a new version. Perhaps this sense of despair is the inevitable price we pay for dance whose surface is as tightly determined as a work by Balanchine—dance based on a pattern of specific steps performed in a specific manner. Seen in this light, the messiness of dance transmission in story ballets may not be so unappetizing an alternative.

DanceView 1997

Educating the Eye

STANDING OUTSIDE THE NEW YORK State Theater one spring morning a couple of years ago, waiting for a morning matinée of "Ballet for Young People" by the New York City Ballet to begin, I found myself as diverted, touched, and amused at the spectacle on the plaza as by anything I could hope to see inside. Lines of well-dressed New York City public school children under the eagle-eyed supervision of teachers were being funneled toward the main doors of the theater in what seemed to be a giant Benetton advertisement come to life. There were groups of adorable black children, adorable brown children, and adorable Chinese children, all in their Sunday best and on their best behavior. The one color that was conspicuously absent from this multicultural show was white. Yet how much whiter could an art form get than this quintessentially European one that they were all going to see? Was this conscious cultural co-opting? Or did this art belong to all? Despite more than twenty years of Dance Theatre of Harlem, questions such as these are far from dead, as the frequently acrimonious debate between critics of all colors at a recent Dance Critics Association conference in Los Angeles proved.

If what was going on was sellout and betrayal of cultural heritage, the children themselves, at any rate, didn't seem to think so. They sat enthralled while the emcee explained that all dance reflects its society, that our classical

ballet began in the courts of France, that turnout very probably found its origins in the aristocratic sport of fencing, that the works they were going to see were by a man named George Balanchine. Imagine yourselves as kings and queens, she suggested, and the thousands of children in the hall bowed to their friends to the left and right of them in the row, mimicking the two dancers on the stage. I was charmed. Everyone has the right to think himself or herself a king or queen at least once in life, I thought. There followed one of the most swoony performances that I have ever seen, by Darci Kistler and Otto Neubert, of the second movement of *Symphony in C.* The children oohed and aahed and even gasped at all the right places, and broke into tumultuous applause at the end. And this, I reminded myself, was only at the slow movement! Their reactions were even more animated for the electric rendition of *Tarantella*, offered by Katrina Killian and Michael Byars, and for the shamelessly beautiful finale of *Vienna Waltzes*, complete with tiaras and evening-length gloves. How natural it all seemed to these children, and, my misgivings outside forgotten, how delighted I was to see it. Get 'em young enough and anything is possible, I thought; this was education of the eye at its best.

Yet once back home, with the fold-out program poster of *Tarantella* tacked up on my bulletin board, it did not take me long to recall that, as a critic, I have often thought that such education of the eye has its drawbacks. In educating children's eyes to something like the classical ballet, after all, we are at the same time alienating them from the world in which they spend most of the rest of their waking lives. Classical ballet is rigorous. It is, we may even say, ruthless: if you get drawn in, so many other things begin to seem pale or pointless by comparison. The danger is always that you might like it too much. And then how would you cope with the chaos that seems otherwise to surround us? Or is it that the real cost is in human terms: how to cope with the fact that so many people around you seem perfectly satisfied with all those other things?

An October performance of the San Francisco Ballet at the Kennedy Center in Washington, D.C., forced me to muse farther on such questions. One of the pieces offered was a 1958 ballet by the Kirov choreographer Leonid Jacobson, called *Rodin.* I thought it rather aimless, perhaps at most an example of the rare "experimental" choreography in Russia in the 1950s. Each of its series of pas de deux started with a static, plastique-style clinch that was given the title of a well known Rodin sculpture. Yet in no case was the pose identical to the sculpture. The pair then moved, and at the end froze again in a spotlight. Sculpture come to life? No, and pointless even if it had

done this successfully. Pointless, that is, to my "educated" critic's eye. But evidently not so for the rest of the audience, which was more than appreciative, so that I went home feeling like a grump. After all, it filled the stage and more important, the evening; there was angst, there was eroticism. What did it matter who had influenced it? The girls were good looking and the boys intense. What more was there to want?

Well, the critic would say, a great deal. Nonetheless, it all made me wonder if we critics realize how completely irrelevant we are to practically all of the people involved in a dance performance. Yet it is we whose eyes are the most "educated." We have looked at so many performances and performers that we can say immediately and with great certainty that Miss X has a supple back or overarched feet, that Ballet Y is a lifeless spin-off of other more vital choreographers' work, or that while Ballet Z may be in the repertory to show off the dancers, it has no intrinsic interest as movement. (That we often disagree among ourselves on such matters gives us pause only occasionally.)

Yet such judgments are irrelevant both to the way the dancers perceive the work they are dancing and to the way the choreographers feel about their creations, not to mention to the way audience members see it from the floor. Furthermore, no one likes to open the morning paper to be told that what he or she had liked the night before was in fact second-rate junk.

My discomfort at this paradox flared up still more intensely a week or so after the San Francisco performances, at a program by Marta Renzi at Dance Place in Washington, D.C. During the first half, Miss Renzi performed what I thought was a reasonably interesting piece enticingly called *The Penguin Dictionary of Science*. In it she lay on her side on the floor while a voice-over read bits of the title book. She tried to hop herself up like a beetle on its back, twisted her bare feet into contorted patterns, and turned her arms into pretzels. After intermission, she did a talking piece, *Artichoke*, whose text, including responses to some staged questions from the floor and one or two spontaneous ones, included an explanation of the earlier dance. And it was at this point that I learned that the earlier dance had actually been about growing old and had included "crippled" movements.

No it hadn't, I objected silently. Maybe her thoughts while making the piece were on growing old, but that's not what we saw. Yet after the stamping and cheering that followed this piece, I melted. The applause, I thought, was reacting to the touching frankness of Miss Renzi's words, rather than either to the rather boring movement or the piece as dance. But who was I to deny the choreographer's cherished feelings about her work or

to "correct" the friendly viewers who had been touched by some aspect of it? I left feeling very alone. Educating the eye, I thought, is not a totally positive undertaking. No longer able to see the performance as a way of merely filling time or space, the educated eye constantly compares it with others it has seen, putting what is seen into the context of the remembered.

All of which made me wonder when education of the eye ceases to be a good thing. How educated should we want eyes to be? Company managers would say, enough to get the bodies into the theater, but not so much that they object when things on the stage are less than sensational. Most choreographers, understandably caught up in their own creative worlds, would say, enough to have them like my work. Dancers would say, enough to have them understand what I'm going through. It is only critics who will tell you that the eye can never be educated enough, but it may be that on this point, as on so many others, the critics are wrong.

Ballet Review 1993

Index

of Names and Titles

(Citations refer to the first appearance within a single essay.)